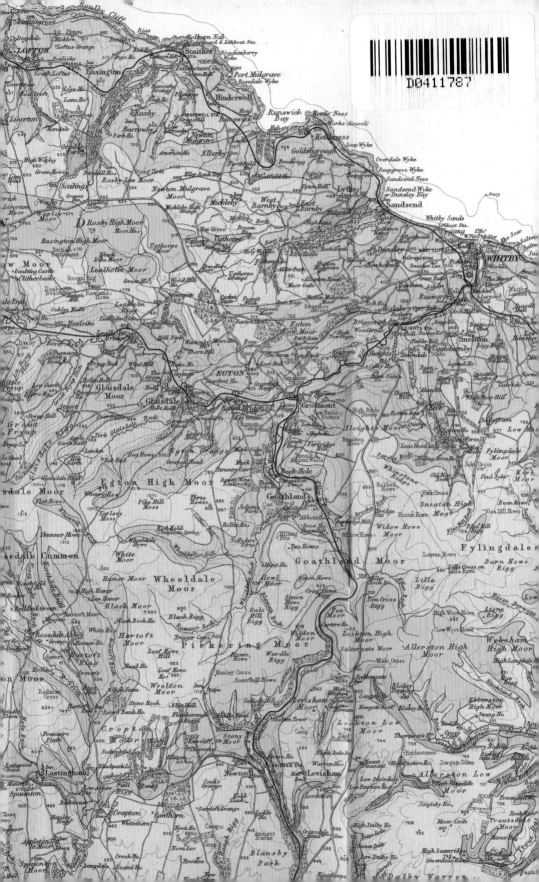

THE MOOR

THE MOOR

Lives • Landscape • Literature

WILLIAM ATKINS

FABER & FABER

First published in 2014
by Faber & Faber Ltd
Bloomsbury House
74–77 Great Russell Street
London WC1B 3DA

Typeset by Faber & Faber Ltd
Printed in the UK by CPI Group Ltd, Croydon, CR0 4YY

A CIP record for this book
is available from the British Library

ISBN 978–0–571–29004–8

FSC
www.fsc.org
MIX
Paper from
responsible sources
FSC® C101712

2 4 6 8 10 9 7 5 3 1

For my parents

It is human nature to stand in the middle of a thing,
but you cannot stand in the middle of this.

MARIANNE MOORE, 'A Graveyard'

Contents

Prologue

Bishop's Waltham

I

'I chose Bishop's Waltham Moors as a subject because I'm interested in the area and I'm concerned about its future.' This was the opening sentence of the GCSE Geography 'enquiry' I wrote at the age of fourteen. 'The aim of the enquiry', it went on, 'will be to discover what the state of the Moors will be in twenty years. Will it be the natural haven it is now OR will it be a landscape of red-brick houses with no wetland and therefore no springs and no river Hamble? OR will the springs dry up without the construction of houses and be lost to the water authority?'

It was typewritten with a hate-mailer's fondness for capitals, and scabbed with what used to be called liquid paper. On its cover was a collage of a kingfisher composed of carefully scissored pieces of coloured paper, and, in painstaking Letra-set, as if the question were the bird's: 'What is the Future of Bishop's Waltham Moors?'

The market town of Bishop's Waltham lies between Winchester's chalk downs and the London clay of the Hampshire coastal plain. Next to the bypass the mediaeval ruins of the Bishops of Winchester's palace still stand. We moved to the town in 1988, from commuter-belt Berkshire, my father having got a new job in Southampton. On one side of the road were the older houses, built in the twenties. On the other, the two acres of dense young woodland in whose centre stood a derelict bungalow, not long abandoned, its front room fire-blackened, the floorboards wrenched up, the windows smashed. A place where foxes went to eat.

At the end of the lane was the road to the next village, and across that road, not quite opposite the junction, a padlocked five-bar gate clogged with brambles; and beyond it not a lane but a narrow muddy footpath, flanked on one side by a ditch and a bank of dredgings, and on the other side by the adjoining house's overgrown laurel hedge. A hundred yards or so long, this path – and when it opened out, onto the first field, it was like arriving at a tunnel's mouth, and looking out on a new country.

The Moors was the name given to these few acres. The first field was meadow, ancient and unimproved: waist-high by late June, and hazy with flowering grasses. Scattered among the grasses were oxeye daisies and knapweed and yellow rattle, meadowsweet, dyer's greenweed and bird's-foot trefoil, and buttercups, and red clover – red clover dense along the path edge, vibrant with bees – and then, at haymaking time, over the bee-hum, the call of lesser black-backed gulls, circling, two hundred feet up.

The path continued down the meadow's edge, a narrow cutting in the sward, until you passed, beyond the left-hand barbed wire, the first of the two craters – not, as local legend had it, caused by Messerschmitts offloading surplus bombs on the way back to Germany (the Portsmouth docks were nearby), but a flint-pit of unknown antiquity, its sides grown with rowan and elder and oaks, its floor home to badgers and rats and, in summer, thick with wild garlic – thick with its thick smell, too.

A line of hazels marked the end of the first field, and then there was the second meadow – less abundant, less diverse than the first, dominated by rank grass. Marking the left-hand boundary of this field was a much denser and older rank of hazels, whose pollarded boughs formed a passageway too dense for anything but moss to thrive in their shadow.

The hazel hedge led to the far line of woodland – with its four-hundred-year-old boundary oaks and ancient boundary bank. And where the oaks and the hazels met was the way onto the moor.

The moor was the centre of this place, the moor was 'the Moors', but the Moors was also the meadow and the wood. The moor was hard to cross. It was mostly purple moor-grass, tussock sedge and rush; it was a pale, rough, unculti-vated place. Even in summer, when the pumping station was active, it was wet enough in parts to give you a trainer-full of slurried peat. Once, as in a dream, I mistook the stream that crossed the moor, with its unbroken surface of green-grey pondweed, for a footpath – out here, where no one came – and plunged to my waist. While the soil was acid, the springs that rose through it were chalk – alkaline – and therefore the moor supported not only acid-loving plants like orchids and even, on its drier tussocks, heather, but, right next to them, chalk species like cowslips and milkwort. I knew that if you added a splash of vinegar to a spoonful of bicarb it fizzed and foamed lividly. And yet here a kind of truce had occurred.

It was on the moor that I began to spend my dusks after school and my before-school dawns, and every weekend, and every holiday. At first I went alone, leaving the house before sunrise and padding across the silent road to the woods at the edge, where, in a wax jacket and an army-surplus scrim scarf, I set up Dad's camera on the Victorian brass-and-lacquer tripod that had belonged to my grandfather (the threaded tripod-hole on a camera's base has remained standard). Until the sun came up, I waited there, with my Thermos, and watched. Sometimes I cycled to the entrance at the other edge of the moor, camera in my rucksack, tripod strapped to the crossbar in its leather case. Occasionally I photographed a distant, enquiring roe deer that had briefly

wandered from the wood. Once, while I was waiting for a heron, a solitary man with a shotgun broken over his shoulder crept across the moor a hundred yards away, and stopped, and gazed, head tipped, into the scrub where I was lying.

Sometimes Dad came with me, and the two of us sat there as the sun rose, on striped camping stools, waiting for deer or herons or kingfishers. He puffed at his pipe (a lesson in the difference between smoke and mist). The hard tapping as he cleared its bole was answered by a woodpecker in the woods behind us. Usually we went home for breakfast having seen nothing but magpies and cows.

Naturally the Moors would be the subject of my 'enquiry'. It preoccupied me for months, though I had hardly thought about its one day being graded and its spellings corrected ('dovelopement', 'signes', 'bieng', 'wether'). One evening, after school, I fixed a row of bamboo canes in a stream's gravel bed, and over the following month went back every day and measured the water level against the centimetred notches. 'Portsmouth Water Authority has a borehole at Hoe pumping station and this is seen by many as the cause of the shrinking area of the moor,' I reported. The pumping station, in one of the fields adjoining the meadow, had been installed during the war to supply water to Gosport, with its naval base. Although over-pumping was apparently 'feircely denied by the water board' (their letter in reply to mine having been lost, its fierceness is unverifiable), my graphs recorded a lagging correlation between periods when the pumping station was active and dips in the level of my stream. I spoke to others who knew the Moors better than me – the couple at Suetts Farm, the council warden – and was told that, following those periods when the pumping station was active, the water levels on the Moors were seen to drop immediately, but would take days to recover. In the early 2000s, following the Moors' designation

as a Site of Special Scientific Interest, the pumping station was mothballed, and the water company was paid to go away and sink a borehole elsewhere. The water table rose and rose, until long-empty ditches became wet again, and the old watercress beds refilled, and parts of the moor that had been dry for years were impassable in anything but wellies.

The moor was not so extensive that you ever felt isolated; metres, rather than kilometres, a stroll rather than a hike. No more than a couple of football pitches. The rumble of the B2177 was always audible; on Sundays the bells of St Peter's seemed to sound from a dozen directions at once. And yet, in the land's instability and surprise, in the suddenness of its moods (underfoot was as quick as the sky), its impenetrable wood and flummoxing bog, and the sands that bubbled as the Hamble springs cauldroned through them, there was strangeness, and there was the possibility of death. When the tenants dredged the silted stream that went from the old watercress beds across the moor to the millpond, they uncovered six skeletons – the bones not white but black: Hereford cattle that had stumbled in, over the years. Animals unsuited to wet land like this.

It was soon after we arrived that the Moors changed. The site had been bought by the council, and the council and its volunteers, over one weekend, or so it seemed to me, came with miles of barbed wire and fence posts, and stiles and kissing gates, and fenced off the inner wood, so that only the perimeter footpaths were easily accessible, and bridged damp spots with duckboards, and erected 'interpretation boards'. The wood had become a place you viewed but did not enter – as if something dreadful had happened there. The moor, the place that the meadow and the wood led to, had been fenced off, too, and an interpretation board positioned at one corner. And that was where you were to stand and make your observations.

The Moors did not, at first, impress on me a human history. They were timeless – that was the nature of their tranquillity. The silted millpond and the choked watercress beds were not haunted ruins – you weren't conscious of any abiding ghosts. Any physical remnants were just inconsequential worryings of the Moors' prehistoric surface. It was only when I returned, as an adult, that I realised that, for instance, the moor had remained wet partly because the headwaters of the Hamble had been dammed, generations ago, to power the grain mill that still stood next to the road; and that the wood had only been prevented from smothering the open moor by managed grazing.

I was told by a local historian I spoke to when writing my enquiry that the Moors had a larger history, too – the kind found in books (though not many tell it). In the eighteenth century, the land southeast of Bishop's Waltham, which included what was now the Moors and extended to the ancient Royal Forest of Bere, had been the haunt of the 'Waltham Blacks', men who came at night, faces blackened with gunpowder, to plunder deer from the Bishop of Winchester's chase, and attack the land of gentlemen – breaching the heads of fishponds, burning hayricks and destroying young trees. Their leader called himself 'King John'. In January 1723 he was able to address, unhindered, three hundred locals at the Chase Inn on the edge of 'the more'. At the meeting, 'King John' announced that he and his men ('some in coats made of skins, others with fur caps &c.') 'had no other Design but to do Justice, and to see that the Rich did not insult or oppress the Poor'.

By the commoners, the Blacks were seen not as a posse of thieves and wanton vandals (let alone agents of Jacobitism, as the authorities claimed), but as defenders of their ancient customs of tenure – the right to collect wood and to pasture livestock – which were being curtailed by the Bishop of

Winchester's keepers. 'King John' was 'determined not to leave a deer on the Chase, being well assured it was originally designed to feed cattle, and not fatten deer for the clergy'. Such was the official fear of 'Blacking', which soon spread beyond Hampshire, that four months after 'King John's' address at the Chase Inn, the so-called Black Act was passed, 'for the more effectual punishing wicked and evil-disposed persons', making it a capital offence for anyone to appear in public 'armed with swords, firearms or other offensive weapons, having his or their faces blacked, or being otherwise disguised'. Seven of the Waltham Blacks were apprehended and taken to Tyburn. According to the account of the Ordinary of Newgate (the prison chaplain), the men failed 'to reconcile the greatness of such a punishment as death to the smallness of the crime, which was only making free with a few deer'.

I recognised this strange landscape in the novels I'd begun to read. In *The Hound of the Baskervilles*, *Lorna Doone* and *Wuthering Heights* moorland was 'ill-omened', 'sombrous', 'dreary'. It was a place of unreachable loneliness, the stage for sacrifice, exile and the outplay of grievance. It was a setting for love, and what came with love. It was a place of discarded symbols. It was wind strong enough to make a bull kneel. It was rainfall measured in the height of children. It was where you went to hide.

I pictured the Blacks arrayed across the moonlit moor, carbines cradled, eyes bright in their sooted faces, the still-warm hinds slung across their shoulders.

2

Twenty years later, living in London and finding myself with time on my hands (I'd lost a job and didn't want another), I

went back to Bishop's Waltham, and learned that the 'moor' was not a moor at all, but a fen, just as the wood was not merely a 'wood', but a 'carr' – a swamped wood. Both fen and moor are boggy and peaty, but while a fen's wetness comes from underground springs, it is chiefly the rain that falls on moors that makes them wet. Fenland is saturated from below, moorland from above. Like marshes, fens tend to be low-lying, while true moorland exists only at high altitudes, where rainfall is heavy. In England, therefore, moorland is confined to the southwest and the north.

The moors were first described in the seventeenth and eighteenth centuries, not by novelists but by horseback topographers and agricultural 'improvers'. They saw a god-less affront. For the Board of Agriculture's surveyor in 1794, Exmoor was 'a useless and void space'. Even the execrable 'Bard of Dartmoor', Noel Thomas Carrington, in 1826 chided the moor for 'shaming the map of England' with its barrenness. Charles Cotton in 1681 described the Peak District moors as 'Nature's pudenda'. The moors of England were apt for 'improvement'.

In *A Philosophical Enquiry into the Origin of Our Ideas of the Sublime and Beautiful* (1757), Edmund Burke cited 'great-ness of dimension' as a quality approaching his definition of the sublime – 'whatever is fitted in any sort to excite ideas of pain, and danger'. 'Privation', 'vastness' and 'infinity' were similarly capable of exciting such ideas, according to Burke's influential thesis. But a moor's magnitude, unlike that of a mountain or a canyon, was chiefly *lateral*. 'An hundred yards of even ground', Burke added, 'will never work such an effect as a tower an hundred yards high.'

Thomas Gray, who'd taken in the Alps during his Grand Tour, saw the Derbyshire moors in 1762 and complained that they were 'not mountainous enough to please one with

[their] horrors'. Yet nor were the moors beautiful: they were, according to Charlotte Brontë, 'far too stern to yield any product so delicate'.

Map the Romantic landscape, then. Beauty lay in the pastoral valley; in the mountains was the sublime – it was between those poles that the undesignated moor stretched out. In Emily Brontë's novel it is moorland that Cathy and Heathcliff must cross to reach lowland Thrushcross Grange, from upland Wuthering Heights. Over moorland R. D. Blackmore's Doones come galloping from their valley lair to raid the Exmoor villages. It is 'the huge expanse of the moor' that lies between Baskerville Hall and the 'mean and melancholy' residence of the villain Stapleton.

In wilderness lived wild things; the desert was inhabited by demons. While God resided in the mountains, and social man in the valley, the moor was where the outcast went – the fugitive, the savage, the misanthrope. 'The wild moors' could have 'no interest' for strangers, wrote Charlotte Brontë. Moorland, it seemed, was merely a 'desert' that you had to slog across to reach your destination. In the valley you sighed; on the mountaintop you gasped. On the moor you merely held your breath.

Examine the satellite imagery and, amid the shimmering green micro-mosaic of the enclosed farmland, the great unfenced expanses of upland moor are as distinctive as urban sprawl. They are divided across two regions, separated by two hundred miles: a handful of neat patches in the southwest – Bodmin Moor, Dartmoor, Exmoor; then, in the north, a wrinkled hide spreading up the Pennine ridge, reaching east into Yorkshire, and extending through the North Pennines to the Scottish border. Whereas the West Country moors are islands jutting from a sea of kinder, cultivated land, northern

moorland is at once more expansive and more dislocated – an archipelago.

I detected deep in me an infinitesimal shying – the old, animal revulsion induced by hostile terrain. 'As you value your life or your reason, keep away from the moor,' Sir Charles Baskerville is warned in Conan Doyle's novel. It was fiction – sonorous melodrama – but the Hound has its flesh-and-blood precedents, and our apprehension of badlands is bred deep as fear of darkness. And yet with that shying there was also a compulsion.

North, according to one lover of moorland, W. H. Auden, is the 'good' direction, 'the way towards heroic adventures'. I would start, I decided, in the southwest, and make my way north via the Pennines and the North York Moors to Northumberland, stopping at the Scottish border – for there the island moors became a moorland sea; and because it was necessary to stop somewhere.

I told myself that no crisis pressed me on my way (or only the unending one of not-knowing) – I wasn't looking for an answer to some question of the heart: it was just that the 'moor' I'd known and studied as a boy had promised something that the meadow, the pasture and the woods had not – if not 'heroic adventures', then a kind of reply to the portion of myself that remained uncultivated. Victorian travellers knew the Sahara's deepest interior as *désert absolu*. I'd *take myself off* – this is the expression I used, as if by the scruff of the neck or bundled into the boot of a car – I'd take myself off, and find my own *désert absolu*, the wild blasted moor I'd read about.

1. The Monster Meeting

Bodmin Moor

I

Charlotte Dymond was eighteen. Matthew Weeks was twenty-three. Both were servants at Penhale Farm, on Bodmin Moor's northern edge. Together, that afternoon of 14 April 1844, they set off south towards the moor.

Matthew was wearing blue stockings and a patched shirt; Charlotte, a green dress and a red shawl. Pattens to protect her shoes. Where they were going they did not say; Charlotte merely told their employer, the widow Mrs Peter, that she would not be home in time for milking. Later, Isaac Cory, the old farmer living nearby, claimed to have seen Matthew on the moor beneath Roughtor, in the company of a woman he could not identify (he knew only that she was carrying an umbrella). Matthew's limp, however, was unmistakable: 'I knew him by the going of him,' he said; 'he walked upon the twist, his usual walk.'

It was late by the time Matthew got back to Penhale; he didn't know what had become of Charlotte. Next morning, she had not returned. Pressed, Matthew said he only knew that he had left her at the bottom of the field that led to the moor, below Roughtor, by Trevilian's Gate. She had entered the moor alone, while he had gone on towards Hallworthy. His blue stockings, Mrs Peter noted, were caked in mud to the knee. It was 'turfy mud', the mud of the turf pits, darker and more staining than the surface peat of the moor. A button was gone from his collar. Close to Trevilian's Gate, a woman's footprints were found.

2

South of Trevilian's Gate, in the shadow of Brown Willy, the twenty-two-year-old Daphne du Maurier experienced the moor's particular pitch of dread. It was November 1930. 'Foolheartedly', as she put it in her diary, she and her friend Foy Quiller-Couch had set off on horseback for the village of North Hill, some six miles from their base at Bolventor in the bleak middle moor. 'In the afternoon we ventured out across the moors, desolate, sinister, and foolishly lost our way, to our horror rain and darkness fell upon us, and there we were, exposed to the violence of night.' They took shelter in a derelict barn. Du Maurier later wrote that she had never known greater despondency. Bodmin Moor is small, eighty square miles, no more; but you can drown in an inch of water.

Eventually, in the darkness, they remounted, praying the horses would deliver them to Bolventor, 'in the direction of those menacing crags we had seen in early afternoon, pointing dark fingers to the sky'. They would have been heading south, now, across East Moor (Bodmin Moor is many moors), over Fox Tor – and past Redmoor Marsh.

From where I was standing, beside the trig plinth on the summit of Fox Tor, the ground sloped down quickly to a sunken plain where the livestock did not go, and even the crows seldom overflew. From up here Redmoor Marsh was the colour of a peach pit, dotted with the odd mountain ash. In 1891, while accompanying an Ordnance Survey official who was correcting the map of the district, the writer Sabine Baring-Gould found himself on and in what he calls 'Redmire'. The moor was unusually wet, he wrote, and six bullocks had already been lost to the mire that year. 'All at once,' he reported, 'I sank above my waist and was being sucked further down. I cried to my companion but in the

darkness he could not see me. The water finally reached my armpits.'

In his day, and until soon after du Maurier's, the Jamaica Inn, in the nearby hamlet of Bolventor, was a temperance house. It was from there that du Maurier and Quiller-Couch had set out. Finally, in the moor's full darkness, their horses returned them there – to 'a supper of eggs and bacon ready to be served with a pot of scalding tea'. It was at the Jamaica Inn, too, the following February, over a peat fire, that du Maurier read another West Country novel of piracy, *Treasure Island* – 'and something must have stirred within me, to come to life again after years'. Half a century later, no longer foolhearted, she passed the inn with some embarrassment, blaming herself for its deterioration into a tourist centre. 'For out of that November evening long ago came a novel which proved popular, passing, as fiction does, into the folklore of the district.'

As I approached the dual carriageway that splits the moor in two, I saw that the hill of Bolventor was surmounted by three crosses, the central one taller than those flanking it, and perched upon by a carrion crow. At breakfast the following morning I saw that the crosses were the masts of a children's pirate ship built in the beer garden. The theme extended to the inn's main attraction: Daphne du Maurier's Smugglers Museum (Incorporating the Dame Daphne du Maurier Room – which featured the mahogany Sheraton desk on which she 'may' have written her novel *Jamaica Inn*). Along the garden's perimeter were six flags: the black and white of Cornwall's St Piran, the Red Weld of Spain, the French and Italian tricolours, the Stars and Stripes, and the Jolly Roger – each one as ripped and faded as a trawler's pennant.

In *Jamaica Inn*, du Maurier describes the vanishing of the brother of the murderous, piratical landlord, Joss Merlyn.

'We thought he'd gone for a sailor,' Joss tells young Mary Yellan, enjoying the fear he is causing, 'and had no news of him, and then in the summer there was a drought, and no rain fell for seven months, and there was Matthew sticking up in the bog, with his hands above his head.'

Matthew Merlyn drowned in Trewartha Marsh, south of Redmoor, beside Twelve Men's Moor. According to Baring-Gould, both Trewartha and Redmoor marshes are former lakes, drained long ago by tin streamers. Baring-Gould finally extricated himself from the mire using 'a stout bamboo, some six feet long'. Matthew Merlyn was less well prepared. Mary is haunted by the story she makes of his death: 'He plunged forward' (she is imagining it, but it is as vivid to her as recollection), 'reckless and panic-stricken, he trod deeper water still, and now he floundered helplessly, beating the weed with his hands.' There was a final detail – something awful, I remembered, as I neared Twelve Men's Moor later that morning: 'a curlew rose from the marsh in front of him, flapping his wings and whistling his mournful cry'. It is this story, more than all the others Joss tells her, that traumatises Mary, newly arrived at the dismal hostelry on the moor. Walking close to Kilmar Tor, where the Merlyns were born, she comes upon the place where Matthew died, and it is the bird she remembers: the curlew, the bird of moor and shoreline, rising from the bog.

The writers and the old fellows you meet in pubs will tell you to look out for grass or 'bright green areas', and to fear the land that looks the easiest; but bogs – 'featherbeds', the locals call them – might be marked here by bright green grass or neon sphagnum, while there they are overgrown with darker rush or yellowish moss, or cotton-grass: Mary, newly arrived on the moor in *Jamaica Inn*, learns to avoid 'the low soggy grass with tufted tops that by their very harmless appearance

invited inspection'. But the dangerous ground did not easily give itself away and I did not know the land well enough to identify it by second nature. I relied on unknown instincts; I kept to the paths and stones and fencelines; followed the sheep.

<div align="center">3</div>

As I walked up the long hill to the moor, a car stopped and the driver offered me a lift. Jack was going up to walk his border collie: 'He's too old for these hills . . . we're both too old.' On his temple was a stippled wen that might have been cancer. Jack and his wife had just moved to North Hill from Solihull. The wife's sister already lived in the village. He knew the moor well – he used to come here on holiday when he was a boy. The dog sat quietly in the back.

To reach the moor you must always go uphill, burningly, leaving the cultivated fields and broadleaf woodland behind. Once I'd said cheerio to Jack and his ambling dog ('Don't wait for us!') I was on the moor proper, and from the black gorse at the track's edge – gorse that might have been burnt or just rotted – a lapwing rose up, like a paperback blasted from a cannon.

To my left was the ridge of Kilmar Tor, one of the exposed granite upsurges that are characteristic of Bodmin Moor and Dartmoor. Its flank, I wrote in my notebook, was like a diseased pelt; that word kept coming to me – *diseased*. The environment was provoking some sort of squeamishness in me. It would ease. It was close to here that the wicked Merlyns had been raised, 'in the shadow of Kilmar'. And this was the 'menacing crag' du Maurier had mentioned. In her novel, too, she described the tors as fingers pointing skywards. But from here the tor was not so much a splay of fingers as a clenched fist. In that same shadow, above the remains of the

railway line that once took Kilmar granite to the port at Looe,
I began to see what the moor was and what it was not.

A rocky climb took me to the summit of Kilmar Tor. I
was not used to the exertion. I pushed through the gorse at
the hill's foot, then the russet bracken, then the moor-grass,
and finally the clitter – the expanse of boulders that rings the
summit of every tor, the interstices packed with heather and
bracken. At the top the wind blew my sweat cold.

Looking down I saw that the track I had been walking on
led eventually to the black emplacement of a conifer planta-
tion, a mile west, at Smallacombe Downs, and to the drown-
ing bog of Trewartha. Far below were Jack and his dog.
Receding from the eastern flank of Hawk's Tor I could see
a stone-and-sod wall as tall as a man, and surmounted by
barbed wire in the spiralling configuration more usually seen
around barracks. To the wall's right the ground was turf,
scattered with clumps of black gorse and mountain ash; the
turf was roughly tussocked, but its colour was the saturated
green of grass after a wet summer. There were black cattle
grazing there.

To the wall's left was the flat moor, a pale dormant beige,
the grass much shorter, cropped to a fuzz by sheep, striped
with a lighter green and scattered with granite outcrops the
size of upturned salad bowls. This line was where the moor
began, but it had not always begun here: Hawk's Tor had it-
self once been pure moor, as barren as the land on the other
side of the wall – and perhaps that land, too, had once been
green, and had been given up. The green land, I knew, had
been 'improved', 'taken in', 'reclaimed', perhaps a hundred
years ago – ploughed with ashes and lime, and drained, season
upon season, to make pasture of the moor.

Twenty feet from the ridge-top of Kilmar I came upon a
tumbling of vast flat boulders that had created a deep cave

tall enough to enter. Its interior walls were flocked with moss an inch deep. The floor was not grass or mud but rock coated in a viscous black-brown fluid that resembled tar or oil and seemed to have percolated from the granite. At the back of the cave, lit by a seep of light from above, eight blocks of timber had been laid in a low tower, as if to dry or to form the basis of a fire that had never been lit. I crouched in my cave and I listened for the wind. 'Kilmar', I had read, derived from the Cornish *Cûl-mawr*, the great place of shelter.

4

The moor was a mountain seething with magma; the magma cooled and hardened and its name was granite. The softer mantle wore away and what remained became the moor. Despite those sinkings, fictional and real, the moor is not soft but hard – the hardest place of all. Bodmin and Dartmoor both are underlain by granite, and to walk across them is to see the mineral in its variety. The clitter tumbled from the summits or was carried down on a bed of thaw-sludge; the boulders were still lined up as they had been sown millennia ago. I inched down the slope of Kilmar and made my way back along the track, towards Minions and the disused quarry at Stowe's Hill.

The Cheesewring is the tottering stack of boulders that tops Stowe's Hill. On the summit stone, thirty metres above me, a jackdaw was nodding, open-mouthed; another joined it and they spoke a language not of caws but of high-pitched grunts and suppressed belches. They sounded like a pair of nervous piglets. I climbed the hill and looked down at the southern moor, my eyes forced wide by the expanse, over the triple rings of Bronze Age standing stones known as the Hurlers to the broad hill of Caradon, its tin-works chimney overtowered by a 250-metre transmitter mast.

On a table of granite I stooped to examine a slightly flat-tened sheep's turd. It was surmounted by a smaller turd, and this in turn was surmounted by a single dropping no big-ger than a bean. A metre away, five slabs of granite had been piled, the base stone a foot across, the topmost no larger than my hand. I would see this form repeated, like a logo, across the moor: not only smaller, natural versions of the Cheese-wring on other tors, but these cairns, carefully assembled, one rock balanced atop another, balanced atop another, at the moor's highest and windiest places, making those places still higher. On the summit of Brown Willy, Cornwall's highest point, the cairn rises from a rubble heap ten metres across, and the topmost stone is unreachable without clambering on the cairn itself and risking its destruction, and your own.

It was an hour before dusk on a cold October afternoon, but the moor was busy with couples and young families pick-ing their way along the rim of the dead quarry to the summit. For the author Walter White, walking the North Pennine moors in 1860, the silence was not only 'oppressive' but 'al-most awful'. When Wilkie Collins came here, to Bodmin Moor, in 1851, he too noticed 'an invariable silence', until he neared the tin works, and 'with each succeeding minute, strange, mingled, unintermitting noises began to grow louder and louder and louder around us . . . men, women and chil-dren were breaking and washing ore in a perfect marsh of copper-coloured mud and copper-coloured water.' The mine was at its most prosperous, employing some four thousand people. Only when Collins and his companions walked on through a fir plantation, towards Stowe's Hill, did the noise die – 'like a change in a dream'.

I was at Stowe's Hill quarry to find a man of the low moor. His name was Daniel Gumb. Nobody knew the moor better than Gumb; he himself was a kind of outcrop, a phenom-

enon risen out of the moor. For him it was Fowey Moor, named, like Dartmoor and Exmoor, for the river that rises from it. Only in 1831 did the Ordnance Survey blithely re-name it in honour of the town that stood beyond its south-western frontier.

Gumb knew the stone, and understood its ways (it had two): knew that the Cheesewring was not several piled stones at all, but a single vast one, wind-worn at its lateral weak points. He knew that the weak points ran horizontal (the cleaving way) and vertical (the tough way) and that, while the granite was hard, it might be split along these points by one who was able to see them. His granite, the Cornish granite, was a coarse stone, and coarser at the edges of the moor where the granite met the slate, than at its centre; and here too, at the edge, was where those other precious minerals were to be found – cop-per, tin, lead, wolfram. The things humankind needed had been made accessible.

Gumb was a stonecutter from Linkinhorne, on the eastern edge of the moor, and a stonecutter's son. Close to the rim of the crater that is the old quarry, I found a rough-faced rock on which was crudely chiselled 'D. Gumb' and a date, '1735'. This was his own work, and once marked his home. Gumb was a stonecutter; it was only natural that his house should be made of granite.

Gumb's story was first told by the Reverend R. S. Hawker (himself something of an eccentric, he excommunicated his own cat 'for mousing on a Sunday'). Introducing the moor, Hawker informs his readers that the 'vast and uncultured sur-face of the soil is suggestive of the bleak steppes of Tartary or the far wilds of Australia'. Of Gumb he writes that 'he was always accounted a strange and unsocial boy . . . usually seen alone with a book or a slate whereon he worked, at a very early age, the axioms of algebra or the diagrams of Euclid'.

The young Gumb was taken under the tutelage of William Cookworthy of Plymouth. A Quaker polymath, who discovered Cornwall's china-clay deposits, Cookworthy nurtured Master Gumb's interest in geometry and astronomy and gave him the key to his library. Nevertheless Gumb remained a stonecutter, and a moor-man. While he might have been an eccentric, a solitary he was not: he married a girl from Linkinhorne. Her name was Florence.

'But where, amid the utter poverty of his position and prospects,' asks Hawker, 'could he find the peaceful and happy wedding-roof that should bend over him and his bride?' The spot was utterly deserted, neither the quarry nor the tin works having yet been founded. 'He discovered a primeval assemblage of granite slabs suited to his toil,' and from them he created 'a giant abode' and 'led the maiden of his vows, the bride of his youth, to their wedding rock!'

A resident of Liskeard recalled visiting the Gumbs' by then deserted home as a boy, before it was demolished. It was thirty feet long and twelve wide, with a granite bench on the right-hand side running almost the whole length. It was here that the family slept. On the opposite side, two further stone benches served for sitting and dining.

If Gumb was seeking isolation it was not the impulse of the misanthrope or the anchorite; he was an affectionate father, and uxorious. His departure to the moors seems to have been not so much a rejection of his fellows as a desire to know better his loved ones and himself, and the moor beloved of his boyhood. In the summer, his own children must have played amidst the Hurlers, in the gnatty moor-haze, and the Cheesewring towering on the skyline would have been the sign of home to them. For them the curlew's cry was not 'mournful'.

The shelter today was no more than a monument: a metre or two deep, its rear filled with boulders, good only for those

retreating from the rain. Hunched in its mouth, I could see the tail lights of cars leaving the car park far below. Hawker includes in his account transcripts of Gumb's own writings. 'On the fly-leaves of an old account-book' and 'recorded in a more formal and painful handwriting', the following entry appeared, dated 23 June 1761:

To-day, at bright-lit noon, as I was at my work upon the moor, I looked up, and saw all at once a stranger standing on the turf, just above my block. He was dressed like an old picture I remember in the windows of St Neot's Church, in a long brown garment, with a girdle; and his head was uncovered and grizzled with long hair. He spoke to me, and he said, in a low clear voice, 'Daniel, that work is hard!' I wondered that he should know my name, and I answered, 'Yes, sir; but I am used to it, and don't mind it, for the sake of the faces at home.' Then he said, sounding his words like a psalm, 'Man goeth forth to his work and to his labour until the evening; when will it be night with Daniel Gumb?' I began to feel queer; it seemed to me that there was something awful about the unknown man. I even shook.

The stranger told him not to fear; and Gumb dropped his head, 'like any one confounded, and I greatly wondered who this strange appearance could be. He was not like a preacher, for he looked me full in the face; nor a bit like a parson, for he seemed very meek and kind.'

The figure pictured in the window of the church in St Neot could be Noah: his robe is a deep burnt red and around his waist is a thick blue belt. In any case, whether it was Noah or the ghost of some arch-druid, when Gumb looked up again, the stranger was not there.

In the gloom I needed a torch to make out the shape carved into the slab surmounting Gumb's rebuilt home: it was a square, a foot or so across, and tipped inside it was another square, whose corners touched the walls of the outer one.

Euclid's forty-seventh proposition, and a Pythagorean proof so basic I wondered that Gumb had bothered to exert himself in committing it to stone. It must have taken days; but perhaps that was the point. It was not for the eyes of men but an answer to God, and a statement as true as his name.

'Florence asked me today if I thought that our souls, after we are dead, would know the stars and other wise things better than we can now.' This was in another of his scattered journals. I imagined Gumb in his stone bed alongside his fleshy Flo, the moor at the granite door, and his turning to her in the utter darkness to whisper the simple 'Yes' that was his answer. And, rubbing my hand across the cooling granite, I knew that it wasn't cold to them in their bed.

5

From the Jamaica Inn the following evening I strolled to Dozmary Pool, the tarn that lies at the moor's centre. At the edge of the lane a black cow gazed over the hedge with glistening muzzle, its infected right eye like a blown lightbulb. In his *Survey of Cornwall* of 1602, the antiquary Richard Carew says that 'the country people held many strange conceits of this pool, as, that it did ebb and flow, that it had a whirlpool in the midst thereof, and that a faggot thrown thereunto, was taken up at Fowey haven, six miles distant'. It was into these waters, they said, that Arthur flung Excalibur – it was also, famously, bottomless.

When I arrived, the sun was settling into a cloud bank on the horizon beyond Camelford. The two low bungalows at the pool's edge seemed deserted, until a mauveish thread of smoke emerged from one of the chimneys, sending its scent low over the water's surface. I stood there for a while, blisters throbbing (my boots had yet to wear in), and watched

the glassy water. There was not a bird in the sky, and even the dual carriageway a mile away could not be heard. The pool was shallow and lifeless and as bright as the sky; its bed was growan – the fine quartz grit you find everywhere on the moor, granite's midway state of degradation from solid stone to powdery kaolin. The water's edge was strewn with water-wort and dead grass; a quarter-ton of sand had been dumped around an inlet to form a miniature beach.

When I turned to go, a figure had appeared, on the water. She was wearing a blue fleece and was standing, arms behind her back, ten feet from the bank, the water up to the shins of her wellies. She'd lit her fire for the evening and had come to observe the idling stranger, but I sensed that her dusk wading was also a ritual.

I asked her if it was very deep. She turned and put her hands in her pockets. 'Contrary to popular belief,' she said, 'not at all. Three feet, maybe a bit deeper in the middle. But you can wade across it, if the fancy takes you.' They didn't get many visitors, she said, because there was nowhere to park.

When Celia Fiennes came here in 1698 she reported that 'it is stored with good fish and people near it take the pleasure in a boate to goe about it', but there was no boating these days . . . 'Oh no,' said the wading lady. 'It's managed by Natural England; they're *very* strict.'

I said good evening and went on my way, and when I turned to look at her she was pushing slowly on, towards the centre of the pool, with hardly a ripple.

6

The following morning, as I climbed the wooded hill to the village of Warleggan, I came across a crossbeam nailed to an oak. Hooked to the beam was a spreadeagled human figure,

wrought from whorls of zinc fencing wire. It was a gruesome, mirthless thing. It was meant as a warning.

The sunken path from the valley bottom was eight feet deep and overarched by stunted beeches. It had been raining up on the moor, and the runoff was making a streambed of the burnished granite underfoot. It was tricky going. Finally the passage opened onto a wooded lane, and beyond the lane was a signpost – 'Warleggan, twinned with Narnia' – and beyond the post a leaf-strewn car park and a circular church-yard, and within it a squat church made of granite.

Inside, pinned to the notice board and peppered with rust-ringed pinholes, was a black-and-white photocopy of a photo from the 1940s, with a typed caption:

```
The Rev. F. W. Densham
Rector of Warleggan 1931-1953.
Seen here in his late seventies at a Merritt
family funeral.
```

The gents surrounding him are dapper in open-necked shirts and polished shoes, but the reverend is a ghost three hundred years old. He stands in black from his shovel hat to the muddied hem of his surplice, and in each hand he wields not the walking pole of the moor-man but a staff of shoulder height and as thick as a truncheon. Crutch, cudgel, crook. He may have felt the need for protection, even if he called them walking sticks (his stiff leg). These rural benefices might kill a man, or drive him to the devil. One day, in the register of services, Densham wrote, '12 hours of rain. Three pails through rectory roof. 1 Kings 18:41', and then (in Latin), 'At night the roof of the rectory caved in under the rain. Praise to God, but not this day.'

To his funeral, in 1953, nobody came but his solicitor. Densham was not a man of the moor; that was his undoing. His

Somerset birthplace might have been Mars. He was a man of the world and yet an innocent. Whereas his new flock might not stray further than Bodmin in a lifetime, Densham knew South Africa and Germany and India. His dog's name was Gandhi. He'd run a boys' home in Whitechapel and a home for inebriates. He knew what the world looked like, and understood that it was not moorland. When the Second World War came, and the village boys were summoned to it, the names of the places where they would be buried were not alien to Densham, as they were to those boys' parents. For one departing soldier – young Harry Wilcock, who'd done odd jobs in the rectory – Densham planted an ornamental cherry.

He offered succour but it was not accepted by his parishioners – not from this man of the Low Church, this man who parlayed with the Methodists, refused to celebrate Mass, and condemned even the most innocent distractions as devil's work. Three months after his arrival in 1931, the minutes of the Warleggan Parochial Church Council meeting requested that 'the Rector remove the geese or ducks from the Long Room, and to thoroughly clean the same and reinstate all the Church property by 29 December 1931 as we are going to hold a whist drive on that date'.

'I have never seen a talkie film,' he told a local journalist, 'and never will. I am against such things as the drama, betting, gambling, dancing, whist drives, because they are worldly amusements coming from hell and leading back there.' Even the annual village raffle was a vice.

Not that he was unkind. He built a playground – seesaws and swings, a sandpit and a boating pond. The village children, of course, were kept away. In 1940 he filled the rectory with bunk beds for Plymouth's child evacuees. The beds were never slept in, nor was the magic-lantern show he arranged attended by a single child.

The villagers might shun him, and teach their children to fear him. They might kidnap his dog, or hide his cow in the disused mine, or put holes in the rectory roof, but he would stay.

For more than twenty years he stayed, and for more than twenty years he continued to preach, even when the tiny congregation dwindled, and finally dwindled to nothing. For years it was ghosts and bats alone he addressed, and to them he sang the hymns – and yet he would be there, punctually, each Sunday morning, and his voice did not waver. If anyone had come in, and sat at the back of the church – as John Betjeman once did, while his daughter played in the rectory garden – he would have heard the reverend's voice ringing clear. In the first six pews he placed cards bearing the names of the rectors who had preceded him; '*They* cannot object to any innovation I make.' From this habit, it seems, Daphne du Maurier concocted the story she put down in her book *Vanishing Cornwall* – the Mad Vicar of Warleggan, abandoned by humankind, preaching twice a week to cardboard cut-outs. It did not happen.

Shortly before his death in 1953 he wrote the following verses:

> When the day to darkness bending
> Brings the rest for which I pine;
> Say will palm trees mark my ending
> Or the lindens of the Rhine?
>
> Will the pathless waste surround me,
> Scarce interred by alien hands?
> Or a stormier grave be found me
> Where the sealine meets the sands?

Densham had come to know those pathless wastes. One Sunday morning in 1901, his predecessor, Reverend Lambert, had set off as usual to the chapel at Temple. He was found dead

on the moor, watched over by his dog. A heart attack, though he was only forty. Densham himself was discovered at the foot of the rectory stairs; dead for days. For all the speculation contained within those verses, and despite his stated wish that Warleggan be his resting place, his ashes were scattered in the garden of a Plymouth crematorium. You can still see in Warleggan the cherry tree he planted for Harry Wilcock.

'They all come to me in the end,' the Mad Vicar had said of his parishioners. 'They won't come to me on their feet, but they come in their black carriages.'

7

I looked down on Roughtor from the summit of Brown Willy, with its heaped cairns and dry bracken. The wind up here was an assault: in the bracken it sang rich and loud, in the grass it was a piping; between the boulders a hollow roar: it was a thousand voices and one, and each buffet hooted across my ears like a blast across the mouth of a bottle. The autumn moor was arrayed before me, with the wall of Dartmoor visible thirty-five kilometres away to the east. You read that the moor was barren, featureless, self-similar. William Gilpin, who, following Burke, maintained that 'simplicity' was a defining trait of sublime landscapes, found 'coarse naked' Bodmin Moor to be 'in all respects as uninteresting as can well be conceived'.

But try to name its colours and you'll exhaust yourself. Beyond the white-grey of moss-spotted clitter, the moor sank through chartreuse slopes, down to the dulled emerald intake of Penhale Farm, to a motley lowland of pale lime dashed with tawny and dun and fawn, and then the intricate tapestry of purple moor-grass, cotton-grass, mat-grass, heather, moss and lichens: chamois, bronze, taupe, walnut – a hennaed,

mouldering, rusting vastness shot with saffron, carmine and topaz, with swathes of reflectivity that shimmered like raffia in the low sun.

Ten feet beneath the summit the wind was first gagged then put out of its misery; my ears still rang with it as I crossed the young De Lank river and made my way across the fatiguing clitter of Roughtor, and over its summit to the sweep of its northern slope.

It was Friday 19 April 1844. Charlotte Dymond had not returned from the moor. Matthew Weeks maintained that he had left her at its edge, south of the Davidstow heath. Work at the farm must continue; there was a pig to be slaughtered. Mr Chapman the butcher came from Trevivian to do the job. The creature had been trussed and the blade made ready. Matthew asked to be allowed to do the killing.

John Stevens, one of his fellow labourers, noted that Weeks was wearing the same shirt he had been wearing the previous Sunday, when he and Charlotte had left the farm together. The first thrust wasn't right; the pig was not killed: the proper artery was missed, or insufficient pressure applied. Matthew stepped back, discomfited – the knife was blunt. Chapman handed him another. Matthew plunged deep and true.

On Saturday he encountered a neighbouring farmer, William Hocken. We must reconstruct the conversation from Hocken's later statement:

'What has become of Charlotte?' he asked.

'I can't tell,' Matthew replied.

'It appears evident to me that there is something serious and amiss in the matter. To be sure, Matthew, you have not put her out on the moor and destroyed her.'

'No,' said Matthew. 'I have not. They cannot swear anything against me.'

But suspicion was mounting. A week had passed since Charlotte's disappearance. Mrs Peter, his employer, confronted him: 'Matthew, there's very bad talk about you, about the maid. The neighbours are saying that you've certainly destroyed the maid. You are a very bad man if you've done it.' Matthew gripped the dresser and hung his head. Next day he was gone.

The moor north of Roughtor, close to the ford over the river Alan, scarcely deserves the name; even in the 1840s it was hospitable enough to be the venue for what became known as the Roughtor Revels. Following the 1830 Beer Act, designed to promote agriculture and discourage sales of spirits, the East Cornwall Temperance Society enjoyed a surge in support. In July 1843 it held a meeting here: three thousand men and women braved the damp. A stage was built beneath the tor. There were speeches, and hymns. The *West Briton* described the scene: 'Long lines of carriages and carts with horses picketed around, groups of booths and marquees, where coffee and more solid refreshments were sold . . . nor were there wanting some few spots where other beverages than those used by the teetotallers might be procured.' The Beer Act had permitted anyone to sell beer or cider for a small excise payment; local licensees did well.

The following year, ten thousand came to the moor, and the revels went on late into the night. 'While speakers addressed the rally for about three hours, others were at the donkey race, wrestling ring, or listening to two cheap-jack orators.' The moor had not known such crowds since the ranks of the Prayer Book Rebellion left Bodmin three hundred years earlier. 'Many remained dancing and singing until a late hour.'

Those who attended, teetotal or otherwise, would have observed, on the bank of the Alan, a black flag snapping in the moorland breeze. They would, moreover, have been aware of

the significance of this place. Aside from the promised donkey races and wrestling bouts, the location's notoriety probably accounted for the increased attendance: 'The Roughtor Monster Meeting', the *Royal Cornwall Gazette* called it.

On 23 April, nine days after Charlotte Dymond had last been seen, a search party set out. Two of the men, Mr Baker, the beershop keeper, and Mr Northam, the publican, searched the north bank of the Alan, close to the ford. Above them was Roughtor, and Brown Willy towering beyond; beneath them, under the lip of the bank, at the water's edge, was what they had come looking for.

She lay face up, gazing at the sky. One of her arms was by her side; the other was outstretched. One leg was bent, the other straight; her stockings were in place but one garter was missing. It was clear that she had spent time in the water and had been set down here by the river in spate. Shoes, pattens, bonnet, handkerchief, bag, shawl, gloves – they had been carried off. Nearby, her necklace was found, torn apart, its coral beads scattered in the turf.

The jury (farmers all) was sworn in, the witnesses called, the verdict announced:

Matthew Weeks, late of the Parish aforesaid in the county aforesaid, labourer, not having the fear of God before his eyes but moved and seduced by the instigation of the Devil . . . did make an assault . . . with a certain instrument, to the jurors unknown, which he, the said Matthew Weeks, then and there had and held in his right hand, the throat or gullet of her, the said Charlotte Dymond, feloniously, wilfully, and of his malice aforethought, did strike and cut.

On the death certificate the coroner, Joseph Hamley, inscribed the words 'Wilfully murdered by Matthew Weeks'. Within hours the man was apprehended in Plymouth, walking with his sister on the Hoe.

'You must go with me,' said the constable.

'What for?'

'You know what for . . . Did you cut her throat with a pair of fleams?'

'I did not.'

The black flag at the Monster Meeting marked the site where the body was found. According to the *West Briton*, it 'attracted much attention and penny subscriptions were received to defray the expense of erecting some monument to mark the spot'. On the map it is marked, simply, 'Monument'. It lies a few feet from the river bank on a strip of turf beyond a barbed-wire fence and a corner of mossy bog. It is eight feet tall and looks hastily hewn; its words have been carefully chosen, however, and carefully sized:

THIS
MONUMENT
is ERECTED by
PUBLIC
SUBSCRIPTION
in
MEMORY
of
CHARLOTTE DYMOND
who was MURDERED here
by
MATTHEW WEEKES
on
SUNDAY
April 14
1844

A monument not to a death but to a murder; not a memorial, but a pointed finger: on a SUNDAY. (Weekes; Weeks; Weaks; the spelling hardly mattered.)

Late in the day on 2 August, Judge Pattison placed the black cap upon his head. At Bodmin Jail, Weeks dictated a letter to his one-time employer, Mrs Peters:

I hope young men will take a warning by me, and not put too much confidence in young women, the same as I did; and I hope young females will take the same by young men. I loved that girl as dear as I loved my life; and after all the kind treatment I have showed her, and then she said she would have nothing more to do with me.

Twenty thousand people turned out. It was a damp day, and there was no harvesting to be done. Mr Mitchell, the hangman, led Weeks to the scaffold. The bolts were withdrawn. The handkerchief he'd been holding remained clasped in his hand.

8

Beyond Roughtor and the boggy grassland to its west was a wide strip of sheep-bitten grass of a dull oxide I had seen nowhere else on the moor. You can know sheep pasture by the clippings of pale dead grass that litter its surface, forsaken cuds that are the only untethered things not expelled from the moor by the wind. On the odd-coloured grass stood one of the moor's eleven Bronze Age stone circles, more exposed than the Hurlers at Minions, the constituent stones more numerous but much smaller, the size of crouched children. Du Maurier's parson, in *Jamaica Inn*, declares that 'the moors were the first thing to be created; afterwards came the forest, and the valleys and the sea.' It was possible to believe this.

Each stone stood in a ring of bright grass inside its own small moat of peaty water. The creatures of the moor came here to drink; the cattle to scratch their haunches. They had eroded the moor's surface with their hooves, and these pools

had formed. The circle outlined by the stones was imperfect. In its approximate centre, where I stood, the tip of a granite boulder had breached the peat. Beside it a loose bole of bog-wood, as big as my head, had been laid down.

My boots looked like they'd done a hundred miles. Peat is acidic, and quickly takes the shine from leather. Two hundred feet above me, among the demolished-looking monoliths of Roughtor's crest, a figure had appeared. Another followed and took the other's hand, and they went away, over the summit's brow. I turned my back on Roughtor, and joined the old droveway to the edge of the moor.

2. Less Favoured Areas

Exmoor

I

The moor's edge will be marked by a cattle grid, and to its left or right a latched five-bar gate for horses and livestock. Step across the grate, mind your ankles, and you're in the moor world: the grate is a frontier, and after those seconds of eyes-down attention as you tread from rung to rung, you look up to find yourself somewhere new.

I'd left Lynton, which overlooks the sea on the northern edge of Exmoor, before eight that morning. The track that took me up through the peripheral gorse-land of Thornworthy Common was a streambed, rushing louder as I climbed, and with a stream's topology – water weed and bubbling falls and water-smoothed cobs. Water, too, is drawn to the routes of easiest passage. Here and there, clots of off-white foam had collected, and were being picked away at by the wind. There was a moment when it went as dark as dusk or eclipse. Amidst the gorse, the joyless Exmoor ponies. They did not mind the rain.

The end of the farmed land was marked by a neat bank faced with plates of sandstone, and then a field that was light green at its lower edge but bearded with rushes as it rose towards the moor. Here the moor's persistence was visible: the cultivated land – the so-called reclaimed land – was being claimed back by the moor. It was as if the farmer had relinquished it, a kind of peace offering.

The moor ahead of me was a foaming, surging mass, a sponge squeezing itself, a waterlogged lung. I could feel its spume coming down on me, hear its roar. The track petered

out into a handful of deep-cut trenches that ramified further until all that was left was a shorn expanse of dirty turf, and then, there, by the gate to the moor, was the lumpen sandstone artefact known as the Saddle Stone, which marked the boundary of the old Royal Forest. Beside it was a line of ravaged beeches, canted towards the high moor as if at once nodding the way and bowing a fretful farewell. Like everything here that is not pure moorland, the beeches are the Knight family's doing (the estate's accounts for 1850: 'BEECHNUTS: £16') and it is the beeches that shepherd you onto the moor, and guide you off it. The drizzle became first a spray, then a fine mist. The mist thickened.

There is no question when the moor proper has been reached: you know it like a cold breath on the nape – the ground becomes tussocked and sopping. The place is at once underfoot and on the horizon. Patches of green-red sphagnum marked the 'featherbeds', and here they were no bigger than a double bed; but who knew how deep. It is in an Exmoor bog, 'as black as death and bubbling', that Carver, the villain of *Lorna Doone*, drowns. 'The black dog had him by the feet; the sucking of the ground drew on him, like the thirsty lips of death . . .' And so he sinks, like Stapleton in *The Hound of the Baskervilles*, into 'the engulfing grave of slime'. A rendering to the underworld.

The gorse and heather had not come this far; here was a treeless land of purple moor-grass and mat-grass and cotton-grass and rush, and low-lying sphagnums and liverworts. The mist, secretly, had become fog, a deadening vapour that surged with the wind and seemed a presence as constant and primary as the peat underfoot. It was water with a rinsing of soap, an occlusion rather than a blinding. My cough sounded like an animal's – in these conditions a noise lasts no longer than its cause. In *Lorna Doone*, when the fog came down, 'it

was dismal as well as dangerous now for any man to go fowl-
ing . . . the pan of the gun was reeking, and . . . the sound
of the piece was so dead, that the shooter feared harm and
glanced over his shoulder'.

There was something about the fog that meant that its
movement was most visible at the periphery of your vision,
just as ghosts are said to be discernible only out of the corner
of the eye. Soon I was lost, but it was the comic disorienta-
tion that happens before true confoundment blooms. I knew
where I was. Here, on the map, east of the Chains and west of
Woodbarrow Hangings and north of the cairns that crest the
hillside above Challacombe, and so I walked south, expecting
to come to a rise, but coming instead to a descent, and then
the path was lost, and the fog was so thick that it seemed to
muffle even the sound of my breathing.

It had a density that instinct told me must be suffocating,
but of course it was experienced only as a chill in the mouth
and in the lungs and in the eyes. Approaching the Chains,
I began to understand that the old topographers' use of the
word 'black' to describe the moors – 'black desart', 'black-a-
more' – was not metaphor: black it is, and the place names,
too: Blackpits, Blackford, Blackland. The sodden heather,
the rush, the burnt gorse, the dead bracken; above all, the
exposed peat. Where drainage ditches had been cut, the
peat's profile was exposed: dark brown and knitted with
rootlets at the surface, a fibrous velvet below, and darkening
and distilling as it deepened to the blackest jelly at the cut-
ting's floor.

The Chains is Exmoor at its wettest. Off the path, every
other step turns a foot or puts it calf-deep in the land. The
drizzle teemed across the moor, noisy on waterproofs and like
the wave-slap of an angry sea on the windward cheek. Out of
the mist ahead emerged what appeared to be a breach in the

hillside, a bite taken out of it from above, white sky or sea beyond; and yet the coast, I knew, was five miles away, and to the north. What I was looking at could only be sky if the world had been upended.

As I approached, I saw that the lip of the breach was fringed with grass that seemed to float inches above the broken ground. It was pond-rush. The water was a white-grey indistinguishable from the sky, as if this pond were the fog's cauldron. You might wade into it and emerge no wetter; duck beneath the surface and continue to breathe. There were no ponies in its vicinity, nor any waterfowl.

2

From Norman times, Exmoor was 'Forest'. Like most of the English moors, it was once wooded to the brink of the summits, its tree-cover stripped by successive generations, from Mesolithic hunters and croppers to the miners who felled what remained for their furnaces and props. But by 'Forest' was not necessarily meant woodland; like Dartmoor and parts of the North York and Pennine moors, Exmoor was the king's hunting ground and larder. In his *Treatise of the Lawes of the Forest*, published in 1615, John Manwood describes the designation as 'a certain territorie of woody grounds and fruitfull pastures, priviledged for wild beasts and fowles of Forest, Chase and Warren, to rest and abide in the safe protection of the King, for his princely delight and pleasure'.

All Devon was subject to Forest law until 1204, when the Devonians bought their freedom from King John. From this date, the Devon Forest was confined to the 'wastes' of Exmoor and Dartmoor. Although the king himself seldom visited, they were protected by laws so exacting that a man found on the moor with a bow might pay with his right hand. Even

a moor-man's dogs had to be 'lawed' – lamed, by the removal of three toes from the right front foot, to prevent them from worrying the Royal Hart.

In June 1818, the Commissioners of Woods and Forests placed an advertisement:

Such persons as are desirous of purchasing an extensive tract of WASTE LAND are hereby informed that the Allotment made to his Majesty on the FOREST OF EXMOOR, in the Counties of Somerset and Devon, consisting of about 10,262 Acres, together with an enclosed Farm . . . will be DISPOSED OF by Public Tender for the highest Price.

Sir Thomas Acland, last lessee of the Forest, bid £5,000; Earl Fortescue £30,000. Mr John Knight of Wolverley Hall, Worcestershire, topped Fortescue's bid by a full £20,000. By 1820 the crown estate was his, and he'd added Acland's three thousand acres to his property.

The Norfolk sandlands, Lincoln Heath, the Yorkshire Wolds, the Fens – all had been drained and ploughed. It was Knight's intention that Exmoor should follow. Scion of a Worcestershire ironmaster and a sugar baron's daughter, he was an industrialist, an agriculturist – and a speculator. He beheld the unexploited wastes between north Devon and Somerset and saw a goad – no roads, no farms, no fences: he would build them. One solitary habitation in its thousands of acres, and a mere thirty-eight trees.

His first task – enclosure: the Forest had never been fenced; its bounds were marked by streams and rocks and valleys – but this was his land and he would show it. In 1824 Knight built a wall around it, twenty-nine miles long. It was an announcement of his will. The moor's first metalled roads followed. And then, for reasons that were already a mystery just fifty years after its construction, he employed two hundred County Mayo navvies to dam the headwaters of the river

Barle, here, high up on the seeping slab of peat known as the Chains. (From the Devonian pronunciation of 'chine' – 'backbone'.)

Nowhere else would I be so conscious of the moor as reservoir, as source and spring. The Chains – source of the Exe, the West Lyn and the Barle – seemed as much liquid as earth; you waded not walked. The Irish shovelled out a crater of seven acres and thirty feet deep and heaped the spoil alongside to block the valley that led down to Pinkery Farm. On the old maps is a channel – 'CANAL' – on a line from the excavation to Knight's base at Simonsbath four miles to the southeast – but it begins (or ends) a good mile from Pinkery Pond. The truth is, the lake's purpose is unknown. Of course, there are theories. It was meant to power mine workings, but no – there'd be no large-scale mining on Exmoor for years; or it was to feed a navigable canal – but where to? Perhaps it was going to irrigate the valley between here and Simonsbath, but it transpired that the peaty water silted up the ground and made it barren. Or it was to power threshing machines, or the incline railroad that would bring sweetening lime to the moor from Porlock. Sir John Fortescue, of the ancestral family, told the author Henry Williamson that it was a boating lake, part of Knight's plans to make a landscaped estate of the moors. On a summer's day perhaps it would be a pleasant place to drift. But on a day like today? Williamson bathed in it, once; but, he said, 'monsters are lurking down there . . . You can't enjoy a solitary swim.'

There are records of Pinkery Pond being stocked with trout in the early twentieth century, but it did not thrive as a fishery. 'On Dartmoor,' Williamson explains, 'where the peat water is also acid, lakes have been made specially for trout; shrimp and snail have been introduced in large quantities – only to disappear, since the acid eats through their shells,

and they die.' The dams of the Pennine reservoirs must be specially treated to keep the acid from eating away at the cement. Slurp a mouthful from your palm and it tastes only of storms, at first, but hold it and your tongue might detect a battery tang.

I edged down the revetment wall to the sound of thrashing, where the water from the reservoir was let through the embankment by a channel cut into the rock. It was a fierce sound; the whole lake looked to be drawn to this spot like sand to an hourglass's waist. If you slipped you'd plug it.

In 1889, Mr Gammon, a widower from the village of Parracombe, left his pony tethered at the water's edge. His clothes were folded neatly on the bank, as if ready for morning. He had been 'paying persistent addresses' to a young woman, who had declined him, and so away he'd gone, his steps firm and sure – 'Then I'm off to Pinkery.'

A Welsh diver was sent down. It didn't take long. Farmer Gammon was a man of his word. The young woman's reaction is not recorded.

In 1912 it was William Stenner. Married, six children, from Riscombe near Exford. It was 9 August and William went to bed early. When Mrs Stenner brought him a cup of tea the bed was empty. The hunt was huge, every able-bodied man from Exford and Withypool, led by the master of the hounds. It wasn't until January that they thought to drain Pinkery; after all, it was a good few miles from Stenner's home.

In the dam are two oak plugs, each fitted into an iron pipe. It took four weeks – four weeks in snow that turned to slush, then froze. At first the plugs would not budge, and when they did, they were forced back into their housings by the water's weight. But inch by inch the water level was lowering. Finally the plugs were jemmied free, and overnight the lake drained, leaving this great black gulf stinking in the frosted moor: and

amidst it the ribcages of sheep, and the remains of a cart, but no body.

For the first time in its history Pinkery Pond was empty. Two hundred and fifty people came to look from miles around. 'A black dismal gorge' was how the *North Devon Journal* described it. The Chains had not seen this many people since the dam was built. And not only people: dozens of herons stalked the dark sludge, slender legs and bills filthy, bellies full of frogs, voices shocked, calling to one another, *Kraka-ark!* Stenner, meanwhile – he wasn't here. In late February, seven months after he vanished, his body was found, close to his cottage at Riscombe, wedged in a flooded adit of one of Knight's abandoned mines. Self-murder was not an uncommon end for Exmoor farmers.

3

It's in *Tarka the Otter* that Henry Williamson transcribes the voice of the heron, Old Nog, as *Kraka-ark!* – and *Krark!* and *Ark!* and *Kack!* and *Gark!* Fleeing the hunt, Tarka holes up at Pinkery Pond, 'deep and brown and still, reflecting rushes and reeds at its sides, the sedges of the hills, and the sky over them'. I looked across the water's surface: it was quite flat and yet, today, it didn't mirror a thing. The reeds at its surface had no reflection; a duck might land on it and cast no double. Tarka waits in the reeds at the tarn's northern end – the side opposite the dam – and watches a hen raven fishing, delivering a mimic croak then pincering the inquisitive frogs when they surface, and piling their corpses on the bank. The otter makes a playmate. 'The raven, who was one of three hundred sons of Kronk, would drop a stick into the tarn and Tarka would swim after it, bringing it to the bank and rolling it between his paws.'

Williamson's story, and Tarka's, is nearing its end. He knew the southwest moors, had made himself know them in order to write with the assurance of a local and a moor-man, of which he was, in truth, neither, however long he stayed. 'What qualification do you, sir, a stranger to Devon, possess that you should presume to write about an otter?' wrote one huntsman. Williamson rewrote *Tarka* – he said – seventeen times: 'chipped from the breastbone'. 'The later versions were written in what can only be described as anguish arising from a sense of insufficient knowledge.' And so he came here, to the Chains and Pinkery Pond, as he went everywhere with his imagined otter (to Dartmoor's Cranmere Pool, too). When Tarka watches that playful raven, you know who the watcher really is, that he sought out the tarn's most likely otter-place – those reeds along its northern shore, where one of the Barle's headwaters enters – and waited there, and watched, until some of his 'anguish' had spilled off.

Henry Williamson returned at the end of his career, forty years after the triumphant reception enjoyed by *Tarka*, when he needed a setting for the outrageous, saturated final scenes of the final novel in his fifteen-novel sequence *A Chronicle of Ancient Sunlight*. *The Gale of the World* was to be the book that reclaimed for him the pre-eminence that Tarka had begotten – the prizes, the adulation, the sales.

'The writing you do when you're on the right beam is almost automatic,' he'd once written. But the beam was narrow – his balance was imperfect, the more so as he aged. Even the novel's dedicatee, Kenneth Allsop, couldn't bring himself to praise it. And it is a shambles, though exquisite in places, as if Williamson himself hadn't been able to bring himself to read it back even once – as if each paragraph has simply been carried forth in the flood of his enormous energy.

The Gale of the World opens in 1945. Having split from his

wife, Phillip Maddison is living alone in a shepherd's cot near Barbrook. The war haunts him – it is up there, on the moor, in the mud. To the Chains, where 100-horsepower quad bikes easily get mired, Captain Maddison drives up from Lynton in his Silver Eagle, on a day of ferocious rain, 'ploughing furrows of sloppy black peat as the vehicle slid and yawed to the crest of the Chains'. Had Williamson done this same trip in his own Silver Eagle? Certainly he knew the terrain, had walked it dozens of times. With Maddison is his dog, Bodger: 'The dog had shivered ever since seeing the gun put under the tonneau cover; for Bodger had once been shot at by his former master.' But the shell is not for the dog.

High above the moor, two gliders are struggling against the coming storm: 'a strange wool-like clottage . . . moving across the black peaks of cumulo-nimbus'. On the moor, Maddison asks himself, 'Have I really given up hope, except a black hope, a Tristan-like longing for the suns which have burned black after falling in rains of fire?' With Bodger, he walks from the motor car into the electric storm, until they reach a tumulus 'where he had often stood to look over the Atlantic'.

Today I could see no further than the fenceline, let alone the tumulus, let alone the sea. 'Soon,' Williamson goes on, 'the Chains, fifteen hundred feet above the sea, was a glittering sheet of water from which a semblance of glassy thistles rose a foot high and side by side, so violent was the down-hurled rain. And the tops of the clumps of sedge-grass were linked by pale blue waving gossamers of St Elmo's Fire. Hurray! Hurray!'

Maddison's euphoria is short-lived – 'this isn't Passchendaele'. Just then, 'he felt a blow on the top of his head, breaking body from legs as the earth rose up to his eyes' – he has been struck by lightning – and with that he blacks out.

*

The equation of the moors with the battlefields of Europe came naturally to Williamson, himself a damaged child of the Great War, 'an extension of my greater phantasmagoria of the Western Front'. In his story 'A Winter's Tale', he benights a returned soldier on a snowbound Dartmoor. Barbed wire could corral more than just cattle; fog was not only fog. Following the Devonport Leat, the veteran is reminded of 'the flooded trenches on the Somme or under Passchendaele'.

In 1925 Williamson arranged his honeymoon in two stages: the first week spent in a cottage on the moor near Dunkery Beacon; the second in France, walking the battlefields and war cemeteries. 'The moor is a black strip,' he wrote, 'black as a rock spider and as savage.' Of the ranked crosses at Arras, a week later: 'black as a wasteland of charred thistles'. What say his new wife had in planning the honeymoon is unclear.

The stripped landscapes of the moor; and then the stripped landscapes of no-man's land. When the eye finds nothing to fix itself on, the mind turns inwards. 'It's not the sea, is it?' asks the young heroine of *The Secret Garden*, seeing moorland for the first time; Rannoch Moor, in Robert Louis Stevenson's *Kidnapped*, is 'as waste as the sea'; Arthur Conan Doyle, visiting Dartmoor, saw 'long green rollers, with crests of jagged granite foaming up into fantastic surges'; even Emily Brontë's Haworth Moor was a 'heathy sea'. And it was to the imagery of sea that others turned, when trying to describe what they'd witnessed on the Western Front. D. W. Griffiths found 'literally nothing that meets the eye but an aching desolation of nothingness . . . You might as well try to describe the ocean.' A lieutenant at Passchendaele recalled 'a sea of mud. Literally a sea.' When Stephen Graham returned, a year after the war, he found a 'landocean'.

Landocean – that was the moor. Henry Williamson signed

up, as a Territorial, to the First Battalion of the London Rifle Brigade. It might be that the war gave him his first insight into man's relationship with the non-human. 'I don't think I am a nature-lover,' wrote the author of *Salar the Salmon*, *The Old Stag* and *Tarka the Otter*. 'I used to be, when I was hopelessly or helplessly in love in my youth. There was nothing else to love.'

Nature-love . . . It was for children, for knickerbockered ramblers and bird-table tenders – to express love for nature was as meaningless as expressing contempt for it. And while his own obdurate and witless crush on 'the great man across the Rhine' was born partly of an acquired knowledge of what it was like when men fought one another freely, with fire-arms, Williamson looked back on his own war – for all that it warped his character, and he knew it had – with something a lot like fondness.

'It was lovely,' he wrote of his arrival at the Front, in late 1914. *Lovely!* Of an offensive the following year: 'Partridges flying from gunfire; larks in the sky. The guns, the lights, the great roar. It wasn't fear, it was magnificent.'

His was a child's exhilaration, and he saw the world as a child from then on. He'd experienced beauty, grave but real, in the trenches. It was something that might be encountered even amidst misery and horror – might, moreover, be witnessed at its most potent in such circumstances. In 1940, reflecting on the new war while staying with a friend at the moorland village of Withypool, a sleepless Williamson 'switched on the light and tried to read of another man's attempt to leave a part of the earth fairer than he found it' – John Knight: 'All the lime in the world mixed with the deep dark heather-soil, could not ripen the wheat in a normal season. The gales tore at the leaves of the root crops of mangold and turnip.' The moor, wrote Williamson, was 'unconquerable'; it was as

constant – as 'ageless' – as mankind's propensity to violence. Untameable.

'A week later,' he concluded, 'I was in prison', arrested under Regulation 18B, like his friend Oswald Mosley, as a suspected Nazi sympathiser.

'Phillip's eyes opened upon the visible world and he realised slowly that he was still alive,' he wrote in the final pages of *The Gale of the World*. The lightning has killed Bodger, but his owner comes to, at the highest point of the Chains, just east of the lake where Williamson placed his fictional otter. It is now, as the novel ends, that the magnitude of the downpour becomes apparent, for it is 15 August 1952, and this is the great storm of that year, which flooded the moor from its watersheds to its edges, and sluiced through the dwellings of Simonsbath, and flushed down the East Lyn to Lynmouth. Walking up to the moor through the village of Barbrook, I had paused at a monument dedicated to Gwenda Oxley and Joyce Hiscock, 'two young girls from Victoria, Australia', who were among the thirty-five who died that night.

4

I took the wrong path, north of the fence, not south. South had been a morass; north was a bog and then a slough. I was following the old wall of the Knight estate – more of a rampart, really – ten feet thick at the base and tapering to an eroded top with a double rank of outward-tilted fence posts.

The path was not, actually, a path but a ditch, its lower bank formed by the boundary wall. I skirted around its pondings, sometimes detouring hundreds of metres up onto the drier moor; or tightroped crabwise along low fence wires. In 1724, during his tour through England and Wales, Daniel Defoe paused at the source of the river Exe and remarked:

'The country it rises in, is called Exmore, Camden calls it a filthy, barren ground, and, indeed, so it is.' It is here, too, at 'the bog at the head of the Exe', that John Ridd, in *Lorna Doone*, saves a little girl who has fallen into 'the black pit' while gathering whortleberries.

The water pooled – *laked* – filthily around gates, gathering there as the cattle do, the ground mashed by their hoovings (the farmer-word is 'poached') – a stew in which dung and peat were indistinguishable. The water was gurgling up from the moor even as it fell from the clouds. Pressed between the two, I made my way – avoiding the worst of the wet.

For hundreds of years, sheep – Exmoors and Cheviots from right across north Devon – were brought here to graze each summer, thirty thousand roaming the moor, and taken back down in the autumn. And John Knight continued to take in the lowland stock from May till October. But a pastoral farmer Knight was not. His ambition was no less than the transformation of Exmoor, in fact the elimination of the moor. That meant wheat and barley, meant the plough, and roads and homesteads. It meant men.

Exmoor is a tableland traversed east to west by four valleys. Lay out your right hand, palm up, fingers pointing left. Between your little finger and your ring finger runs Kinsford Water; between your ring finger and your middle finger runs the Barle; between middle and index, the Exe; and between index finger and thumb, Badgworthy Water, home of the blood-loving Doones. It was the Barle that Knight would first colonise, making his centre of operations the house at Simonsbath, in the heart of the moor, where all of its thirty-seven trees were to be found. He ran things personally. When his men broke the ground for the first time, the first time the heart of Exmoor – its spine – had

ever been broken, Knight was there to see that it was done right.

To make the wet moor farmable required an effort that scarcely seems sane. First you must drain it: cut herringbone trenches to allow the water to flow off. Then with teams of six bullocks you pare off the top three inches of turf; then you burn the turf; then you spread the burnt turf over the pared land; then subsoil, and add three tons of lime per acre (limestone, burnt and crushed, reduces the peat's acidity and allows plants to absorb nutrients); then plough; then wait till summer before sowing – and still palatable grass is not guaranteed, even in the valleys. Moor is moor. At this elevation, in this wind, with this wetness, barley and wheat struggle. Not that this stopped John Knight. Till the day he left Exmoor and his son took over, he continued to persevere with arable farming as if this were Worcestershire.

For the first twenty years, there were no true farmsteads, and only the valley slopes were improved. What was needed if the moor were to be routed, in Knight's view, was *single* men (God knew, no wife would want to bring her children here). The system Knight followed was that of the Scottish bothy, men in shared quarters, working and eating and drinking together, sleeping in hammocks. It was Knight's error. Where there are only men other men will not willingly settle; and where there are only men there can be no real society. Knight's Cheviot sheep were not doing well on the high moor, and he drafted in a Wiltshire shepherd to watch over a new flock of merinos. 'They are likely to be of great use if I can prevail with the shepherd to put up with the solitude, of which I almost despair. I am doing my best to fit up the White Rock Cottage for this family, but society I cannot provide; indeed several servants have lately left my station for want of company.'

In 1841 John handed control to his eldest son Frederic, moving to Rome in 1842, where he continued to follow activities on Exmoor until his death in 1850. 'I am going to try to let Honeymead and Cornham, with allotments of the forest, for what I can get for them,' Frederic wrote to his sister. First Honeymead Farm and Emmet's Grange; then Wintershead, Horsen, Crooked Post, and finally, to William Hannam, the farm at Cornham, most isolated and exposed of them all.

5

William Hannam was born in Wincanton, one of ten, in 1811. His father was a farmer–butcher and the boys followed him, those who lived. William was thirty-one when he married Elizabeth. His first farm was near North Cheriton in Somerset – a mere eighty acres, but dear on account of 'a Quantity of Yong orcherds'. In 1843 Charlotte Emma was born. The farm was too small to give a living: the orchard bore him not a single fruit. Blossom would not fill his daughter's belly.

He suggested that he take on the tenancy of his father's land. No, said William senior; you'll make your own way. His father had been to Exmoor himself, fifty miles west, to buy cattle from Mr Knight, which 'turned out rather profetable'; the land there was fine and fruitful, he told his son, now that the moor had been enclosed. The cattle were the best to be had, and Knight's rents were – nominal.

'After attending a Sale at Exmoor I think it must be in the year 1841 or 1842,' Hannam recalled in his 'history', 'my Brotherlaw Mr Hay and a first Cozen Mr George Baker with my Father went to Exmoor to see if they should like a Farm . . . It being a great Quantity of it verey Ruff wet Land they were indused to decline taking it.'

Nevertheless in September 1844, with a neighbour, Hannam took a mare and gig, arriving at Honeymead Farm the next day and attending a sale at Cornham Farm the day after, held by Mr Knight's steward. 'The Cattle was in first rate Condition,' Hannam wrote, and the existing tenants 'all seemed Highly taken up with the Contrey and the apperence of the Crops'. He returned in December, staying again at Honeymead Farm, where he admired Mr Matthews's five hundred Southdown ewes. 'Altho the Frost was so severe in the Room where I slept the Jug was Frozen to the Bason they were looking remarkably well.'

Hearing the 'favourable oppinion' of the existing tenants, and seeing 'everything looking so prosperes – I was indused to ask of Mr Knight . . . If they had a Farm they could let to mee . . . I believe I told him I should like a part of Cornham.'

Always 'indused' or induced. The word of a regretful man unable to acknowledge his mistakes or ill luck. But going to Exmoor was not folly, only the hard act of one who had no choice but to be an optimist. The winters might be harsh but the lambs would thrive, and his daughter would run with them in the meadows of the Barle.

He spoke to his father: 'He said it would require more Cappital than I had to take so large a Farm as they would like to let but he thought wee may be able to take a Farm as for him to have a part and no doubt some Money could be got . . .' Later that month, William went to Exmoor with his father, who negotiated a lease on Cornham Farm of twelve years, from Lady Day (25 March) 1845.

Hannam's *History of Twelve Years Life on Exmoor* is kept in the Bodleian Library in Oxford, 560 pages bound in buckram – pages whose lines close in on one another as the account continues and the mind becomes stogged: that West Country word meaning 'stuck in a bog'. By the time the final months

come round, each sentence takes minutes to interpret. If he had a reader in mind, it was his children or God, or his own better self. It was written in retrospect, from 1858 to 1862; yet Hannam's memories are bright, as painful memories *are* bright, if they are not burnt out altogether. At times his recollection seems to come more quickly than his writing hand. This accounts for the flooding urgency of his penmanship. This and his anger.

When Hannam arrived in 1845 the house at Cornham still smelt of sawdust and limewash; the hearth was gleaming and untempered. The future that Hannam saw might have been hard, but he was accustomed to hardness. Hibberd at Emmet's Grange might have surrendered his lease before the first summer was out; the tenants of Wintershead and Horsen and Warren might be too afeared to take up theirs in the first place. But Hannam would stay.

On Lady Day 1848, Emmet's Grange – over the hill from Cornham – was occupied once more, for Knight had appointed a new agent, Mr Robert Smith – East Midlands sheep breeder, agriculturist of academic bent, and name in the annals of the Royal Agricultural Society. In the Society's *Journal* he published his prize-winning essay on 'Bringing Moorland into Cultivation', which began: 'All lands as yet uncultivated or unreclaimed are properly termed the waste lands of England.' It was as a result of Smith's activity that Knight's remaining unoccupied farms were let. Three years later, Thomas Acland, former steward of the King's Estate, observed, 'Mr Hannam has a herd of yearlings . . . in as beautiful condition as any one would wish to see; and makes very good cheese.' But the moor was closing in on William Hannam.

'Poor old Mr Groves who was quite an Invaleed,' he wrote. 'He occupied the Farm about twelve Months ['the Farm'

being Pinkery, down the valley from the mystery dam]. People began to press him for Payment of what he owed them and being of a weak mind he destroyd himself by Blowing his Brains out by the Road side not far from his own Dore.' But Hannam was not weak-minded; he was, he knew, a person suited to privation, and he remained.

He seems to have sought out enemies as others seek out friends; in Robert Smith he was satisfied to have found something better: a kind of nemesis, although his contempt was not completely reciprocated, nor its reasons fully recorded. Hannam knew the land; Smith had studied it. If Hannam was a labourer, Smith was a scientist – or at any rate a man who believed that science could obviate the need for labour. To work one's body raw was a sort of idiocy. What was a man like Hannam but a relic of a bygone peasantry?

Smith had learnt his business from his father in Lincolnshire, and was known chiefly as a breeder of Leicester sheep – he was not yet forty when he was elected to the Council of the Royal Agricultural Society. Emmet's Grange was 670 acres of waste bounded by a fence. What induced Smith to leave behind the fertile farmland of his youth is unclear, but it is with some pleasure that Hannam records that he was 'possessed of but little or no Cappetal'. There is a story that he had been all but ruined by some protracted legal dispute with a fellow exhibitor at the Rutland Show. He needed a salary, a home, a task. Charles Knight, Frederic's brother, wrote to their father that the new appointment 'understands perfectly how to manage the farmers, and has no wish to spend money unnecessarily'.

To plough the moor Smith preferred oxen; horses lacked the strength to move this fibrous, heavy soil. What's more, once their autumn work was done, the oxen might be slaughtered for beef. Nothing if not efficient, Mr Smith.

The moors which will form the chief subject of the present paper are situated at too great an elevation for the growth of grain crops with profit, and have thus as yet not commanded sufficient attention. But . . . it is evident that the increasing consumption of food by a population becoming every year more dense, upon fixed areas, must ultimately bring many high lands, hitherto neglected, into notice for the production of stock.

And it was not merely the land's elevation that presented the incoming farmer with a challenge: he must consider 'the prevailing direction of the winds, the length of time the sun continues above the local horizon, the difference of temperature between day and night, as also the extent of dry surface in the neighbourhood'.

Smith advocated 'the encouragement of liberal covenants', by means of 'low rents, long leases, or by pecuniary assistance'. 'A tenant who proposes to rent and cultivate a farm of 300 acres of rough hill land', he wrote, 'is usually a man of the neighbourhood, who has a heart for "roughing it", and can turn his own hand to the plough when wanted. This tenant at once disclaims all idea of a smart house.'

The moor's occupation had finally been achieved. But it was often the desperate who tenanted the farms, and as they came to know what they had taken on, their desperation could only intensify. According to W. H. Thornton, the curate of Simonsbath, 'the lowness of the rents per acre had attracted broken-down farmers from afar'. But by 1852 only two farms retained their original tenants – Henry Matthews at Honeymead, and at Cornham, William Hannam.

Hannam's 'history' was started in 1858, the year the moor shrugged him off for good. He had first seen the farm in the summer: the valleys and the moor were at their best: lush, promising. He had met fellow tenants flushed with contentment. But he was wiser than to expect ease. He knew well

...esson that ease might come with labour, but that labour
...ne did not guarantee a thing. You might work from cradle
...o old age and still die in beshitten penury. And yet he had
expected something fine; the moor had promised some sort
of living, and some sort of life for his daughter. In April –
when the apple trees back in Cheriton were in blossom and
the daffodils were showing on the lowland verges – the place
he had come to, the place he was to bring his loved ones to,
'was looking miserably Bad . . . the Forrest was looking very
Barren not a Green Blade to be seen.'

Dismayed that the agreed accommodation had yet to be
provided, four of the new tenants had resigned almost im-
mediately; Hannam stayed – it might have been that the ac-
commodation at Cornham was in better condition, but his
father's investment tied him to the farm. He would have per-
sisted even if it had meant sleeping in the barn.

'There is on Exmoor', he told himself, 'everey thing that
Nature need provide to bring it into Cultivation' – valleys
for shelter; streams for watering cattle; stone for building,
fencing and drainage. He might have been parroting Mr
Knight. And as summer came, and his wife and daughter
joined him, he worked the land hard. The forty-five-acre field
to the west of the farmhouse was, he said, already exhausted
with attempts to grow corn, but after dressing, it gave up a
good crop of hay. The smaller field was wet and covered in
rushes: Hannam cut drainage gutters into it, sluiced the field
with fertiliser, and, where the rushes had stood a year ago,
cultivated a field of red clover for his cattle.

In 1847 his father died. Hannam himself had contracted
typhus, and was incapacitated for 'maney wicks'. 'It was a
great Anksiety on my Mind and partickulerly as My Mrs
was laid up at the same time – it was in the Month of June
and July we were then Milking from 40 to 50 cows.' The

Hannams recovered, but this period of inactivity hastened the farm's decline.

During 1851–2, Robert Smith drew £69 for the purpose of 'entertaining gentlemen seeing farms'. 'There is not the leist Doubt', wrote Hannam, 'that Mr Smiths was intended as a Modell Farm to induce others to follow his steps.' Hannam also remembered the day when the editor of the *Mark Lane Express* had been given a tour of the Knight estate, and Smith's meadows in particular, and the article that followed in that paper, 'representing the advantage to be derived by renting the Exmoor Farms'. Not a word was written, he complains, about 'the enormeos Expence he had bin at to make those meadows . . . I think Mr Knight in time will see that Mr Smith has spent scores of pounds uselessly in Cutting Gutters to take water on that is a Newsance to the Land instead of a Benifitt' – that water being 'the bog water taken of the hill that have never bin Broken or Limed'.

Hannam contended that Smith had made 'a great mistake in neglecting the Fences to Drayn the Bogs . . . There never was a Man come on Mr Knights Property yet that made so maney mistakes as Mr Smith.' He was particularly scathing with respect to Smith's attempt to grow wheat – 'I was at his house repeatedly,' he writes, 'and I never saw a Loaf of Bread made with it neither have I in 12 Years I have bin on the Moor seen a Loaf of Bread fit for any one to eat.'

It is at this point that we begin to understand Mr Hannam's feelings with regard to Mr Smith. Smith, if Hannam is to be believed, was close to ruin when he came to Exmoor, and applied to borrow a large sum from one Mr Lovebond of Bridgwater. The well-named Lovebond, however, would only lend the money on condition that Smith was able to offer security. Thus Smith came to the tenant of his employer. 'He asked me to join him for three hundred pounds – Mr

Smith said he did not require it but a few Months until he
got his Salerey.' Hannam put it to Elizabeth, who 'had great
objection to it at first but we thought it over what power
he had in his hands to do us a deal of good or injurey and
I was induced to assist him with my signature'. Hannam's
refusal to renew the bill led to a worsening of his relations
with Smith.

During the spring of 1853, he lost forty ewes and 150
lambs; but he was not alone: 'I believe nearly Half the Lambs
on the Forrest Dyed that winter.' The following winter was
worse still, according to Hannam the most severe that had
been known for forty years – 'It mattered not what sort they
were or what we gave them,' he says of his sheep, 'we could
not Keep Life.'

That same winter, he took on a labourer, a 'Person by the
name of Dowdling and two of his Boys'. In January, dur-
ing what Hannam calls 'a little Frost', the elder Dowdling
was loading trenching sod when his fingers became frostbit-
ten and he 'was obliged to have the Tops of severall of them
taken off'.

'He must be a Notorious Lasey Fellow,' says his erstwhile
employer, and 'at last I was obliged to discharge him'. Han-
nam continued to employ the sons, however, only to find that,
in the absence of their father, they grew wilful and also lazy.
Finally the elder boy, John, vanished with Hannam's pony.
'My Wife said he is leaved you have bin Grumbling with him
or finding fault – I said I see I have Enemeys . . . his mind is
poisoned by some one to try to do mee injury.'

Hannam continued to hang on, but his financial circum-
stances were worsening month by month. By 1851 his rent
was already in arrears. Knight, however, agreed to cancel his
claim, upon receipt of £400 from Hannam's father's execu-
tors (Hannam's brother and brother-in-law). The executors

would not oblige; after all, William was still in debt to their late father.

'I began to feel myself in an unpleasant situation – I owed a good Bitt of Money to different people in the Neighbour-hood.' Hannam saw what the farm's loss would mean. At Smith's instigation, he arranged a meeting with Knight's appointed receiver, Mr Fowler, in Birmingham, but Fowler explained that he could do nothing for him; his journey had been wasted. It had cost him three days. His resentment of Smith deepened.

In September, however, Fowler came to Exmoor and agreed to allow Hannam to continue at the farm. But on returning to Cornham, when the full extent of his debts became clear, Hannam 'found they were verey disattisfied'.

'I rode round the Farm after they were gone. I satt on my Poney on Little Cornham and where I had sight of the Farm and a feeling came over mee I must confess I shed maney Tears.'

The following month, one of his daughters (he now had two, and a son) came running up to him while he was working in the fields. Men, she said – one in the house, two in the fields. The bailiff 'informed mee their Business was to take every thing on the Farm boath within dores and without and they were to take every head of cattle'. On 8 October 1856 a forced sale of the farm's remaining assets took place. 'The horses was an amence sacrifice I had a beautiful lott of ponies – Mr Smith Bt severall of them at conciderable less than their value.'

Cornham was sold, but Hannam was allowed to stay on for another year, until Knight offered him £150 to 'leave the Farm Quietley'.

For three days I watched the falling snow. The road to Corn-ham Farm was blocked. The sculpted roadside drifts over-topped the beech hedges; abandoned cars were scattered along the steep road to Lynmouth. A funeral in Brendon had been postponed; the hotels and bistro in Lynton had signs in their windows saying they would reopen next week. In the Valley of the Rocks the snow was lighter, as snow often is lighter by the sea, but where it had gathered in a strip along-side the cliff-edge path, cloven prints were traceable.

R. D. Blackmore had gone to school on the other side of the moor, in South Molton, and had become acquainted with the moor itself during visits to his grandfather, who was rec-tor of the village of Oare. 'Sometimes of a night,' he wrote in 1898, looking back, 'when the spirit of a dream flits away for a waltz with the shadow of a pen, over dreary moor and dark waters, I behold an old man, with a keen profile, under a parson's shovel hat, riding a tall chestnut horse up the west-ern slope of Exmoor, followed by his little grandson upon a shaggy and stuggy pony.' There's a moor word: *stuggy* – 'thickset' or 'stocky'.

Blackmore's story of the Doones was based on real legends of Exmoor outlaws, disinherited aristocrat–thieves hounded from the Scottish borders, 'moss-troopers' accustomed to raiding and riding and hiding in wet country; men who could gauge a bog's depth in feet from the colour of its surface moss-es, and for whom the moor, far from being a fearful place, was a sanctuary. And yet even the Doones do not live, pony-like, on the open moor, but snugged into the Badgworthy Valley, the combe that channels deep into Exmoor five miles upriver from Lynmouth. 'Doone Country', on the map.

Following the success of the one-volume edition of *Lorna*

Doone in 1870 (the three-volume edition had been a flop), tourists came to the moor in search of the places it described. Some were disappointed. Baedeker's 1887 guide noted a 'discrepancy between the actual scenery of the Doone valley and the description of it in *Lorna Doone*' – just as, thirty years earlier, the *Bradford Observer* was surprised to find the Brontës' Haworth 'a large and flourishing village' rather than a 'struggling hamlet' surrounded by 'barren heath'. The 'actual' Doone valley, of course, was the one described in the novel.

The little girl John Ridd saves from the bog at Exe Head, with her basket of whortleberries, turns out to be the granddaughter of a witch, Mother Melldrum, who lives in a cave in the long-dry Valley of the Rocks. 'Then' as now, the valley and the rocks that tower around it are occupied by a colony of feral goats (they have a Facebook page). When John asks Mother Melldrum 'when [he] may go to see Lorna', who is imprisoned in the Doone Valley, the witch tells him to have 'nought to do with any Doone'. As proof of her powers, she directs his attention to a rocky promontory, on which 'a fine fat sheep, with an honest face, had clomb up'. 'Behold the end of that,' she says; and at that moment a 'lean black goat came hurrying . . . with fury and great malice'. After a tussle, the goat butts the sheep over the cliff onto the shore below. 'His body made a vanishing noise in the air, like a bucket thrown down a well-shaft.' John catches the goat by the right hind leg and hurls it after the sheep – 'to learn how he liked his own compulsion'.

That morning there was blood on the snow; but not the blood of death or injury. Clattering along the narrow path high above the sea was an hours-old kid, rickety as a stool with a leg too short, an automaton with a buckled cam, and no bigger than a cat. It was bow-backed and beard-grey, with black pop-socks and a white toupee. In the snowy gorse a

few feet uphill from the path, its mother was giving birth to a second kid. A slicked black leg was visible. And even as I watched, two billies drawn by the scent of blood or something more particular were circling, waiting for the mother, and with such persistence that even when you clapped your hands at them they simply stood there, marbley righteous gazes fixed on the labouring mum. When I left the valley, she had dispossessed the second kid, and was being chased along the steep slope above the cliff by one of the priapic billies, while the two newborns stood side by side, staring at a patch of snow.

I walked up the East Lyn to the Doone Valley – the Badgworthy Valley, rather – the river strong and iceberg-green with snowmelt, its waters somehow syrupy, as moving water sometimes seems to be when very cold.

I followed the river up through the wooded valley towards Brendon. The snow thickened underfoot, until, when I emerged at the village, the ploughed snow was head high along the edges of the lane to the moor, and the surface was so slippery that it was possible to proceed only by seeking out stepping stones of iceless tarmac. As I climbed higher, the ice gave way to a layer of compacted snow, and this in turn deepened as I went on and up. Every twenty feet or so, a wedge of muddied snow as big as a bull had been dumped on the verge from the plough's bucket.

In the corner of a steep field, a flock of twenty urine-coloured sheep were huddled on a scrape of mud. In the opposite corner was a ring-feeder containing hay, and a plait of brown lines was carved into the snow, showing the paths the sheep had taken, back and forth, between the two corners.

I got to the moor edge above the Doone Valley half an hour later: the cattle grids were choked, only the upper ridge

of their bars showing; boulders of snow had tumbled onto the road from the plough-heaps on the verges. There came a point where I could go no further (the plough had turned back). There were no animal prints up here. Nothing extended from the moor's duned surface. The spindrift coming off it was like birdshot. The course of the road had become indistinguishable from the moor, which rolled away for a few metres on either side before becoming indistinguishable from the sky. Like a form of blindness. When I got back to Lynton, I strolled to the Valley of the Rocks to check on the goat-kids. But I couldn't find them or the adults. There was just a glut of afterbirth in the thin snow.

<div align="center">7</div>

Overnight a few hours of rain cleared the roads. The morning sky was unsullied, and the sun of alpine clarity. I got a lift to the end of the long driveway to Cornham Farm.

On Lady Day 167 years ago a sale had been held here. 'It turned out to be verey Cold severe weather,' Hannam wrote. On the first day attendance was poor, on the second day it was 'so Cold people could scarcely live'. James Coombes of Crooked Post had bought five hundred sheep 'at a verey low price the autom previos'. But 'he had only 400 Acres of Land and not a Foot of it Cultivated or fit for that Class of Sheep'. During the winter, 'they got verey Poor and I have hird they were scarcely able to walk down in the Spring'. Every one of his stock perished. 'I believe he went out in the Morning after Showing them and found 60 Dead.'

Mark de Wynter-Smith is the current tenant of Cornham Farm. We were sitting in his warm kitchen. Through the window, the moor was dazzling; the room seemed shaded, a bunker from that intensity. There was a feeling of being

contained within castle walls. 'One year we got hundreds of sheep buried,' he said. 'I think we lost about fifteen or twenty that year. If it stays cold it's fine, and they can be in there for a week or ten days. But when it starts to thaw you get the drifts, six, seven, eight foot high, and they're underneath it, and when it thaws it sinks, and they'll suffocate.'

Tracing the bounds of any moor is impossible: the thresholds of vegetation and soil are tidal; the frontiers of ownership, improvement and designation ebb and flow. But in 1995, in order to aid the allocation of farming subsidies, a 'moorland line' was drawn by the Department for Environment, Food and Rural Affairs, delimiting 'land within England which has been defined as predominantly semi-natural upland vegetation, or predominantly of rock outcrops and semi-natural vegetation, used primarily for rough grazing'. This area of 'official' moorland lies within a further designation, for land that is resistant to cultivation, where farming has become uneconomic without subsidisation: Less Favoured Areas.

'A hundred and seventy years ago, when Knight arrived,' Mark said, 'there was nothing here. I often think, when you look at what is here *now*, all this was *moor*. If you abandoned this area, if you just left it – I'd say twenty-five years – it'd go back.'

Mark has been farming at Cornham for sixteen years, above and below the moorland line, in a Less Favoured Area, within what is known by yet another designation: Severely Disadvantaged Area. It's a hard farm, still; technology has come on since Hannam dug out his drains in the field beyond the window, but the climate is no kinder. The higher the farm, the higher the rainfall and the lower the temperatures. It has been estimated that the plant-growing season in Britain shortens by thirteen days with every hundred metres of elevation.

'The moor will turn around and *bite* you . . . We've had ewes and lambs buried in April. Last year was horrendous. The weather was terrible, it was just knocking lambs down like billy-o.'

When he first came here, somebody, wryly, bought Mark a rain gauge. 'It held three and a half inches in the little pot at the bottom, and I got sick of emptying it at lunchtime, so I put another pot on the bottom, which held six and a half inches, and I occasionally emptied that by teatime. One particular year, six or seven years ago now, we didn't get one dry day from the beginning of May all the way through to September. We'd got sixteen hundred cattle and eight thousand ewes and no silage. And all of a sudden the weather looked like it had turned, and we went and we got the silage done, and we got nothing but rubbish, wet rubbish.'

Just as moorland improvement escalated during the Napoleonic Wars, so, following the Second World War, the Hill Farming Act encouraged further improvements – subsidies were awarded per head of livestock, and grants paid for each hectare of moorland drained and taken into cultivation. During the 1960s and 1970s, some hundred thousand acres of blanket bog were being drained in Britain each year. In the 1980s, when it became clear that overgrazing, draining and burning were damaging Britain's upland ecology – drying out the peat and creating near-monocultures of grass – a slow reversal began.

When Mark came to Cornham in the late 1990s, subsidies were still being paid on the 'headage' basis – per cow or sheep. The winter feeding areas were like 'bombsites', he said, 'just black pits; we had huge rafts of ground where there wasn't a blade of grass. We were overstocked, hugely overstocked; we did a lot of damage in the winter. It was very stressful.'

The subsidies have since been decoupled from production, and are paid according to the size of your farm, removing the incentives that led to overgrazing. 'You get paid so much per hectare, and it's good, in a way, because stock numbers have come right down and prices have gone up.' At the same time, the Environmental Stewardship Scheme was launched, a system of grants designed to encourage landowners to adopt management practices that favour biodiversity, including the preservation and regeneration of peat bogs. You might be paid to spend a week blocking the drains your father or grandfather spent two weeks digging. On Exmoor and Dartmoor, the 'rewetting' of the bogs is subsidised by South West Water, it having become apparent that degradation of moorland peat leads to discoloration of water downstream (seventy per cent of England's water comes from the uplands). Cheaper to prevent discoloration at the source than remove it at a treatment plant.

In the paddock close to the farmhouse, the snow was thigh deep. From the tops of east-facing doorways ranks of icicles had been induced to a slant by the night's winds. Most of Hannam's original barns are intact. In one that appeared at first to be empty a shaft of light disclosed a plume of steam. A massive contented bull was stationed there, in the semi-dark, radiating heat like an Aga.

'You think you're doing all right,' Mark said. 'But without the subsidies you're still doing crap. Without the subsidies you wouldn't be farming up here, full stop. Every cow on the farm, if I took the subsidy away, every cow is losing hundreds of pounds. But we've taken the decision we want to stay farmers. This is what we want to *do*.'

He was getting on his high horse, he said – he wasn't a politician. But his anger was of the stifled variety I would encounter among other farmers and gamekeepers – a belief

that his industry has been slickly undermined, that he is being exploited and somehow taken for a moron; and a fear that the public view farming with confusion, and contempt. An outmoded tax-drain.

The hill farmer has become an environmental steward, a cultivator of grants and subsidies. Productivity is no longer a requirement, or even desirable; it's possible to run a farm without generating a single side of beef or leg of lamb. Farmers like Mark are paid to encourage golden plover and sphagnum moss, to rejuvenate and tend the peat (whose only purpose, in Hannam's day, was as a fuel to heat your home) and to maintain the moor for people like me, who come up to admire it.

'Occasionally,' he said, as we stood at the door to William Hannam's cowshed, looking out over the reddish ewes gathered in their pen – 'occasionally, you can go out in a field, when it's snowy like this, and foggy, and set off in a direction you want to go, and all of a sudden you get halfway across and you think: I've gone wrong here.'

Mark drove us up the hill to the field called Little Cornham, overlooking the Barle Valley, where William Hannam sat on his pony and 'shed maney Tears', upon finally understanding the impossibility of his position.

'There was nothing square or jagged left,' writes R. D. Blackmore of the blizzard moor, 'all the rugged lines were eased, and all the breaches smoothly filled.' If for Blackmore it is a purification, for the newcomer Lockwood in *Wuthering Heights* the snow obscures a land that is already featureless: 'The whole hill-back was one billowy, white ocean; the swells and falls not indicating corresponding rises and depressions in the ground.'

In March 1861, during a return visit to Exmoor, William Hannam learned of the agent Robert Smith's dismissal.

'I think he was Beat and all Power was taken out of his Hands,' he writes. 'He then put an Articall on the North Deavan Journall Puffing up What he had done on the Moor and that he had resigned the Agencey.'

Shortly a rejoinder appeared in the same newspaper:

Sir, – I observe an article in your last paper professing to give an account of my Exmoor property. The account contains many inaccuracies.

Among other things it states that Mr Robert Smith has resigned my agency. I beg to assure you that, on the contrary, I felt it necessary to dismiss him from the agency.

If I did not trace the hand that penned your article, I should not have felt it necessary to make these remarks.

Your Obedient Servant,

F. W. Knight

Smith had also resigned his place on the Council of the Royal Agricultural Society.

In the last pages of his 'history', Hannam writes of his return to his boyhood village, Elizabeth having left him for good, taking the children with her. He has lost the will or means to express himself clearly – the underlining is violent, the nib-line cleft under the pressure of his hand:

I saw they were all tierd of mee and all Ashamed of what they had done and were Ashamed to see mee as the knew the had Robbed mee of My Birth right and tried to sett my Children against mee . . . I called on old Mr Ritchards [a friend of his father's] thinking to get a Little from Him on my Behalf but He was as bad against mee as aney or worse . . . He said I was stubborn.

Mark and I looked out over the moor. Stark against the contoured snow, the black course of the Barle wound along the valley floor; on the valley sides, stands of beeches; and among these trees, if you looked carefully (Mark had to point them

out to me), stags bearing their treelike horns, standing quite still – and everywhere across the hilltop moors, passing from valley to valley, the deer's intricately plaited tracks – not dirty, as the tracks of the sheep had been dirty, but soft rufflings in the snow's surface, despite the animals' size. And far off on a hillside, ringed by tall beeches, William Hannam's Cornham Farm, which had looked pure white earlier in the year, but today, against the unearthly white of the moor, was the colour of an old tooth.

3. The Abbot's Way

Dartmoor

I

From the river Dart, on the edge of Dartmoor, a shallow leat leads to Buckfast Abbey. I followed it past the low-lying 1970s conference centre dedicated to St Cuthbert (once the abbey school) and the lavender plot with its 150 varieties (Walberton's Silver Edge, Miss Muffet, Ballerina, Nana Alba . . .) and past a river-fed lawn green as Astroturf. Ahead, reflected in the water's surface, the steeple of the abbey church. Suzuki minivans bearing the abbey's coat of arms zipped about the grounds.

Finally the leat led me to the black-robed abbot, who was waiting for me at the church door. He knows the river, Father Abbot. As a boy, before he joined the community, he and his friends would camp on the abbey land, and creep down for a dip. It was not hard to picture him as this boy: even garbed in black, with his pectoral cross hanging over his habit-front, he had a boy's cheer and a boyish bumptiousness. In the late seventies, long before he was elected, he stood one day and watched the flooding Dart, higher than it had been for years – the water moving, ton by ton, down from the moor. All of it the moor's. Flooding is rare this far downstream, but another summer, years later, a passing mill-man was washed away.

Water up to his welly-ankles, the brother who would become abbot had looked on as the old timber suspension bridge was first unpicked and then, piece by piece, carried off. He was young and reckless. 'I suppose God had other plans for me.'

I attended each of the abbey's offices, the horarium – Matins at 5.45 a.m., Lauds an hour later, Mass at 8 a.m., Compline at 9 p.m. – and breakfast, lunch and dinner in the vaulted refectory, while a novice wearing a headset microphone read from a biography of Dickens. ('When he was only five months old, the family was obliged to move to a smaller house on a poorer street, with no front garden . . .') As the days passed, and the story of Dickens progressed, each office became indistinguishable from the next, and my time there I remember not as activity interspersed with episodes of prayer but rather prayer interspersed with episodes of study, and those gentle collective meals, and long hours of a kind of bright somnolence.

In the desk in the corner of my room was a copy of the Rule of St Benedict. There are four kinds of monk, it began: 'coenobites' – monastics like my hosts, living under the rule of an abbot; 'anchorites', who reside alone and are 'well trained for single combat in the desert', and 'the most vile kind', 'sarabaites', who have 'been tried by no rule'. Finally there are the 'landlopers', 'who keep going their whole life long from one province to another, staying three or four days at a time in different cells as guests. Always roving and never settled.'

Sometimes, between offices, I spent an hour in the abbey library. It occupied the long narrow room that was once the chapter house, and was entered by a heavy door whose braided hoop handle turned loudly in the west cloister. The window panes had a yellow tint; it was as if a light drizzle of grease had fallen on everything. The parquet flooring had been swept but had not been polished. The room had an air of neglect – the rattish smell of books long unopened, of bookworm frass.

From the ceiling hung fogged glass globes. The walls were lined with floor-to-ceiling shelves holding volumes of liturgy,

church history, cartulary, theology. I'd been told by Brother Daniel, the guest master, that there was a section on local history, where there were books about the abbey and the moor. I found the card-catalogue cabinet and located the Dewey numbers, but I couldn't find the corresponding shelves. At the back of the library was a door set with a pane of frosted glass. I was wary of trespassing: much of the abbey was out of bounds to guests. I pushed the door and found myself in a large room, a church, the church that had been built, originally, by the French monks in 1886, to be used while the new church was being constructed. It was unoccupied now; the paper was peeling from its walls. High up in an internal wall was an unglazed stone-framed window, and through the window, ten feet above me, I could make out further bookcases, thinly illuminated by daylight. I returned to the library and looked for the staircase to this annexed section. There was only the wall with its shelves of untouched books.

It was later, when I talked to one of the other guests, that I learned this extension was accessible only via the second-floor guest quarters. The room, in the twelfth-century Abbot's Tower, had a sloping, creaking floor and was lit by a single leaded window and a single bare bulb. It contained shelves full of duplicate copies of the abbey's newsletter, going back to the 1950s, and a tall bookcase tilted into a rhomboid, on which dozens of books about the moor were packed, mostly from the nineteenth century, as well as several copies of the two twentieth-century histories of the abbey, both written by resident monks. I returned to my room with a stack of books from these shelves, and sat at the high open window, from time to time looking out to follow the swallows as they swagged and spiralled over the lichened cloister roof. When the bell tolled, I would put down whichever book I was reading and go alone down the long stone staircase, three flights,

and wait in the chapel for the twelve monks to enter, one by one, and take their places along the walls on either side.

2

The village of Buckfast is dominated not by the abbey, not any more, but by the Buckfast Spinning Company, where Axminster carpets are made. There has been a mill for wool at Buckfast for a thousand years. Corrugated hangars occupy the riverside from the abbey gate for half a mile downstream. The factory windows look out onto the abbey grounds. For years the plant pumped its effluent into the Dart – the washoff from scoured fleeces, chock full of sheep-dip dieldrin and the detergents used in the scouring. For a generation there were no otters for miles downstream; even trout were scarce.

Buckfast became a Cistercian abbey in 1147, following the Benedictine Revival. During this period, upland Britain was transformed by monasticism: it was the monks who brought large-scale sheep grazing to the moors – here on Dartmoor, and on the moors of Yorkshire, where large tracts of 'waste' were often gifted to the abbeys by lay people.

Patrick Leigh Fermor believed that Trappist abbeys were established 'in flat landscapes because their monotony, like the repetitive dunes of the Thebaid, impels the mind to the contemplation of last things'. 'O, beata solitudo; o, sola be-atitudo!' wrote St Bernard of Clairvaux: he might have been right that 'happy solitude' was the one true happiness, but it was not all that directed the monks to the moors. These exposed and fruitless landscapes were counterparts to those colonised by the Desert Fathers: places of *horroris et vastae solitudinis*, in the words of the eleventh-century *Exordium Cistercii*. The allusion to Deuteronomy was deliberate: the 'desert' to be conquered was not only external.

But nor was it simply a wish to be tested that brought the Cistercians to the moors. The desert might be made to bloom. 'Idleness', the Rule of St Benedict states, 'is the enemy of the soul.' In the thirteenth century, more than a quarter of freehold land in England belonged to monasteries. In 1340, Buckfast was included in a list of monastic houses supplying a Florentine wool merchant: together with Forde Abbey in Dorset it was producing ten sacks per year – the wool of about 2,500 sheep. In 1531, Buckfast's chief steward, Thomas Dennys, was charged with investigating whether the land historically associated with the abbey belonged to it by law. On what evidence he concluded that 'the three moors called South Holne Moor, Buckfast Moor and Brent Moor, be parcel of the Abbot's manors' is unclear, but it was an important confirmation. For the Cistercians, whose forerunners had required wool only for their own white vestments, sheep farming had become a business.

Four hundred and fifty years after Domesday, mere months before Henry VIII embarked in earnest upon the suppression of the monasteries, one Gabriel Donne was appointed Abbot of Buckfast. He was Thomas Cromwell's man, and discreetly prepared for the abbey's surrender.

There would be no resistance here. The brothers might as well line up to dive from the bell tower, or walk shackled into the Dart: how many abbots and monks hanged, in Yorkshire, following the Pilgrimage of Grace? Even before the king's commissioners arrived in the southwest, the abbey's property was being sold off, acre by acre. On 25 February 1539, William Petre and his retinue filed into Buckfast, required by the king to obtain its surrender. Petre had been born in Torbryan, only six miles east of Buckfast. The moor would have been known to him, if only as a brown horizon, a trackless

waste. In the chapter house, the deed of surrender was signed by Donne and his ten monks, each tonsured and dressed in white, ceding 'with unanimous assent and consent . . . all our said monastery or Abbey of Buckfast', including 'fairs parks warrens vivaries waters fisheries ways roads' – and 'vacant soils'.

Five centuries of monastic life at Buckfast was ended. The abbey was the crown's, down to the dust beneath its floor-boards. Mitres, rings, plate, cloth of gold, all were carted to London. The monks were pensioned off: this, Petre knew, was how a peaceful surrender was achieved. Donne received the substantial annual consideration of £120. Following the Dissolution, Petre bought from the king the abbey's largest manor, South Brent. Buckfast itself, including the abbey and its demesnes – those 'vacant soils' of Dartmoor: South Holne Moor, Buckfastleigh Moor and Brent Moor – were bought by Sir Thomas Dennys, who, with Donne, had overseen the abbey's surrender and, eight years earlier, had verified the abbey's legal right to those soils.

The commoners, whom the abbot had allowed to pasture their cattle on the moor, were from then on excluded. Dennys had the abbey demolished; its lead gutters were melted down to make bullets. The five bells were sold to Buckfastleigh parish church, for £33. For three hundred years, only ruins stood.

In the early seventeenth century, the Devon antiquarian and topographer Tristram Risdon described the ruins of Buckfast Abbey as 'the skeleton of a huge body whereby may be conceived what bigness once it bore'. But in J. M. W. Turner's watercolour, *Buckfastleigh Abbey*, painted in around 1826, the ruins have quite gone. In the foreground, hanging from a framing tree (like every Turner tree, it looks like an ancient olive but might be an ash), two small boys are after

birds' nests; far below, the broad Dart recedes to a wide val-
ley plain, and what looks like a white castle, complete with
crenellations. To the west, a column of smoke rises and is
carried off by the moorward wind, and all around the moors
rise. It is not, in fact, the abbey, but the neo-Gothic mansion
built in its shadow by the new owner, Samuel Berry, eighty
years before Turner's visit. The Abbot's Tower, where the
library annex was located, Berry preserved as a folly; the rest
of the ruins were flattened. It had taken more than three cen-
turies, but the abbey was laid waste.

On 5 November 1880, soldiers had gone to the 'unauthor-
ised' monastery of La Pierre-qui-Vire in France, which had
been founded thirty years earlier. The monks were evicted
– though with less ease than their Buckfast counterparts 340
years before. Two years later, seeing an advertisement in the
Tablet, they took possession of the grounds of Buckfast Ab-
bey, and by the end of 1882 the community had settled there.
In 1906, the abbey's first abbot, Boniface Natter, was selected
by the Abbot General as Visitor to the Subiaco Congregation.
He and his travelling companion, also from Buckfast, Dom
Anscar Vonier, boarded the SS *Sirio* at Barcelona, whence
they were to sail to Argentina.

Vonier's account of what followed appeared in the *Tablet*
a month later: 'About three o'clock in the afternoon, I left
him on the upper deck and went below. I was about to return
when suddenly there was a shock which, by the description
of all who felt it, produced a most strange sensation; it was
for me the impression that the deck of my cabin was being
driven in.' The steamer had run aground. The abbot was
last seen clinging to a plank, his hand on his face, 'as if to
make the Sign of the Cross'. Uncounted Spanish and Italians
bound for Argentina were also drowned.

At Buckfast, the Office for the Dead was said for the abbot

and Vonier, a knell rung on the abbey's solitary bell. After a fortnight Vonier returned to Buckfast. The Bishop of Plymouth gave the Requiem Mass for the deceased abbot, and Vonier was appointed in his place.

His first act would be to begin the rebuilding of the abbey church on its original Cistercian foundations. To his friend the Abbess of Dourgne he wrote, 'I am only thirty. In another thirty years I shall not be so very old, and during all that time I shall apply myself to this task without ceasing. Given time and patience one might construct a world.'

It was to be built by the brothers themselves, by Peter, Hilarion, Richard, Ignatius and the others, using manual hoists and block and tackle, and wooden scaffolding. Peter was sent to the Abbey of En-Calcat in France to learn from the master masons working there. The Buckfast monks started at the east end, with the sanctuary and transepts. It took thirty-two years.

One of the noviciates who would help to butt and dress the yellow Bath stone was named Louis, though it was neither the name he had been born with nor the one that would appear on his headstone. His parents had christened him Karl Kehrle. Even as a boy he had the pendulous ears of an eighty-year-old. He had come to the newfound abbey in 1909, from Mittelbiberach in southern Germany. Leaving the alumnate, he became a novice in 1914, taking his vows two years later, whereupon, once again, he was renamed: until his death he would be known as Brother Adam.

He had been a sickly boy, since stepping off the train at Buckfastleigh station; homesickness and the rigours of novitiate life made him feeble. His life would be marked by illness, by 'breakdowns' and 'overwork'; a sickly child, he became a sickly man. In 1915, in the spring, it was decided that what young Adam needed was sunshine and fresh air, and he was

released from his work in the stone yard, to assist Brother Columban in the apiaries.

At first the monks went to the moor with wheelbarrows, each one stacked with hives, one brother pushing and two more tethered like mules ahead; later it was horse and cart, the brothers hopping off to push when they came to the steeper hills; later still, Horace from the Co-op drove them in his truck. One day each August, Brother Adam and his men would set off, before the sun woke the bees, the hives sealed and packed, up the long track to the moor.

Up from the abbey, up through Hockmoor and up through Burchetts Wood, up to Scorriton and onto the moor at Lambsdown Farm, all the while the abbey church itself, with its stones he had dressed, receding into the valley until hidden altogether by the trees and the rounding hills.

Kneeling to examine a hive, Brother Adam spread the skirts of his habit around him, like a tent's flysheet, to keep the bees out.

In 1918 he took over from Brother Columban as the abbey's head beekeeper. Disease was rife in British hives. The native black bees had been decimated. Adam and his men swept the corpses from the hives like cinders from a grate. Farmers would come to the abbey clutching skeps full of dying bees. Acarine, it was called, the Isle of Wight disease, and thirty of the abbey's forty-six hives were destroyed. It would happen again, Adam knew; the hives' only yield would be these rotting heaps, and then not even that. He must concern himself, therefore, not merely with productivity but with the genetic improvement of his swarms. His work would be to develop a more resilient strain. Adam travelled the world, collecting queens from the oases of the Sahara and the islands of the Peloponnese, and posting them back to the abbey on the edge of the moor. When he returned, he would use his acquired

knowledge to set up a breeding station on the high moor, at Sherberton, and there he would cultivate his new strain.

3

The morning before I left the abbey, I wended my way down to the Dart, through the tall meadow grass, to the dappled cobble bank. I removed my clothes, hanging them from the branches overhead, and dropped into the water. In the weir pond, four foot-long trout were hovering over their shadows, maintaining position with an occasional tail-pulse. They would stay there all day. Above them, pussy-willow fluff furred the water's surface.

Before the Great War, an annual bazaar was held in the meadows, and boating took place on the weir pond. In one of the books from the abbey library I found a photo taken in 1903, showing three craft floating on the pond, jerry-rigged from cider barrels. Aboard one of them, in the company of a female singer brought in for the festivities, is a monk. Amidst the fun, his expression is that of a man at work. The black habit never comes off – the builders clambered up and down the steeple scaffolding with their skirts flapping, and Brother Adam's was caked with wax. The monk on the boat is in fact the abbot, Boniface Natter, three years before he went down with the *Sirio*.

It didn't seem fanciful, as I glided out into the deep middle of the weir pond, to mouth the word 'benediction', or to consider that the force of this water – golden from the peat – was the force of the moor, that the current's massive power was also the moor's power, just as the wind that came off the moor was an expression of the moor. I might swim upstream, swim then slither then crawl, and eventually find my way to the moor's wet heart, at Cranmere Pool.

It was while I was sculling to and fro that I noticed, paddling at the water's edge a hundred yards downstream, a monk, one of the older members, whom I didn't recognise. Basking. The skirt of his habit was hitched up to the waist, the top rolled down to expose a hirsute white navel. He stepped tentatively into the water, and deeper, until it lapped his knees.

The holy offices had been relocated while the church was being done up for the abbey's millennium celebrations. The vaulted chapel had once been the abbey's cellar. It was dimly lit by fluorescent lights concealed behind a false back wall. During the offices I stood at the back and listened to the monks' plainsong, led by Father Abbot. During the four days I stayed at the abbey I came to recognise those twelve voices – the hearty baritone, the glossal mutter, the high pure tenor – and grew familiar with the outward manner of the men's prayer: the rocking back and forth, the tender mouthings and frownings. At my final Mass, the incense cracked like something ancient finally giving way. The monks didn't flinch. I stood in my place and watched as the handful of celebrants queued – 'The Blood of Christ'; 'The Blood of Christ'. When it was at an end, Brother Daniel tipped an inch of holy water into the empty chalice, swilled it and, with an extended finger, rubbed the chalice's inner wall; then drank it down in a single draught. He wiped the rim with a white cloth, folded the cloth and laid it over the chalice.

As I walked away the next day, under the ancient gate William Petre and his henchmen had used, the bell followed me – dull as an anchor being struck with a shovel. In its knelling I heard the monks' plainsong, and I continued to hear their voices as I approached the moor, and for days to come.

4

Two days after finishing with Buckfast, in 1539, Petre was sixteen miles west, signing off the surrender of Buckland Abbey on the other side of Dartmoor. It would have taken him that long to cross the moor from Buckfast with his retinue, the horses and notaries and cooks and guards (guards against bandits, against wolves, against the Devonians who wished them ill). Chances are they'd have taken the route known, today, as the Abbot's Way. According to W. G. Hoskins, the author of *The Making of the English Landscape*, the name 'is of no historical significance: merely further evidence of the obsession with monks, nuns, underground passages and priests' hiding-holes that bedevils so much topographical writing . . . Nevertheless' – he concedes – 'the track is of considerable age, most probably early mediaeval, and must have been a recognised way over the southern part of the Moor . . .'

As I dropped down to the Avon Reservoir on the moor's eastern edge, I passed through a patch of newly scorched gorse, burnt off by the farmer. Flitting from blackened branch to blackened branch, knocking cinders into the air, throwing up ash, a dozen finches noisily occupied their own hell. There seemed to be bones everywhere: partial crania, the fine bones of crows, a sheep's spinal column still skirled with wool. By the Dart I had found a fox's skull, light as a blown egg, its jawbone intact and articulable.

A farmer I met told me about his prize black ram. One day, because of its temperament (it went for every other ram it saw), it was enclosed in a separate pen. Next morning, the ram was gone. The stockman followed a trail of black wool, said the farmer, and on a moorland bank above Princetown, he found the black ram, breathing heavily, lying with a gory hole in its temple where one horn had been smashed clean

off. It was treated; it lived. When, years later, the ram vanished again, it was easily identified when spring came – in a dried-up leat, the big square skull with that familiar void above the temple.

Forest law decreed that all livestock such as were roaming the moor at night would incur a penalty to their owner; therefore the abbots saw that a lay brother occupied a grange on the moor, to care for and to protect the herd, and to shepherd it into a walled paddock at night. Wolves would come up onto the moor, drawn by bleating. Ten lambs taken in a night. Twenty. The ruins of the grange lay somewhere beneath the dark waters of the Avon Reservoir.

The name of the last lay brother to occupy it was Henricus Walbroke. Who was he? How did he know his God? Was he closer to Him here, or further away? On a quiet morning, might he, at this distance and beyond the hills, have heard the dull toll of the abbey bell five miles away, in another land? The grange was finally deserted at the time of the Black Death.

There would have been no shortage of building stone on the moor – the walls of Bronze Age people would be pillaged for the walls of their mediaeval descendants, just as the stones of those walls would themselves, in time, be used in tinners' huts and farmers' folds. When, prior to the reservoir's construction in 1957, an archaeological survey was done, potsherds were found here, and charcoal, and whetstones, and a bung from a cider bottle.

On the hillside beyond the reservoir, a lone ram stood and bleated relentlessly. On every granite outcrop a buzzard waited.

I rested on a dais of moss in the centre of a cairn circle above Buckland Ford, and ate six Snack-Sized Cornish Pasties. The grass – mat-grass, mostly (*Nardus stricta*) – was tall and white and straw-dry, tiring to walk over. Under the Cis-

tercians grazing had been intensive: the Welsh monks were recorded as running flocks at a density four times that of neighbouring lay farmers. By thwarting the growth of scrub, and by selective grazing that encouraged the dominance of unpalatable vegetation such as mat-grass, sheep altered the appearance of the moor. It was grazing, largely, that was responsible for this pallid grassland. The moor was the colour of dough; of bread; of toast. It was a peasant stew, in a shallow bowl. The reservoir, a mile back now, was black even under the blue sky. The larks were as many as stars; on a warm day like this, their song was as good as a drink. The sheep continued to make their noise. In one ear, the soft wind.

From the plain ahead rose a grassless mound a hundred feet tall, the waste tip of the old china clay works of Red Lake. It was there for an hour, at the edge of my vision, a brindled cone shimmying in the heat haze. The Dean Reservoir; then the waste tip; and going between them a disused tramway; and here and there, in the deep pale grass, the footings of ruined brick buildings that once served the works. The tramway now was rutted with the dried tracks of mountain bikes. Five miles from the nearest dwelling I found a single black high-heeled shoe, and tucked snugly into it – surely deliberately – an empty bottle of Evian. Where the peat was exposed, the sun had turned it brown, and cracked its surface, like pottery baked too quickly. On a hummock above the old tin workings at Erme, a lamb had been deftly plucked – its carcass had been taken away, only a scattering of fine wool tufts remained, each tuft rooted by a scab of blood. The only livestock visible were the black Galloway cattle five miles off, towards Princetown. For a mile there were no larks to be heard – just the sound of the dry grass as I stepped through it; and the noise of swallowing, loud in my throat.

5

Foxtor Mire is the supposed model for the Grimpen Mire of *The Hound of the Baskervilles*, the 'huge mottled expanse of green-splotched bog' in which the villain Stapleton 'is forever buried'. I hazarded a foot into a patch of spongy reddish sphagnum and the surface vegetation for metres ahead undulated like a water bed. It was here (here!) that Dr Watson had stood, on first arriving at the moor: 'It's a bad place, the great Grimpen Mire,' Stapleton tells him; it was a version of Bunyan's Slough of Despond, 'such a place as cannot be mended . . . whither the scum and filth that attends conviction for sin doth continually run'. And it is here, too, that the newcomer first hears the howl of the beast: 'A long, low moan, indescribably sad . . . It filled the whole air, and yet it was impossible to say whence it came.'

It is not only in fiction that the Hound has appeared. In 1946, long before he published his first novel, John Fowles was a marine based at Okehampton, fourteen miles away on the northern edge of the moor, training new recruits. One night, searching for a section missing on the moor, he found himself alone on a tor . . .

Suddenly and silently a massive black shape moved and stood in a breach of the rocks above me. I haven't forgotten the moments of pure atavistic terror that possessed me before I had the sense to pull out the Very pistol I was carrying . . . And yes, of course it must have been a wild pony; but what I saw, like many a lonely and bemisted moorman before me, was the Hound. They, after all, did not carry Very pistols; nor had they read Jung and Freud.

Hound, Beast, Big Cat – only the moor's absence given substance, a gout from the mind's recesses spat out into the world. The Hound's pedigree can be traced both to East Anglia's slavering Black Shuck (a killer dog with glowing eyes)

and to an earlier telling – or retelling – of a Dartmoor hell-hound story in Sabine Baring-Gould's 1897 novel *Guavas the Tinner*. Conan Doyle was apparently told stories of a diabolical Dartmoor hound while golfing with his friend Bertram Fletcher Robinson in Cromer. The pair made their trip to the moor soon after.

Such monster myths are not confined to the moors, but they predominate in places where huge space abuts human habitation. Bodmin Moor has its Beast – in 1994, a boy unearthed a big cat skull on the banks of the Fowey (tests showed it was the rotted head from a leopardskin rug). In 1984, marines were deployed on Exmoor to hunt the 'big cat' blamed for tearing the throats out of scores of sheep (the predator was not found, the killings soon ceased). In 2004, a 'black panther' was run down and killed on the Whitby–Pickering road outside RAF Fylingdales – the corpse spirited away, it was alleged, by the MOD: 'It's in the basement,' one of the policemen there told me, 'in the deep freeze, with the little green men.'

Those who most often report sightings are not newcomers like Sir Henry Baskerville, addled by the strange environment, flummoxed by disorientation, susceptible to the myths of a place whose true stories they are yet to learn, but those who *know* the land – farmers, villagers, gamekeepers – and into whom its menace has percolated. Familiarity doesn't exorcise the moor of its threats – because they are *there*; they don't change. That they are, in part, threats to the spirit rather than to the body makes them no less potent than the trawlerman's fear of the sea. It is not the Hound that kills Sir Charles Baskerville, but his fear of it.

The Hound, of course, turns out to be simply a big starved dog. But the Hound of the ancestral Baskerville legend recounted by Dr Mortimer at the start of the novel – the 'great, black beast' that 'tore the throat out of' the abductor Hugo

Baskerville – this beast was something more real. Its ancestors were the West Country 'wisht hounds', familiars of the 'Dark Huntsman', which skulked and bayed in the night-time wastes, and carried to hell the souls of unbaptised babes. *Wisht*: a Devon word, meaning 'sad and uncanny'.

The novel's main players, Sir Henry Baskerville, the Stapletons, Dr Watson and Holmes himself, like its author are outsiders – incomers. If Conan Doyle had known the moors, he would not have concocted a solution so prosaic; he might have allowed the novel to close with a last unfettered howl.

Perhaps we retain some residual memory of what it is to be another species' prey. Say there is a fog, perhaps you are wary of being benighted, perhaps the weather is closing in; you walk faster, you turn to glance behind you, you stumble, knowing, even as your heart races, that you *aren't* being followed – but needing to check all the same. Fear condenses into something solid in the mind, as fog condenses into wetness on the cheek.

I passed Siward's Cross, a granite waymarker of adult height, and was on a clear pale bridleway over grey prospects. I found myself walking backwards, north towards Princetown, where Conan Doyle stayed while carrying out his research, watching the valley below me darken, and the darkness, as if borne from the mire, seem to approach me (it was not quite a fog), preceded by a cooling of the air and a wind that intensified as if adjusted by a dial. When I turned, I could see, distantly, the outline of what anyone would recognise as a building of state.

6

Water is important to David. Oil is important to him. For him, God's love is a liquid, or not a liquid exactly, he says

– more like a vapour, the vapour of a liquid, of an oil. Shimmery. 'Think of Mary Magdalene,' he told me, 'when she's anointing Christ on the cross and she tips the jug of oil over him, and it's the shimmer of the oil.'

I'd handed in my passport at the portal and been led across the scoured forecourt to a locked door, and another, and then the chapel, where we found David placing a photocopied order of service on each of the low municipal armchairs – foam cushions, scratched pine arms. He was in for burglary. He was small, or rather diminished, and had the prison pallor, the tallowy whiteness that goes deep; white that showed through his wiry beard. He eyed me wetly, kindly, with a kind of urgent curiosity.

I asked for two sugars, and he said is this all right? – shaking a sachet of Canderel. It was all they were allowed – real sugar gets pilfered for prison hooch. David knew the moor well, he said, although all he could see from his window was concrete. In the story 'Silver Blaze', written before the dog book, Dr Watson describes Tavistock lying 'like the boss of a shield, in the middle of the huge circle of Dartmoor'. In fact, Tavistock is well off beyond the moor's western edge. It is Princetown that is Dartmoor's 'boss', and dominating Princetown – a circle in the circle of Princetown in the circle of Dartmoor – is HMP Dartmoor.

It's been feared and hated by inmates since it was opened as a depot for prisoners of the Napoleonic Wars, in 1809. Hated on account of the cold, and the knowledge that beyond the double walls lies a greater barrier still, and the isolation. If it is hard to escape from, it is also hard to get to. It's a place where you might be forgotten.

There are two Sunday services, just as every prison activity has its shadow iteration: one for the general population, a second for the 'vulnerable' community – rapists, child sex

offenders, batterers of the elderly; coppers; judges; clergy. Attendance at the first service was up on last week. For the first time in eighteen years, Brenda the organist was accompanied by drums, played pianissimo by a dreadlocked newcomer. The singing was lusty and atonal: Louise the chaplain led clear as a lark (a moorland lark), the congregation clamouring to follow her tune and growing in confidence with each new verse. A stained-glass window carried the words 'I know that my Father and Mother every day and all days watch and wait for my return'. On the hymn board were the numbers 568, 207, 738 and S11 (they only had one 5, Louise explained).

'What,' David asked me, after I watched him and the other inmates, each of them in grey tracksuit trousers and blue-and-white striped shirt or grey felt overcoat, queue to receive the sacrament – the tentative outstretched tongue, the gulp of real wine – 'what', he demanded gently, 'holds a person back from taking part in the Eucharist?'

'Some of you, I know,' Louise was saying, 'have difficulties with alcohol. Please don't feel you have to participate; God will not love you less for skipping the Eucharist. Do whatever is right for you.'

In *A Prison Chaplain on Dartmoor* (1920) Clifford Rickards writes of a burglar he came to know:

Here is no Bill Sykes, with the bullet head and cruel beast-like features, such as we meet with in pictures and detective stories, but a quiet, placid, and pleasant-featured youth . . . I must dispute the conclusions of Lombroso, who declared, after long study of prisoners and prisons, that all criminals could be identified and classified by their abnormal appearance.

The Italian criminologist Cesare Lombroso also believed that thieves could be known by their 'enlarged orbital capacity and bulging forehead'.

As soon as the first group of prisoners had finished their tea and coffee and were led away, the second group arrived. 'Sexual offenders', according to Lombroso, can be known 'by their bright eyes, rough voices, swollen eyelids and lips, and occasionally', he says, 'by the fact that they are humpbacked'. ('Tommy-rot' is Rickards's response.)

This service was packed as usual, but Brenda had to go and play at the service in Lydford, so the singing was unaccompanied. Sex offenders are mostly older and, often, more 'socially integrated', as Louise put it to me afterwards. 'Pillars of the community' – until the downloads came to light, or the man spoke up for the boy he had been. 'These are people who were often very busy in the outside world. They struggle to fill their time inside.'

They knew the tunes, some of them had known them all their lives; knew the words without looking down at their hymn books. Certain voices swelled until all tune was lost.

A few chairs to my right, a young neophyte interjected every so often to endorse the sermon on the subject of wisdom: 'Yes, yes. Because He forgives *everything*, doesn't He, Louise?' It wasn't sarcasm. He couldn't help himself. From behind, from the older men, one-time teachers or accountants or council officers, aggrieved inhalations.

The men were invited to articulate their prayers aloud. At first there was silence, just the sound of the rooks outside, and the occasional rooklike interjection from the walkie-talkie on Louise's belt. Then: 'Thank you, God' – a voice from behind – 'for the birds. They bring me much pleasure.' Another voice, this one chattier, less anguished: 'Thank you for taking care of my boy after his operation.'

As the period of prayer was concluding, the first voice returned, more loudly: 'Please, God, this *place*, the *warders*, they *have* to communicate, they must do *something* about the

systems in this country; the NHS —'

Softly Louise interrupted, 'Thank you; let's have a chat afterwards, shall we? I'll come and see you.'

As Louise and I walked with David back to his cell, after the other men had filed out of the chapel, he lifted his face to the wind, and told me: 'You remind me of a friend of mine.'

There was a time when some of the cells in the vulnerable prisoners' block overlooked the moor, Bellever Tor visible through the bars, but eventually these cells were decommissioned – drugs were being catapulted in over the perimeter wall. Now all the cells face inwards. You might be in Pentonville or Strangeways – apart from the cold, and the wind, and the sound of the wind, and the larger silence that enfolds even the most raucous wing. The men still work the moor, on the prison farm (it's a rare patch of intake that has had such a large and steady workforce), or clearing snow from Princetown's roads.

The town itself is little more than an outgrowth of the original prison barracks. That night, as I walked to the Plume of Feathers, the sky was not moor-black but cadmium yellow, the mist thickened by the light from the floods that keep darkness from the prison. I was conscious of a great emptiness beyond the village edge. Princetown was a ship labouring through high seas; or a space station, seeking a live planet. From a roadside tree a robin sang, as it must sing every night on this street that never knows real darkness.

Princetown is a settlement built of the moor, as if ripped up from it, out of it: everything is granite or the colour of granite. The old warders' social club was boarded up and fenced off. The High Moor Visitor Centre, once Rowe's Duchy Hotel, where Conan Doyle and Bertram Fletcher Robinson stayed, looked as if it had never opened and never would. On

North Hessary Tor, red lights measured off the two hundred metres of the telecommunications mast, each one pinkening the underside of a stratum of mist.

Whole days go by when all that can be seen from your cell window is mist, like a sheet nailed over it. Then it withdraws, like a mirror wiped clean, and the hard world returns.

Like the Knight family on Exmoor a few years later, Thomas Tyrwhitt came to Dartmoor to break it. He'd been at Oxford with George, the Prince of Wales, and went on to be appointed, first, his secretary, and then auditor for the Duchy of Cornwall – hence the town's name, originally 'Prince's Town'. In 1785 he began to enclose and plough 2,300 acres of moorland southwest of Two Bridges, northeast of what is now Princetown. Root crops survived, just; a little flax. But he could hardly have chosen a more exposed spot, and nothing would flourish at this height and against these winds and in this vinegar soil; the black land reverted to waste no sooner than it was 'improved'. Plough in a ton of lime per acre and still nothing thrived but white grass and ponies. 'Extensive tillage will not pay,' observed the Dartmoor topographer Samuel Rowe, in 1848, 'for the reasons that the lime is wanting, and the expense of obtaining it, heavy, and that in most seasons the cereal will not attain maturity.' ('You're always going to be on the back foot,' a farmer put it to me. 'There's very little brown earth. Most of it is black, which is peat, and peat is just a pile of carbon.')

Tyrwhitt built lodges, roads, the Plume of Feathers. People would follow, he believed. But who wanted to live here, 1,400 feet up and a day's drive from the nearest town? Leave it to the foxes. Tyrwhitt, however, was a man of his age.

When the Peace of Amiens failed in 1803 he saw his opportunity. Men might not come to the moor willingly, but

the moor would keep them here if they were brought. The prisons at Bristol, Peterborough and Plymouth were over-flowing; the prison hulks were full. A new shore depot was required. From the Bristol *Times and Mirror*, 15 July 1805: 'Mr Tyrwhitt has suggested to the Government the propriety of erecting a building near [Princetown] for depositing such prisoners as shall be brought to Plymouth.' In 1806 Tyrwhitt laid the first stone – granite taken from the surface and from the quarry known as Herne Hole, just as every stone that followed would be taken from the moor. Why here? Well, the fuel peat; the stone; the turnpike to Ashburton; but most of all this: Thomas Tyrwhitt had pledged to settle this land, and settle it he would – albeit with manacled French rather than free English.

By December 1808 the bulk of the work had been completed; but already, before the first prisoners arrived, it was failing: the floorboards were rotting in the constant fog; the leat froze solid; the supply roads were a frosted swamp. Preparations were being made for the arrival of the first French prisoners: Hammocks: 5,000; palliasses: 5,000; bolsters: 5,000; blankets: 5,000; clews (pairs, for hanging said hammocks): 5,000. In May, 2,500 prisoners were marched across the moor from Plymouth where they had been docked, plus dozens of carts of provisions – shepherded over North Hessary Tor, where they were able to look down on the prison, their new home.

The depot was a near-circle a mile round, and within that circle was another, and between the two circles nothing. The outer wall was twelve feet high, the inner wall fourteen; a palisade within the inner wall was eight feet high and crowned with a sprung wire hung with cow bells. 'This melancholy sight', one prisoner wrote, 'strikes the view and conveys to the soul a kind of bitterness.'

And they were not only French – Napoleon's allies were varied: Malays, Dutch, Chinese, Poles, Danes, Swedes, Austrians, all thrown into the freezing hangars. But a hierarchy emerged, like sediment settling in stilled water: Les Lords, Les Labourers, Les Indifferents, Les Minables, Les Kaiserlics, lastly Les Romains – those desperate creatures who, it was said, gambled the clothes from their own backs, and killed over half a raw potato. These – 'Romans' because of the blanket 'togas' they wore – were confined to the freezing, rat-swarmed roof space. Once, when the cart came to take away the waste (so one report went), a group of Romans cut the horses down with homemade blades and feasted there and then on the steaming flesh. When American PoWs from the War of 1812 began to arrive in March 1813 they were housed alongside the Romans; it was a lesson in depravity: *this is what you have come to.* Violence followed: the Americans were ambushed. Another wall was built, to keep the two apart. Eventually the Romans were carted back to Plymouth and tipped into the hulks.

The American privateersman Perez Drinkwater was landed in Plymouth in January 1814 and marched to Princetown at the end of the month. He wrote to his brother in Maine:

It either rains or snows the whole year round, and is cold enough for a great coat the whole time and the days are very Long heir now I want to get out of heir before the war is over so that I can have the pleasure of killing one Englishman and drinking his blood which I think I could do with a good will for I think them the worst of all the human race.

'There was not a bed, or a particle of bedding, that was not in an impure state,' wrote the Inspector of Prison Hospitals. 'I could not get anything purified on the moor.' In 1816, with Napoleon's defeat, the prison was emptied out. During its operation 1,478 deaths were recorded. For years, their remains

emerged from the earth – rootled up by pigs and foxes and unearthed by ploughmen. In *A Prison Chaplain on Dartmoor*, Clifford Rickards writes that 'an officer engaged some twenty years ago in charge of a party digging the foundation for the road leading down to Black-a-Brook told me that they dug through a mass of bones and relics yards deep'. Eventually the bones were reburied in the churchyard and in the cemeteries for the American and French alongside the prison grounds. Purple moor-grass, mat-grass and cotton-grass, and, under the peat, the bones of uncounted prisoners.

For thirty-four years the prison remained empty, aside from a spell as a naphtha-gas extraction plant (the project failed – Dartmoor peat, it turns out, makes rotten gas). It was in 1850 that the first British convicts were sent here. Carved into the granite arch that every new arrival passes under are the words *Parcere Subjectis*: Spare the Vanquished. Ask the question, though, and a warder would tell you the meaning: it was Latin, all right, but not Virgil – Dante: *Abandon hope*.

Over dinner at the Plume of Feathers, I dug Rickards's book from my rucksack and found his description of his Sunday routine. After services, the convicts were given an hour in the exercise yard. 'Here they walked round in single file in a wide circle,' he writes, 'but no talking was allowed. I usually joined them, and took my walk inside the circle of men, but walking in the opposite direction, and any prisoner who liked could step out of the circle and join me in my walk, whilst we conversed together.' This rather stately reverend, then, walking against the flow, as if on a treadmill, within the circle of killers and thieves and rapists, within the double circle of the prison walls, within the larger prison of the moor itself – waiting for one of them to drop into his circle. 'In time,' he wrote, 'I found the men gladly availed themselves.'

7

Sherberton Farm stands between Dartmeet and Two Bridges, off the old tramway from Thomas Tyrwhitt's home at Tor Royal, half a mile east of Princetown. The farm, one of the ancient tenements of the old Royal Forest of Dartmoor, is sprawling – its longhouse is still extant, and when I passed down the yard, the stockman was chasing thirty sheep through a narrow gate. 'Didn't get a hand on them,' he said.

The monks of Buckfast Abbey took their hives to the moors each August, to allow the bees to forage on the flowering heather, which produces the sweetest and most lucrative honey. It was in order to maintain the purity of the breeding stocks, however, that Brother Adam was advised by his mentor, Brother Columban, to establish a breeding station for his new bee, further west, in the middle of the high moor. A queen will fly a mile or two from the hive; if she were to encounter a foreign drone the strain might be compromised. Up here, five hundred metres above sea level, wild bees are scarce.

To reach the breeding station, you drop down from Sherberton Farm, then cross two footbridges over the split stream, like a double moat. (Before getting to work, the monks would string together a couple of bottles of beer and hang them in the water to cool.) The walls needed attention; the gaps had been threaded and arced with barbed wire. Beyond the line of the wall was a double rank of conifers to keep the wind at bay – the valley provided some shelter but at this altitude the wind is hard to evade. Under the dark branches of the conifers and up a flight of six stone steps strewn with pine needles. The clearing was bright. It was like coming upon an abandoned village.

In the shade of the trees, dozing ewes observed me with shock. Then they rose curtly and trotted away. In the centre

of the site were the remains of a bonfire, and in the ashes could be seen the remnants of hives. The whole place was strewn with boulders as big as engine blocks, bedded in dead bracken. The hives stood clear of the turf on thick steel poles a foot high. Some of these poles were empty – the hives having been removed or fallen, and it was these that had been burned by the Exmoor apiarist who had recently revived the site. Most of the hives remained, like miniature floodplain dwellings perched to avoid seasonal waters.

In 1932, following the death of his father, Brother Adam experienced his first 'breakdown'; he went home to Germany, but stayed for only three months before returning to Buckfast to continue his work. In 1939, with the onset of war, he took to his bed from Christmas until Easter. In 1944 his two brothers were killed, the younger, Friedrich, by Allied bombs.

The foreignness of the community was never overlooked by the people of the moor. The Cistercians after all were an alien brotherhood, and mostly German-born, even if many of them subsequently became naturalised. It was alleged, during the First World War, that a tunnel had been built from the abbey to the sea in order to communicate with German U-boats. If these monks could build a mighty church with their bare hands, then a tunnel, surely, was no challenge. During the Second World War, the rumour was that the Sherberton hives had been positioned in such a way as to direct overflying enemy bombers to the docks at Plymouth: an arrow in the moor, pointing southwest. According to one story, the abbey's hives were mistaken for training targets by the resident army and machine-gunned – until the soldiers saw him: the slender German in habit and veil, striding up the gorse hill. That shrill, ungainsayable voice. The War Office coughed up for the damage.

He returned to Germany two years after the end of the war, to nurse his grieving mother, who had sent him to Buckfast forty years before. She died ten days after his return to England. He continued to visit Germany throughout his life. It was as if his work at Buckfast was simply a long-term secondment. His work as a bee breeder made him famous: he received an OBE; a documentary was filmed; acolytes came; he dined with Barbara Cartland at the Waldorf (he, cheerful in black; she, morose in pink). Brother Adam – Karl; Louis – ceased to be head beekeeper in 1992, soon after the first election of the current abbot. Honey production was down and the abbey coffers would be better spent elsewhere. To Adam it was clear that he had been ousted, if not deposed.

When I'd mentioned him, dead fifteen years, Father Abbot had given a surprising impersonation of the old man: a lisping effeminate Germanic trill, a voice cultured by that of the hive and by self-importance and by long taciturnity. Adam, it seemed, had been made callous; he had earned the mockery of his brethren. He made the younger monks *weep*. And yet – the man's voice, in recordings at least, was restrained. You can detect in it a certain self-satisfaction, and a certain steeliness, but it isn't absent of gentleness. 'You have to be ruthless, but you also need the intuition.'

He died in a nursing home near Ashburton. His Buckfast Bee is still bred: it is robust and docile and profligate, and disinclined to swarm.

8

From Sherberton to Widecombe-in-the-Moor is about five miles. In the churchyard is a pitted granite cross. Short-armed, like one of the moorland waymarkers, it carries the words 'Pray for Olive Katherine Parr', and on the other side,

'Beatrice Chase 1874–1955'. It was erected by subscription; by the time she died she had no money to her name – only the property down the hill in Venton, and the associated mort-gages. Parr became famous first as Beatrice Chase, the author of *The Heart of the Moor*, and then, partially fictionalised, as 'My Lady of the Moor' in John Oxenham's novel of that name. She had wanted to be buried in the garden of her cot-tage in Venton, beside the cats, Tiger and Vim and Mike, in a lidless coffin and clothed in a Dominican habit. Instead a patch of the churchyard peat was reconsecrated. Around the stone a clump of heather has been planted.

Like Brother Adam, she was sent to the moor 'for her health', after contracting TB in the London slums where she had worked with her mother, who came to the moor with her. It was not only tuberculosis that brought her here, however: 'I had had also a great personal sorrow,' she writes in *The Heart of the Moor*. Her fiancé, it seems, in the First World War, though he is never mentioned again.

Like Adam, too, she was devout and fierce, and she become more devout and more fierce as her life went on, and soured, and the bounds she had imposed upon it became tangible to her. She told herself she loved the moor – loved moorland – and, like every lover, she came to exhibit some of the loved one's temperament. She deteriorated as her fame and the at-tendant adulation and visitors waned; as she began to sight her limitations, and not only the limitations enforced by age and solitude and ill health. She could not refrain from mak-ing her deterioration public.

In one brief, intense volume of letters to a certain Ida (we can assume that both Ida and the letters are fictions) she re-calls her arrival on the moor with her mother in 1903. They had, at first, come here only for an extended recuperation, but they made an offer on the house and moved in. Three

years later, however, it had become clear that it was too small for their purposes. 'We could not afford to build a new house, and there seemed nothing for it but to sell and go. So my sweet Venton was put up for sale, and every day I expected its death warrant. That year, to put a climax on my sorrow, my faithful friend, Abbot Boniface, went down in the wreck of the *Sirio*.'

One month after the disaster, she says, 'I was suddenly conscious that the Abbot was beside me . . . I knew it with my mind instead of with my eyes.' And then 'I suddenly felt his soul touch mine.' The sensation, she said, 'was extraordinary. If you can imagine the feel of a warm bath to cold, tired limbs, the scent of lilies, the taste of honey, the sound of heavenly music, the sight of gorgeous colours . . .'

The abbot had a message: 'Don't sell. Don't attempt to build a new house. Throw out a wing across the little green garden at the back, and it shall be done at very low cost.' And thus on the little green garden was built not only an extension to the house but, from the moor stone, a thatched chapel, with stained-glass windows. It was to this chapel that the monks of Buckfast Abbey came, twice a week, to hold Mass. It was to become the heart of a minor cult of salvation.

Her home, now, is occupied by her one-time tenant, Peter Hicks, and his wife. He'd be eighty next year, he said. He had trouble with his hip. He came here with his parents and sisters in 1948, his parents having been evicted from their dairy farm in Kingskerswell. 'Farms were hard to get. Everybody was coming home from the war and wanted the land. She had a hundred applicants for this place; she chose us. I think we were the only real farmers – some were ex-policemen, ex-army majors. She wanted real farmers.'

We were talking in his shaded front room, his armchair pulled close to mine – the room where Parr had once written

her books, while, in the chair beside her desk, her short-sighted mother had laboured with her glass beads, beads of numerous colours, stringing them together to make bracelets, necklaces. Mrs Hicks, seventy years later, clinked industriously in the kitchen. When I'd arrived she had been conducting six skittish ponies along the lane from their field to the yard behind the house.

'She died just before her eighty-second birthday, in July 1955,' Mr Hicks said. 'Died in hospital at Newton Abbot. It was called the poor house; she was penniless.'

The people of the moor, whom she spent her life alongside, she wrote about as if they were livestock: amoral, adorable, pitiable, blindly faithful, capable of terrible acts. The Lady of the Moor was a Londoner. She wrote 'sketches' of the Devon folk in her books, but this writing was not a matter of transformation: she looked out of her narrow window as if at a painting. She was an occasional visitor to Princetown: 'I can never see that a prison is a sad object. A lunatic asylum yes, or a workhouse which shelters much helpless suffering, but a prison is surely a bracing sight. It contains only the people who deserve to be there.'

She might write of the Dartmoor sun: 'In December, he hugs the south, lolling all day on the dusk purple-blue couch of Holne Moor, as if high heaven has lost its allurement' – but she was also capable of a truer vigilance: 'The curious position of the pupil of a sheep's eye gives it a strangely short-sighted expression. Instead of being upwards or perpendicular in the iris, like a cat's, it is right across or horizontal. The eye looks to be made in two pieces joined in the middle by a long black seam.'

'She could be kind,' Mr Hicks said. 'One day she asked me to repair that gate over there.' He looked out of the window. 'It took two nails and about ten minutes. Ten shillings – this

is 1949. Now, ten shillings is ten shillings. And then the next day she had the police up here. I'd been driving the tractor across the road without a licence; I was under sixteen – constable and the sergeant. One day you'd think she was dropped from heaven and the next day you thought she'd come from hell.'

In a palm-sized pamphlet titled *The Innocent Victims of War* and printed in 1914, the unnamed narrator, attended by one 'Beatrice', encounters a 'non-believer'. 'Beatrice' informs the non-believer that the reason she does not believe is simply that she has not *truly loved*. 'To really love,' she goes on, 'you must love someone who is bad in himself and *who is bad to you.*'

Olive Parr was not only the daughter of Admiral Chase Parr but, if we are to believe her, the descendant of Katherine Parr, Henry VIII's bride. 'Beatrice Chase', on the other hand, was bereft of forebears and of blood. Together, during the war, she and the writer John Oxenham founded the 'White Knights', whose (they claimed) fifty thousand soldier members pledged allegiance to God and above all to 'purity' while overseas. Their names were inscribed in a Roll of Honour, and in turn Parr and the small congregation of her chapel prayed for them. On the wall was a banner bearing the Knights' motto: 'Hold Honour; Shun Shame'.

In *My Lady of the Moor*, Oxenham describes the chapel: 'The seats were of dark red wood and the rafters of the roof were black. Everything else – save the tiny red lamp, a large missal, a prayer book or two, and a rosary of ruby beads hanging over the front seat – was purest white.' White is the colour of Parr/Chase's story: 'a white, unbroken perfection of silence'; 'that white silent hour'; 'the whited sepulchres'; 'his great white friendship'; 'brilliant white sunshine'; 'the full white joy of living' . . .

After Oxenham's death, and then that of her mother, and the world's slow dwindling of interest in her, her vehemence only strengthened. She had embarked on what she herself was pleased to term a 'crusade', and she was unwilling to turn back. The world was wrong. It might be fixed. On 4 October 1929 the *Western Times* carried the headline 'Woman Novelist Apologises: False Statements Made About Abbot'.

The case had been brought – with some reluctance, it seems – by Abbot Anscar Vonier, successor to Parr's friend Boniface Natter, who accused her of libelling him in two letters. The nature of the defamation is not recorded. Parr, 'looking her usual confident self', and wearing a black sequinned dress and black coat and black scarf and black velvet hat (to match her accuser's attire?), paid the abbot's costs and withdrew her statements – 'which at one time I honestly believed to be true'.

Twice weekly, the report explains, 'the monks of Buckfast have visited [Parr's] chapel for the purpose of conducting services, but recently, it is said, they could not be spared'. She was excommunicated. The chapel was deconsecrated for good. 'As the Apostle saith,' wrote St Benedict, '"Put away the evil one from among you."'

In April the following year the same paper carried the headline 'Widecombe Mystery: Sudden Appearance of London Nurses at Home of Miss Chase: Authoress Seeks Protection of the Police'. 'Miss Chase', it reported, and you'd be right to detect a smirk, 'is under the impression that there is some plot afoot.'

At about 10.30 a car arrived and remained underneath the window of her house until she made enquiries . . . One of the nurses said 'A Dr —— rang up, asking us to come at once.' Later, during the course of a conversation, Miss Chase was informed that a specialist was to come from London at once.

In the end no specialist turned up, but 'Miss Chase declared emphatically that if the culprit was found, proceedings would be taken'.

A week later the paper picks up the story: 'Further Light Thrown on Recent Incident'.

The *Western Times* learns that reports from the London Nursing Home which sent the two nurses to the residence of Miss Beatrice Chase . . . state that a cultured woman's voice gave the call and said Miss Chase 'was a mental case and would probably resist admitting the nurses, and every effort must be made to gain entrance and place her under restraint' . . .

You'd find her walking every day. Knee-high stockings, henna-dyed hair, dubbined brogues with a climbing heel. Balky as a moor pony. She prided herself on her regime – up before the birds, ice bath, twenty-mile stroll (nothing!), five hours' writing, five answering her 'numerous letters'.

She issued summonses; she wrote letters; she made phone calls – seventy a day, until they confiscated her phone: to the police in Tavistock, to the Medical Officer at Newton Abbot, to Parliament, to Eisenhower (his men were killing birds on the moor!). If something upset her, why *would* she demur from seeking satisfaction? 'If girls don't like being battered and murdered why do they drink in pubs with strange men and then go down dark lanes with them?'

She opposed the National Parks Act and the designation of Dartmoor as a National Park; she opposed blood sports, thinking them unsporting; she opposed the military's use of the moor for training; she opposed the suffragist movement and wrote a pamphlet entitled *Woman's Emancipation (By one who does not want it)*. Her opposition was seldom less than vehement. It was, for her, a kind of celebration.

Twelve years after her apology to the abbot, she continued to rail against the abbey in private. 'I expect you have

heard', she wrote to a friend during the Second World War, 'that twenty-three of the Buckfast crowd are now registered as enemy aliens, including the abbot.' She mentions a member of the community, the chaplain at Ashburton, whose two brothers are fighting in the German army, and who 'hears the confession of our forces . . . Thus does the British Govt. encourage, aid and abet aliens!'

Without pause she moves on to 'the man about whom all my troubles arose', who, she claims, 'broke his vows, threw up his priesthood, left the Order, returned to Germany, got married and acted as an agent–spy between them and the USA. And for his sweet sake did the bishop dispossess us all here and cast Our Lord out from his moorland shelter.'

The identity of the man is not known, and hardly matters, but it seems likely that he is connected to the libel case of 1929. 'Thank God', she concludes, 'I am done with them for life.'

'When they took her away,' Mr Hicks told me, 'they had twelve police here, and the Medical Officer of Health for Newton Rural District Council. He was called Dr Davis. And I can see her now, she threatened to shoot 'em all. She did have a revolver. And she, lying in bed, and this Dr Davis, very tall, couldn't stand up in here, he was stood at the foot of the bed – I can see her now: "What stock do *you* come from? I'm an *admiral's daughter*."

'Very sad thing about it, she was nearly eighty, they put her in a straitjacket, two rather large women trussed her up. There was no need for it, no need at all.'

Today the chapel is almost indistinguishable from the other outbuildings; no roses or ruby light – the window frames and boarded gable have been painted in the same green that covers the woodwork of the adjoining barn and the doors and lintels inside the cottage. The 'deliciously artistic waves of

thick grey-brown thatch' of Oxenham's day have been re-
placed by corrugated iron that extends from the roof of the
adjoining barn. The chapel is used as an office.

'The last people she asked to see was my mother and
father,' Mr Hicks said. 'The hospital rang. She just said two
or three sentences. And the gist of that was "Do not worry,
Peter will be all right."' She had left him Venton House.

That night, I slept next door in Higher Venton Farm,
where Mr Hicks's daughter ran a B & B. Mine was the cor-
ner room above the shared porch, with its wall that bulged as
if filled with water; and I dreamed of a scenario that I was
aware, in my dream, had been repeated again and again. I
saw an old woman, frail and naked, terrified and little-girlish,
running from a house at night, turning right and making her
way up the road; and it seemed to be my role to halt her, a
few metres from the gate, to calm her and bring her back,
because she was confused. The front yard, at the time, in the
dream, was that of my grandparents' house in Essex, and the
old woman had been a version of my grandma, my father's
mother (though she herself never behaved in that way). But
as this dream settled in me, that morning and during the
following days, the front gate through which the woman had
fled became the gate of Venton House, and the road she had
run up, or tried to run up, became the dark lane outside.

9

In Exeter's public library is a postcard that was found at
Cranmere Pool, the bog that lies high on the moor's north-
west shoulder. The man who left it there had sharp teeth and
whiskers; he was uncommonly tall. Here is what the postcard
says:

Henry Williamson came here on 30 March 1926, to take notes for 'Tarka the Otter'; and spurred a big dog out of a boggy hollow 210 yards S.S.W. from the Pool – which on old maps is called CRAW-MERE. With above came R. E. Hibbert. This is our second attempt. Last time we were caught in a barrage of shells.

Williamson was on the trail of his fictional otter, accompanied by his brother-in-law (the 'big dog' was a male otter). 'I recall a time came when I could bear my doubts no longer,' he explained later: 'I must go on foot from scene to scene of actual country.' His postcard message is accompanied by a drawing of a bird – a crow, perhaps – and the elongated owl colophon that appeared at the end of his books.

In the eulogy he gave at his friend's memorial service in 1977, the poet Ted Hughes recalled how, when he himself was a boy growing up beneath the moors of the South Pennines, *Tarka the Otter* 'gave shape and words to my world'. He went on, 'A world I was already given to completely – my world of wild creatures in the South Yorkshire countryside – became a world of Henry's radiant language.'

Hughes had got to know Williamson when the latter was in his sixties, and Hughes in his early thirties. 'Still spellbound by his magical book, albeit quite unconsciously, I had found myself living . . . on Tarka's river, the Taw.'

He and his wife, Sylvia Plath, had moved to the village of North Tawton, three miles from the northern edge of Dartmoor, in the summer of 1961; he stayed there for the rest of his life. 'Cut off by Exmoor to the east and Dartmoor to the south, North Devon felt like an island,' he wrote later.

The winter was the second coldest of the century, according to farmers Plath spoke to. She wrote a fragment, an unfinished poem, 'New Year on Dartmoor', about a visit with her new daughter to the snow-dusted moor, with its 'blind, white, awful, inaccessible slant'. She stayed on at the house

in North Tawton for a year, as her relationship with Hughes acidified, before removing herself and their children to London. 'How lucky I am to have two beautiful babies and work!' she wrote to her mother, on Boxing Day 1962.

The range warden's hut stood beside the cattle grid, between the military camp and Moorgate Cottage. Its windows were blocked with shutters painted the same naval grey as the cell doors of HMP Dartmoor. It was half an hour before dawn and the sky was glowing like a paper lantern. The taxi pulled away and I listened as it returned to the valley and there was silence.

But there was never silence on the moor, and I soon became conscious of a dim whirr, like the sound of someone gently circling their palm on the top of my head. Above me, granular in the luminous sky: a sky-wide river of starlings, travelling west to east, from their roost in the firs of the camp to their daytime feeding grounds. How long ago had the first embarked? For three minutes I watched them, head tipped skyward, the horizon all around me. Occasionally, a stray could be tracked, an individual that did not conform to the general flow, and rather than flying west–east somehow was making its way north–south, until it was collected by the current and taken east with the rest.

It was December, six months since I had stayed at Buckfast Abbey. My time in the southwest was almost at an end, and this flypast was a hello, a welcome, a sort of valediction. I stood beneath the great current as if behind the curtain of a waterfall. It seemed that it would go on forever. And suddenly it ended, like the leader of a reel of film slipping off its spool, and there were only a few stragglers, a few latecomers. And then none – and there, in front of me, the moor, and brightening its horizon the promise of the rising sun.

A light appeared at a door within the camp perimeter and four young soldiers emerged, bearing rucksacks big as settees, and trudged up the hill into the woods that the starlings had just deserted. 'Ha!' I said – aloud – 'Ha!' – and set off, picking my way over the frosted rungs of the cattle grid.

It was not yet dawn, but I was sweating under my waterproofs. The army had built a ring road into the northern moor – a track, rather, its tarmac deteriorating as it reached deeper into the moor. I took the eastern branch, with Rowtor on my right, and gained height as the incandescent scarf of mist on the horizon unfurled itself. I began to see the red-and-white striped poles that marked the range edge, each one fixed with a warning not to pass the perimeter when the lights or red flags were showing, and in no-nonsense black on yellow: 'Do not touch any military debris it may explode and kill you'. Later, I saw a couple of vans filing along the edge of a valley, bearing the logo of Landmarc, the firm contracted by the MOD to manage its estates.

Next to one of these poles was the only Dartmoor pony I'd see all day, nosing a dropped hanky. She barely lifted her head. Behind me, Harter Hill was slowly unveiled in orange; on the hill's top, the steel shutters of a military bunker glinted, but from my low angle the sun itself could not be seen. The mist on the eastern horizon was like the smoke from a fire whose diffused glow alone was visible. Then the sun was there, and the whole moor was lit and grand and warm, until I passed East Okement Farm and entered a still-shaded valley, and the temperature plunged.

The moor was around me now. As I climbed away from the young East Okement river the air warmed and the sun hit me again as I entered its beam, and when I stopped to look back I could see the shadow of my head and shoulders extending, a quarter of a mile away, from the shadow-line of the hill.

All day I was aware of my shadow. When I looked back at my day's photos that evening, it was often there, stretching bluely into the frame.

A pale bar lengthened slowly across a dark puddle, from left to right; the reflection of a jet's contrail. High up now, I entered a bank of mist, and yet as soon as I had done so, it seemed, the bank or rather stream of mist was behind me, hundreds of yards behind me, in the valley bottom, and the way ahead was clear. Where the track forded the infant Taw, I veered south along the stream bank, its surface hidden by grass and rushes, and hiked for ten minutes until I came to a range of tinners' spoil heaps, and clambered onto the biggest. On its flat top was an out-of-place stone, a stone that could not exist here naturally, any more than the tin streamers' heap was natural. It was the size of a coffin, a fallen monolith. Carved into it were the words 'TED HUGHES OM' and underneath, '1930–1998'.

The 'silence of the desert', according to Jean Baudrillard, is 'a visual thing, too – a product of the gaze that stares out and finds nothing to reflect it'. On the Hughes stone I sat and looked south into the motionless moor. It was no more still, in fact, than it was silent: almost every bit of vegetation, from the taller cotton-grass and purple moor-grass and mat-grass to the bog bean and cross-leaved heath and sundew and mosses, right down, it seemed to me, to the tiny fronds of lichens and liverworts – all of them moved against a draught that could not be felt on the skin. The moor had appeared, at first, to be as static as a photograph, but it was a video of infinitely high definition.

'Dartmoor is generally imagined to be a region wholly unfit for the purposes of poetry,' wrote H. E. Carrington, in his introduction to *Dartmoor: A Descriptive Poem*, in 1826, 'but

they who entertain such an opinion know very little of that romantic solitude.' With the publication of his father's book-length eulogy, the moor began to be considered as a destination in its own right. It could not be said that one had truly *visited* 'Devonia's dreary alps', however, unless one had stood at 'the urn of Cranmere'.

Situated on the plateau above the far bank of the Taw, Cranmere Pool was one of the moors' uttermost centres, a place of Wordsworthian 'visionary dreariness' – where dreariness was so absolute that it constituted nothing less than a form of the sublime. It became the focus of Dartmoor pilgrimage. 'Here', wrote Samuel Rowe in 1848, 'the image of "a waste and howling wilderness" is fully realized.' (Deuteronomy again.) It was 'exceedingly difficult to find without a guide' and indeed 'hides itself almost as successfully from the Dartmoor explorer, as the Nile concealed his fountains from the antients'.

In 1854, James Perrott of Chagford installed a stone cairn at the site, within which he placed not a honey pot but a pickle jar. He and others guided the strangers over the moor to the famous 'pool', to place their cards in this jar, as Williamson had done. Handshakes were exchanged, sherry handed round.

In 1876, William Collier, head of the Dartmoor Hunt, observed that 'writers of Dartmoor guide-books have been pleased to make much of this Cranmere Pool, greatly to the advantage of the living guides, who take tourists there to stare at a small bit of black bog'. He goes on to explain that no body of water has existed at the spot since a fox was run to ground at Okement Head, 'and by digging out the terrier Cranmere Pool was tapped'. It was, he said, nothing more than 'a delusion and a snare for tourists'.

From West Okement Head, the split granite blocks of distant Green Tor resembled a battle cruiser at anchor. The pla-

teau, as I rounded the recessed bog that is Cranmere Pool, was a vivid orange-brown, its surface scattered with bog-ponds, their black interiors showing through the reflected surface blue, and the upper inches of the taller heads of cotton-grass extending from the water (in the valleys, where the frost remained, these stems pierced a lid of ice). Rising out of some of the dark pools, sometimes three feet above the surface, were block-islands of peat clad with moss of such intense greenness that it seemed alien here. The walls of some of these peat blocks were steaming in the sun.

The ground became drier as it sloped east, and the tussocks of dead grass were more prominent, defined by the low light, until it was as if the moor's surface was clamouring with countless blond heads, always turned away from me, facing the horizon. As I trod the watershed of the East Dart, I told myself that, six months ago, I had swum against the river it fed into; that over the course of twenty miles or so the Dart would derive from the moor a power that was like a gale's.

Crossing the moor, west to east along the watershed, between the sources of the Taw flowing north and the East Dart that filtered south, were the tracks of a quad bike, and it was these tracks that I followed to Hangingstone Hill, where, long ago, a pass had been cut through the peat, to ease the crossing of huntsmen and shepherds.

10

The Reverend James Holmes Mason was a resourceful man. In 1810 he won the bidding for the prison's filth and carted it off at 10¼d per load. (We can assume he did not undertake this task personally.) The moor requires pungent fertiliser to make it fruitful – and labour. Since 1807 the reverend had been conducting Sunday service for up to two hundred men

in one of the prison airing sheds. In 1809, requiring more space, he applied to the prison board for permission to move his services to the infirmary. The board refused, expressing surprise that he had been conducting services on prison property in the first place.

Two years after Mason won the ordure contract, building began on Dartmoor church, a short walk from the prison gate. It was to house up to six hundred worshippers and was 'to be executed upon the plainest and most economical style possible . . . to be built of the moor or granite stone by Assistance of the necessary number of French prisoners'. Mason was appointed as minister in 1813.

On 3 October 1814 a coach arrived from London carrying a box addressed to the new minister; it contained a two-volume church Bible, two prayer books, a book for communion service and a book of church offices. These were followed by 'Velvet Cushions' and 'Hassocks'. In December, Mason received a letter from the board: 'We cannot but express our surprise that such frequent Applications should be made to us on Account of the Articles wanted for the Use of the Church, which might with more propriety have been included in one general Demand.' On 10 January the new incumbent requested from the board: one or two sweeping brushes, two scrubbing brushes, some coarse cloths, a mop, two water pails, some soap, a set of fire irons, a hearth brush, a table and chairs, a looking glass and a clock. No soap, said the board, and no fire irons.

The burial ground was consecrated on 1 November 1815. In the sparse yard, you walk between the modern headstones to six parallel lines of numbered granite markers, belonging to those prisoners whose families could afford them. But between these graves and the civilian graves, and easy to overlook, since it is featureless, is a half-acre of unoccupied sward, and this is where the unnamed prison dead are buried.

The church itself has been deconsecrated. The walls are constantly damp, and from each window a single diamond pane has been removed in order to allow air to circulate. When it rains, the cartouche inscribed in memory of Thomas Tyrwhitt ('inseparable from all the great works in Dartmoor') spills water from its lower ledge like a reservoir's overflow sill. It's a not a mop you need, the caretaker told me, it's a pump.

That evening, as I approached, the church was lit from within, and along the frosted path that led past the burial ground, ranks of jam-jar lanterns were flickering.

Inside, it was full, and the famous cold was eased by the presence of warm bodies, and warm breath rising visibly. There was a mood of hushed jubilance. At trestle tables at the back, the ladies from the High Moorland WI were laying out mince pies and mulling wine in a polished urn. The scents made their way up the aisle. Louise, the prison chaplain, was waiting archly for a straggler from the Salvation Army band before she began the service, while, standing centre stage, one of his bandmates directed him on his mobile. He was enjoying his performance – 'For goodness' sake, I said *right*!' He rolled his eyes for his audience. 'Turn right, *then* left!'

The delayed band member bustled up the aisle to muted cheers, and unlatched his French horn from its case. The congregation rose, and the band started up, and we took in a collective breath of the cold ecclesial air.

The lady in front of me, ninety if she was a day, yodelled out an unbroken kettle-cloud; ahead of her two children of eight or nine emitted hot nebuli, while the shrieking of their baby brother was visible as a pale stream. From the men, barely a whisper of vapour was discharged (although their lips could be seen to move) – other than from the six sat at the very back, who could be heard clearly, even from my seat

halfway up the aisle, every word, their volume hardly drop-
ping during 'Silent Night', their voices rising to a cracked
hilarious bellowing for the last chorus of 'O Come All Ye
Faithful'.

The fifth reading was from Matthew 2. It was given by one
of these singers, who'd been shepherded down the road from
HMP Dartmoor by a couple of voluble warders – a reward
for good behaviour: only these six, of the hundreds. I didn't
recognise any of them from my visit in the spring. While he
read, there was the occasional exchanged smirk from the oth-
ers, but it wasn't mockery. He was nervous, but he'd prac-
tised, and his reading was good. 'When they heard the king,
they departed; and behold, the star which they had seen in
the East went before them, till it came and stood over where
the young Child was.'

They were the first in the queue for the mulled wine. When
they had been served, they stood in a line, close to the door,
each holding a warm white plastic cup and a mince pie, backs
to the cold church wall, and quietly watched the remaining
congregation, some of whom went to them with their own
cups and paper plates, and approached the reader, and spoke
to him.

The lanterns were still flickering when I went out into
the cold night, down the churchyard path, and towards the
Plume of Feathers and the gate onto the moor.

The pavement was dicey. The frost from the night before
persisted where the daytime wall-shadows had lain, and this
frost was acquiring a fresh, softer nap as the night deepened.
Leaving behind the pub car park, and its security light that
came on as I passed, I climbed up the old track that led to
the Grimpen Mire, passing the darker shapes of cattle en-
trenched along a wall. I thought, for a moment, I could make
out the form of someone on the footpath a hundred yards

ahead of me. But it was impossible, not out here, not on a frozen December night.

After half a mile or so, when the lights of Princetown were hidden, apart from the halogen glow of the prison and the topmost red lights of the radio mast, I looked east into the moor – and then up, into a sky that had no stars. It was impossible to see any difference between the two.

Thomas Tyrwhitt had come to Dartmoor 'to reclaim and clothe with grain and grasses a spacious tract of land, now lying barren, desolate and neglected'; he had laid down walls and roads, and stripped the surface and ploughed and limed – but found he had to be content with his wretched 'Prince's Town'. The moor persisted.

From behind me, from Princetown, there was music – Santa's Sleigh on its trailer, being towed from street to street by the Rotary Club. Tannoyed snatches of a carol (unidentifiable) were buffeting across the moor, like individual birds blown from a flock. I turned, and walked towards the music, back towards the prison lights, my pace quickening against the cold.

II

4. The Waste

Saddleworth Moor

I

It was the opening scene of a fairy tale – a story of a lost child. Under Bleaklow the causey paving was slicked with bluish oil, natural runoff from the surrounding peat. The path's edges were closely flanked by purple moor-grass, knee high, so that to follow the path was to follow a cutting, or rather a passage of hindered growth. It was as I approached the summit of Bleaklow, a mile away, that a movement on the path ahead of me caught my eye, a creature, a bird – only a small bird, and yet a cause of momentary alarm, as every movement that is not created by the wind can be an alarm in a landscape that is so exposed. It was a meadow pipit, no bigger than a sparrow, and commoner on these moors than grouse or curlew. It settled on a flagstone ten metres ahead of me. As I walked on, it took flight again, but did not veer into the miles of grass on either side, but rather flitted on down the path, where it settled again, bobbing its tail and monitoring me as I approached, and as soon as I had closed the distance and was ten metres away again, it flew onwards – and so on, for half a mile or more, as the incline steepened and the grass began to thin, so that it was as if the bird were leading me, waiting for me to follow. I suppose the path was a bird-path, too – a discreet passage, close to the ground; perhaps they drank from its puddles, or enjoyed the warmth stored in the stone. Still I wondered, afterwards, why the bird had not simply flown away from me, into the concealing grass.

I'd arrived on the northern moors the previous morning – a *rambler*, at the start of the Pennine Way. Over the thirty-

odd miles I walked during the days to come, it would hardly be necessary to tread more than a mile upon grass or bog or heather. Almost the whole route was paved with a course of gritstone flags, put down to prevent erosion. They had been prised from the floors of derelict mills, and into the surface of some of them holes and channels had been carved to accommodate the footings of looms. Most, though, lay rough side up – upside down, that is – for better grip, so that the side on which those other men and women had walked, the mill workers, faced down into the peat, and it was possible to imagine them or their ghosts continuing their work beneath the ground, upturned like reflections. The effect of this path, which was often visible for miles ahead, winding across the grasslands, was to bring a sense of scale and incline to the open moors, where a hill's steepness and distance can be impossible to judge, and to rid them of some of their menace.

I knew Kinder Scout as the site of the so-called Mass Trespass of 1932, the access rights march during which Benny Rothman and four hundred acolytes had skirmished with a squad of gamekeepers armed with batons. If you examine the footpath maps from the 1930s, Kinder Scout and Bleaklow and the other private grouse-shooting moors of this region are blank lacunae, and they dominate. At Bowden Bridge Quarry, Rothman stood on a boulder and addressed his men. His blood was up; he was not tall, but he was trim and had flair. These were *their* moors, they were entitled to set foot upon them; the Enclosure Acts of the nineteenth century had taken common land from the people and privatised it for the benefit of the wealthy. Every attempt to improve access by parliamentary means was frustrated by the lobbying of influential landowners.

In 1877, forty-five years before the Mass Trespass, the Hayfield and Kinder Scout Ancient Footpaths Association

published a walker's guide to the region. Folded into twenty-four and pasted onto the half-title page is an etching: it resembles an illustration of clouds or a chart of an archipelago of reef-fringed islands. But this is the Dark Peak, and the reefs are the mapmaker's incline hachures, superseded in modern maps by contour lines. In both maps, modern and antique, the Kinder Scout plateau itself is a stretched arrowhead, its altitude virtually constant across its four-mile length. On the modern map, the contour lines that mark the surrounding area give way on the plateau to dozens of blue veins indicating watercourses, each one feeding the several streams that fall from the plateau. If you draw back and examine the map again, you see that Kinder Scout *is* a kind of cloud, saturated, irrigating the fertile land below.

The Association had been formed the previous year, when a public meeting was held in Hayfield, 'touching the rights of the public to traverse certain parts of the district', during which the following address was given:

For a long time past, and in several parts of the kingdom, various lands, paths, roads and rights, having no distinct owner but the general public, have been gradually infringed upon and absorbed by individuals, and ultimately lost . . . It is undoubtedly true . . . that attempts have from time to time been made, and are now being made, to mislead travellers as to their right to traverse certain paths. It is also undoubtedly true that landowners have been considerably annoyed by trespassers, often in the form of excursionists.

These were neither the words nor the sentiments of young men from the cities, and it was unsurprising that the Trespass, when it happened, did not enjoy the support of the established walking groups. Among the Association's vice presidents were two knights, a JP – and one James Watts, cotton magnate, and *owner* of Kinder Scout. The association wished to reconcile the rights of the walker and the landowner. Its

author was scrupulously even-handed: 'The Editor, some time ago, witnessed a sort of free-fight amongst a number of Sundayschool teachers, who armed themselves with beautiful specimens of foxglove, torn from a bankside . . . In the melee nearly two yards of wall were thrown down.' 'On another occasion a number of tourists observing how steep a field was, proceeded to roll the coping stones from the wall, to the great danger of the sheep below.' What was more, 'At a railway station a tourist was innocently displaying his "find" during his rambles – sixteen moor-birds' eggs.' The keepers had to defend the moor from these people as if it were a fortress.

Nevertheless, here and there, the author's personal umbrage seeps through: 'If the pedestrian actually wishes to amble over the Scout, and thus make a closer inspection of it, *he must first provide himself with an order*, as since the "enclosures", the lands have been "preserved", and the public, imagining what was once their own is now their own, have not infrequently come into unpleasant collision with the gamekeepers.' An 'order' was written permission from the landowner, which was often withheld, especially during the grouse nesting season, when the birds were vulnerable to disturbance.

The keepers' annoyance, in 1932, when confronted by the trespassers (or would-be trespassers) was partly bewilderment. What did these people *want* here? They had warm homes. Buses and shops and pubs. And besides, the land wasn't theirs. Property was property. Disturb the grouse and, come August, you'd see the effect when Mr Watts and his friends shot the moor. Nothing to shoot meant a land without value, and without employment. It meant hard questions for the keepers. Five years later, the Saddleworth poet Ammon Wrigley wrote to the *Oldham Chronicle*:

When the owner of a moor brings his friends for the August shoot, and few birds are found, the sport is poor. Then he wants to know why they are scarce, and what his gamekeeper has been doing. If it had been a wet, stormy nesting time, he has a good answer, but if the spring had been dry and mild his answers are not always accepted as satisfactory.

On Kinder Scout, as Benny Rothman and his men approached, the keepers formed a line and gripped their sticks. They were ready, and the home advantage was theirs. It seems to be the case that the trespassers failed to make it to the plateau – few of them were prepared for the kind of greeting the keepers were ready to give them. The Trespass was no trespass, then (although some veered from the permitted path), but nevertheless a principle had been given birth to, and the hamfisted injustice that sent the leaders to prison ensured that the day was theirs.

I climbed the long flight of stone steps called Jacob's Ladder, which would take me up to Kinder Scout. I was stuck in myself and in the ordeal of the climb. Every excursion into territory that was unfamiliar to me, whatever the legal status of the land, felt like a kind of trespass. At the Church Inn at Saddleworth, later in the year, I would find myself sitting beside a group of four male walkers in their sixties. When I got up to leave I asked if they'd come far; there was a pause, and their spokesmen looked at his pint and said: 'Yes.' I waited, and asked where they'd come from: another pause, a silent sigh: 'We've been all round, pal.' He'd taken my question for sly competitiveness, I suppose; but what I also sensed was that they looked at me in my midrange Gore-Tex and heard my voice, and knew that I was a tourist on land that was intimately theirs. For them – men from Oldham and Manchester – walking was not only a matter of leisure or 'inspiration', but

a perambulation of their earned estates – a sort of gamekeeping. However many miles I might have done, they knew a poacher when they saw one.

It took twenty minutes to gain the high ground; to feel that the moor had been reached. It was not the 'view' that held my attention. To look upon moor is a lateral experience: neither down nor up but across. So too, the objective is not a summit, a pinnacle (there is none), but the place where incline gives way to flat land, and where the flat land is everywhere around you – omphalos, *désert absolu*. The gritstone outcrop called Edale Rocks was a pale black; a shadow on the horizon. Beyond, the surface of the moor began to change. The exposed peat dominated, and soon I was walking between blocks of peat – 'hags' – whose flat tops alone bore a cap of crowberry and heather, sometimes mere mohicans of vegetation. It was as if these tables of peat had been excavated and dumped up here on the moor-top, fly-tipped. Moorland was at once surface and interior – it exposed itself all over. It was not hard to see what it was made of.

A plant dies and decays; it returns to the atmosphere the carbon dioxide it extracted during its life. In waterlogged conditions – in the absence of oxygen, and therefore the micro-organisms that cause matter to decay – no such release occurs (although small amounts of other gases, such as methane, are emitted). The vegetable matter, mostly the remains of sphagnum mosses, simply decomposes, compacts and accumulates. This is peat. It is the lack of oxygen that accounts for its preservative properties; it is why bodies buried on moorland have been disinterred, eyelashes intact, not only after decades, but thousands of years after they were buried; it is why ancient tree pollen can be recovered from bogs for analysis, and why tree trunks are frequently dug up where scarcely so much as a sapling has been seen for thousands

of years. For Henry Williamson, it was the peat that gave Exmoor its 'ageless' quality: 'The heather here was the same heather of a hundred thousand years ago,' he wrote. 'Life is a spirit not an individual. The leaves and stalks were gone into the peat, which nourished the present plants . . . There was no age on the moor; there was no change, which may be the same thing.'

It is peat's amassed carbon that makes it a sought-after fuel. One of the 'rights of common' enjoyed by the moor-folk historically was turbary – the cutting of peat for the hearth. Wherever peat was accessible in any quantity, you found signs of peat cuttings, where communities had come in summer to recover the fuel that would sustain them through the winter. (There was a theory that Dozmary Pool on Bodmin Moor was a flooded ancient peat cutting.) Peat's carbon hoard also accounted for what was being done to the moors today.

Hundreds of thousands of miles of old drainage ditches were being blocked up, from Dartmoor to the Pennines. Peat that had been exposed by erosion was being limed and re-seeded; grazing densities were being reduced and burning of grass and heather by graziers and grouse-moor managers was being controlled – all to 'rewet' dried-out bogs and conserve active ones. Just as 'waste' was brought into cultivation fol-lowing Waterloo and the Second World War, in the name of increased national self-sufficiency, so the undoing of those interventions today was perceived as a matter of survival.

When peat is caused to dry out (by draining, overgrazing or burning) oxidisation changes its properties – no longer a store of carbon dioxide, it becomes a source. And, with the warming of the planet that carbon dioxide causes, peat for-mation slows. The bogs dry out further, and more of that gas is discharged. It is what the ecologists call a 'feedback loop'. And if, as you examined the black face of a peat cutting, you

pondered the 'feedback loop' and our attempts to intercede, then not only did it make you terrified, not only did it seem that the moors had advanced from the margins to the centre, but you were vulnerable suddenly to the realisation that in the peat's slow piling-up underfoot – maybe a centimetre every decade – in that process was also a titanic power. The ebbing of the land from wet to dry to wet to dry: it was a measure by which populations thrived or declined.

But the exposed peat was not new, nor were farmers and keepers solely to blame for the degradation of the bogs. The oxides that began to be emitted from Manchester and the surrounding areas during the Industrial Revolution killed off the sphagnum moss that is both the chief creator and the protector of upland peat. When the sphagnum had gone, the water table sank and the peat dried out and was washed or blown away; coupled with 'frost heave' – the daily cycle of freezing and thawing that occurs up here for six months of the year, and further undermines the peat – this had caused the peat to thin, year by year, and prevented vegetation from regaining a foothold. Then there were the sheep whose grazing prevented revegetation, and finally the walkers and mountain bikers.

Up ahead, mapless, in shorts and a scarlet windcheater, a man twice my age looked like he was off to feed the ducks. When I passed him later, at about 630 metres, he was gabbing merrily into his Samsung, and rolled his eyes as I passed. I steadied myself on the trig point and watched him till he'd gone, then I looked at where I was.

Eighty years ago, grouse had been shot in great numbers here. And yet it was not 'moor' – or no longer, anyway. It was a scraped terrain; it was like a site of abandoned industry or mining. The heather had gone; the grouse had gone – all that was left was the grassless black peat, and these great rafts of millstone grit. Two thousand feet up, fifty miles from the sea

– and I'd arrived at a place that felt *littoral*, an acre strip that seemed recently to have been released from a flood.

Using the voice recorder on my mobile I described what I'd found. Five or six audio files, each of a minute or so. When I played them back that night, in my room at the hostel in Crowden, all that was audible was the wind – a sound like a train passing close by; and, behind the wind, the *s*'s and *t*'s of a struggling voice. Each recording was the same – interminable and alien. I'd started to feel, as I walked, that the moors were what had been allowed to remain after some catastrophe; that was just what had happened.

The anonymous author from the Association, back in 1877, recorded of 'the Scout' that 'the impression which it makes on different minds is very various – one able writer speaking of the moors as "black", "dismal", "dreary" and even "disgusting"'. He goes on to quote Spencer Hall, author of *Days in Derbyshire*: 'Next to the sky and sea what can be more sublime than the mountain-moorlands, so subdued in their grandeur, so calm in their wildness, so like in their general character, yet in particulars so varied.' The able writer was not wrong: the landscape I was looking at was black; it was disgusting (sometimes it felt like trudging through a midden), but Hall – printer, poet, topographer, mesmerist, man of his age – knew what the moor was: if there was grandeur here it was a subdued, muffled, gagged grandeur. Thomas Hardy, in *The Return of the Native*, wrote of heath and moorland's 'chastened sublimity'. But a chastened sublimity, a subdued sublimity, is no sublimity at all.

To get to the waterfall known as Kinder Downfall you had first to wend through a network of deep gullies – 'griffs', they were sometimes called – that had been water-cut into the unprotected peat; these were sometimes ten feet across

and twelve deep, so that, in order to navigate, it was necessary from time to time to clamber up one of the damp crumbly peat slopes that were the walls of these gullies, and take a bearing.

It was nightmarish – a black maze in which you could see nothing further than the next black wall ten feet ahead, and those on either side, and behind you more of the same. Look up – a slot of white sky; and crossing it, from time to time, the low underbelly of a passenger jet dropping towards Manchester. Pakistan Airlines.

'Everybody smiles fat smiles at the big green carpet,' Edward Burne-Jones had written, 'but I like other landscapes better, and now and then I want to see *hell* in a landscape.' Well here it was.

Finally the black corridors opened up and light and distance returned, and it was possible to see the course of the Pennine Way. It hugged the edge of Kinder Scout so that the view of the low land, four hundred metres below, with Hayfield and its farms and Kinder Reservoir, lay to the left as you approached Kinder Downfall, while beneath it, like a scrap of foil, was the mere called the Mermaid's Pool, in which a hamadryad was known to bathe. (Her bower was a cave in the side of Kinder Scout, and she conferred upon those who saw her everlasting life.)

The massif of Kinder Scout slowly diminished behind me as I followed the way that had been laid out over the wet High Peak, reddish with unfruited cotton-grass – and it occurs to me now that this very ease, to have a path put down before me, to be spared the need for navigation and vigilance, relieved me too of the burden of careful looking. To walk on moor (especially in the wet) is to be always attentive; it's easy to suddenly find yourself knee deep: the Pennine Way flagstones elevate you, just as a bridge elevates you above water

or crevasse, and elevate you too above close experience of the landscape. It made the going easier, and made the walker a spectator. Often it was pleasant, and that very pleasantness blinded me to what it passed over. The following hours are hard to order: it was tiredness, perhaps, or the effect of what I'd seen that morning, but the miles of moor that followed were so self-similar, even in their details, as to elude proper distinction. It was the old moor experience: moor as 'trackless', as featureless, void. It was what happened when you suspended looking.

When I became aware of the Snake Pass, the high reaches of the A57 that links Manchester and Sheffield, with its speeding motorbikes and white vans (every other vehicle a white van, it seemed), it was as if I'd been shaken from a dream that had begun on the plains below Kinder Scout. The Snake Pass was a drugs route, a guns route; police pursuit drivers trained on it. 'Think bike' said the signs. Like most moorland passes, with their unbroken prospects and long straights, the accident rate is high, and the accidents are terrible.

2

The walk from Black Hill to Saddleworth Moor takes you off the pavestones, over Dean Head Moss, a shivered expanse of shallow bogs and deep griffs and isolated hags. Rolls of jute mesh had been pegged out on the exposed peat slopes to create a footing for new grass. They resembled fishing nets cast out to dry. Grass seed was scattered, and lime. The peat here had become so acid that vegetation struggled without assistance – acid enough that it could be tasted, if you licked a dirty hand. Acid as lemon. Here and there, white polypropylene bags of the sort used to transport builder's sand shone amid the black griffs, each packed with a quarter-ton of heather

brash and put down in clutches by helicopter. This, too, sur-plus heather mown from another moor, would be scattered on the bare peat, and from it heather seedlings would grow. We had a notion, it seemed, of the moor's proper appearance, its rightful ecology. (They were called 'dumpy bags', these sacks. I liked the word – 'dumpy', describing appearance and function at once.)

The way was marked at first by knee-high limestone cairns (stark in this gritstone landscape), each built from perhaps forty fist-sized rocks, and then, as the ground wettened, only by low fence posts every two hundred metres, sometimes on the opposite bank of a deep peat gully that was to be crossed – waymarkers that might once have stood as tall as a person, but had, inch by inch, year by year, been drawn down into the moor. It was one of these posts that had been used by the goshawk.

I'd seen the bird leisurely quartering the moor, a mile away, hunting with the ease of all raptors, of all predators when hunting, as if its next prey – wherever it was, at this mo-ment; perhaps five miles away – had already been appointed for death, just as the goshawk's eventual killing of it was pre-ordained. There was no urgency to its searching, no anxiety; panic would be reserved for its prey.

I'd followed a scattering of feathers – feathers that might, as I approached, have been wool or the fluffy white fruit of cotton-grass. The trail was long – the down-feathers scattered over the bog by the wind. The meat hadn't yet browned – it had been killed no more than an hour ago. This bird, what-ever it was, had been flying with the moor beneath it, alone, or the slowest of several of its kind; and now it was only these scattered feathers that clung to the oily peat or were trapped, shivering, in the rushes – plus this remnant, balanced on the top of a waymarker post.

It resembled a miniature goat's skull, with two sharp horns, and between those horns – which were really the dual extensions of the sternum, the wishbone V – the meat membrane was still fresh and elastic. One of the 'horns', the right, was neatly wound with sinew. What made me look, I can't say – only that the remains of any killed creature command the attention; but at the foot of the post were not only bloody feathers, and dropped gouts of meat, but a cavity in the ground, barely big enough to reach three fingers into, and not at all deep. And at the bottom of that cavity, which was partially filled with dark water, something glinted – manmade. There were a splinter of bone, a sodden under-feather, and a perfect metallic cylinder, which at first I took to be a bullet casing or shotgun cartridge, and then an ampoule of poison. Then I read the number visible in tiny print around the cylinder's perimeter, GB 12S 23594, and realised that it was a ring from the leg of a racing pigeon – released, I found out later, from the town of Mixenden, north of Halifax, or rather heading home to its coop behind that small terraced house on Clough Lane – once, maybe that very morning, cupped in the warm hands of its owner, and now here, a gristled breastbone, on a post-top a mile from any place that is named on the map. I looked into the cavity again and saw ambling there, in the darkness, an orange beetle.

3

I was striding towards the Greenfield–Holmfirth road when, crossing a band of wet land, my feet were taken from me and I was waist-deep in the ground. I'd dropped into a narrow peat chasm, its mouth barely wide enough to admit me, and overgrown by grass. It was filled with black water, and it had a sewer reek. I pulled myself onto dry land, and removed and

emptied my boots, and changed my trousers for dry ones, and caught my breath. Not fear; *anger*.

The road was fast and loud. Its detritus extended far into the moor on either side – drivers' rubbish (nappies, takeaway cartons, bottles and newspapers and wrappers), the road-men's varied crap: heaps of hardcore, discarded roadwork signs, smashed plastic bollards, a forgotten neon tabard; and then the runoff of the road itself – a sootish hydrocarbon co-agulate that was thick in the gutters and spattered the verge grasses and steel barriers. There were rags all over the place, as if a clothier's lorry had upturned or been ransacked at the lay-by: two black coats, a plaid shirt, a pair of denim shorts, a sock, a bra. Slung from an iron stake amidst an impenetr-able swamp of flowering rush was a small white vest. A black patent leather loafer; a white plimsoll. The banks down to the moor were thick with flowering balsam and stinging nettles; the roadside heather was stunted and woody and leafless. I walked along the drainage ditch for a half-mile, to reach the lay-by where a flagstone path led onto the moor; the traffic did not slow for me. The sky was cloudy but intensely bright, and there was a warmth that seemed to come from the land rather than the sun.

At another lay-by a minibus was parked and standing be-side it were a man and a woman, both surveying the moor with binoculars; it was not plovers or goshawks they were waiting for, they said, but the group of young people they had dropped off on the other side of the moor, whose task it was to cross it to this lay-by. 'Duke of Edinburgh Award,' the man explained, without taking his binoculars from his eyes. I stayed with them for a while and watched the flat moor as the lorries thundered past, until the teenagers appeared, a mile off, six of them, girls and boys, filing along the causey paving, and I set off towards them. The moor on either side was mire,

and black. It was something I had not seen elsewhere, like the silted bed of a lake, sparsely scattered with purple moor-grass and cotton-grass and heather, but in wide tracts nothing but slicked peat – and deep, you could tell, deep enough to trap you to the chest, so that the paving was a bridge which it would be perilous to leave. Out of these peat fields the tips of more fence posts protruded by inches, and it seemed not so much that they had sunk into the peat but that the peat had risen slowly around them. Where a ridge of heather led away through the mire I veered east. Turning back, I saw that the watching couple's attention had switched to me, and the man with his binoculars – too far away to be heard – half-heartedly raised his hand.

The moor had looked flat, but when I turned again towards the road, the road was no longer visible, and its sound had gone. As I went slowly downhill, the moor dried and broke up. The cotton-grass was thick here, the moor red with it. The sheep were unused to people, but they seemed fearless – they stood a few feet away and looked back at me. One had in its flank a flyblown hole as big as a fifty-pence piece; it was quite black, with no blood or scab at its edges, and was closely hemmed with clean wool.

Wherever the land was steep it had been eroded; no attempt had been made on this moor to revegetate the peat. The land dropped by stepped wedges, and as it became more precipitous I realised that I had entered a marshy clough – which gradually narrowed, until the clough developed a voice, the sound of water. This was called Shiny Brook. It would lead me, after two miles, to Wessenden Head Reservoir. The stream quickly broadened, and its banks grew steep, until it was necessary to regain the higher, flatter, drier ground in order to trace its course. Where a tributary spring seeped into the brook the bank was pillowed with star moss and sphagnum a foot

deep. Further along were small cliffs of an ash-coloured shale. The sound of water was overwhelming, the cacophony of shepherded trickles.

A waterfall marked the confluence of Shiny Brook with the narrow gully of Hoe Grain, which began half a mile away, beyond the A635. The day's heat had risen, but the stream promised no refreshment: it was a livid orange from iron, and its surface was rife with greyish foam that clustered at every turn or fall. Close to the confluence with Nearmost Grain I sat and watched a wheel of this foam spinning on the surface of a deep pool, and saw that as each fresh dab of foam came downstream, it was taken into the circulating disc on one side, along with filaments of dead grass, while on the other side larger blobs of foam were released back into the flow. I stood to leave but was transfixed. I don't know how long I stayed there. At Nearmost Grain was an area of flat grass alongside the stream, a picnicking and lovemaking spot for those who knew the way, and at its edge, close to another cliff of lighter shale and mud, were the remains of a sheepfold, a stone-built corner surrounded by dark rushes. Built into the remaining wall was a 'cripple hole' – a foot-high gap that can be blocked by a slab of rock to control the release or confinement of your animals.

Where Shiny Brook became Wessenden Brook a stepped weir had been installed. The stone floor of the dry channel that led from it was green with algae, and where the held-back water seeped between the dam stones it left a greasy deposit that was black or iron-orange. The sky had dimmed and the cloud cover thickened; but the temperature had not dropped. I made my way alongside the deep dry chasm, towards the first of the chain of reservoirs.

In a letter to Elizabeth Gaskell written in 1854, Charlotte Brontë thanks her friend for sending a copy of Dickens's journal *Household Words*, one of whose articles, 'The Great Saddleworth Exhibition', she tentatively attributes to Gaskell. It's true that the descriptions of the moors resemble those of Gaskell, not only in her novel *The Moorland Cottage*, published three years earlier, but in her later biography of Charlotte. But in fact the *Household Words* account was written by the novelist Geraldine Jewsbury, who had gone to Saddleworth in a 'light butcher's cart', with two sisters whom she named as Miss Clytemnestra and Miss Cordelia Stanley, 'dealers in fish and game: fine high-spirited women, who live by themselves and scorn to have the shadow of a man near them'.

'The "Saddleworth district", as it is called,' she continues,

lies on the confines of Yorkshire and Lancashire. The high road runs along the edge of a deep valley, surrounded on all sides by a labyrinth of hills, the ridges forming a combination of perspective which seems more like clouds at sunset, than things of solid land . . . there is an oppressive sense of loneliness. At every turn the hills shut out the world more and more.

(In *The Life of Charlotte Brontë*, Gaskell would write of 'the feeling which [the Haworth moors] give of being pent up by some monotonous and illimitable barrier'.)

At the exhibition at the Saddleworth Mechanics' Institute, Jewsbury and Clytemnestra and Cordelia found plaster casts of 'murderers and criminals . . . also the cast of that unhappy youth with the enlarged head, who seems to be sent to die of water on the brain for the especial interest of science'. There was a room of stuffed birds, including what Clytemnestra (who knew her moorcocks) judged 'the most beautiful grouse

she ever saw'. The focus of the exhibition was items of the local textile industry, including a knitting machine, 'which turned out beautifully knitted grey stockings'. There were also carved cabinets, old armour, tapestries, carved ivory boxes, and 'the shoe and patten of a certain Mrs Susannah Dobson'. Visitors were entertained by 'an organ or seraphim, which was constantly played'.

It was during their journey *there*, however, that the ladies, in their butcher's cart, visited what was still, twenty years after the event, the chief cause of Saddleworth Moor's notoriety. 'We came to a wild tract of moorland . . . not a habitation in sight, only the hills shutting us in more closely than ever . . . A sharp turn and a sudden descent brought us to a little wayside house of entertainment lying in a hollow under the high road.' The inn, she explains, was 'the scene of a ghastly murder'.

Saddleworth is the name of the parish accounting for the old mill villages and hamlets that line the river Tame – Diggle, Dobcross, Delph, Uppermill, Greenfield. The old black church stands high on the moorside overlooking the Church Inn and the village of Uppermill.

Eight months had passed since I had walked from Kinder Scout to Shiny Brook, and the moor was renewed, redrawn. Today was a day of blacks and whites – the white of the scudding clouds, and of the 'dumpy bags' scattered about the moor; and most of all the snow left over from last week, in its fullest spectrum from bluish to yellowish to incandescent white; and the blacks more varied still: peat both wet and dry, heather and gritstone and decayed bracken. (On my desk are two items I collected that day: a stick of bog-wood, and a sheep's femur – almost identical in size, shape, texture and weight.)

I found the municipal graveyard downhill from the church-yard; it looked abandoned, overgrown with dead brambles and dead balsam and holly trees that seemed to be ailing – the new growth was yet to appear, in this extended winter, and between the graves the snow was still solid. There was none of the moor vegetation I was becoming familiar with – neither heather, nor bracken, nor gorse; nor the tough grasses that clothe the moors where heather and bracken and gorse do not. In *Wuthering Heights*, the 'peaty moisture' of Gimmerton's moorside churchyard is said to 'answer all the purposes of embalming on the few corpses deposited there'. Sabine Baring-Gould, conversely, claimed of Dartmoor that 'the roots of the grass and heather are ravenous after lime, and for this reason it is that of the many interments on the moor hardly a particle of bone remains' (disproven by the churning up of the bones of Princetown prisoners years after they were buried).

The cemetery footpaths were brown, rather than the black of peat. The turning and interments over the years had altered the soil such that the moor's encroachment had been prevented, just as the higher fields at the moor edge had, over the generations, been deliberately turned, drained, limed and fertilised to the same effect. It seemed the municipal cemetery was full: across the road was a hoarding advertising 'Valley View Private Burial Ground', the words printed over a cluster of divine sunbeams. A new kind of moorland diversification, though there were no visible graves in the field.

The poet Ammon Wrigley, whose ashes were scattered on the moor and whose bronze likeness, lean and watchful, stood by the canal in Uppermill, was of those generations that viewed agriculture as war. Every field ceded to the moor was a pitiful defeat. In one of his prose books about Saddleworth, *Songs of a Moorland Parish*, published two years

before the start of the First World War, he writes of the lo-
cal fields 'going back from cultivation to the barbarism of
the moors', and continues, 'in the old fight with the moors
bygone Saddleworth men never spared their strength . . .
they made war on the foot grounds of Stanedge and drove
the moor out of hollows and up steeps where a man could
scarcely get foothold.'

These were frontline communities; they knew that the moor
was a foe to be gone at without rest. It was a duty. From the
churchyard, the upper line of the moor was visible through
the leafless trees; it had never been looked at with fondness by
the people of Saddleworth, who knew what it was.

The church was locked and appeared to be deserted, but
from a sunken flight of steps at the rear a stream of boiler-
steam rose into the cold spring air. The winter was not over:
the snows of ten days ago, at the height of lambing, had been
ruinous for hill farmers; lambs born on the moor had
perished by the thousand; where the drifts were deepest,
sheep (alive and dead) still lay buried, waiting for the stock-
man with his probing stick and shovel. My visit had twice
been postponed on account of the late snow; even ten days
after it had last fallen, it was still deep on the moor-tops,
filling hollows and heaped along walls.

I had come to the churchyard to look for a grave. It didn't
take long. It had been positioned at the corner of the old
churchyard, as if to enable it to be found easily. The epitaph
was attributed to one James Platt. It commemorated the vic-
tims of the 'ghastly murder' Geraldine Jewsbury had men-
tioned in 1854: 'Here lie the dreadfully bruised and lacerated
bodies of William Bradbury and Thomas his son both of
Greenfield who were together savagely murdered in an un-
usually horrid manner.' The verse that followed had three
stanzas; this was the second:

Such interest did their tragic end excite
That once they were removed from human sight
Thousands and thousands daily came to see
The bloody scene of the catastrophe.

The men's epitaph, then – a report of public ghoulishness, written, surely, for those selfsame ghouls (myself included, 180 years later). A fourth stanza was apparently so gory that the bereaved family vetoed it. The aftermath of the murders was recounted in detail by the press. It became a regional obsession. The old man's last words. The son who never came to.

The two men were the innkeeper William Bradbury, known as Bill o' Jack's (his father's name being Jack), and his son Thomas, a gamekeeper. They were discovered by Thomas's sixteen-year-old niece Mary, who had come to the inn for some yeast at about 10 a.m. In the *Manchester Courier* of 7 April 1832, five days after the killings, Thomas Smith, 'a gentleman who happened to be passing by the spot', described the scene he found on entering the building:

The floor was covered with blood, as if it was a butcher's slaughterhouse. The wall of the room, on three sides, was sprinkled with human blood, which had flown from the bodies of the murdered men, in consequence of heavy blows with some iron instrument, and even the glass of the windows on the fourth side, were splashed with blood to a height of five feet from the floor. I went up a wooden staircase, the stairs of which were covered with blood, from the footmarks of persons who had come from the lower room, and there I found a number of persons and two men lying upon a bed literally covered with bruises from head to foot.

It was this report, as well as those of the Manchester and Oldham press, that provided the public with its images: the room was 'plashed' with blood – 'encircled' – 'dyed' with blood. According to the *Manchester Courier* of 14 April, the surgeon Samuel Heginbottom 'found two pounds of coagulated blood

near the pantry door'. The gore was spectacular; the callous-
ness – well, thrilling.

Through bloodied lips William had said, simply: 'Pats.
Pats.' That was what it sounded like to James Whitehead,
who was present, although Samuel Heginbottom would later
say that William's utterances were incomprehensible. The
chief weapons appeared to be a broken horse-pistol, discard-
ed nearby, with 'some locks of Thomas's hair adhered to it',
a poker, a swordstick, and a round-headed spade of the sort
used for digging turf – sharp, and then blunt, and then sharp
again. William was in his eighties, but his son, not yet fifty,
was hearty enough. The blood told of a long struggle against
men superior only in weaponry. Candles were scattered over
the flagstones.

The name of the place was the Moorcock Inn (the moor-
cock being the red grouse), but the people of Saddleworth
Moor, and all those who were regulars at the inn on the road
to Holmfirth, knew it by its so-called 'warty' name, 'Bill's o'
Jack's'. And it was by this name that the murders came to be
called. The inn was already known to city trippers to Saddle-
worth Moor, who would stop there for a ham-and-eggs tea,
or a glass of ale. A custom of the South Pennines was the
September 'wakes', mill holidays, of which Bill's o' Jack's
was a Saddleworth hub. Even before the murders, the inn
had a certain notoriety – a place of cock-fighting and fist-
fighting. In later years its 'dancing shed' was, to quote Joseph
Bradbury's *Saddleworth Sketches* of 1871, 'a disgrace'. In the
days after the murders, as reports of their atrociousness
circulated, the crowds grew. According to the *Manchester
Guardian* '30,000 persons visited on Sunday alone'.

The focus of local gossip and the inquest itself were Wil-
liam's supposed words as he lay dying: 'Pats. Pats.' This was
quickly taken to mean Irishmen – tinkers, navvies, itinerants

– and this explanation was reinforced by the testimony of the chief witness, Reuben Platt. Platt, who lived in the high settlement of Primrose, was believed to have been the last person to see William Bradbury before his murder. Prior to the murders, he had, he said, walked with Thomas from the inn to the grocer's at Spring Grove. On the way, his testimony continued, they encountered 'three Irishmen', about whom Thomas had expressed concern – one of them, he told Platt, had stolen a pair of stockings from his father.

Platt's description of the three was circulated to the Yorkshire and Lancashire constabularies.

One was tall and thin-looking, with a scar on his nose; he was dressed in a dark coat, short, light-coloured trousers, half-boots, and appeared to be from thirty to thirty-four years of age. Another wore a velveteen shooting jacket with broad laps and fancy buttons. He had a full red face; appeared to be about five feet nine inches in height and thirty years of age. The third had on a blue linen slop, with a broadish hat slouched over his face, so that it could not be seen.

The men, he said, 'skulked' as they spoke to them, and, as they watched them pass the inn, continued to 'skulk'.

For many years Irish travellers had come to Saddleworth Moor to collect broom for basket weaving; recently, it was said, Thomas Bradbury, in his role as keeper, had prevented them from doing so. Suspicion against the Irish hardened. But with the failure to identify any suspects matching Platt's description, attention turned to two other Bradburys, unrelated to William and Thomas, living at Hoowood, near Holmfirth. James and his son Joseph were known locally as the 'Red Bradburys', even before their association with the bloodshed at the Moorcock – renowned scoundrels, according to Joseph Bradbury forty years later: 'Jamie was a strong, powerful man, rough, rude, and uncultivated, a hard drinker,

a hard hitter, and an implacable foe. With many of the keepers engaged on the moors extending to the place where he lived he was on terms of chronic hostility.'

One of those keepers was Thomas Bradbury. The day after the murders, Jamie Bradbury stood trial at the Pontefract Sessions, charged with poaching, a trial at which Tom Bradbury, as gamekeeper, had been due to appear as both witness and prosecutor. The night of the murders, the Red Bradburys were seen drinking at the Church Inn (then the New Inn). Tom o' Bill's, Jamie was heard to say, wouldn't be giving evidence against *anyone*.

5

The sunken footpath to the hamlet of Primrose was like a toboggan slide. It took me forty minutes to cover a hundred metres. It was at Primrose that the poet Glyn Hughes lived for several years during the sixties. Those years he spent watching the moor from his back porch – the moor and its people. He never forgot his own foreign status, first as an incomer, and then as a poet, even in a parish where poetry – or at least that mode represented by Ammon Wrigley – was not distrusted. Looking out on Saddleworth Moor, a landscape that had been largely untouched by the sentimentalising brush of tourism, Hughes saw the moor as it had long been seen.

Deserts, though many are actually monuments to man's destruction of the natural world, have a peculiar attraction for the human psyche, projecting as they do the huge spaciousness that we each feel our soul to be. As I matured, and discovered the fatalities that continuously threaten mortal life – war, sickness, failure, poverty and guilt – maybe this desert had a particular grip upon me.

That such places might answer something in us that presents itself in the wake of certain griefs (griefs of society or of the individual) was articulated by Hardy in *The Return of the Native*: 'haggard' Egdon Heath, he wrote, 'appealed to a subtler and scarcer instinct, to a more recently learnt emotion, than that which responds to the sort of beauty called charming and fair'; he went on to predict that 'human souls may find themselves in closer and closer harmony with external things wearing a sombreness distasteful to our race when it was young.' Moorland, like its peatless, sandy counterpart, heathland, was not 'landscape', in any of the established senses of that word; it didn't possess 'beauty of the accepted kind'.

The primroses that gave the settlement and Hughes's cottage their name had long gone by the time he moved there, and it was impossible, now, to imagine flowers ever thriving on this hill. Writing in 1975, Hughes recalled with some pride the blizzards that cut off the moor villages, just as they had been cut off in recent days. 'Between the door of the house and the door of the barn – maybe fifteen yards – it was possible to be lost.' Today the remaining snow was bermed a metre high against the house walls. I climbed a broken stile onto the rough pasture, into the moor-wind, and stepped over the fallen field walls, and climbed the steep bouldered incline to the moor. I looked down over the rough ground – a roofless barn, the farmhouses at the moor's edge, the more affluent properties lower down, and the church tower with its English flag, telling me where I was.

The snow remained along the sunken paths and along cloughs and brooks and the footings of walls; its surface inch had frozen and refrozen and hardened to a brittle shell. There was a word for this sort of partially melted and refrozen snow – *névé*, from the Swiss French for 'glacier'. The snow was not the dense impasto it had been on Exmoor, but a fussy

finepoint, outlining hags and griffs, hills and boulders, walls and fences and vegetation. The snow made visible the actions of the wind on the moor, and the lightness of the moor's components: slopes of windward snow displayed on their surface a fine sifting of peat that lay like a shadow; other, flatter areas were scattered with fine stems of dead grass (purple moor-grass is sometimes known as 'flying bent', for its tendency to become airborne when dead). The snow, where it remained, was also a reminder of the moor's in-habitants – to look at the tracks (sheep, rabbits, foxes, grouse, crows) it was clear that the moor, even at its most remote, was busy with prey and predator. The snow, which had taken these prints soon after its first soft fall, had hardened so that even my own heavy tread barely left a mark. These older, lighter prints of animals, fixed in the stiffened snow, would be preserved until thawing occurred. A temporary fossilisa-tion. In a patch of ground newly released from the snow, I noticed a spiral of dead moor-grass centred on a nest, and within that nest, curled no bigger than my fist, a baby hare that might have been sleeping.

The farmhouses at the moor edge had a look of aban-donment; the yards were scattered with building waste and rusting JCBs, the concrete driveways cracked, the gardens overgrown with rhododendron, the houses' windows board-ed up or smashed – though chimney smoke showed that some were still occupied. And beyond the villages, the mirage sky-line of Manchester was visible twelve miles away, glinting – its towers whose names were Piccadilly, River Street, CSI, New Wakefield Street. Turn in the opposite direction, east, and there was the moor plateau, forbidding, and rising be-yond it, the moors of the Pennine range.

The obelisk that rose from the edge of the plateau would in turn be visible from the windows of those same towers.

It was erected to honour the local dead of the Great War, and the names of those who had died in the Second World War were appended to the original list. It was built of the same dark gritstone as the mills in the valley below, and the church in between – black, the same burnt-looking brownish black as the fifty-ton outcrops that were exposed further along the moor edge. The poppy wreaths laid in the cornices in the monument's base had been weighed down with bricksized chunks of lighter sandstone, dumped there, it seemed, to bury the wreaths rather than secure them against the wind. I stood and looked up at the pinnacle and enjoyed the child's illusion that the obelisk was tipping away from me, on and on and on.

I walked a circle over the moor – hard walking made harder by the wind, across rank heather and exposed peat, skirting snow-filled cloughs (it was hard to know how deep they were, and how wet) – first east, and then down to the Greenfield–Holmfirth road that I had first crossed in the summer. I had a route in mind – a circuit of memorials.

At Hollin Brown Knoll I had expected to find some further commemoration, but not even flowers had been left – or if flowers had been left they had been taken by the wind or by the glacial bulldozering of last week's snowdrifts. But half a mile from the road was a moorland tree – it was a skeletal mountain ash, shoulder high and growing from a snowy hollow. Something shone on the ground nearby – I made my way over the granular snow, and crouched to examine what had been left there.

In the cleft of a bole of bog-wood, rising proud of the snow, three silver Christmas-tree baubles had been placed in a row, though none had been hung on the tree above. There were no footprints in the surrounding snow. A seasonal offering, perhaps, for one of the children who had been buried here fifty

years ago. Perhaps Keith Bennett, the boy whose body had not been found, and whose mother had spent her remaining life pleading with his murderers to reveal its whereabouts.

Many details are known. The children were driven here, through Greenfield, onto the moor, from their Manchester neighbourhoods – Gorton, Ashton, Longsight. Given a drop of sherry. Would you mind helping us look for my glove? the woman, Myra Hindley, would ask.

The man, Ian Brady, was an amateur photographer, and had a darkroom at home. He had taken hundreds of pho-tos of the moor, it transpired – many of Shiny Brook and Hollin Brown Knoll, where I had walked last summer: griffs and hags, promontories and shale exposures: a specialist's records, nondescript quadrants whose significance he alone understood.

'As far as I am concerned they are photographs that I have taken,' he told the judge.

The judge: 'These are photographs of this cemetery of your making on the moorland, are they not?'

'These photographs are snapshots.'

A week later, at home, I found myself unable to sleep. It was early, one or two in the morning. I came upon the story on the internet, first just the 'breaking news' icon, then a face I knew: pouting, imperious; vain of its owner's facility for barbarism. Brady, it seemed, had divulged to his mental health advocate the whereabouts of Keith Bennett's grave. A TV documen-tary maker had interviewed her and she had revealed that Brady had placed in her safekeeping a letter addressed to Bennett's mother, to be opened only after his death.

The mental health advocate was arrested, her home and Brady's cell searched. I refreshed the webpage repeatedly, over the coming hours, and fragment by fragment the story was fleshed out.

This was not the first time Brady had claimed to know the body's location. In 1987 he had been taken from his secure unit onto the moor, but when he got there, dressed in trench coat and sunglasses, he was unable, he said, to locate the site. The moor didn't match his memory. The land had shifted. 'Who moved that mountain?' he said.

Keith's mother, Winnie, was dying. She maintained that Brady knew where her son was buried. She wished to do properly by Keith and by herself. And yet what hope was there that the body would be found? The man had dug by torchlight, all those years ago, and in a state of trancelike exhilaration. Fifty years had elapsed; for the past ten he had been force-fed – his mind was collapsing, a tunnel whose props have rotted.

The next day it was announced that Winnie had died. The news, the possibility of the grave's discovery, had been too much, it seemed. But it wasn't that. She hadn't been told – for the very fear that the shock would kill her. And yet her life had reached its end, just as the news had 'broken'. And the news, in the end, came to nothing. There was no letter, no grave.

The police, when they searched the moor in the 1960s and 1980s, probed the ground with white rods, just as farmers will probe snowdrifts for buried sheep. Pushed into the wet ground. The tip lifted to the nose, sniffed. When they returned to their homes, night after night, to their wives and children, their clothes reeked of methane from the peat they'd turned.

6

I walked alongside the road-fence for a mile or so, until I came to a track through a field that led down to a conifer

plantation. The road divided the moor from the pasture. The track was messy with the prints of sheep; the field's lower reaches were thick with rush, and the rush was thick with pheasants from the wood. This was no longer grouse country – even on the moor-tops, the heather was sparse.

All that remained of the Moorcock Inn – 'the bloody scene of the catastrophe' – were its foundations and door-columns and lintels. The interior was filled with mossed spoil. It was hard to find the footprint of the building I had seen in old photographs. The moor rose yellow above the road, while in the valley bottom the string of reservoirs, built in the seventies, sparkled through the conifers. During her visit in 1854, Geraldine Jewsbury met some of the remaining Bradburys here, including Thomas's widow, Ann, who was 'extremely kindly and friendly' but 'looked as if she had seen a horror which has put desperation between her and the rest of the world'. It was said in later years that the surviving Bradburys did not fail to exploit the inn's newfound notoriety. Business was good. Even in the days immediately after the murders, tourists eager to see the aftermath, including the dead men's blood-starched shirts, were admitted on payment of a small charge. Years later you could still buy a postcard showing 'relics of Bill's of Jack's' and one of the verses from Platt's epitaph. Souvenir plates and jugs were manufactured, showing the inn, with its courtyard and its distinctive arrangement of windows that seemed to have been inserted into the front wall randomly. Above the bar, a ceiling stain was said to be William Bradbury's blood, though regulars knew well enough that the cause was a spilled chamber pot.

Had the crime occurred at one of the town pubs – the Church Inn, say – the story would still have been news; the crowds would have queued to see the stains. But just as it was the isolation of the setting that had facilitated the crime, it

was the setting that turned a double murder into the material of myth.

Bill's o' Jack's was well known in the locality and beyond. Many of those who visited in the days after the crime had been there in the past as patrons, and had stood and taken ale at Bill's bar, or strolled in the summer yard and turned full circle to view the girding moor, and wondered what it was like to live in such a place. In Joseph Bradbury's account of the crimes in *Saddleworth Sketches*, one of the subsequent landlords tells him that he never locks his doors at night. Asked 'how it was that he could neglect the most ordinary precautions in such a lonely situation, and with the memory of the awful murder constantly before him', the landlord replies that he and his family are 'accustomed to the loneliness so that it did not affect them, and that, so far away from neighbours, the locking of doors would be no precaution against men determined to break into the place'.

Joseph Bradbury is dismissive of Platt's three 'skulking' Irishmen, and wonders if William's supposed last words – 'Pats. Pats' – were not, rather, 'Platt. Platt', and whether it was not more likely that Reuben Platt, in reporting the three 'skulking' Irishmen (and in such photographic detail), was seeking to divert suspicion from himself as the last man known to have seen the Bradburys alive. Joseph was not alone in these suspicions, whether fair or not: 'some people thought hardly of him as long as he lived' – though nobody was ever charged with the murders.

The Moorcock continued to be a tourist destination until the 1930s, when it was demolished on the orders of the local water board, which feared that its ruinous drains would contaminate the Yeoman Hey Reservoir. Where the field sloped away, the top part of an arch was visible under the plantation track – the inn's vaulted cellar, used now as a sheep

shelter, but empty apart from a pink tub that had once con-
tained Crystalyx Extra High Energy forage supplement, and
(a single beam of low light penetrated the dark recesses) the
fuzzed ribcage of a dead lamb. I spent some time toeing the
mossy rubble, and found the corner of a stone sink with a
leaded plughole, and a green glass bottle, and beside the path,
a piece of blue-glazed porcelain, the lip of a jug.

7

I crossed the dam that withheld Yeoman Hey Reservoir from
the larger Dove Stone Reservoir. From the site of Ashway
Gap Lodge (now only a picnic ground ringed by a thicket of
rhododendrons) I climbed the steep path to Ashway Rocks,
onto the plateau called Little Flat. Here on the map was a line
of butts, the stone structures from which grouse are shot, but
all that remained of them were a few broken rings of black
stone wall. The heather that must once have been thick on
these moors was sparse – shooting no longer happened here;
it was no longer managed for grouse, and the natural moor
predators were unmolested. I saw crows and a sparrowhawk,
never seen on active grouse moors, and, flitting between the
surface boulders as if buoyed on a current, a stoat. Occasion-
ally it stopped, and stood on its hind legs and watched me as
I approached, before moving on with such suddenness that it
seemed to simply vanish.

The memorial I had come to find was smaller and older
than the obelisk above Saddleworth, a private cross to mark
a single death. It took me an hour of back-and-forth over the
windy plateau of Ashway Moss, until at length I turned back
towards the path I had taken, and there it was, standing eight
feet tall, quite conspicuous, suddenly, and on a spot I felt sure
I must have walked within yards of. The lodge at Ashway

Gap, in the valley below, had once been the dwelling of James Platt – scion of the huge Platt Bros. textile machinery firm – and this moor, in the days of heather, when the butts were intact, was his shooting estate.

It was a Greek cross with a slender pedestal six feet tall, carved with floral curlicues; it had stood since 1857, or soon after; but it had fallen many times in the intervening 160 years, and had been broken many times – smears of cement and rusted iron clamps and pins showed where it had been repaired. Where the pedestal joined the cross, a T of iron had been bolted on either side, from which, fore and aft, two long slim outriggers reached to the ground six feet from the base, so that from a distance the structure had a peculiarly decrepit appearance, with its slender body and small head, like a figure striding across the moor on oversize crutches. Old photographs show that these struts or ones similar have supported the cross since it was first erected – such a slender form being incapable (its builders must have realised) of standing unaided against the snow and gales that attack this edge. It's hard enough for a person to keep his balance, when the wind is at its worst.

A stone tablet fixed into the pedestal's lower half stated that it was here that 'James Platt MP for Oldham lost his life 21st August 1857'. (It should be noted that just as the Red Bradburys who were suspected of the Bill's o' Jack's murders were unrelated to either the victims or to Joseph Bradbury the author of *Saddleworth Sketches*, so this James Platt was no immediate relation to either the James Platt who penned the rotten verse on the grave at Saddleworth church, or the Reuben Platt who appeared at the inquest, and who might also have been involved in the murders. It is this local poverty of names, so to speak, that makes the use of patronymics – 'Bill o' Jack's'; 'Tom o' Bill o' Jack's', 'Amy o' Charlie's

o' Jackie's o' Ben's o' King's o' Sim's o' Sig's o' t'Owl Rag's o' Bank Gap' – essential in telling one individual from another, whose christened name and even occupation might be identical.)

The *Oldham Chronicle* two days later announced the 'melancholy and untimely death' of the local member of parliament. It was on the moor above his residence that James Platt and his friends had gone, at the height of the season, 'attended by a party of gamekeepers and others, whose office was to drive the moors for them'. Shortly before lunch, the men were shooting on Ashway Rocks. 'Mr Platt had just crossed a little hollow, Mr Josiah Radcliffe was following at a distance of four or five yards when his foot slipped, and in recovering himself . . . the contents of the left barrel were lodged in the calf of Mr Platt's right leg.'

Platt hopped a little way, and said 'Oh! Oh!' before collapsing. The calf was open almost to the bone, the report continued, 'and portions of it blown away'. A tourniquet was applied and the man carried down to the mansion, a door having been torn from the shooting shelter on the moor for a stretcher. The party finally arrived at Ashway Gap (it is a steep descent, even unencumbered), and although 'there was no immediate danger apprehended by the medical men', it seems that the blood-loss was unsurvivable – 'the bed and mattress on which the sufferer lay being completely saturated in blood'. Mr Radcliffe, said the report, 'was almost beside himself with grief, and it was feared for some time that he would lay violent hands on himself if not prevented by those around him. He took Mr Platt around the neck and bewailed his fate in the most heart-rending tones.' The report concludes, 'The works of the Messrs. Platt were immediately stopped.'

8

I turned southeast towards the fourth, smaller, reservoir, Chew, which lay two miles from the others, on the high moor. I followed the moor edge, tracing a clean snow-line across an expanse of peat, black under one foot, white under the other. Sometimes the peat showed through gaps in the snow, sometimes small islands of snow persisted amidst the peat. I was reminded of the Taoist yin-yang symbol: in light is darkness, in darkness light.

I had been told by a retired Manchester police officer, who walked once a year from Kinder Scout to Saddleworth, that on each occasion he made a point of walking past the engine block of a Lancaster bomber that had crashed on Bleaklow during the war; and sometimes it was there and sometimes it wasn't, he said, because it sank and rose from the moor, year by year, so that one summer it would be on the surface and the next it had gone under, circulating in the ground according to currents he couldn't explain. It was the nature of the moor, he believed, that it would in due course give up whatever had been buried there.

Prone to mist and self-similar, high in altitude and broken by valleys and escarpments, moorland can be as disorienting to the pilot as to the walker. Most of the moors I visited had seen a scattering of plane crashes, especially during the Second World War, when inexperienced pilots, returning from missions or undergoing training, committed some small misjudgement. On the edge of Tiger's Marsh on Dartmoor is a hillside that is still bare since a Flying Fortress exploded there in 1943. Boles of melted aluminium stud the peat. It is characteristic of moorland that such remnants tend to be preserved, just as the standing stones and waymarkers remain undisturbed after thousands of years. A few years ago, the

sons of the farmer who owns the Bill's o' Jack's field were out herding when they came across a trail of red, white and blue wreckage. It led, after a hundred metres or so, to a micro-light's seat, into which the pilot was still strapped.

Across the valley from where I stood, close to the gritstone outcrop that jutted finlike from the moor edge, was the site of the worst of all the moors' aviation disasters. It happened in 1949. Twenty-four people were killed when the Dakota, en route from Belfast to Manchester, came down. It was the workers from the Greenfield paper mill who were first to arrive, having heard the explosion echoing down from the heights. Even for men who had seen war, the scene was ghast-ly. But what struck me about the event, and its quick trans-formation into news, were the amateur snaps taken by locals in the days that followed, some of the incinerated wreckage, others showing, trailing away down the path to Greenfield, an unbroken line of men, women and children climbing up to see what had appeared above their homes.

I walked southeast for an hour, all the time expecting the path to take me off the bouldered edge, down to the valley and the reservoir, when, over an expanse of dead mat-grass and exposed grey stone, I saw the dam wall – not below but above me. The snow had more or less gone, and as I walked up the Chew Valley the sun came out. I clambered up the bank onto the track that crossed the dam, and stood and peered over the black-stained wall.

It was a field of ice, a vast bright rink. After the walk here – the paths of slush tainted piss-yellow by the peat, the col-lapsing peat hags, the moor streams choked with orange al-gae – the sight of the frozen reservoir was a balm; a spectacle of piercing purity. Rising from the ice surface were crests of thicker, whiter ice extending from one bank to the other, re-sembling not so much waves as low dunes. I set out towards

the reservoir's far shore, where Chew Clough fed into it and the ice turned from an intense pale arctic blue, to a rosy edge-slush, to the near-black chop of buffeted water where the ice had melted.

From the rim where the ice was becoming water, as the warmer incoming flow from the moor repelled the frozen surface, I saw a flurry of tiny white birds lift into the air, as wading birds will flush in sequence as you approach them along a shoreline. I stood and watched the line where ice met water, where they had taken off from. Only when it had happened twice more did I realise that there were no birds – no birds here at all – and what I had thought was a flock of waders were fine platelets of ice being torn away by gusts of wind, and flung up – twenty feet into the air, and scintillating.

I sat down on the rocky beach and had a King-Size Pork Pie and a sachet of Orange-Flavoured Capri Sun. I listened to the slush at the shoreline, sifting and shuffling, and watched as, again and again, the fine ice-shards were snatched into the air – as much light as matter – and strewn over the hard ice behind.

As I took myself away from the reservoir, down the Chew Valley along the reservoir track and past the abandoned quarry that had provided the reservoir stone, I became aware of a group of perhaps fifteen people on a green hillside named on the map as Charnel Holes. They were all dressed in black. Even the children, I noticed, toddlers and babies, were dressed in black under their brightly coloured quilted coats. There was an aimlessness about the group's movements, as if they were waiting for the beginning of something. It was only as I got closer, after five minutes of walking towards them, that I identified the black caps of the men, and the long black dresses and tights of the women.

I watched as one of the men – in a long black coat, bearded,

and clasping the wide brim of a black hat – joggled awkward-
ly down the steep hillside, through a stand of dead bracken,
towards Chew Brook, his other arm outstretched for balance.
What I'd taken for solemn ritual was just holiday larks – the
end of Passover. Other, younger men followed the rabbi, and
then the little boys with their long sidelocks swinging, and a
toddling girl, while the women, four or five of them, stood
around a pushchair, and one of them yelled something to the
rabbi, and the women laughed so hard that, for a moment,
they became silent.

5. The Desert

The Calder Valley

I

About fifteen miles north of Saddleworth Moor is the Upper Calder Valley. I'd come, that morning, from Heptonstall, the cobbled village on the hill, with its strange ruins – the dead roofless church of St Thomas à Becket alongside the living church dedicated to St Thomas the Apostle. It was as if a deceased father (Thomas Snr) had been embalmed and seated, glass-eyed, in the living-room corner.

In a field below the new cemetery, where Ted Hughes's mother and father, and Uncle Walter and Sylvia Plath, are buried, a sheep was wearing a hat – those 'sluttish' sheep Hughes seemed to hate. Or what resembled a hat: a comic miniature topper, jauntily tilted over its double-tagged ear. How had it happened? It must have stumbled, somehow, as sheep – imperfect – will stumble, or it had been butted, and fallen headfirst into its own or another's mess; and thus the gleaming black turd – weighty as a can of beans – had got clamped to the corner of its head above its left eye. I photographed it; but then watched the sheep as it watched me, and saw the filth that had drained from the turd and grouted its left eye and clagged its neck and chest. There was no humour in it, because the sheep didn't care.

From Heptonstall I walked down the steep cobbled lane to Hebden Bridge and followed the Calder east. The Calder Valley is a ditch made dim by its narrowness – there are those here who can name the date each year when sunlight will come to their yards. The suicide rate is high. Historically it was the place of fugitives – at Heptonstall I'd stood on

the pavestone grave of David Hartley (d. 1845, aged twenty-five), hanged king of the Cragg Vale Coiners, the band of forgers who hid and worked in the remote gorge formed by Withens Clough. The Calder Valley is a byway, too, as all valleys become byways of a kind: where rivers run, paths will follow, and if viable, roads and railways – thus the shallow Calder, the deep Rochdale canal, the Leeds–Manchester railway line, the A646 – lain down, side by side, like pipes in a utilities trench.

It had been the wettest summer on record. Hebden Bridge had been flooded, businesses had been ruined. Split sandbags were still scattered about. A tidemark was visible at waist height on the walls along Market Street; silted shops had to be sluiced out and mopped. A canal barge had been lifted by the waters and dumped across the towpath. The steep foot-paths up to the moor were scoured to the bedrock; no longer footpaths but streambeds. Where once a stream had been shallow, now it was deep. Where a stream had been wide and slow, now it was narrow and rushing.

Once I had passed the bright barges of the Hebden Bridge stretch, the morning canal was reflective as obsidian and pop-ulated only by outraged Canada geese. I stood and watched one pass. With each honk a fistful of steam was ejected from its throat. Like most Calder settlements, Mytholmroyd was once a cotton town. Now only a single clothing factory re-mains. Above the factory and above the village, to the south, was Scout Rock.

For Ted Hughes – 'Teddy', unless you were his aunt ('Ed-ward!') – Scout Rock was the oppressor of his childhood imagination, and the limit to his world. Beyond it were the moors, a barrier as impassable – and as unforgiving – as the Atlantic or outer space. But *beyond* the moors, south, that was where the world was. And thus it was the dead moors that

signified the life he might go on to have. He would return to them again and again. As a boy, the future poet laureate would stand on the table and look out of his attic bedroom window – south; and it was not the world he saw but the valley, and the rock. Its face was black-green; if you were to fall from the top – as some ancestor of his had, famously, whilst out rabbiting – you'd die, and that would be it, forever; but the slope that lay at the foot of the forty-foot fall was hidden from here by trees.

The canal where he fished (gudgeon, stickleback); the big road with its lorries; the railway; the river – and then the hill and the woods and the rock. 'I lived under it as under the presence of war, or an occupying army,' he wrote later. It was an ancient limit. And thus what a revelation – *the* revelation of his first eight years – to be taken there by his older brother and to look *back* upon the place that, previously, he had only looked *out* from – to view the viewpoint! Banksfields, the Mount Zion chapel, and there – 1 Aspinall Street, Mytholmroyd, South Yorkshire, England, Britain, Europe, the World, the Universe . . .

His task was to belittle the war-rock; having seen that it might be conquered physically, step by step, he sought to overcome its presence in his mind. 'Living beneath it was like living in a house haunted by a disaster that nobody can quite believe ever happened, though it regularly upsets sleep.' From Aspinall Street he and his brother Gerald climbed backwards (to strengthen the legs), up the opposite valley side, to the first field and the second – the one owned by the Co-op – through Redacre Woods and Hill House Clough, past the house where old McKinley the retired gamekeeper lived, until you could turn on your heel and look back past the farms – south – over the town in its valley, with the great obelisk on Stoodley Pike to the west, and the rock before you, and see

that this highest place was not the highest place at all, but was dwarfed by the green hills beyond it, where his ancestors had farmed, hills that had *always* been there, and that those hills in their turn were dwarfed by the moors rising beyond them. When the child Cathy, in *Wuthering Heights*, asks Nelly what lies beyond the hills, she is told 'hills again, just like these'.

I too went 'up Banks', as the boys called it, and like them I went backwards (backwards was the way to see the world), the narrow pathway between the fields unscrolling beneath my feet, the view expanding, past Hill House Farm, and Throstle Bower Farm and Wadsworth Banks Farm, to the Heights Road. Teddy and Gerald came this way on dawn hunting trips – the only gunmen in these parts, aside from the keepers and, in late summer, the grouse shooters – with Gerald's .22 Winchester or the old BST air rifle, to pick off rats and rabbits and stoats and grouse, returning to Mrs Hughes before breakfast, with a brace of something – or, more often, having flushed nothing but their faces.

To take a square of moor and make it farmable is an act of need; to put a golf course on it – prissy greens, striped fairways, shingled paths – savours of hubris. I followed the fence-line (a clogged mire, as moorland fencelines often are) past Hebden Bridge golf course, looking for a way onto the moor – *into* it. Midgley Moor didn't welcome the walker: the heather edge was also a hedge, dark and impenetrable. And when I found a path there was almost nothing but heather. Today the light was so erratic that the heather's tones were elusive. I knew that heather flowered purple, that bright carpets of it might be seen come July. And so the promise of colour to come was part of what I was seeing; and yet this rough carpet seemed to swallow light. The dark heather, with its dark roots, and beneath the dark roots the dark earth. Even the footpath puddles were black. Strung across a fence were seven scraps

of brightly coloured cloth – weathered remnants of a line of bunting; but it wasn't bunting. Hebden Bridge retained its fairtrade wholefood emporia and scented candlemakers, its 'cupping' practitioners and 'no-hands' masseurs, and its Buddhists – for these were Tibetan prayer flags, sanctifying the peaty air. The colour, against the moor, was pungent.

It's true of outstretched, treeless vistas – take the sea – more than of any other, that your experience of them is created by the weather and the light (there *is* little else): a heather plain first seen in morning sun can be unidentifiable when walked across again in, say, mid-afternoon drizzle. And weather is fickle at this altitude; time and again it would happen to me – the rain would arrive, or I'd walk into the downpour, and it would seem that it had set in for the day; any let-up was inconceivable, and the sunshine of the day before was only a dream, or an experience of another lifetime. And then – and, as I say, it happened again and again, sometimes several times a day – the rain would cease, or at least ease, and the sun would pour itself bounteously across the moor, and the moor was made entirely new. Almost instantly the larks would begin to sing, as if they had been poised up there, and of course I heard in their song a kind of festivity.

Here and there, in the peat-porridge, were the footprints of grouse. For miles, as I traced an irregular spiral towards the moor's highest point, the darkness was relieved by strips burnt last year, where green moss and bilberry were beginning to show, and the surface stone could be seen; relieved also by the collapsing grouse butts, circular fortifications sunk into the ground, big enough for a 'Gun', as they call the paying shooters, and his loader. And then I'd enter an acre of heather, waist deep, from which grouse would burst with their shrill indignant gabbling and glide, wings fixed in an arch, over the moor.

You can tell yourself, as you walk, that you are likely to flush a grouse, and that this is how they will behave – that they are likely to tear outraged from the heather at any moment; you might even spot one, trying to hide, ducking behind a boulder or in the deeper growth, and know that, as you approach, it will leap into the air with that disgusted clucking caw – and still it will shock you; still it will send your heartbeat galloping after it.

The rain let up, and the sun showed – and downhill to the east the black heather was suddenly red – something in the sun's angle working to highlight its soft, woody stems, and uphill to the west the moor was gently steaming, and the beads of water that every stem carried were visible; and all around me, it seemed, the larks were rising, as if on zip-wires, and for the first time during my landloping I heard the curlew, returned to the moor for the summer: a 'wobbling water call' was how Ted Hughes described it. I had heard winter flocks of them on beaches, and yet that same sound, a drawling rippling trill, possessed a completely different quality when set against this solitude. It was not only bleak or mournful. It was magnificent in its strangeness. It was a sound I would grow to love.

In a tribute to his friend Ted Hughes, Glyn Hughes wrote that the featureless landscape of the South Pennines 'forces the imagination to strive'. But the old moor-words, the words of the early topographers and 'improvers' – 'bleak', 'waste', 'desert' – did not always present themselves. It was Emily Brontë's lesson: sometimes, the sun shines on the moors. Below me, on the turfed remains of a quarry, a ewe shook a cloud from itself, and the bright vapour was snatched away by the wind.

Say it 'My', not 'Myth'. The locals won't be slow to put you right. Early the next morning, with Mytholmroyd below me,

I struck out north across the sodden moor, in the direction of Haworth. Spring was imminent but this felt like a kind of interregnum, and the sun was soon swept up by the low cloud. I went the way the boys would go, Teddy and his friends Derek and Donald and the others, along the Heights Road to Crimsworth Dean Beck, then up the rough woodland stream to the 'roarer' at Lumb Hole – and then on to the deep moor.

'A hedgeless country,' W. H. Auden called the watershed moors he knew, 'the source of streams.' To enter the moor is often to follow a stream to its source, and any stream's source is often, too, a moor's centre. The southern moors take their names from the rivers that rise in them: Bodmin Moor was once 'Fowey Moor'; on the Chains of Exmoor I had trudged through the stoggy springlands of the Exe; on Dartmoor I'd seen the source-bogs of the Dart.

It was alongside this tributary of the Hebden Beck that the picture was taken that triggered Hughes's poem 'Six Young Men', in which he details the unforeseeable trench death of each unforeseeing subject. 'I can never escape the impression that the whole region was in mourning for the First World War,' he wrote elsewhere.

The photographer Fay Godwin came to the area in 1977 to work with Hughes on their *Remains of Elmet*. In a prefatory note, Hughes explains that 'the Calder Valley, west of Halifax, was the last ditch of Elmet, the last British Celtic kingdom to fall to the Angles. For centuries it was considered a more or less uninhabitable wilderness, a notorious refuge for criminals, a hideout for refugees.' The second edition (a later one was printed without Godwin's images) is an uneasy, mythic volume, Hughes's poems on the history and landscape of the Calder Valley eclipsed by Godwin's monolithic photos – light as a fluid, shade as something tectonic; death *everywhere*. Her images record the findings of a careful newcomer: the skulls

and ribcages; the ruined chimneys and farmhouses; the bald, bold immensities of the rock; the grassland that is also a sea.

Another photographer, Martin Parr, lived in Hebden Bridge in the 1970s. Among his photos of the area is a series of Crimsworth Dean Methodist chapel, one of which shows the chapel in 1975, twenty years before it was closed. It rises charcoal grey from a dove-grey fog, on the edge of the broad and shelterless valley. The only points of contrast are the three lit squares of its windows – not quite white, but a still-paler grey, and one window paler than the others. Despite this, and the telegraph poles leading the eye to the smothered horizon, and the two parked cars that tell you that it is the seventies, it's an old scene – a scene of shelter amidst desolation. Firelight from a cave mouth.

It might resemble a mill, but there is no question that it is a place of society. It had been put up in 1845 for the Methodists who'd previously met nearby, at Hardibutts Farm or Cross Ends Farm. Today, like other chapels, it is someone's home, but its severity has hardly been softened, even if its roof now has a skylight and its chimney a TV aerial. Even if the windows are hung with flowery curtains.

The intake along Crimsworth Dean was scattered with eviscerated rabbits (remove the foxes' main prey and the grouse count will rise), and here, on a bed of flattened dead bracken, was a single Converse basketball boot, dropped, perhaps, by a river-swimmer last summer. If Godwin and Parr had shot the moor in colour, it'd look the same. White sky, grey heather, black peat. As you leave the old chapel, the moor rising on either side is cut with vertical drainage channels and horizontal ditches or walls (or the low remnants of old walls, or lines of bracken or rush where a wall once stood), so that the appearance, from a mile away, is of exoskeletal plating, like the flank

of a crustacean. Scattered across the valley side, set between these channels and clefts and walls, are the old farms, each of them derelict, each of them once a home as well as a place of employment. Then there are the stones from these ruins, and from the ruined walls, scattering the moor downhill, sometimes for hundreds of metres – each stone quarried nearby, centuries ago, and hewn and dressed, and now part of the moor, again, being taken back into it.

A great river once covered this land, a river that began in what is now called Scotland. It had deposited its sediments, which, under compression and cementation, had become the geologists' 'millstone grit' – a series of sandstones, siltstones and mudstones. Millstone grit's darkness is such that in buildings it tends to look cave-damp, and the mortar between the blocks appears bright, and where it has been repointed brighter still. It used to be thought that it was just industrial pollution that accounted for the blackening – after all, the air was thick with soot. But the quarried stone has always been dark. Thus every house and barn and chapel is grey-beige-black, and blacker where the elements bite hardest – along the footings; on south-facing walls; under eaves. The renovated buildings are sandblasted, but they soon darken, even in the absence of mill-soot.

And then onto the moor proper – 'Walshaw and Lancashire Moors', read the bright white sign: not a hiker's moor, not for picnickers or campers. Every other step put me ankle deep in bog; and where it was dry the going was made slow by substantial tussocks. The moor was black under the pale grass; sometimes a slick, sometimes a slurry, sometimes a gruel – it was impossible to tell what was meant to be a path and what was merely a breach in the surface vegetation caused by a slippage of the peat. All over the moor were these crescent depressions, peat cliffs a foot high, displaying the ground's

laminations. It was in peat's nature to slip and crack and col-
lapse. Deep under its surface it was riven with water channels
and excavations – 'pipes'. It was unstable. On another occa-
sion, nearby, I followed a brown stream up from a reservoir
onto the high moor, and came across a ten-foot cliff where the
peat had recently collapsed into the stream, boulders of the
stuff at the water's edge, scattered with pieces of ancient bog-
wood, some as big as my leg, remnants of the forest that once
covered this land. And again you could examine the substance
of the moor – a metre's depth of surface peat, underlain by
the pale grey sandy 'pan', then the shale and mudstone and
millstone grit supporting it all. Studding the peat face was a
rank of black orifices, seeping brown water.

I was soon off the moor and approaching the Worth Val-
ley, though the moor didn't quickly let go of the land, and
the ancient intake was strewn with the dark rushes that come
when the old drains fail. 'The moor gets closer every day,'
the old folk say. To keep it at bay you have to work, and go
on working.

In the Worth Valley the bracken was the colour of singed
paper. In places (along ditches; in crevices) it was black and
oily. The valley fields were stubble, and onto the stubble muck
was being spread. It was a bright morning, the light low and
decisive, and the shadows of trees on the distant valley side
were indistinguishable from the dark trunks that cast them.
As I came into the valley, off the moor, I came into the sound
of bells – clear in the clear air.

2

There are several biographies of Mad Grimshaw written in the
years after his death, in 1763: the first a eulogy by his friend
Henry Venn, vicar of Huddersfield. His years at Christ's Col-

lege had been dissolute ones. 'For more than two years,' said Venn, 'he seemed to have lost all sense of seriousness.' When he was ordained in 1731, and was awarded the curacy of Tod-morden, a few miles from Hebden Bridge, he continued to drink; he preached but once a week, on the Sunday, and he spent his remaining time fishing, playing cards and hunting.

In 1733 he married Sarah Lockwood, of Ewood Hall near Mytholmroyd, and the following year experienced what his biographers call his 'reformation', when he 'left off his diversions'. William Myles records the cause of this transformation as his reading of Owen's *Doctrine of Justification by Faith*: he was 'led into God's method of justifying the ungodly, hath a new heart given him, and behold! he prayeth'.

The biographers tend to call Sarah his 'first' wife; but since there is no mention of a wife in the long years after her death, it seems likely that, if he was married twice, then Sarah was his second wife, and his last. The pain of her death, six years after the wedding, welled in him. If he was grim it was with reason. When one of his parishioners committed suicide he pitied her, prayed for her, envied her.

It was in the year of Sarah's death, 1739, that he began to make preparations for his own. William Grimshaw was thorough in all he did: 'Whenever Almighty God is pleased to receive my soul unto Himself, I require my executors to bury my body in the same grave with my deceased wife, Sarah, in the chancel at Luddenden':

To attend my funeral I desire that 20 persons be invited (of my next relations and intimatest acquaintance) and entertained in the following manner:– Let 5 quarts of claret (which will be every one a gill) be put into a punch-bowl, and wine-glasses round till done. Let every one have a penny roll of bread to eat therewith; let every one be come, and let all sit down together to the same as an emblem of Christian love.

He turned to Brooks's *Precious Remedies Against Satan's Devices*: it spoke only to his guilt. 'Still he was conscious of many sins he had taken no cognizance of,' writes another biographer, Joseph Williams, 'was buffeted with most horrid temptations, lusted after every woman he saw . . . Fifteen months he groaned under the spirit of bondage.' William Myles wrote that 'his troubles were aggravated by having no kind friend to whom he could disclose them.'

It was in 1742, three years after Sarah's death, that his guilt appears to have begun to ease, and it was in this year, too, in the spring, that he went across the moor to become vicar of Haworth. He told Venn: 'I was now willing to renounce myself: every degree of fancied merit and ability: and to embrace Christ for my all in all.'

'Haworth', wrote Grimshaw's friend John Newton, 'is one of those obscure places, which, like the fishing towns of Galilee favoured with our Lord's presence, owe all their celebrity to the Gospel. The village would scarcely be known at a distance were it not connected with the name of Grimshaw.'

The bleak and barren face of the adjacent country, was no improper emblem of the state of the inhabitants; who in general had little more sense of religion than their cattle, and were wild and uncultivated as the rocks and mountains which surround them. But by the blessing of God upon Mr Grimshaw's ministry, this desert soon became a fruitful field, a garden of the Lord, producing many trees of righteousness planted by the Lord himself, and the barren wilderness rejoiced and blossomed like the rose.

Even a hundred years later, when the engineer Benjamin Herschel Babbage was invited by Grimshaw's successor, Patrick Brontë, to inspect the town's sanitation, he found Haworth a vile deathly place: the mortality rate was as high as in Whitechapel; the roads were impassable in rain; the middens – shit, ashes, offal – overflowed into the watercourse. And

the graveyard – new corpses laid a foot deep in the ground, shoulder to shoulder with the long dead, and covered with a single flat stone. Today you can walk from one side to the other without treading on mud. The ground did not breathe. The interred drained into the wells. When Emily Brontë died in 1848, aged thirty, she had outlived the average Haworth citizen of those times by four years.

The new incumbent, William Grimshaw, found only a dozen communicants at his church when he arrived in 1742. But as Venn wrote, his 'lively, powerful manner of representing the truths of God could not fail of being much talked of, and bringing, out of curiosity, many hundreds to Haworth church'. Grimshaw never failed to preach twice on Sunday, with an evening lecture and prayers at his own home (Sowdens, which still stands guard between the town and the moor). Soon he was drawing worshippers from beyond the boundaries of his parish. A three-decker pulpit was erected against the south wall of the church, its sounding board emblazoned with the line of scripture that was Grimshaw's lifelong creed: 'For me to live is Christ, to die is gain!' He had found his vocation; it had been waiting for him, here, at this black moorland parish.

In Haworth he established two 'circuits', which 'he usually travelled every week alternately', preaching up to thirty times a week at gatherings at the moors' scattered farmhouses. 'Being alarmed himself', writes Myles, 'his preaching was suited to alarm his hearers.' He befriended John Wesley and held meetings for the Methodists at Sowdens. An itinerant preacher, an evangelical, a friend of the Methodists – but he was fiercely opposed to the administering of Communion by lay preachers. 'I am determined to live and die a member and a minister of the Church of England.'

He rose at five in the winter, and in the summer at four.

He preached in barns and sculleries and open fields, walking
to the bounds of his parish and (secretly) beyond – William
Myles wrote that he had been known 'to walk several miles in
the night, in storms of snow, when few people would venture
out of doors, to visit a sick person'. I envisioned him bestrid-
ing these moors, a mighty figure, a boomer. But the diary of
one Mr Birdsall, who saw him preach at a barn at Bingley on
New Year's Day 1753, offers a different picture: 'A broad-set,
sharp-looking little man appeared habited as a layman, and
buttoned up from the storm. He quickly loosed his garments
. . . His voice in prayer seemed to me as it had been the voice
of an angel.'

In August 1748, John Wesley preached at Haworth; then he
and Grimshaw, and a young Methodist lay preacher named
Culbeck, set off across the moor for the town of Colne, whose
vicar, Mr White, was known to be hostile to the Methodists
and to Grimshaw's own 'itinerating'. Luke Tyerman's 1871
biography of Wesley describes the encounter:

While Wesley was preaching, a drunken rabble came, with clubs
and staves, led on by a deputy constable, who said he was come for
the purpose of taking Wesley to a justice of the peace at Barrow-
ford. Wesley went with him. On the way a miscreant struck him in
the face; another threw a stick at his head; and a third cursed and
swore, and flourished his club about Wesley's person as if he meant
to murder him. On reaching the public house, where his worship
was waiting, he was required to promise not to come to Roughlee
again. He answered, he would sooner cut off his head than make
such a promise. For above two hours, he was detained in the magis-
terial presence; but, at length, he was allowed to leave. The deputy
constable went with him. The mob followed with oaths, curses,
and stones. Wesley was beaten to the ground, and was forced back
into the house. Grimshaw and Colbeck were used with the utmost
violence, and covered with all kinds of sludge.

Grimshaw was unstoppable – a cataract of faith, of unblinking certainty, with a bullwhip poised for those idling in the fields or the alehouses on Sunday. There is a report of men throwing themselves through the windows of the Black Bull rather than face the rampaging minister. Mad? If that's what they thought, then he'd use it.

When the Methodist founder George Whitefield preached at Haworth, he declared that it was unnecessary for him to enlarge upon the topic of evil, since the congregation 'had so long enjoyed the benefit of an able and faithful preacher' – at which Grimshaw sprang to his feet: 'Oh! Sir, for God's sake do not speak so; I pray you do not flatter them; I fear the greater part of them are going to hell with their eyes open.'

The 'putrid fever' (typhus, probably) that was rampant in Haworth in 1763 did not deter him from his rounds. His final instructions for his funeral differed from those he had written in 1739, after Sarah's death: he was to be buried in a simple elm coffin, and those words that had become his motto were to be painted upon it: 'For me to live is Christ, to die is gain'. To his housekeeper, Mary (again, no wife is mentioned), he said on his deathbed: 'I have nothing to do but step out of my bed into heaven.'

They took the coffin by litter, one horse behind, one ahead, back over the moors, first to Ewood Hall, where he had lived with Sarah, and then on to the church at Luddenden, where he was buried alongside her. 'He loved much,' wrote John Newton, 'because he had been forgiven much.'

3

The deacon wore a white cassock with a rainbow stole, and a small pectoral cross. She had a long blonde bob and a bright, moorland face, though in fact she was a newcomer to the

valley, a newcomer to the moors, from Chelsea, who admitted that until recently she had never cultivated so much as a flower bed. She wanted to disarm with her honesty. She wanted to learn from the community she had been placed upon. It was her first service, and her nerves were shared by the congregation.

One of the ladies, in a trim charcoal tweed jacket, told me that the moors used to be on the doorstep, here, when she was a child. There was often this contradictory nostalgia about the moor's proximity: on the one hand for the days when the moor was nearby, before residential development; on the other, for a time when the men maintained the drains and limed the land and kept the moor edge at bay: the moor both feared and loved, even by those who lived beside it.

'The moors were our playground,' she went on. 'Not like today. Not like this little girl. This little girl,' she said again. The five-year-old snatched from the street outside her home in Machynlleth, as yet unfound, but understood to have been murdered.

Claire Gill was the name of the new preacher. She was 'Claire'. She wouldn't allow 'Deacon Gill'. Her new circuit included Oxenhope, Haworth, Lees and March. Today, for Harvest Festival, the congregations were combining at Oxenhope's modern chapel, built in 1990 to replace the stone hall to which the community once came. Only once, in living memory, according to one of the older ladies, was that building full to capacity. As the congregation dwindled, its upkeep became too expensive. A monumental place for a monumental practice, but it was the very size of the old halls that made their continued use impractical. The old chapel in Keighley, I was told, has been turned into a mosque.

'We went in with the housing association,' said the same lady, and later I saw that the chapel was in the style of the

residences that neighboured it – brown brick, brown roof tiles, salmon-pink cladding. There were few here under forty, and only two or three men. It was an old congregation, a 'dying' one (even its members conceded), and the chapel was much smaller than the old one, like a community hall or hotel conference room. Here were the combined congregations of four churches, on a festival Sunday, and they numbered fewer than thirty.

'This is a great change for me,' Claire announced, 'and also a great privilege.' The congregation was used to change. They willed her to impress them; they laughed quickly; they were vocal in their agreements. They wore large pastel-coloured quilted jackets. It was unclear if the levity had been brought by Claire, or was part of modern Methodism, or was merely an exception made by Claire, and accepted by those gathered, for the celebration of the harvest. 'Forgive us for forgetting Your words,' Claire said. 'For listening to our minds.' Then, no longer addressing God: 'Forgive others; forgive *yourself*.'

On the altar were unbruised apples and shapely pears and sprigs of ivy. Underneath, stacked jars and cans. They'd be driven to the Salvation Army. Perishables are not wanted these days. Afterwards, the flowers would be removed from the altar and the windowsills and handed out to each of the departing women.

'Coming from Chelsea,' Claire resumed, 'there weren't many valleys filled with corn.' She had bought a garden trowel recently. It had broken the moment she'd put it in the mud. The congregation enjoyed this. The humour enabled us to relax; the laughter encouraged Claire.

One of the ladies gave a reading: '"A farmer went out to sow his seed. As he was scattering the seed, some fell along the path, and the birds came and ate it up. Some fell on rocky places, where it did not have much soil. It sprang up quickly,

because the soil was shallow. But when the sun came up, the plants were scorched, and they withered because they had no root. Other seed fell among thorns, which grew up and choked the plants. Still other seed fell on good soil, where it produced a crop – a hundred, sixty or thirty times what was sown."'

'The parable of the sower encourages us to get our hands dirty,' Claire said afterwards. 'Being a Christian is a messy thing.'

The windows were bright, the radiators hot. The women were spruce and welcoming and delightful. Claire's cassock was perfectly white.

She went on, 'Where better, I said to myself. Where better to talk about sowing and reaping than – Oxenhope?' There was a three-second pause. 'Oxen as in cows, although *one*, I'm a vegetarian, and *two*, I'm absolutely petrified of cows! Add to that the second word, "hope" – isn't that wonderful? To live in a place that has hope?'

We understood that something had been said about the village, about its hardiness. Claire hitched her cassock so she could crouch down to pick up the plastic bags by her feet. One of these she handed to her assistant. In this bag were smaller bags, freezer bags, containing a handful of items: cocktail sticks, a birthday-cake candle, a date, a marshmallow, a Fruit Pastille, some raisins.

Of the old Wesleyan Methodism only a few hymns remained. The only things that were grave were the recited words, the hymn words – words that were not meant to be comprehended. It was a social occasion, a pleasant ceremony of community, an opportunity to partake in the old community affirmations. It was a kind of gentle party.

Claire was walking behind her assistant, handing to each of us, from her plastic bag, an orange with a yellow ribbon

drawing-pinned around its waist, and then returning to the lectern and showing us the finished article – a Christingle of the kind made by Sunday-school children at Christmas (there were no children here; their absence, now, was felt). The four cocktail sticks were to be stuck into the orange; on their ends the marshmallow, the raisins, the date, the Fruit Pastille, were to be skewered. We did as we were instructed. Passers-by might have paused and wondered about the laughter.

The Christingles represented 'the fruit of nature's harvest', said Claire, while one of the ladies searched under her pew for a dropped Fruit Pastille. The candle, in its pointed holder, was to be pressed into the top of the orange. The candle was God, was light. (The candle was not to be lit, for health-and-safety reasons.) But the adorned oranges were not Christingles.

'I call them – *Oxenhopes*,' said Claire.

The orange represented the world; the yellow ribbon represented 'God, encompassing the world'. It also represented 'our promise to look after the world'.

'The four cocktail sticks remind us of the four corners of the world, as well as the four seasons.' Claire held up her orange: 'I've spent the whole week', she said, 'trying to stick different things onto cocktail sticks!'

We each held our oranges before us, our Oxenhopes, and we sang 'He's Got the Whole World in His Hands', and then we prayed: 'We pray for those whose crops have failed. We pray particularly for the family of April Jones.' The lost girl, again, abducted from the streets of another rural community ringed by hills. Her abductor would, eventually, be imprisoned, and a funeral held for the child; of her body's whereabouts, however, the man claimed to have no knowledge.

There was a long, deepening silence; only the tick of the

wall clock was audible, and the passing traffic on the Hebden Bridge road. The sobriety lifted with the collective, relieved 'Amen', and coffee, and Claire's handmade shortbread, and the handing out of the flowers to the ladies as they left for their homes. Once I had said my thank-yous and had my piece of shortbread, I slipped my Oxenhope into my rucksack pocket, and struck out for Haworth: Brontë Country. *'Hope'*, one of the ladies was telling Claire, not unkindly, 'means "valley".'

6. The Flood

The Haworth Moors

I

The moors around Haworth are patterned with paths that lead nowhere, depleted veins that take you into the moor and stop dead, as if to go any further would be to pass a threshold into another reality. Closer inspection might reveal the footings of a derelict cottage or barn, but often there is nothing at the end of these paths but a view, and higher up not even a view – just the flat encircling moor. These are the old 'turbary roads', whose destinations were turf and peat cuttings, now healed over and absorbed back into the moor. It was one of these ways that we followed towards Crow Hill.

I'd been led here by Steven Wood, a historian whom I'd met that morning at his house in Haworth. In his front room were four bookcases (the bulk of his library was upstairs, or stored on hard drives). There were the multi-volume dictionaries and thesauruses, the dialect dictionaries and etymological source-books and lexicographical bibliographies; then the case full of volumes of *Gargantua* and *Pantagruel*, in every translation and various editions, along with biographies, an encyclopaedia and critical studies of Rabelais. On a hook on the side of this bookcase a violin was hung.

Steven is not an academic, and wouldn't call himself a scholar (in his former career he worked in the haematology department at Keighley Victoria), but, alongside his work on the history of the township, he corresponds with Rabelais experts internationally, and he has compiled an anthology of every one of Rabelais's thousands of classical references. Two years' work. It was not written for publication, he explained;

it was only a tool to further his own reading. In the corner bookcase were also the volumes on Irish traditional music, and spiral-bound sheet music (he plays the English concertina, the fiddle was his wife's).

For thirty years Steven has been studying the gasworks and mills, turbary paths and packhorse tracks, homesteads and landholdings, pubs, roads and railways of Haworth township. He didn't tend to use those theme-park terms 'Brontë Country' or 'Brontë Land', and spoke wistfully of a time before the grocers and butchers on Main Street were displaced by '*Ye Olde* thises and *Brontë* thats'. His work was an attempt to disprove the words of the *Nelson Leader* of 1906, which he quoted in one of his books: 'Take away the Brontës from Haworth and you have practically nothing left' – an echo of John Newton's pre-Brontë dismissal of the town a century earlier. The chapter dealing with the famous family is at the end of the book – after the chapters on the gasworks, the reservoirs and the quarries. ('Deep House', he writes of one of the disused quarries on Nab Hill, 'is a misnomer introduced by the Ordnance Survey, which clearly did not like the local name, Deep Arse.')

As we walked, he would come out with a word he had recently discovered, some word of implausible, laughable specificity – '*taghairm*: "seeking inspiration lying wrapped in a bullock skin behind a waterfall"!' or '*mallemaroking*: "the carousing of seamen on icebound ships in the Greenland whaling fleet".' In his backpack he carried a Thermos (scalded with hot water, the coffee first superheated in the microwave), and a foam swimming float.

As we gained height, as we neared the famous moor, the sky at once closed in and became a mist, and at the same time brightened, and there was the feeling, all afternoon, that we were labouring in the topmost layer of mist, and if we were

to climb even a few feet higher – stand on a wall-top, say – our heads would emerge into the clear air and we'd be able to look down onto it. All day there was the unfulfilled promise of brightness.

It did not take long for the grass to give way to heather, and as the mist became denser, grouse began to appear, like pop-up targets, on outcrops and walls. Where the heather had been burnt – last year or the year before – wet green moss was growing. There were clumps of leggy heather, here and there, and dead brown bracken thick on the slopes. We were on the edge of the grouse estate, and grouse could be heard every few minutes – sometimes seen, jinking in pairs (there is, they say, no better shooting), or on the ground, showing themselves proud against the skyline, and making that noise: I was getting used to it (just as I'd get used to the call of the curlew) – an old, old woman who laughs uproariously with-out getting the joke.

Grouse moor is a patchwork of strips and squares that mark the burning cycle – resembling, from above, the self-shaved head of a madman. It was the discovery that regular burning increased grouse numbers that facilitated the up-surge in shooting in the nineteenth century. The ideal re-gime was to burn the moor in ten-year cycles – a tenth of the moor each year, to create a variety of ages: young heather to feed the grouse, older, taller stands to provide cover. Hence this never-ending cyclical ignition of the land: 'swaling' in the southwest (where it is carried out to improve sheep graz-ing), 'swealing' here in the South Pennines, 'swithening' or 'swiddening' in North Yorkshire. Smoke is as familiar on the winter moor as mist. Newly burnt land is claggy with damp soot; the land burnt last season still carries the blackened stalks of old heather against its paler surface, like a scanty hide. Ground burnt a year back has a short growth of new

heather, dull green but still scattered with the bones of the old growth, now gone the grey-white of driftwood. In early summer, these white twigs reach brightly out of the polished green of bilberry.

And among the heather, small heaps – reddish, wormlike grouse droppings, or the white quartz grit laid down by the keepers. Grouse need grit in order to digest their food, and will find a natural source (a track or streambed) if it is not supplied. The grit that is served up for them can be medicated to rid the birds of strongylosis, a disease caused by a caecal threadworm, which can devastate a grouse population. So the moors are scattered with this medicated grit – set out in small heaps, or in plastic trays or, as here, in the cavities of concrete building blocks.

The track became a steep path, edged by short green turf, as we passed the muddled ruins of the first stone house ('Near'), then those of the second ('Middle'), then – the sense of space expanding – the highest and final of the three farms ('Top'). In the seventeenth century, they had been owned and occupied by three weaver brothers. There was something mythic about it: three farms, three brothers, their unknown resentments and jealousies. In a place that had become famed for its isolation, a kind of island community had existed – their lozenge of improved land separated from the valley, isolated on the high moor.

On a low wall above Top Withens we sat and ate our lunch, Steven on his swimming float, I on cold stone. (He later told me that it was in fact a gardener's kneeling mat: 'I found it many years ago, on the North Traverse of Great Gable.') From the pocket of my rucksack I took some raisins, a marshmallow, a date, a Fruit Pastille and an orange with five small holes in it.

Farming here began in the sixteenth century, or earlier, Steven told me. Meadow, pasture, oats. Cattle, not sheep.

In 1567, Thomas Crawshaye and his sister Anne sold, to one George Bentley, '16 acres of land with edifices thereupon builded lying in Stanbury in a certain place there called Wythens'. Of the generations who farmed and lived here before, nothing could be known.

Of Bentley it was known only that he was a clothier by trade, and that he bequeathed 'Wythens' to his son or grandson, William. In 1591 William Bentley's will decreed that his estate was to be divided between his three sons, Martyn, Luke and John. William specified certain rights that each brother was to have over the others' land. At the freshwater spring on Martyn's land, for instance, Luke and John were permitted to 'fetch water, wash clothes and to do all manner of honest business', while it is thought that the stone used to build all three farmhouses was drawn from a small quarry on Luke's land. In 1813 the first record exists of an owner for Top Withens itself, in John Crabtree, who in turn leased the farm to one Jonas Sunderland.

No other ordinary rural dwelling, home of farmers and weavers and quarrymen, has been described and recorded in such detail, in its gradual decline. Steven was its great historian; the photographs and postcards he had amassed, taken over the past century, were like the frames of a time-lapse film, showing the building's bit-by-bit disintegration: first the windows, then the chimney, then the ridge-piece, the gable-points, the slates, the rafters, then – course by course – the walls, until all that was left was the stone corral we saw today. But it was no longer really a ruin, for its ruination had been halted and it would not decay any further – the walls had been repointed and recoped. Top Withens could not be allowed to obey the rules followed by the ruins on the surrounding moors. It had been roofless for decades, now, and the wall-tops, iced and rounded off with modern cement,

were the palest thing in the green-brown-grey landscape. It was built into the slope of the hill and overlooked the vertiginous sweep of the valley. The instinct was to look out.

Steven brushed off his kneeling mat and slipped it back into his rucksack. I rebuckled my gaiters and he pulled up his red socks. The pommel of his walking pole was worn of its varnish. He had twice my energy and was always in front; if I paused to admire the view, I would turn back to find he was fifty yards ahead, binoculars in hand, still talking.

We ventured west, over the steep grass hill that rose behind Top Withens, and there we turned to look back briefly, and the moor, in the mist, had become bland as a fogged sea: only a slight smoothing indicating the threshold of sky. We strode on, onto the boggy heather top of Delf Hill and the flat ridge of moor that would lead to Crow Hill, following first a sheep trod and then the remnant turbary road, worn deep into the moor.

The heather here was sparse and low, the ground too boggy for it to thrive: the cotton-grass – a wet-lover – grew abundantly, lending its deep red to the heather's reddish wood. Light puffs of mist were gliding over the moor like cannon smoke. The county boundary traced the ridge, Steven said; a shallow ditch marked its course. We were to follow this ditch, once we found it, to Crow Hill, across Stanbury Bog and the springs that fed the streams that fed Walshaw Dean Reservoirs. But we were unable to find the line, which Steven was certain we must have crossed unknowingly. As we were retracing our steps, a roar came out of the mist.

2

Moor time is stone time, tectonic time. Epic processions of ice, million-year cataracts, molten injections, marginal

hardenings, piecemeal exposure. The igneous remnant that is Bodmin and Dartmoor; the sedimentary crushings and foldings of Exmoor and the South Pennines; the catacombed, honeycombed limestone moors of Cumbria, the volcanic extrusion of the Border moors – ponderous terrains. You feel it as you walk, just as all those writers felt it – 'changeless', 'timeless', 'ageless'. But approach the surface (the light) and moor time accelerates. It might take a mere three centuries for a foot's depth of peat to build. Then there is the sphagnum and heather, which will eventually decompose to form that peat. From decade to decade, from generation to generation, the hillside bracken ebbs and flows; moss and sedge appropriate wetter ground, and are displaced by heather in drier times. More frequently there is the growth, death and degeneration of the tangled sphagnums, in June the white eruption of the cotton-grasses and the hazy inflorescence of purple moor-grass, bilberry's fruiting in July, heather's brief purpling in August, then the descent of bracken from green to brown to near-black. And the moor's zoological cycles: the lambs' arrival in March; the curlew's May return; in June, the hatching of the lapwings.

But the moor is not always gradual, and its happenings are not always predictable. Moors are water-sources and river-heads; water is everywhere, even in summer, even when the top peat is cracked dry. It is this wetness that accounts for the reservoirs that are clustered on moorland. It trickles, drips, seeps, or 'perches' on the moor's surface – but it can be sudden, too. The grieving of Lynmouth experienced its suddenness in 1952. The people of Hebden Bridge had seen what it could do. In 1824, six-year-old Emily Brontë was shown that the moor, her sober, lugubrious moor, was capable of snapping.

Steven and I had been looking for the site and source of the catastrophe, 'the late earthquake and extraordinary

eruption', as the then incumbent of Haworth called it in the sermon he gave ten days later. The preacher was Patrick Brontë, father of Charlotte, Branwell, Anne and Emily. He had come to Haworth with his young family in 1820. It was an era of foreboding; for Evangelicals there was little question that the Apocalypse was imminent. And yet the catastrophe, dramatic as it was, might not have assumed for the curate such a powerful symbolic dimension had he not feared that three of his children – Anne, Branwell and Emily – had been killed by it. Shaken, he published several accounts afterwards – a summary of his sermon, a number of letters to both the *Leeds Mercury* and the *Leeds Intelligencer*, repeating his assertion that it was an earthquake, and a verse account printed as a pamphlet for Sunday-school children.

The cataclysm occurred at around 6 p.m., on what had been a fine day at the end of a dry summer. Patrick had sent the children to play on the moors, 'accompanied by the servants'. The parsonage lies between the churchyard and the moor, and, as the children had stayed out longer than expected, their father went upstairs to look for them from his bedroom window.

The heavens over the moors were blackening fast. I heard muttering of distant thunder, and saw the frequent flashing of the lightning. Though, ten minutes before, there was scarcely a breath of air stirring, the gale freshened rapidly, and carried along with it clouds of dust and stubble; and, by this time, some large drops of rain clearly announced an approaching heavy shower . . . I heard a deep, distant explosion, something resembling, yet something differing from thunder, and I perceived a gentle tremor in the chamber in which I was standing, and in the glass of the window just before me.

It is a vivid moment: the darkening moor, the children gone – that infinitesimal tremor of the window pane. 'God', he

goes on to explain, 'occasionally, without the intervention of second causes, produces earthquakes, as he did at the destruction of Korah, Dathan and Abiram, with their rebellious adherents.' The 'earthquake' was God's warning to the people of the moor – and nothing less than an earthquake would suit the reverend's biblical purpose: God produced such phenomena for varied reasons, he said in his sermon: 'as manifestations of his power and majesty'; 'as instruments of condign and final punishment'; 'as awful monitors to turn sinners from their ways'.

It was a 'solemn visitation', but Brontë nevertheless attempts to provide a scientific explanation for his audience. An earthquake, he told them, might be caused by 'sulphur kindled underground' or by the 'kindling . . . of what miners usually call fire damps', or by water: 'when a number of streams suddenly rush into one place under ground . . . till the expanding element, urged on by the encumbent streams, obtains a vent, and either forms itself into a standing lake, or rolls onward in an impetuous torrent'. And it was this last, he believed, that had caused the cataclysm, 'which, though it may be called by some the bursting of the bog or quagmire, had all the precursors, accompaniments, and results of an earthquake, and justly merits that appellation'.

In the introduction to his verse account (addressed to 'my young readers'), Brontë gives a further description: 'A part of the moors in my chapelry . . . sunk into two wide cavities; the larger of which measured three hundred yards in length, above two hundred in breadth, and was five or six yards deep.' The editor of the *Leeds Mercury*, who visited the site, judged this scar to be 1,200 yards in circumference and its depth 'from four to six yards'. Even by Brontë's smaller measurement, some three hundred thousand cubic yards of peat were displaced from this rupture alone. 'From these

cavities ran deep rivers,' Brontë's account continued, 'which uniting at a distance of a hundred yards, formed a vast volume of mud and water, varying from thirty to sixty yards in breadth, and from five to six in depth, uprooting trees, damaging, or altogether overthrowing solid stone bridges, stopping mills and occasionally overwhelming fields of corn, all along its course of ten or fifteen miles.' The *Mercury*'s report was no less vivid:

A most amazing quantity of water was precipitated, with a violence and noise of which it is difficult to form an adequate conception, and which was heard to a considerable distance . . . we feel happy, however, in being able to state, that it was not fatal to life in a single instance. The torrent was seen coming down the glen before it reached the hamlet, by a person who gave the alarm and thereby saved the lives of several children, who would otherwise have been swept away.

It's possible that those children were the Brontës, with the servants, Sarah and Nancy Garrs. We can in any case be confident that they were nearby. The moor had become, for Emily, not just fugitive and perilous, but a forum for divine communication. Even in this land they knew so well, the ground beneath your feet might be made to give way, might 'erupt' and liquefy and send a punishing wall of sludge into the peopled valleys below.

It was a bog burst – what geomorphologists call a 'mass wasting'. Under normal conditions, the bulk of the peat blanket, known as the 'catotelm', is impermeable to water, while the top, 'active' layer, called the 'acrotelm' and formed of vegetation in various states of decomposition, continues to absorb water until it is saturated, at which point further water either pools on the surface or flows off into the moorland streams. In the various historical accounts of bog bursts, including Patrick Brontë's, the phenomenon is usually reported as occurring during or immediately after a violent rainstorm,

following a long period of exceptionally dry weather. During such drought periods the acrotelm may dry out and shrink, so that deep vertical fissures form in it. When torrential rain comes, these fissures allow water to penetrate into the cato-telm, destabilising the peat's layers and lubricating the inter-face between the peat base and the underlying shale or clay on which it sits, until the whole liquefied bog suddenly slides downhill as if tipped from a dish, a black tide rafted with blocks of surface peat and carrying vegetation, boulders, eve-rything, in its wake.

In the valley, and all down the Worth, mills were stopped, leats clogged and drinking water tainted. From the river Aire at Horsforth, ten miles away, 1,270 kilos of dead perch and trout were recovered. According to the *Mercury*, 'the water, when taken into a glass, appeared nearly as black as ink'.

It was no earthquake. But, at his parsonage window, Patrick Brontë had *heard* that low rumble from the moor, a detona-tion deeper and more solid than thunder, and he had *seen* the window of his marital bedroom shudder as he watched for his children. It was the father who experienced that detona-tion, more than the man of Gòd. Unmentioned by him in his sermon and publications on the event, the curate himself went out to search for his children; he found them huddled in a porch, with Sarah and Nancy.

Their mother had died almost exactly three years before, on another day of 'clouds and darkness', and when he gave his sermon she cannot have been far from his mind. It was only when his children were delivered to him, soaked and shivering but unharmed, that the event – call it what you will – was allowed to take on the qualities of a miracle.

For Emily, the moor's timelessness had been rudely skewed; it was a signal to her not of nature's indifference but rather its wilfulness, its deep-lying violence. And yet they had been

spared. The moor, which might have drowned them all, had not. Twelve years later, she wrote the poem whose first line is 'High waving heather, 'neath stormy blasts bending'. It describes a moorland storm, and it is possible to recognise, in the moor's flooded streams, which extend 'wider and deeper', and the 'desolate desert' they leave behind, the Reverend Patrick Brontë's description of those 'deep rivers' flowing from the 'riven earth'.

Introducing his verse account of the 'Extraordinary Eruption', Haworth's incumbent offered a warning to his young readers: 'This talent of reading which you possess, will prove a blessing or a curse, just according to the use you make of it.' It was the works of Wordsworth and Walter Scott, available in the library at Keighley Mechanics' Institute, that supplied his daughter Emily with a yardstick to survey her landscape. That the Haworth moors lacked the loftiness of Wordsworth's Lakes or Scott's Borders did not matter. In *Wuthering Heights*, when Catherine asks about 'the abrupt descent' of Penistone Crags, which she sees from a distance, she is told 'they are not worth the trouble of visiting. The moors, where you ramble, are much nicer.'

Her family called her 'the Major'. She whistled 'in masculine fashion', she was an excellent shot, she liked animals (but once beat her dog, Keeper, 'until his eyes swelled up'). She liked to draw, and was a fine baker. She liked to look out of windows. Her eyes were sometimes those of 'a half-tamed creature', sometimes 'kind' – blue, according to one who knew her; hazel, according to another; dark grey, said yet another. She was tall, she was (according to an 1883 biography) *slinky*, *long-armed* and *elastic of tread*. Her brother, Branwell, said she was 'lean and scant, with a face about the size of a penny'. Her lips were frequently compressed.

She had no friends, really, other than her siblings. According to her sister Charlotte, 'she had scarcely more practical knowledge of the peasantry amongst whom she lived, than a nun has of the country people who sometimes pass her convent gates'. But she was no monastic – she was vulnerable to loneliness, she missed her sisters dreadfully when they were apart. And when she herself was sent away, it was miserable exile. Aged seventeen, she went to the school at Roe Head, eighteen miles away. She managed three months. The separation had been intolerable, 'her health was quickly broken'.

It was not 'homesickness'; not exactly. Mrs Gaskell, no stranger to moorland, opens her biography of Charlotte by marking out the boundaries of the Brontës' world:

All round the horizon is this same line of sinuous, wave-like hills . . . crowned with wild, bleak moors – grand, from the ideas of solitude and loneliness which they suggest, or oppressive from the feeling which they give of being pent up by some monotonous and illimitable barrier, according to the mood of mind in which the spectator may be.

But, for Emily, the moors were never a barrier; rather she depicts them as a frontier:

> Come, sit down on this sunny stone;
> 'Tis wintry light o'er flowerless moors
> But sit – for we are all alone
> And clear expand heaven's breathless shores.

At Roe Head, according to Charlotte, 'every morning when she awoke, the vision of home and the moors rushed on her' – the unendurable ache of the phantom limb. The moors did not merely liberate Emily's imagination, they were an extension of it. To return, at last, and be amidst the cotton-grass on top of Ponden Kirk (the 'real' Penistone Crags), or edging along a beck, even on a dull day, was to restore an equilibrium

of pressures, internal and external – like the unpopping of the ears that occurs when you emerge from a deep tunnel. It was not *love*. What that stubborn land inspired in Emily Brontë was more like narcissism. She would return to the parsonage from the moors with 'her face lit up with a divine light'.

3

The roar we'd heard coming out of the mist was a quad bike. Steven and I watched as it approached, its rider standing in his footings, a rifle slung across his back. It was hard not to encounter Jason if you walked here much, and this wouldn't be the last time I came across him. 'Two of us on Lancashire, and four on Walshaw,' he said, explaining the gamekeepers' allotted 'beats', as he turned off the engine and dismounted. 'It's a fair lump.'

After the flooding of Hebden Bridge, a pressure group, Ban the Burn, was established: it was not water that had caused the floods, but fire.

For 150 years Walshaw Moor was owned by the Savile family. The name is well known in the region; people still talk of Savile land. Walshaw Moor was bought from Lord Savile in 2002 by Richard Bannister, who owns a chain of factory outlets. In the local papers he is a 'retail tycoon'. He spent large sums on the moors' management, and it was this, especially the burning of heather on peat bogs, that Ban the Burn opposed. It was the peat bogs, spoken of as 'sponges', that regulated the flow of rainwater from the moors into the streams, they claimed, and now the damage to the peat, high above the town – bankrolled and sanctioned by this tycoon – was being felt by the citizenry in the valley below.

Three years after Mr Bannister bought the land, English Nature prosecuted his company for illegally building and up-

grading tracks and dumping spoil on this protected habitat (it was a Site of Special Scientific Interest and a Special Area of Conservation). A fine was paid; the damage was reversed. In 2011, Natural England (the subtle change of name had resulted from an intergovernmental amalgamation) started further proceedings against the estate to 'modify ambiguous consents', that is, to revise existing agreements made in a letter by English Nature in 1995, before Mr Bannister acquired the land, agreements that allowed unspecified amounts of burning, including on blanket bog. Then, in March, Natural England took Mr Bannister's company to court, alleging forty-three separate breaches of existing land management consents – including draining a peat bog, installing new grouse butts and converting a streambed into a track.

Jason, the keeper, was ex-army. He was wearing a desert camouflage jacket, with, on its shoulder, the number twelve in a black spade. His quad bike had a wooden crate fixed to the front and a long plastic holster or scabbard, for his rifle, fixed to one side. I asked about his 'weapon' – was that the right word? He'd had it built to his specifications, he said, crouching to place it on the ground between us: matt grey-green (the body), matt black (the telescopic sight); polished chrome (the barrel). Fixed to the base of the stock was a bipod for steady shooting. 'It's a Remington 243. It's a custom stock on it, heavy-duty fluted barrel on it. This is just a moderator,' he indicated the broad pipe fixed to the muzzle and wound with camouflage tape. 'Look at the thickness of the barrel – they don't get as warm. About three-and-half-thousand-feet-per-second muzzle velocity, these.'

Foxes were hunted at night, 'lamped' with a spotlight, then shot between the eyes. Crows were the main daytime target. 'There's just a few of them about today. They've been running up and down Walshaw Dean. We have rail traps for

stoats, weasel, rat, mink. I caught a mink about three weeks ago, just other side of Alcomden Stones. Catch rats up here, squirrels —' Squirrels? 'Yes, bounding through the heather; they'll take the eggs.' He showed us the cartridges used in the Remington – bright brass.

His home was provided by the estate – Steven had pointed out the renovated farmhouse high above the reservoir, with Jason's caterpillar-tracked ATV in its drive and white doves flapping underneath a sycamore. 'It's a grand place to live,' he said, and then the upland caveat: 'It's great when t'weather's nice.' Later in the year, in a field above Ponden Clough, I came across a kind of camp built into the corner of a derelict stone barn above the beck, a few lengths of timber swathed with camouflage netting: a hideout big enough for a person to lie in – a sniper's nest.

'I can't believe this fog, it was grand earlier. It keeps coming and going. I've been scratching my head a few times. Even though you know it, you'll think you know where you are, then all of a sudden you'll think: oh no.'

Steven and I followed Jason's tracks back towards the Alcomden Stones and found where they crossed the boundary ditch we'd missed. 'Crow Hill's a grand spot,' Jason called as he drove back into the mist. 'You can see Blackpool Tower on a clear day.'

The boundary ditch was marked, intermittently, with stones carved 'KC', for 'Keighley Corporation', Steven explained, and the date 1902 – some tipped over, others sunk in the peat. The heather became denser as we approached the higher ground above the bog, and the mist cleared such that the bog was visible, and the heather moor where we'd met Jason could be made out, the blocking and striping of its surface showing where it had been burnt.

Two hundred years ago, when the bog burst, the moor here had been stripped down to the underlying shale; people came to look, just as the people of Exmoor went to look at the drained Pinkery Pond – not only from the nearby villages, but from miles around. Ten thousand of them, it was said. Nothing like it had been seen in living memory. 'A few', Patrick Brontë wrote, 'gravely contemplated the sunk and riven earth, and, in pious ejaculations poured out their hearts unto God'; but 'several graceless persons wrangled and disputed with each other, even in the very bottom of the cavities, and on their edges; utterly regardless of the warning voice of Providence.' The land had unsheaved itself, had shucked off its peat mantle. It was a sore, still streaming. But it settled, and scabbed, and today there was nothing to be seen of it; only the dip of wet land that might, one torrential day, after a hot summer, release itself again. This was what we had come to look at: nothing.

Steven and I walked down through the old sandstone quarry, along a shooters' track that had been surfaced with an incongruous bluish hardcore, the blue of storm clouds. Six smart square wooden butts had been dropped into the moor, neat as flat-packs. Their floors were laid with ridged boards of the kind used in garden decking; each butt had been spray-painted with a single number, using a stencil. Shadowing this line was an old line of derelict stone butts, their walls snugly mossed and their imploded interiors thick with rushes. At the foot of a lateral working that ran alongside the track, rising from a heap of shale, an old wooden pallet had been fixed upright. In front of it was the shape of an animal. Steven pressed the rubber eyecups of his binoculars against the lenses of his spectacles. 'It's a fox!' he said. Rolling down the eyecups, he passed the binoculars to me. It had been sheared from sheet steel and was holed and dinted

by bullets. And though it had not been painted, the target had corroded to a livid orange, giving the metal fox a living-fox colour.

4

The North Pacific island of Gondal eludes the topographer. The major prose accounts – 'Gondal Chronicles', 'A History of the First Wars', 'Augustus Almeida's Life', etc. – have been lost; the descriptions that remain are written almost all in verse. Despite sharing its name with a tropical Indian state, Gondal is a windswept island of 'damp mists', 'wild moor-sheep' and 'dreary' moors, of which the best known surround the upland lake of Elnor, site of one of Gondal's battles. For Gondal is a bone-strewn place, and its history a history of bloodshed. The island is divided into four principalities: Gondal, Angora, Alcona and Exina. The island's capital, Regina, lies on another lake, Elderno. The winters are ferocious, the seas violent. The ecology, too, is familiar: heather, gorse, linnets, grouse . . . But its politics, its social structures and martial history are extraordinary. Three decisive periods can be identified: the so-called First Wars, fought during the founding of the kingdom; the wars that led to King Julius's dominion over Gondal; and finally the civil war between Republicans and Royalists.

The poetic accounts of Gondal, written by Anne and Emily Brontë, chart the emotional extremes of the island's protagonists, especially its exquisite queen, variously called Geraldine, Rosina, Alcona and A.G.A. For most of their lives, even into adult publication and fame, the Brontës continued to explore and expand the fantasy worlds they had conceived together as children, and their notes and diary pages show that the extant poems represent the flarings of a much more

extensive and detailed co-written prose account of the island nation. It is known that Emily revised several of her poems that originally contained Gondal names and places to make them more palatable to a reading public – substituting, for instance, 'Edward' for the fictional 'Elbë', and 'Northern shore' for 'Angora's shore'.

The 'history' from which the poems emerge is one of political and sexual treachery, of conquest and defeat, treason and remorse, and above all of Queen Geraldine's beauty and the dismal fates – exile, suicide, madness, assassination – of those Gondalian gentry whom it captivates; and ultimately of Geraldine's own assassination while walking on the moors, and the ensuing gory civil war. It is the love affair between her and the emperor (or 'king') Julius Brenzaida that forms the saga's core and is the engine of the island's political machinations. In 'Song by J. Brenzaida to Geraldine S', Emily has the emperor recall the setting of their trysts:

> Wild the roads, and rough and dreary;
> Barren all the moorland round;
> Rude the couch that rests us weary;
> Mossy stone and heathy ground.

Elsewhere she writes of the aftermath of a skirmish on the shores of Lake Elnor, the moor turned into a battleground:

> The dead around were sleeping
> On heath and granite grey
> And the dying their last watch were keeping
> In the closing of the day.

Charlotte's friend Ellen Nussey recalled a day spent with Emily, Anne and Branwell (Charlotte was ill) in 'a small oasis of emerald-green turf', where they were 'hidden from all the world, nothing appearing in view but miles and miles of heather, and glorious blue sky, and brightening sun'.

The moor for Emily was 'Eternity . . . where life is bound-
less in its duration, and love in its sympathy, and joy in its
fullness'. It was 'a sea' – 'stretching into infinity' . . .

'Her native hills were far more to her than a spectacle,'
Charlotte wrote; 'they were what she lived in, and by.' The
moor was Heathcliff and Cathy's playground in *Wuthering
Heights* – 'it was one of their chief amusements to run away
to the moors in the morning and remain there all day, and the
after punishment became a thing to laugh at' – just as it had
been a playground for Emily, and her brother and sisters. If
the moor was the gamekeeper's noisome heap of dead crows,
it was also the morning chorus of uncountable skylarks; if it
was snowdrifts deep enough to obscure the bog, it was also
the white tufts of cotton-grass waving over that bog in sum-
mer. If it was dreary it was also glorious.

'Every moss, every flower, every tint and form, were not-
ed and enjoyed,' Ellen Nussey remembered. Even the small-
est waterfall or heather-stand was, Emily knew, its own world
of inexpressible plurality. And yet when Charlotte came back
from the moors one day, in December 1848, with a 'lingering
sprig of heather' for her dying sister, 'the flower was not recog-
nised by the dim and indifferent eyes'. The Major had already
gone – had stepped, conclusively, beyond the breathless shore.

5

The next day I walked up from Haworth, past a blue sign put
up by Yorkshire Water: 'Some of the paths on the moor can
be muddy and slippery'.

According to the *Telegraph & Argus*, a national newspaper
had reported a new phenomenon on Haworth Moor: 'dog-
ging'. It was not dogging in the old sense of 'shooting grouse
over dogs'. The people of Haworth, were not, according to

the paper, 'shocked' by the article so much as 'baffled' (there was a picture of the parish council chairman in the car park above Stanbury: 'BAFFLED'). In the original article, a woman named 'Sam' reportedly confided: 'I've read *Wuthering Heights* a few times and the thought of being out on the moor with a fella like Heathcliff really gets my blood running.' In the local paper the council chairman was quoted: 'I've been the local elected representative for fourteen years and never once has a resident, businessman, worker, walker, or car-park user ever contacted me about such "bawdy fresh-air frolics".'

From far below, the broken stone wall that lined the horizon resembled the remains of a hilltop fortress, and Top Withens seemed like an outlier of that structure, a watchtower. Close to the old shooting lodge, two antique railway wagons had been put down as a shelter for the Guns. Nearby, in the heather, was a stone outcrop with a plaque set neatly into it. It was a memorial to a gamekeeper, 'A man with many friends who loved his dogs, his guns & these moors'.

The six-inch Ordnance Survey map of 1852 shows a footpath running uphill southwest from the village of Stanbury. This is the path you still follow today, if taking the route from Stanbury, rather than the longer way from Haworth. Lining the upper section of the footpath, along the Sladen Valley, with perhaps three hundred metres between them, are the cross-hatched blocks of three buildings, farmsteads; and each is labelled with the same name: 'Withins'.

Surrounding the row of farms is the improved land, maybe a hundred acres in all; but the improved land lies within a sea, indicated then, as now, with the symbol for 'heath or rough grass', a recurring green eyebrow representing the ankle-turning tussocks found on moorland:

\\\\\//// \\\\\////

The Sunderlands, whom Steven Wood had mentioned, would continue to occupy Top Withens until the end of the nineteenth century. Jonas and his wife, Ann, would have witnessed the aftermath of the Crow Hill bog burst, and quite probably the event itself: what was a distant rumble for their parson, at his window in the valley, would have been something greater for them, and more terrifying. Perhaps they climbed the hill behind the house and from there looked north to Ponden Clough and saw the tide of black charging down from the moor, with its burden of peat blocks and boulders. It is likely, too, that Jonas and Ann were familiar with the 'slinky' six-year-old daughter of the new parson, and her siblings, who would roam the moor in the mornings and late afternoons; perhaps Jonas and Ann had seen the children, with Sarah and Nancy Garrs, in the hours before the eruption, and worried for their safety. Who can say? In 1849, the year after Emily's death, Top Withens was occupied by the Sunderlands' son, Jonas, his wife, Mary, and their three children, John, James and Ann.

Early in 1872, the publisher George Smith, planning new editions of the Brontës' works, commissioned an illustrator. He wrote to Ellen Nussey with a request: 'It has occurred to me that you may possibly know the real names of some of the places so vividly described.' The illustrator was Edmund Morison Wimperis. There is no record of Nussey's reply, but a further letter from Smith thanks her for her assistance, and later that year the new edition of *Wuthering Heights* included an engraving by Wimperis that showed, with considerable topographical fidelity, the Sladen Valley, with Near Withens, then Middle Withens, and, in the position of Top Withens, a vastly enlarged pile with a ring of ravaged trees: Wuthering Heights. Notwithstanding the other, truer models for the fictional house, it was Top Withens that came to be associated with *Wuthering Heights*.

When Jonas Sunderland died in 1888, the house was conveyed to his daughter, Ann, who lived there with her husband, Samuel Sharp, and their daughter, Mary. By now, seventeen years after Wimperis's visit, the Haworth moors have become 'Brontë Country' (the term first appears in a guidebook published that year), and this exposed farmhouse is accreting its peculiar notoriety.

In 1893, two days before Christmas, Harwood Brierley of the *Leeds Mercury* braves the trek from Stanbury. Inside, having been welcomed by Mrs Sharp, he finds 'a good specimen of a north country moorland home', with 'a fire that was not blue and smudgy, but red and yellow'. He sits in a high-backed chair and looks across the small room at another high-backed chair, in which sits 'a wistful little home-bird' – seven-year-old Mary:

The prettiest little creature that these wilds could surely show, her eyes dark yet 'gazelle-like', but she had a certain unobtrusiveness of frame that told of long journeys to and from school, of the coldness and general unsuitability of the clime, and the lack of the influence of many playmates. There was something that affected me in her vapid listlessness.

Two years after Brierley's visit, Ann Sharp was dead, and Samuel was left alone with the girl, in the stone house. One of Steven's postcards shows Top Withens at about that time. There are no people to be seen, but on the sward by the wall are six or seven blurred white geese, and in the yard what appear to be a mountain ash and four sycamores (shorter than the two trees that stand there now). What had been a small community was just a man and his young daughter, and their geese and cattle, tussling with the moor. They might both turn as austere as the land about them. A year later they were living at a farm called Sheep Holes, in the comparatively fertile valley of the Worth.

The three Withens farms had finally been abandoned, and the famous house was left to the sheep and the kestrels, and the tourists. When Whiteley Turner, author of *A Spring-time Saunter: Round and about Brontë-land*, came here in 1905, the association of the house with Wuthering Heights was already being questioned: the building only indicated the 'situation' of Wuthering Heights, he said; 'Law Hill, Southawram, near Halifax, where Emily Brontë was teacher from September 1836 to March or April 1837 is recognized as the original externally.' (In fact High Sunderland Hall, visible from Law Hill, is now taken to be the most concordant model.) He quotes the famous description of the fictional house –

. . . 'Wuthering' being a significant provincial adjective, descriptive of the tumult to which its station is exposed in stormy weather. Pure, bracing ventilation they must have up there at all times, indeed: one may guess the power of the north wind blowing over the edge, by the excessive slant of a few firs at the end of the house; and by a range of gaunt thorns all stretching their limbs one way, as if craving alms of the sun.

Elizabeth Southwart's *Brontë Moors and Villages* was published in 1923, eighteen years after Whiteley Turner's 'saunter'. She found 'a house on the sky-line, alone . . . not only lonely, but desolate. The upper windows, which once had leaded panes, diamond shaped, are now paneless, flapping pieces of cotton vainly trying to cover them; the outside is neglected, a few ruffled hens the only sign of life.' The house had been unoccupied for some thirty years, but the chickens – one of which, having lost an eye, was named Nelson – belonged to someone.

In September 1921, the *Yorkshire Evening Post* had sent its man to Stanbury to investigate: 'A fortnight ago the farm buildings presented a dismal picture. The windows were all broken, there was a layer of peaty mixture over the floors,

and the papers left by picnic parties were scattered about. It is different now . . . For Top Withens is about to become the home of an ex-soldier.'

The ex-soldier, whose name was Ernest Roddy (though he is not named in these accounts), had 'set about his formidable task in no uncertain style'. Those 'flapping pieces of cotton' were his work.

I'm a native of Haworth, and for many years it was a joke with me that some day I would set a poultry farm at Top Withens. I came out of the army unfit for my former work, and having a fancy for poultry, I took a training-school course. I was unable to get a suitable holding, but a short time ago I met the landlord of Withens. We talked, and then he said – he knew my old joke – 'Well, there's Top Withens waiting for you.' Immediately I decided to take it.

Asked if he'd had 'any trouble with ghosts', Roddy replied, 'I can't speak for the birds but I've slept better in the attic than I've slept for many a long month.'

He will make the house comfortable, but will occupy only the rooms he requires, and he intends to get a big supply of books for the winter, for he will live alone . . . it may be at times he will find himself unable to get down to Haworth, four or five miles away over the moor. Then he will have the company of Nell, his fox terrier, Tommy, his horse, his 150 head of poultry and his books.

In April the following year, the *Post* returned to see how Roddy had fared over the winter. 'I think Top Withens is the place for me all right,' he said. 'The hens get on well, so do I . . . everything's all right at Top Withens. We have had some rough weather up here, but it's not done any damage. It's been fearfully cold at times since Christmas, and there have been days when the snow's been so thick I couldn't get the cart down to Stanbury.' But, he said, 'a man can't be lonely at Wuthering Heights'.

Some of the glancing references to Roddy in the Brontë-land literature suggest that he had been gassed in the war, but here he is reported as having suffered from a 'crushed stomach' due to being buried in a trench. Furthermore he had contracted malaria while fighting in Greece. 'He says the life on the moors has done him any amount of good.'

'When I first came up here,' he goes on, 'I brought a couple of cats with me. But they didn't like living here and returned to the village.' Nell the fox terrier had died; her replacement, Jerry, 'was in sad disgrace', having killed fourteen of the chicks. Tommy the horse, too, had died since the reporter's last visit. 'He strained himself pulling a cart over the moors.'

It was a year or so later that Elizabeth Southwart met him. 'At Higher Withens lives a solitary, a discharged soldier trying to regain his health. Every day he creeps down below to seek his fellows, and sometimes he stays there all day, for that solitude is too much for any human being who has not sought it voluntarily.'

In 1926 Roddy finally left Top Withens. It is unclear if he is the same discharged soldier whom Southwart meets earlier in her book, at Oxenhope: 'almost as friendless and poor as Jane Eyre, he came to see what the moor could do for him. He has his cottage, his hens, his dog. At times, he told us, the fight seems rather hopeless, as things are – but he was not grumbling . . . the loneliness, but not the desolation, of the moor was in his face.' But then, the country in those days was full of such 'lonely' men; men who refused to grumble, who required solitude but found they were poisoned by it. I'd been told that Ickornshaw Moor, three miles east, was busy with veterans in the postwar years, sent for their health to live in the peat diggers' huts.

'He could have given us the information we asked for in a

few words,' wrote Southwart, 'but he walked with us a good part of the way.'

Roddy, it seems, had been a French polisher before the war, and when he moved down to Haworth he returned to this for a time; he also worked as a postman and a hawker of yeast, which he sold door to door, walking across the moor from farm to farm. In 1985 one old farmer, George Bancroft of Ponden, remembered him: 'When he landed home at neet he wouldn't be worth the robbing.'

The remains were Grade II listed in the fifties, only to be delisted in 1991 as they did not 'possess sufficient special architectural or historic interest'. When, in 1997, the MP for Keighley sought to have it relisted, she was told by the Culture Secretary that the site must be positioned 'more accurately in the great saga of *Wuthering Heights*'.

The association of the farmhouse with the house of the novel remains tenuous. So why does it persist? A *Times* headline in July 1972 read: 'Brontë Society clash over Haworth Farm'. Mrs Joanne Hutton, the former curator of the Brontë Museum and a member of the society's council, had complained about an 'undemocratic decision' to restore the ruins. 'There are at least four places commonly thought to be Wuthering Heights, but no one is certain,' she rightly said. 'This will perpetuate a romantic myth.'

It is enough, it seems, that she came here, Emily, that the ground nearby received the print of her pattens, that the peat has preserved – compacted six inches beneath the surface, by now – an atom of her spit, or a discarded eyelash. That she also occupied this space. Even an Ordnance Survey map is an inadequate guide to any place.

It's true that in her poems of Gondal the themes of *Wuthering Heights* can be spotted – the love whose conclusion can

only be death, the will to suicide or murder, the inevitability of betrayal (and of vengeance), the uncultivability of the human animal – but while it is possible to view the poems, and indeed the creation of Gondal itself, as the mere roughs or templates for her novel, it is truer, I think, to say that each was a part of the greater whole, that the lost prose histories and the poems and the solitary, teeth-gnashing novel are equally components of Emily Brontë's life's work – Gondal – and that Wuthering Heights is not locatable in the environs of Haworth or its moors, or anywhere in Yorkshire, or England, or Scotland, but on that fogbound imaginary island in an imagined North Pacific.

6

Walter Farrar was another discharged soldier, formerly an infantryman of the King's Royal Rifles. His brother, Tom, had been gassed; Walter himself had been shot (in the groin; his forehead nipped) and left in no-man's land for two days, semi-conscious, while a German sniper fired at him. But the brothers lived. Walter – Walt – was close to his sister's boy, Teddy, and they remained close until his death. As he cringed in his shell hole, he hallucinated the moor and the valleys. In his nephew's poem 'Walt', 'All that day he lay, he went for walks / along the Heights Road, from Peckett to Midgley, / Down to Mytholmroyd'. It was with his uncle that Ted Hughes went walking when he returned to the valley as an adult and an established poet. And Walter was there, too, when, early in September 1956, Hughes brought back his new wife from Cambridge – brilliant, explosive, blonde: an American. 'Your transatlantic elation / Elated him', he wrote later.

Sylvia Plath paid at least three visits to Top Withens, but

during this first trip to Yorkshire the young couple and the older man walked to the ruins from Stanbury. 'There are two ways to the stone house, both tiresome,' she wrote in her journal:

One, the public route from the town along green pastureland over stone stiles . . . to terrain of goatfoot-flattened grasses where a carriage road ran a hundred years back in time grand with the quick of their shaping tongues worn down to broken wall, old cellar hole, gate pillars leading from sheep turf to grouse country.

On another visit, made a few weeks later, she and Hughes walked the other way, from his parents' home at Heptonstall, the ten miles or so across the moor – 'across the slow heave, hill on hill'. It was this walk that she recorded in an essay published in the *Christian Science Monitor* in 1959. Here Hughes, not Walter, is the guide, and Plath the fearful tourist (she knew her audience): 'Surely, I console myself, Withens will be over the next hill. Of course, Withens is nowhere at all by this time: it is a figment, a castle in the clouds.' Finally she asks her husband 'Are we lost?'

'Goodness no! Withens'll be just over that way.'

She was ecstatic, at first. To her mother she wrote:

How can I tell you how wonderful it is. Imagine yourself on top of the world, with all the purplish hills curving away [it was September, the heather was in flower], and gray sheep grazing with horns curling away, and black demonic faces and yellow eyes . . . and at last, a lonely, deserted, black-stone house, broken down, clinging to the windy side of a hill. I began a sketch of the sagging roof and stone walls.

For Hughes, twenty years after Ernest Roddy had left, the floor was 'a rubble of stone and sheep droppings'. Plath did not, at the time, see it as he did – 'We could buy this place and

renovate it!' she exclaims, in Hughes's poem 'Two Photo-
graphs of Top Withens' ('except, of course, except', he adds,
'For the empty horror of the moor').

For them both it was a critical encounter: for Plath it rep-
resented long-held myths proven true (the myth of the novel
and the novelist, but also of the moor itself); for Hughes it
was where he was able, in later years, to place his wife in his-
tory, and to raise her ghost.

According to her friend Elinor Klein, who was visiting
when Plath made a second sketch, Plath 'sat cross-legged on
the marshy ground. She drew with quick precision and great
concentration. The sketch was finished in fifteen minutes.'
There's a brutality to her drawing's line: unvarying in its
weight, but unwaveringly precise. The stone window frames,
the slumped roof, the yard wall that has fallen and been re-
built a dozen times. Record it as it is. The twin sycamores are
drawn as if they are creatures; a couple who have weathered
the catastrophe around them.

Hughes photographed Plath in one of the trees (the crook
high enough to require a leg-up). This, according to his po-
ems 'Two Photographs of Top Withens' and 'Wuthering
Heights', was on the walk from Haworth with Walter Farrar.
I'd like to see that photo, if it exists: the beaming face of a girl
at ease in this landscape that was quite alien to her, a story-
land shown to be real.

In his later work Hughes was able to identify his wife with
the woman who was this landscape's chief inventor, Emily
Brontë – both of them defeated, it seemed to him, by a quest
for something that was beyond mortal reach.

When Plath next wrote about Top Withens, in 1961, she
was living in sight of another moor, Dartmoor. It was partly
a response to her new home, to Dartmoor's own 'tilted' and
'unstable' horizons:

> If I pay the roots of the heather
> Too close attention, they will invite me
> To whiten my bones among them.

Anyone who has seen the white stalks of heather a year after burning will know that they are bones. The tree in which she perched, aged twenty-four, was still there when Hughes returned to the ruins alone, years later – 'unchanged beside its partner'.

7

Top Withens stands at the head of South Dean Beck, at 420 metres above sea level, and thus affords a view of twenty miles east, much further on a clear day – on a clear day you can see the Aire valley and the Drax power station, forty-four blue miles away, and then – beyond visibility, but straight ahead – the Humber, and then the sea, and Europe. Face east, for that matter, and there is no higher ground between here and the South Urals.

If the ruins are a viewpoint they are also a landmark and a waymarker and a destination. They are not the only construction on the moor, but these remains are the most prominent, 'like the centre of a pie', according to Plath. It is a bipartite symbol: ruins; trees. It is impossible not to associate these two trees with the one-time occupants of the building, and infer between them (the trees), as Hughes did, some indomitable bond.

Today the trees were inked against the glowing mist, the windward of the two shorn of its leaves, while a few remained on its taller leeward companion (come May, it would be the latter that budded first, and came into leaf, while the other was still bare). I stayed for two hours and watched as more leaves fell. Intermittently a hen kestrel settled on an upper branch, before wheeling into the mist.

To the trunk of the smaller, leafless tree, a dull zinc plate, little bigger than my thumb, had been fixed: it had been there for more than twenty years – the bark had grown around it, so that it peeped from the interior like an eye from its socket:

LES
26th June
1924–198

The final numeral had been enclosed by the bark. It had been put there with the intention that it should be discreet: it was not a public monument but a private one; only somebody who was searching for such things was likely to find it. It was some six feet up, at the 'back' of the tree (away from the main path or the short grass where people stopped to picnic). But the discreetness of it was also accounted for by the fact that those who had erected it, those friends or family of 'Les', believed that it was a minor vandalism. I wondered who 'Les' was.

In the crook of the same tree, in its mossy crutch, a single white pebble of quartz or glass had been left; in the crook of the other tree, and weighed down with three shards of sandstone, a bunch of carnations – tributes to Emily Brontë, or perhaps to Plath. In the middle of the autumn moor those flowers were pathetic; their cultivated brightness gaudy in the grey clutch of the sycamore.

I went inside (can one go 'inside' a building with no roof?). The floors had been cleared of debris and a lawn had grown on them, kept short by the feet of visitors and by the sheep that shelter here. In what had been the peat store, two stones had been lifted from a corner and placed in the centre of the room, and between them were the singed branches and litter of a failed campfire. The branches could only have come from the sycamores. Scraps of tin foil were scattered about; a pair of bundled socks lodged in a wall cranny. The wardens

came, from time to time, to pick litter, to clear the cinders from the ruins, to take the offerings away. A sheep rubbed its brow against a stone wall as if deriving some comfort from it.

I walked on, south over the high moor towards the chain of reservoirs at Walshaw Dean, and the Walshaw estate, and onto the dark plateau that lies between Withins Height and the area known as Middle Moor.

I left the dry flagstones of the Pennine Way and stepped into the moor, for I had time to spare, and made my way, once more, along the county boundary, which here was indicated by a line of erosion and the ruts of the keepers' quad bikes, so that to follow the boundary was to follow an intermittent peat wound. Four miles to the east, the Ovenden Moor wind turbines were visible – twenty-three of them rising from the plateau above the Deep Arse quarry, their motions as regular as the nodding donkeys of the American oil lands. In the summer, their white motion would have its counterpart in the waving white heads of cotton-grass that flourish on this bog.

'The loneliness of the moor', Elizabeth Southwart maintained, 'is not the lack of kind, but the hunger for something unattainable.' Every few hundred metres a white stake protruded from the ground, 'stoups' placed by the keepers to mark the way, like the 'guiding wands' that show the safe path across the great Grimpen Mire in *The Hound of the Baskervilles*. Up here were the sources of the Black Clough, which feeds the middle of the three reservoirs below. There were no walls to be seen; the grass was sullied purple moor-grass, tinted red in places by the presence of cotton-grass. There were swatches of low heather, and strips where there was no ground cover at all, only the wet black peat. Some of the paths on the moor can be muddy and slippery.

This was what it was to live at Top Withens: to come out of your warmed house and see, in front of you, that long valley

and your brothers' busy farms, and the distant line of Ilkley Moor; but behind you, always, hidden by the hill, this sodden tableland, just ten minutes' walk away, where it was possible to look about you and see nothing of the world but bog.

8

In an interview Ted Hughes gave to an American fishing magazine in 1999 he again recalled a walk over the moors, to 'this old farmhouse said to be the original of *Wuthering Heights*', with his new wife – the walk Plath described so cheerfully in the *Christian Science Monitor*.

'Halfway across this moor,' Hughes wrote, 'a grouse got up out of the heather. It was obviously wounded or sick and just fluttered away and collapsed again. I caught it. My instinct was that if it were sick or wounded, you killed it. So I killed it. And she went berserk.'

It turned out that grouse were part of her mythology. When she was a little girl in Massachusetts, she'd been on some bus and the fellow sitting beside her had begun to tell her a story of 'the heather bird's eyebrows'. She had treasured this vision of the heather bird's eyebrows. She'd no idea what a heather bird was. From the moment of first meeting her, I used to hear about this wonderful bird. Of course, it turned out to be a damned red grouse . . . So I'd not only killed this helpless thing in front of her, I'd killed the legendary bird.

The experience Hughes ascribes to Plath is similar to that of the protagonist, Millicent, of her story 'Initiation', written five years earlier, when she was twenty. As part of a high-school sorority initiation, Millicent is made to ask each passenger on a public bus what he or she ate for breakfast. She comes, at last, to a 'small and jolly' man. 'In his brown suit with forest-green tie he looked something like a gnome or a

cheerful leprechaun.' His reply to her question is 'heather-birds' eyebrows on toast'.

To his surprised questioner he explains, 'Heather-birds live on the mythological moors and fly about all day long, singing wild and sweet in the sun. They're bright purple and have *very* tasty eyebrows.' It is the man and his strange reply that inspire Millicent to forgo the sorority's inane initiations – the thought of the heather-bird, 'swooping carefree over the moors . . . singing and crying out across the great spaces of air, dipping and darting, strong and proud in their freedom and their sometime loneliness'. Then comes the moment when she must tell the sorority that she does not want to proceed, and 'from somewhere far off, Millicent was sure of it, there came a melodic fluting, quite wild and sweet, and she knew that it must be the song of the heather-birds as they went wheeling and gliding against wide blue horizons through vast spaces of air, their wings flashing quick and purple in the bright sun.'

And now she found herself on and in the mythological moors, and her new husband held in his murderer's hands the corpse of the poor heather-bird.

It was Kevin, Jason's boss and the head keeper on the Walshaw estate, who told me about the heather-bird's eyebrows. A cock grouse, it seems, can engorge its combs almost instantly in sexual or aggressive display. They become larger as spring approaches, reaching their maximum darkness, engorgement and rigidity during the breeding season. Cocks with smaller combs tend to pair with fewer hens, and the colour and size of the combs is diminished in birds burdened by disease. It has been found, furthermore, that the combs reflect ultraviolet light at a frequency invisible to humans (but probably visible to grouse), and that the intensity of this reflected light, too, ebbs in sickly birds.

Kevin had taken me up from the middle reservoir in a green Land Rover with a swivel spotlight on its roof and the 'Walshaw and Lancashire Moor' grouse logo on its door. Between the seats lay a Beretta shotgun, the brown lacquer rubbed from its stock.

Soon after Natural England began its legal action against the estate, a joint statement was issued. The parties had 're-solved their ongoing dispute regarding management activities conducted on the Moor, and confirm that they have entered into a new management regime which is considered beneficial to the environment and biodiversity of the Moor as well as the economic interests of the Estate'. And that was that. The estate's habitats were to be mapped: 'dry heath', 'degraded blanket bog', 'active blanket bog' and 'sensitive areas'. While an 'active programme of peat re-wetting' (i.e. drain-blocking) had been agreed, the modified consent allowed burning of blanket bog to continue. The forty-three breaches were to go unpunished; the estate would be allowed to maintain its existing infrastructure. It would also receive £2.5 million in environmental stewardship grants. Why Natural England had ceased to pursue those forty-three breaches was not explained.

The keepers' liking for Mr Bannister, the owner, was genu-ine. 'He's all right, is boss,' Jason had said when Steven and I met him on the moor the day before. Mr Bannister ran the moor for his friends and associates – it was not a commercial activity but his pleasure. Previously it had been underman-aged for years, Kevin told me – just two keepers, until Mr Bannister bought it, where now there were six (Kevin and five younger men, including Jason).

From above the chain of reservoirs, the valley was pale: the moor-tops were dark, but heather was sparsely scattered on the hillsides. For now, there were none of the regular burning

stripes and chequers I'd seen on Crow Hill, or on the lower-down Lancashire Moor. But there was regularity: the regularity of the three reservoirs and their channels and sills and towers; the regularity of the blue-grey tracks and the fire-breaks and culverts and lunch-huts; and, on the far hillside, what resembled neatly mown fields. This was not hay; it was grass, and the grass was white because it had been killed, with glyphosate; and what had appeared to be the marks of mowing or ploughing were the up-and-down tracks of the quads from which the spraying had been done. When I returned, later in the summer, the area of dead white grass covered the whole hillside.

The job of Kevin, as head keeper, was to see the grass replaced with heather and the moor's productivity increase. It was a five-year project. He wanted to see an improvement in the annual 'bag' – the number of grouse killed. He had a figure in mind but (a smile) he would not share it. Last year, three thousand grouse had been shot on this moor; this year the numbers would be down because of the rain. 'I can't remember a worse year.' The broods had been washed away; the young had drowned in ditches; the insects the grouse fed on had been decimated.

Kevin parked beside a small stone building, the lunch-hut built by the old Lord Savile, whose family had owned the estate until Mr Bannister bought it. Beside the hut, cut into the moorside, was a ledge of rough grass on which a flat-topped boulder had been laid, and, in a semicircle edging it, a low stone bench – a place for the Guns to sit and eat the lunch that was prepared for them, and look out on the moor, before the afternoon's drives.

Behind the stone seating, hidden in the rushes, a stream made its gentle noise. We stood in the rain, he in the water-proofs Mr Bannister had bought and wearing a green tweed

cap. This, the huge arena surrounding the reservoirs, was Kevin's beat (I thought of a policeman's beat). He spoke about it proprietorially and, despite the visible magnitude of his task, with optimism. He had expected to stay in his previous post till he retired; he'd liked his boss and enjoyed the work. But he could not resist the challenge of this moor, when the offer came – the opportunity to improve it, and the resources. Mr Bannister did not stint when it came to his moor: his duty was to his ancestors first and then to his descendants, and then to the men, his friends, who came here to shoot.

If Kevin wanted equipment he only had to name it. The best boots, the best waterproofs, the best rifles and shotguns; as many GPS units as were required. New Honda quads, new Land Rovers. Above all, Kevin was given manpower, and it was manpower that turned a poor moor into a productive one.

While his friends had yachts or sports cars, Mr Bannister (when Kevin spoke of him he was always 'Mr Bannister' or 'my boss'; never 'Richard', never even '*the* boss') had this moor – his family land. And he wished to leave his mark on it, to improve it, which meant improving the habitat for grouse. And so his men – Kevin and the others – were content, and knew they were fortunate, even if they were not well liked. This absence of good feeling towards them was deeply felt by them. At one time, the gamekeeper had known his position to be honoured. Where once there had been respect for the profession even among poachers, now it was part of the job to defend your very existence.

Within the grounds of Mr Bannister's lodge, where Kevin (but not Mr Bannister) lived, was a new prefab barn with a concrete floor, and within the barn, in one corner, a workshop. Inside the workshop – its walls and even its ceiling neatly ar-

rayed with tools (chisels, welding masks, a gas mask, sanders, saws, spray-stencils for numbering the butts) – stood Freddie and Robbie. It was as if they had been expecting us. They betrayed no surprise at this stranger – pale skin, soft hands – with his pale soft questions.

Robbie was a keeper. He was in his late twenties; he was highly qualified, opinionated, watchful. He lived in the keeper's cottage at the foot of the lane, with his wife and a dozen dogs. Freddie, much older, had been a keeper and a butcher but was now the estate's maintenance man – it was he who had built the wooden butts we'd seen at Crow Hill, and he made the traps. 'You'd have it in your house!' Robbie said, hefting one of Freddie's wooden stoat traps.

Whereas Robbie and Kevin wore the issued green waterproof jacket and black boots and a green fleece zipped to the throat, Freddie wore a blue-and-white quilted lumberjack shirt, and jeans, and wellingtons. He had a long beard that made it hard to tell how old he was; but he was conscious of his seniority. He was a sort of adviser, even to the experienced Kevin. It was to him the others turned when they wanted confirmation of a story or fact. 'He has a calming influence,' Kevin told me afterwards. 'If one of the younger keepers is a bit of a hothead, he soon calms him down. They know they have to respect a man like that.'

It was Freddie's opinion that town people and country people were incapable of understanding one another. He said it without scorn. It was simply something he'd learnt. Robbie had a soft Islay accent; he'd worked on the Scottish moors. His wife, a textile designer, came from Glasgow. I wondered what she made of their moorland cottage, miles from the nearest town.

There was a time, years ago, when the Guns would see no reason to 'break' their weapons when walking from drive to

drive, that is, to release the hinge between the chamber and the barrel so that the gun was inoperable and safe. These days, if a gun was seen to be 'locked', Kevin said, even a beater was entitled to take it from its owner and break it. Freddie remembered when he was beating, as a fifteen-year-old, a man swinging his shotgun towards him. 'I thought: he's going to shoot me.' Freddie was barely twenty yards away. He was wearing a donkey jacket with plasticised shoulders; he turned, pulled the jacket over his head and ducked. He felt the spray of shot on his back and legs. He felt the wetness that followed. 'He bought me half a pint.' The wetness was sweat; the shot hadn't drawn blood. But it had stayed with him a lifetime: the man's careless shot (he wouldn't name him, this friend of his long-ago employer), the pellets he'd picked out of holes in his trousers and from between his bootlaces and from the plastic material of his jacket's shoulders. Then the half-pint of ale. Things had changed, and for the better. Those who are peppered these days are not the beaters but the Guns, when one of them turns carelessly and lets go at a neighbouring butt. This is what you heard: the old divisions had gone; but: 'Of course, you still treat the Guns with respect.'

'Things have changed.' The Guns, I sensed, had lost some of their certainty, some of their officer-class boldness. It seemed that the deeper satisfaction had gone out of the sport – just as it had gone from fox hunting and stag hunting. The term was 'blood sport', but where was the blood?

These days, Freddie preferred to watch the wildlife rather than kill it, he said. But he saw this as part of a natural, biological development, the cessation of blood-thirst that came with age, just as any carnivore loses its impulse to kill as the years pass. 'I've had my time; now it's their turn.' He repeated this.

'A grouse's death is a glorious death. If I had the choice I'd rather be a grouse than a cow going to the slaughterhouse. It's a glorious death. And if I were flying over the moor, and I were shot, I'd think: so be it.'

'Well, if you were being . . . Well.' This was Robbie, and his hesitation created a wary silence. 'Like halal meat,' he went on. 'In terms of welfare. Well that's *your* religion. This is ours. This is our religion.'

Even if it was not quite a religion, to invoke religion – and cruelties committed in its name (the blood drained from the animal's throat, the slow death) – was to make a statement about the importance of the grouse-moor tradition, a tradition whose rituals were burning and the killing of predators, and the nurturing and medication of the birds, and also (a word even the beaters used) barbarism. It was a statement, too, about the lengths the protectors of the moor and the tradition would go to.

'It *is* a religion,' said Kevin, as he led me away after the other men had offered their hands. In *Remains of Elmet*, Ted Hughes, a man familiar with the shotgun's recoil, wrote of grouse shooting as an activity 'nearly religious'. If Kevin and Robbie and Freddie and Jason, and the others I would meet over the coming months, were devout in their rituals, then it was the devoutness of the insecure. Robbie, whose cottage came with the job, and who had seen this moor improve in his five years here, was right to feel embattled.

Kevin said he had no idea why Natural England dropped its case against his boss's company, or how, precisely, the parties had 'resolved their ongoing dispute regarding management activities conducted on the moor', as Natural England's press release put it. I believed him; his relationship with Mr Bannister wouldn't have allowed for the sharing of business confidences. But it reinforced the sense that secrecy

surrounded the case and its resolution. The Minister for the Natural Environment himself owns a grouse moor (the Minister for the Natural Environment!). It was not hard for the environmentalists to conclude that he had influenced Natural England's decision. I'd seen a transcript of a letter from him to the Secretary of the Moorland Association, which lobbies on behalf of grouse-moor owners. By hand, at the bottom, he had written, 'Thank you for dinner'.

Later, as we stood with his wife in the warm kitchen of the house that formed part of Mr Bannister's lodge, Kevin said: 'You're tied to the job. Not in a bad way, but you are tied to it.' And his wife nodded.

Down in the valley, in Hebden Bridge, a few days after the first flood there was a second, and as they continued to clear up again – shovelling out the sludge, scrubbing the floorboards, scraping down the walls, waiting for the loss adjuster – the people watched the level of the Calder and the Hebden, and the streams coming down off the moor.

7. Blackamore

The North York Moors

I

Mick spoke about the desert fondly. For their twenty-fifth wedding anniversary he and his wife had gone to the Negev, birding. 'I like it. I'd been in t'desert when I were in forces, and I seem to like it.' His foot was prone to infection and he'd taken recently to wearing desert boots, for their breathability. No, they weren't waterproof: 'What would you need water-proof for, in t'desert?'

He hadn't warned his wife he'd be bringing someone back. 'Excuse the mess,' she said, as he led me into the back room that might once have been a dining room. 'This is Mick's domain.'

He had the silhouette and carriage of one who has gone on being active despite failing health – the broadened waist, the limp, the hand pressed to the lower back when he stood; and yet a litheness and alertness in his movements, and lean legs, and a bright, sun-burnished face under the pale grey beard. The stick – a simple birch with a crook head – went every-where with him. You could tell, as he settled into his chair, that sitting was a relief; but he didn't slump.

I'd met Mick that morning at a lay-by near the Fylingdales radar base. From his neck, still, hung the Zeiss compact 'bins', his ID lanyard, and sunglasses whose lenses had the translucency and colour of peat water. Pegged into his shirt pocket were a couple of insulin pens. Before him on his table – the table the family had once sat at – was a straight pint glass full of orange juice and, on top of stacks of papers and books and newspaper cuttings, a book entitled *The Birds of*

Durham, published by Durham Bird Club, a hardback with the heft of an old family Bible. An object with which a burglar might be incapacitated. A white envelope was being used as a bookmark. It had my name lettered on it, a reminder.

Pill jars (more brown glass) were stationed about the room – on the table and the shelf-ledges and the sideboard; and two canisters of insect repellent. The bookcase screwed to the chimney breast behind his chair was lined with more monographs: *Thrushes, Nightjars, Gulls, Stonechats, Peregrine Falcons, Birds of the Middle East, Grouse*.

Mick's operation was set for the end of the month. It was his one chance, he said. 'Being a diabetic now don't help. Now it's sort of set in at the back of my legs. But!' he said. 'There are ways round it!' He was still getting used to the automatic clutch, but the new motor would get him most places.

After he was invalided out of the RAF Regiment, Mick had gone back to working on farms, as he had as a boy, but his injury had intervened. Since then (the late seventies) he'd received war disablement pension. He went up to the moors every day. The hen harrier was his bird. Of the keepers, he said: 'Most of them are what we call *piss and wind*. He shouts at me, I shout at him.' He spent whole days up on the high ground, watching the moors, waiting for harriers, watching the keepers.

A graph of hen harrier numbers over the past century would also chart the intensification of grouse-moor management. It is a bird of fen, marsh, heath, bog and moor, and until the late nineteenth century was found throughout England. In Devonshire it was called the blue furze hawk, on account of its association with gorse-lands; in Wales the blue kite; in Northumberland the dove-coloured falcon; in John Clare's list of Northamptonshire birds it is the ash-coloured falcon. It is the male's pale blue-grey pigmentation that ac-

counts for its regional namings (the brown female was once thought to be a separate species). Those who describe the hen harrier are invariably struck by its bluish pallor – appearing starker still against a dark backdrop of heather or blanket bog. Myself I'd seen them only in pictures and on TV.

On the fen close to his home in Peterborough, Clare observed in 1823 a male hen harrier 'almost as big as a goose' that flew 'in a swopping manner not much unlike the flye of a heron'. In the mid 1800s, William MacGillivray observed 'the gentle flaps of their expanded wings, floating, as it were, on the air'. A French ornithologist, Lafond, described how the bird patiently, vigilantly quartered the moor, sometimes doubling back to rescan promising ground – *comme s'il cherchait un objet perdu*, 'as if searching for something lost'. The male's display flight is prized by birders – the steep climb topped by a somersault, followed by the steep dive checked just above the ground, and this repeated again, and again, across the sky.

Keepers have always held it in special contempt – and who knows the moor and its inhabitants better than the keepers and their fathers and their fathers' fathers? Not only is the hen harrier a butcher, they say; in merely passing low over a moor it will flush the grouse from the heather, disrupting shoot days. It is capable of humiliating a keeper. Its ghostliness, its stealth, its tendency to leave slaughtered grouse uneaten, its association with places of mire and fog – all have contributed to the bird's reputation as somehow unsporting, unseemly.

As the efficiency of the grouse shooters increased, so they and their hosts expected to be presented with sufficient quarry. Whatever posed a threat to grouse on the moor – weasel, fox, crow and every variety of bird of prey – was to be eliminated. It had been straightforward, in the early days: trap, poison, shoot; stamp on the eggs, stamp on the chicks

(harriers nest on the ground amid the heather). By the turn of the twentieth century the bird was extinct in England. Its numbers only recovered when the keepers and their men abandoned the moors to fight in the Second World War. In the 1970s there were an estimated five hundred pairs in England. In 2012, when the unlicensed killing of raptors had been illegal for more than fifty years, only a single nesting pair was known of. Again there was the threat of national extinction.

Mick was a deterrent – 'My worth is that I am *about*, and the keepers *know* I am about. I was coming down the road,' he said of an occasion the previous year, 'and there was some dead ground, and I saw the hen harrier go across. I watched it for a bit. And I drove further down, and in the dead ground coming after the harrier was [he named the keeper] in his four-wheel-drive vehicle, so all I could do, I just stopped in the road, and I just stood there so he could do nothing but see me.'

The keeper broke his gun and went on his way.

When a nest is found, concealed, as they tend to be, in a stand of tall heather, the first thing Mick does is seek out the keeper whose beat it lies on. Let him know he knows it's there.

'It's gradually changed. Since grouse became big money. You know, these numpties from the city are willing to pay so many thousands. And then they can go back and brag amongst their mates. And the pressure has been put upon the moorland. It's been sanitised. There's no balance left. In tooth and claw. Up there it's like a mini Serengeti, you know; there's everything. They want to turn it into a monoculture. There's a place for shooting, it's part of our heritage – but there's a place for the harrier, the buzzard . . .'

It was the 'bean counters' he reserved his deeper contempt for, the invisible, biblical entity. 'The bean counters control

the world!' Shaking his stick in his lap as if it were a pike, suddenly ready for the fight: 'Shrouds don't have pockets!'

We'd go looking for hen harriers tomorrow, though he didn't hold out much hope of our seeing one.

From the corner desk a tawny owl was blanking us. 'Bloke said he'd found one at the roadside, did anyone want it. I said, "I'll get it stuffed."' He took a long drink of his orange juice. 'I didn't have one.'

2

Two days earlier, on Danby Beacon, I'd stood beneath a five-metre post crowned with a fire-basket formed of tarnished steel flames. It was a beacon, put up to mark the jubilee. A flurry of pings pulsed into my pocket – reception returning as I gained the high ground. Here, a mile from the nearest dwelling, home to grouse and curlew and lapwing and plover, was an old place of human communication. Four hundred years ago the beacon that stood here (only a crude iron basket to hold the fuel) was to be lit on invasion by the French. During and after the Second World War a radar station occupied the moor-top, part of the early warning network known as Chain Home, a precursor to the modern facility across the moors. Eight aerials had stood here, visible from across the East Riding. Dozens of servicemen and servicewomen lived here, on the moor. All that remains, amidst the rust-coloured sheep's sorrel, are the crumbling footings of the dismantled aerials, a gun mount, an anchor point for a mast cable, a workstation's doorstep, a few shards of corrugated asbestos, and the old track that runs east along the moorside from the beacon to Lealholm Rigg. The gun emplacements of the old radar station have been superseded by new lines of shooting butts.

The bell heather was starting to flower. Along the shel-
tered gullies and east-facing track sides; in sun-spots and
dells. There was something tentative about its blooming, as
if those four or five royal purple flowers that were slung from
each stem-head, fulsome as teats or water skins, might be re-
tracted. This was the darker, lower, sparser and more regal of
the two common species. (The lighter, pinker sort that cov-
ers the high moors – called ling, the 'true heather' – would
flower later, in August, when the Guns came.) The moor was
not yet colourful, but its tone was shifting, and even from a
distance the dark moor-top heather had a tint of mauve. The
heather had always carried the colour within it – within its
green, within its black and its grey and its brown. Even the
burnt patches, even the cinders, seemed to hold a remnant
purple. The moor was tipping towards summer.

As the mature heather came into flower, new growth was
emerging from the rootstock, through the reindeer moss that
grew amidst the grey litter of last year's burn. It was this new
growth that the young grouse preferred – it grew about an
inch a year, and was its most nutritious when three years old.
And this too (it came to me as a sort of revelation), this too
would, in time, flower, and grow to perhaps a foot in height
over the course of say ten years, and then the keepers would
burn it to the ground, and in its place fresh growth would
come. The flowering of the heather was an excitement I
had been waiting for all year, and now here it was, gradually
changing the face of the moor, not by brushstrokes but by
stippling.

The moor behind me had been sluiced by water that had
run off the track, exposing the reddish shale that underlay
the peat. It was close to this field of shards, where the runoff
had collected in a shallow trench, that the cotton-grass was
flourishing. This was hare's-tail, the bolder of the two British

species, its fluffy white fruit-heads plusher than those of the other sort ('common'). Each stalk clutched its own tuft to the wind. The patch of white hung on the moor as if it had been floating across its surface and had got snagged. And once I noticed this first expanse of cotton-grass, I noticed other white patches, scattered across the moor – a shimmering white so pure that it was not dulled by distance.

Above Clitherbeck Farm, a Land Rover was parked by the old Pannierman's Causeway. A line of eight mounds measured off the distance between here and the brow of a tumulus, half a mile north. The tumulus – 'howe' was the regional word – was unnamed; it had been constructed as a burial place, had once contained the cinerary urn of some Bronze Age chieftain. The open hills were where those humans placed their dead – far from the ongoing world, but visible to it. Down in the dales, where they lived, not a single tumulus has been found. Once, the moor was clothed – hazel, birch, willow – but the presence of these burial mounds, surely intended to be visible from afar, suggests that the hills had already been stripped by the time they were constructed.

'Inviolate', 'pristine', 'wilderness': the writer-words clung to these hills, words that made us aliens here, but these moors – all of the English moors – were as manmade as cornfields, or battlefields. It was not just 'wilderness' that brought those lone hikers to the causey paving, not even a mistaken or deluded *notion* of 'wilderness'; it was something darker, the same impulse that summoned those hundreds to the site of the crashed bomber on Saddleworth Moor – a desire to experience ruination and expose oneself to the aftermath of catastrophe.

'England's Last Wilderness' was the slogan used to promote the North Pennines. The moors could be wild, but wilderness? It was no more than an idea. When the ice withdrew,

ten thousand years ago, the forest came – not the 'wildwood' of myth, the unbroken baize that stretched from coast to storied coast, but a kind of scattered wood and scrub that was to be found on all but the highest peaks: preserved in the peat on the scoured edge of Cross Fell, at 893 metres above sea level, birch pollen has been found.

This was the 'moor', then, after the ice age: woodland on the slopes, scrub and scattered stands of trees higher up, heather or bare rock on the summits.

Man came. For the Mesolithic tribes there was not the line that can be seen today, where wooded or cultivated lowland gives way, abruptly, as a wall is crossed, to treeless upland: there was no 'waste', only the small drop in temperature felt as you climbed from the valley bottom; the breeze louder in the trees, wetness in the air.

If you noticed that the deer, the aurochs, the boar, fed at those places in the forest made open by senescence or windthrow, then it was there that you would wait with your bow. And it was wise to maintain those places where hunting was easiest, even to make those areas more desirable to your prey – you might snap off the succulent branches from spring birch, to entice the deer, or encourage more growth of the grasses that the aurochs favoured. You might even learn to make further clearings. Scrub could be harrowed up, or set fire to. Your tools were no match for full-grown trees, but if you pared a ring of bark from a tree's waist, no matter how great that tree might be, it would, in time, die.

In the high wet places, where new tree growth had been prevented, waterlogging occurred, and peat began to form. And as the peat deepened so the land became more acid, less fertile – where once trees had grown, now the roots of saplings could not reach sustenance. The moor emerged piecemeal, as a scattering of clearings that finally coalesced. Five thousand

years before Christ, wheat was being grown in some of these clearings; oak and elm were being felled for cattle fodder. You realised that by felling more trees – by now, your axe was up to it – you were able to provide more and better food for your people. It was possible to domesticate cattle and corral them in the clearings you had made. You learned that each crop of wheat (and later barley and oats) took something from the land, and that your cattle's dung might, when scattered there, allow the land to be sown again. You cleared more land.

The uplands became bare of all but scattered stands of birch and alder. Little else would grow on this cold and wet and windy ground, apart from shrubs and mosses and grasses. Hardly anything above waist height. During the first millennium, the climate deteriorated. The temperature dropped by two degrees, the growing season was shortened. As the winters lengthened, the peatland expanded, and the uplands – now exposed – became hostile: migration to lower land occurred, as if by gravity. And as man dropped, he felled the trees at the moor's margin, so that the moor followed him down the valley slopes.

By the time the Romans left, the moors were much as they are today: a harsh place for summer grazing, cultivated for crops only by the extravagant, stubborn or desperate. It was man, then – man, with the climate, but not 'nature' alone – that made the moors. And it was man who continued to shape them: sheep grazing under the abbeys discouraged the resurgence of all but the least palatable vegetation: mat-grass, purple moor-grass, cotton-grass. In the nineteenth century, as the cities grew, streams were dammed and reservoirs excavated; in the twentieth, forestry was planted – the deforested moors wooded once again, albeit with plantations of conifers rather than the broadleaves that had grown there five thousand years before. Heather was made to dominate the northern moors, as

the tracks were metalled, and railway sleepers laid down, and the gentlemen came up with their guns.

On top of the mound nearest to me was a man with a shovel – dressed in green, with knee-length camouflage gaiters. Not an archaeologist. Nor were the mounds themselves subsidiary tumuli, as I'd thought (in my ignorance), but derelict grouse butts – an old line disused for years.

The traditional grouse butt is a circular bastion, five feet across, chest high, its stone walls coped with heather turf. He was renovating this line, ahead of the summer's shoot.

A few weeks earlier I had spent an afternoon on the moors north of Ilkley, looking for the site of Turner's painting *Grouse Shooting on Beamsley Beacon* (executed ten years before his painting of Buckfast Abbey). It rained; the fog came down, hiding the famous views. Paintings of the moors are scarce, and those that exist invariably depict 'sporting' subjects – the fox hunt, the deer hunt, the otter hunt, the shoot. One of Turner's other works in this series shows the Guns settling down for lunch among a circle of marquees: a cart piled with provender, a spit waiting for the birds, a beer barrel ready to be tapped – like the encampment of a victorious mediaeval army. The moor alone, however, was neither sufficiently picturesque as a subject nor sufficiently dramatic – too desolate for the school of Claude, too flat for that of Salvator Rosa. It was no fitter for the artist's attention than a starless night sky or a boatless and becalmed sea.

Comme s'il cherchait un objet perdu. The only sign I saw of the keepers was a larsen trap – a chicken-wire cage containing a rabbit's haunch and a 'call bird', a sodden crow meant to entrap others of its species. It was impossible to pinpoint the spot where Turner had stood. In any case his painting was a fiction, for one of its subjects was Turner himself (sec-

ond right, big nose). In the painting, he and his companions, including his patron and host Walter Fawkes, are walking over the moor, accompanied by loaders and packhorses and pointers. What is curious about the painting is its colours: perhaps they have faded, but Beamsley Beacon, on the first day of the grouse season in 1816, is not purple but brown and khaki; heather, in other words, is not dominant. This was in the days when grouse were still 'walked up' – that is to say, shot at as you walked across the moor. A good day's bag was a dozen birds; more than twenty was outstanding. Even in 1857, during James Platt MP's fatal afternoon on the 'well-stocked' moors above Saddleworth, ten shooters had, by lunchtime, bagged only 'about four brace of birds, having then had two or three drives'. (There had always been an element of danger associated with the shoot, and Turner's painting was also a sort of memorial: on 13 August, the day after he made his sketches, his host's younger brother, Richard Hawkesworth Fawkes, was accidentally shot and killed.)

It was technology that transformed grouse shooting; first the expansion of the railway network, which allowed the moneyed city man to board the Friday-night sleeper and be on the moor after breakfast, and then the development in France of the breech-loading shotgun, in the 1840s, which facilitated quicker reloading. The old muzzle-loaders had required a wait between each shot while the breech was packed, and the smoke they generated meant a further delay while the air cleared. When smokeless powder was introduced in the 1870s, there was nothing to prevent the crack shot from dispatching as many birds as daylight, energy, wealth – and numbers – allowed.

The demand for quarry led to intensive moor management – draining of the moors, predator control and, most important, the cyclical burning of the heather. At the same

time, walked-up grouse shooting gave way to a preference for 'driven' shooting – that is, shooting from butts, as the birds are driven from the heather by a line of beaters. Whereas once one might have had to trudge across the sodden moor all day in order to dispatch birds sufficient for one's own dinner, now one could simply saunter the short way from drive to drive, and stand in one's butt, and wait for the coveys to be driven into range. On a single day in 1872 Lord Walsingham took 842 grouse on Blubberhouses Moor; in the same year, Sir Frederick Millbank killed 190 in twenty-three minutes, accounting for 18,231 birds in the season. In 1888 Walsingham exceeded his own record, shooting 1,070 birds in fourteen hours. The bags of fifty years before had become unthinkable. On the first day of shooting in 1915, as Gallipoli raged, 2,929 grouse were bagged on the Littledale and Abbeystead moors. A new record.

The butts are either built above ground or else sunk into the peat. Often it seems as if they are meant to shield as well as conceal. You'll see wooden butts; sometimes just a bracketed fence panel, redolent with creosote and painted with a number. On the moors above Haworth I'd seen Freddie's 'flat-pack' butts, dropped into a wedge cut from the moor. But the finest, and all the old ones, are stone-built, with gravelled or turfed floors, the butt's number carved into a slate tablet, and a bright steel eyelet screwed into a nearby rock for your dog's leash.

The butt where the man was shovelling was sunken and canted; it looked like it had been shelled. The top line of stones and turf had collapsed inward. Most of its depth was filled with sheep-trodden spoil. The man was ankle deep in it, cutting it with his spade-edge and carrying each shovelful away. He was to exhume the butt's old shape, to expose the carefully placed stones, and to replace those stones where necessary. He

had cut a narrow drainage trench from the entrance. It was filling with a dark water. All he knew, he said, was that the butt – the whole line – needed to be ready by August. He was tired, sweating even in the rain; the peak of his cap was dirty where he'd tugged it down. He'd be here all day. Back tomorrow. As long as it took – and then on to the next one.

The heather, the cotton-grass, the broad view down the dale, the cry of the curlew. And then an incursion from another world – Typhoon, Tornado, Hawk. Whatever its name, the jet topped the skyline like a cat mounting a fence, and closed in, black and eloquent, sailing over the moor, corkscrewing into the low cloud, then returning to its base, beyond the horizon. The noise was not intolerable, only an urgent, showy roar – and this sound chased the craft like a shadow, and eventually, each time the jet returned, it was the *noise* I found myself tracking across the sky, just behind the jet itself. It came three times, tipping its wings as it passed, and it seemed to me that there was some indulgence in this wing-tipping, some joyfulness in its quick spiralling or banking. The villages, the farms, the bridges, the railways, the electricity pylons – every human thing in the valley was, for the purposes of the pilots, just a stand-in target, and the moors only contours to be negotiated. The dale was a replica for hostile terrain. The jets – or jet, I never saw more than one at a time – came and went all day, and I didn't begin to grow accustomed to them. When I spoke to the villagers, in a shop and a pub and a B & B, they said they heard every sortie. You didn't get used to it.

The valley lanes took me back to Danby, twining the river Esk, first to the village of Danby itself, then across the railway line and up through the higher settlement of Ainthorpe and over the wet fields. The rain had been going on all month: the cows were moody, the milk yield was down, fluke-worm was

a constant worry for the farmers. Wherever the cattle went they mashed up the ground and left the grass inedible. The Esk was opaque with silt; not clear gold as the southwest's rivers had been: push a finger through its surface and its tip was obscured; take a handful and your palm was left gritty. At the farm where I was staying I had a hot bath in spring water tinted by the moor's off-wash: it was the hoppy colour of a moor tarn, and grew darker – stewed tea – as the bath filled. Well, the Victorians thought peat baths therapeutic. In certain spas it had been possible to experience something called a 'peat enema'. I was offered bottled water to drink, but I preferred the brown stuff.

The rain went on into the night, and the moors filled up. It was the wettest June on record, and for some the coming months would be ruinous.

<div style="text-align:center">

3

</div>

Danby's church, with its square Norman tower, stood bunkered deep in the green dale, far from the nearest homestead, dating to a time before the railway, when 'Danby' was only a parish of cottages scattered down the valley, like seeds in a furrow, and passers-through were rare. It was low and ringed by yews that were almost black – pretty on a sunny morning, but built and rebuilt, it seemed, by people who were accustomed to having to cower from the weather. Pinned to the porch notice board was a poem written by the church cat, whose name was Toffee. It went: 'I meet so many people, who come here to pray / so I'm really busy, day after day'.

Canon John Christopher Atkinson, vicar of Danby from 1850 to 1900, was a walker – seventy thousand miles 'in the prosecution of his clerical duty', but the same again in leisure. Round the world five times. 'Far the larger proportion

of those miles walked alone.' The extent of his wandering was matched only by Danby's postman, who reckoned his daily rounds amounted, over the years, to a quarter of a million miles. I was reminded of Thomas De Quincey's claim that Wordsworth had, in the course of his life, walked 180,000 English miles, and that it was to this 'mode of exertion' that 'he has been indebted for a life of unclouded happiness, and we for much of what is most excellent in his writings'.

Atkinson was seventy-seven when *Forty Years in a Moorland Parish* was published, in 1891. It was not his first book, but he was an ambivalent author. In his Introduction he concedes that the volume 'may be of little or no interest to any besides myself'. The second edition includes a photograph of the author in his study at the parsonage – on his desk are an in-tray and a black upright typewriter; in the background is a shelf of leather-bound books. The canon himself is letter-writing or correcting proofs, his spectacles so dainty as to be almost invisible. It was taken around the time of the book's first publication. He is white-haired and white-bearded, though his hair is as thick and brilliantined as it must have been when he first arrived as a young man. He has the physical stability and uprightness of those who continue to walk every day (aged eighty he was still enjoying fifteen-mile rambles), and the look of painless concentration of one for whom study is a comfort.

A scholar–clergyman of the old variety, a kind rare even then, he put in his book, which was subtitled 'Reminiscences and Researches', everything he had learned about his parish – it was compendium, companion, miscellany, florilegium, bestiary, yearbook, gazetteer – derived, as he put it, from 'my "stores, things new and old"'.

Responding, before the book was published, to the editorial suggestions of Macmillan's reader, he replied: 'Frankly, I

should be at a loss how to set about "gathering the material into a story".' Thus, some of his chapter titles: 'The Witch not Always or Necessarily an Imposter', 'The Wise Man', 'Barrow Digging', 'Bee Customs and Notions', 'An Old Oak Chest and Some of its Disclosures', 'Calf Burying', 'Holy Wells', 'Black Land', 'The Dog Whipper', 'Geological Considerations', 'Lost on the Moor' . . . In it goes, in it goes. And where a subject finds no easy place within the body of the book: 'Appendix'.

Atkinson had first come here in 1847. 'Before me, looking westward, was moor, so that I could see nothing else . . . It was a solitude, and a singularly lonely solitude . . . and yet not dreary, nor could one feel altogether alone.' And this was the moor experience; it was what I had known on the Chains and the wide bogs above Top Withens – this aloneness that was not fully aloneness; a solitude that was never whole. 'There was perpetually so distinct a personality in the matters which passed in succession through the mind, that the effect was rather one of conversation than that of solitary reflection.'

Atkinson was of a scientific bent, but not immune to visions. Having one morning taken the train from York to Grosmont, returning to his parish for the Sunday service after 'a pressing call from home', he climbed, in his horse-drawn trap, up the moorside to Egton. 'When we reached the heights from which we could see well into Eskdale, it was – so far as the testimony of actual vision went – full of water as far as the eye could see.' The valley was flooded to within a hundred feet of the moor-tops. Like a man in a film, he rubbed his eyes; the vision persisted. 'Eskdale and all its tributary dales were inundated, drowned, submerged.' He went on, higher still, towards Danby Beacon, and saw 'a great sheet of water with deep, narrow, far-reaching gulfs or inlets, and only the moorland heights standing out of it'.

Gradually, as the sun rose and intensified, he saw 'threads and streaks of the dissembling surface detach themselves', until finally the mist (for that is what it was) evaporated to present the bright morning dale, familiar once again.

Atkinson was a southerner, an Essex man, although his previous appointment had been in Scarborough, thirty miles away from Danby. When he arrived in Danby, at the invitation of the parish patron, Viscount Downe, he found the living not godless, exactly, but neglected. Seeking his way to the village from Danby Beacon, he came upon a signpost, 'but the arms which had once borne the names of the places the various tracks led to were gone.'

Danby's then minister was 'an old and infirm man, and did not care to face the elements in bad or stormy weather'. (A distinction may be drawn between 'stormy' weather and 'bad'.) It was a fine day, therefore, when Atkinson was brought to see his church. 'It must suffice to say that my conductor, the "minister", entered without removing his hat.'

The altar table was covered in crumbs (the Sunday-school teachers ate their lunch at it); a 'dirty shabby' surplice was hung over the broken altar railing; the pulpit: 'reeking with accumulated dust and scraps of torn paper'; the font: 'a paltry slop-basin'. One effect of the persecution of hawks in the district, he noted, was that their prey thrived, especially mice, which had done several hundred pounds' worth of damage to the church's American organ. 'They have actually eaten some of the wooden stop-couplers quite through.'

Prior to his departure, a friend had told him: 'Why, Danby was not found out when they sent Bonaparte to St Helena; or else they never would have taken the trouble to send him all the way there.' 'However,' wrote Atkinson, 'I had my own reasons.' According to an obituarist, 'the only personal regret he had was a certain solitude, not the solitude of the great

moors, but solitude in his problems and researches.' It was the plight of the rural scholar–priest.

In the spring of 1895, five years before his death, he wrote to his friend and publisher George Macmillan about a local man ('an artist in many parts of his idiosyncrasy') who, while walking on the moor, had undergone something like an epiphany: 'he had never known himself experience the presence of Divinity so powerfully before . . . I don't think I am ever on the moor without something in me that answers to that. What we mean by Heaven must be nearer sometimes than at other some. Don't you think so?'

Merely a hard walk up the dale-side, and through the gorse-line; a heaven graced by larks.

<p style="text-align: center;">4</p>

The Nelson Room in Middlesbrough's Dorman Museum contains the collection of eggs and mounted birds bequeathed to the museum in 1914 by Thomas Hudson Nelson, ten years after it was founded. Among the hundreds of blown eggs are those of the hen harrier (coloured the palest of peach, and the size of a goose's), and its prey, the red grouse (apricot-sized, and white-grey stippled with black). Also present are a wretched-looking peregrine, its brow still furrowed with contempt, and three red grouse in a glass vitrine, each look-ing in a different direction with the far-off, cocked gazes of catalogue models.

Among the many people who have worked at the museum since 1944 are those who say they have seen a ghostly fig-ure, thin, pale, bespectacled, and always wrapped in a grey cardigan. Frank Elgee, the museum's late assistant curator, was a sickly child: scarlet fever left him partially deaf. Sick-ly, till the age of fourteen – when he developed pneumonia.

It was 1896 when, unable to sit for a scholarship to grade
school on account of his poor health, he became an office boy
at William Jacks the ironmonger's. He lasted two years – an
empyema, untreated since his pneumonia, led to 'a complete
breakdown'. He was eighteen. His parents – despairing – took
him away, Middlesbrough being no place for the boy to die.

In the village of Ingleby Greenhow, ten miles south, on the
western edge of the moors, young Frank was pushed about,
each day, in his bath chair. He knew the village well – for sev-
eral years the family had spent their summer holidays there.
It was nearby, under Urra Moor, that Frank first began to
know the changing land that lay between here and the sea.

'My mother used to wheel me down to the stream, and . . .
I would sit for hours watching the birds, wagtails, dippers, red-
starts and swallows. I also used to sit in the garden facing the
Cleveland Hills, watching the rosy light of the sun flash on
their craggy summits.' He was an avid lepidopterist: spotting
a passing peacock from his chair, he would hand his sister the
butterfly net and send her after it. At dusk, he and his father
would paint the railings outside the cottage with jargonelle-
pear essence, and, in the morning, carefully pick off the
moths trapped there, and drop them into the killing jar.

He was a spectacle, this studious man-child from the town,
gazing up from his chair, as if returned from war. The boys
ran to watch him pass. So pale! His nickname was 'Daddy
Whitehead'. He didn't mind.

Three months later, Frank was still not dead. The family
returned to Middlesbrough, where he was able to look out of
his bedroom window on a clear morning and see the moor-
tops change, as summers passed, from purple to brown to
purple to brown.

He spent his days reading Scott and Byron, and the Sher-
lock Holmes mysteries, and improving his Latin, French and

German, and studying entomology, botany, geology, conchol-
ogy, and being wheeled by his mother around Albert Park,
where he became familiar to those others who spent their
days there. On his bedroom wall he hung an engraving of
the Dauphin of France, imprisoned in the Temple; he would
look at it and – 'Oh, poor *boy*!' he would cry.

In 1904 – rid of the confounded chair – he was appointed
as assistant curator at the Dorman Museum. Finally his life
began. Of these 'youthful days', he wrote, looking back, 'nei-
ther girls, nor a lung and a half, nor hot weather nor cheap
lodgings could hold me from the moors. They commanded
and I had to obey.' He was, for that short period between
his partial recovery and his marriage, a 'lover' of the natural
world, because, in the words Henry Williamson had applied
to his own youth in Devon, there was 'nothing else'.

'It would have been natural to have been in love,' Elgee
wrote. 'I was: with a cold stony waste of hills and dales.'

While walking on the moors during the summer of 1906,
'trying to convince myself that I was as strong as I ought
to have been', he slipped 'down the almost-vertical side of
a deep griff or ravine'. The incident is recollected in diaries
written years later, and the reader begins to wonder if some
kind of allegory is being offered, when he emphasises the
heat of the day and tells us that the bottom of the griff was
'bone dry' . . .

'Had I been wiser in moor lore,' he writes, 'as soon as
I quitted that griff I should have borne away to higher
ground.' Instead he marches on, following his compass, and
finds himself 'in the depths of another waterless griff . . .
number two seemed worse than number one . . . the climb
out made me speechless.' Having escaped, the slight young
man with his lung and a half, who only a few years before was
being wheeled around in a bath chair, stumbles into another

griff, and another; 'I must have crossed six at least.' And yet onward he trudges, and on (heather-walking is tiring even on a cool day, even for those with two lungs), over the scorching moor – until 'suddenly, without warning, the earth opened in front of me'. Not another griff, but the Hole of Horcum, the vast scoop-shaped valley close to the Whitby–Pickering road.

The exhausted invalid is euphoric: fourteen years later he would write that the experience made the land 'as much mine as if I held the title-deeds . . . it has been a source of fertile thoughts; and often, at the most unexpected moments, its image emerges from the background of my consciousness as though demanding my attention.'

It was the following year when his mother died, she who had pushed him up so many hills. It was during this year, too, that Frank Elgee can be said to have begun his great project. From then on he continued to holiday on the moors with his father – his father who had bought him Canon Atkinson's *British Birds' Eggs and Nests*, and who had tutored him in French and German. Unable to find a description of the moors in his own tongue, Frank first turned to accounts in other languages, of other moors – to Schröter and Früh's *Die Moore der Schweiz* and Graebner's *Die Heide Norddeutsch-lands* – and then, to himself.

It would be his modest reply to Gilbert White's *Natural History of Selborne*. The fact that the domain he planned to examine – in every aspect from its vegetation to its geology to its birdlife to its archaeology – was far larger (and its terrain more physically demanding) than White's Hampshire parish did not discourage him. He would not allow his tribute to be incomplete. He called the area – the moors of northeast Yorkshire – 'Blackamore', the term the topographer William Camden had used in 1607 ('that is the black moorish land').

In August 1911, he and his father took a holiday – an hour's

ride on the train, to Danby. It was there – in his boarding house – that he met her, Miss Harriet Wragg, headmistress.

'Your interest in me I cannot thoroughly understand,' he wrote to her in December, 'owing to the utter lack of such interest from others during my dark and dismal past. Like you, I used to think myself immeasurably below other people in every way, and when anyone expresses a deeper interest than usual I feel strange.'

The moor would be his accomplice in wooing her.

If the wild, Wagnerian music of the mountain were to lull you to sleep, lo!, a vision would enter your dreams – the Man of the Moors, cleansed of all imperfections, perfect in soul, mind and body, handsome and strong! And he would touch your brow, and at that touch the vigour and exhilaration of all the moorland breezes would flow through your veins and lighten your weariness of spirit.

She, reflecting later, would write of Frank's relation to the moors, 'I shall never forget once watching him, diminutive, frail as a plant, standing at the base of a hard, rocky cliff, his white hand resting on its face as it might rest caressingly on the face of his wife, and I knowing that he loved four hundred square miles of moorland with the same reverent intimacy.'

Frank was not blind to the scale of what he had taken on; nor was it hubris. 'Those who have explored the district will understand how arduous a task it is to examine thoroughly an area nearly as large as an average English county,' he wrote, in his introduction to *The Moorlands of North-Eastern Yorkshire*. It was finally published in 1912, the year after he met his wife-to-be ('To Miss Wragg, B.A., of Shirley, Warwickshire, I must here express my best thanks for many suggestions'). He had worked at it for two years, but it was the happy culmination of a lifetime's sombre thought.

From the moors he would write Harriet long letters, his passion for her entwined with his passion for the moor, and

glistening with pretty details: 'I must not forget to tell you', he wrote in August 1912, a year after they met, 'that I found two rare beetles on a dwarf sallow growing in the bog. They were a bright coppery colour with a green head and thorax . . .' They married soon after. His transformation was complete: no longer the half-deaf, wizened cripple, squinting feebly at the hills. He had become 'the Man of the Moors'. But whereas the title Beatrice Chase of Dartmoor assumed, 'Lady of the Moor', represented a kind of self-coronation, Frank wished only to be possessed by the moors he knew.

Elgee's ambition was to answer a question, he said: simply 'What causes the moors?' He realised that to understand a landscape was to understand its words, and that moor-words were precious. He knew that the burning of the moor was 'swiddening', and that a burnt strip of moor was, naturally, a 'swidden'; just as he knew that the burnt heather stalks were 'gouldens', and those patches of white cotton-grass I saw above Danby were not 'patches', nor 'swathes' nor 'tracts', but 'hassocks'; and that the phenomenon I witnessed on the moors above the Calder Valley – the moor steaming as the sun came hot after rainfall – had two names: 'summer geese' or 'summer colts'. 'See,' he quoted a moor-man, 'see how the summer colt rides.'

Before he could explain the 'cause' of the moors, Frank had first to explain what they were, and for this he again drew on his aptitude for languages. Moorland, after all, was not purely a British phenomenon.

The word is in all essentials identical with the old Norse *mor*, signifying peat, turf, heath or Ling, and if we look at its meaning in the Gothic languages we shall find that it is everywhere the same, though with some elasticity in its application. In Suio-Gothic, *mor* is a marshy place, also the undergrowth in a wood; Danish and Swedish *mor*, a tract of fenny land; Danish dialect, *moor* or *mor*,

land where turves may be cut; Anglo-Saxon *mor*, waste land, a moor, heath; Dutch *moer*, and German *moor*.

(From the Anglo-Saxon came the application of the word 'moor' to lowland areas of fen and marsh and other 'waste': Sawston Moor in Cambridgeshire, Otmoor near Oxford, Somerset's Sedgemoor – and, of course, those Moors I'd known as a boy.)

Elgee's ambition was to elucidate his moors' multiplicity. They were *not* barren. He didn't deny that they could be 'dreary', but he understood, as Emily Brontë understood, that dreariness was only one of their moods. It was their variety he loved, and reading his book you do not doubt that love is the right word. He describes the face of the moor with the tenderness and stifled excitement of one describing the face of a new lover. With an eye for colour, he recalls a sward on the northern side of Stockdale, with its 'beautiful clumps of bright green Hair Moss . . . of a brighter green even than the turf itself; here were the bristly leaves of the Heath Rush, there tufts of greyish Mat Grass with occasional bosses of purple Ling.' He was not so much describing the moor for others as adoring it by close attention.

Even where the moor appeared to be uniform, it was not; even within a single square mile the varieties of moor might be classified and ranked. In his taxonomical system there were the Fat Moors, with their deep wet peat; then the Thin Moors, with their shallower, freer-draining, drier peat; there were the Mosses, or bogs, some of them thirty feet deep; there were the Slacks and Gills and Moorland Slopes – and each such moor type, naturally, was connected by 'insensible gradients'. And then again, within each moor were various further designations: the Fat Moors alone contained 'Pure Heather Moor' and 'Heather and Bilberry Moor' and

'Heather, Flying Bent, Cotton Grass and Common Rush Moor' and 'Heather, Flying Bent, Common Rush and Sweet Gale Moor' . . .

He had systematised the moor, and named it, but he had not shaken its mystery from it. Frank was partial to quoting Goethe (in the original):

> *Die unbegreiflich hohen Werke*
> *Sind herrlich wie am ersten Tag.*

> Thy works, unfathomed and unending,
> Retain the first day's splendour still.

5

In the morning, after another brownish bath, I filled my bottle with brownish water and set off. The new bracken was pushing through the bed of dead stalks as I climbed up to the moor. Its green was vivid against the pale beige, as the leaves of bilberry were vivid against the unreflecting brown of the heather. In an abandoned quarry the sheep were absorbed in their grazing, and scarcely moved when I passed by. Where a half-acre of heather had been recently burnt the land's texture was revealed, deep trenches advancing to the horizon. Grips was the word. Drainage ditches, like those I'd seen on Exmoor – cut after the last war, under a grant system that had since been reversed, to make productive pasture or arable land or forestry of the moor; or by the old keepers, in the belief that heather favoured drier ground, or that draining discouraged grouse disease. But pasture soon turned back (bad land is bad land), and a dried-out grouse moor, it became clear, was grouse moor no longer – their insect food declined; their drinking water was depleted; the chicks fell into the grips in winter and were swept away.

Where the path had been worn deep, a measure could be taken of the land's layers: a foot of surface peat, its top few inches riddled with heather roots; then the peat-stained yellow sand; followed by a band two inches thick of what Elgee describes as 'a hard brown substance' – the 'pan', composed of iron, silica and organic matter leached down by rain from the soil above, and virtually impermeable. It is this – the pan – that keeps the Fat Moors from draining, discouraging the growth of anything but grasses and dwarf vegetation, such as heather and bilberry, and preventing all but the hardiest trees from growing. Even those that do take root, such as birch, will not survive on land grazed by sheep or burnt for grouse.

And everywhere were grey sandstone boulders, clustered in field-clearance cairns, scattered among the burnt heather, edging the path, or standing alone in a burnt swathe – 'swidden'. The locals, Elgee wrote, had a term for these solitary outcrops, too: Crow Stones. Like 'Black Hill' and 'Red Marsh', it is a common naming on the moor maps.

The North York Moors are hard to configure in the mind's eye: on a map they have none of the easy coherence of the southern moors, or even those of the Pennine ridge. The moor edges are bitten into by the dales, and to go from one moorland spur to another means a long round trip on heather, skirting the dale's edge, or else a deep descent – three hundred feet; more – into the dale and up the other side. I met a retired keeper, who raised his hand to explain the dales to me. These moorland spurs were fingers, the dales their interstices; the high moor itself was a palm – a palm-full of peat.

From this brown flat silent land, down. Down, into the green dale, forested, noisy with combine harvesters and cattle. As I slipped down Crossley Side into Little Fryup Dale the heather stopped suddenly and was replaced first by a band of gorse, then one of bracken, then a steep patchy grassland,

before the green valley floor was reached. Then once more up – over the narrow moorland spine of Glaisdale Rigg, and down into Glaisdale itself, and climbing again to the uplands – to Traverse Moor, onto the heathered palm of Egton High Moor.

I saw the tree first; then the pyramid. The tree was three miles away; the pyramid – truncated, black against the sky – ten miles. It lorded over the moor, even at this distance. Its ugliness seemed to exist as a radiance. When an ordinary Egyptian, a shopkeeper or farmer, saw a pyramid he was not awed; he wasn't inspired – what he felt was dread.

The heather was unrelenting, dense and even as a lawn, and not a flower anywhere. 'Wandering over the moors at all seasons of the year,' Frank Elgee had written, 'the naturalist cannot but be impressed by the paucity of bird and animal life.' And that was how it seemed – these moors weren't the Serengeti; what defined them was their very lack of diversity, biological or otherwise.

But there were always, always the grouse. Grouse grouse grouse grouse grouse. From beside the path a frumpy brindled hen spun up. The alarm call is traditionally transliterated as 'Go back! Go back!' It spoke for the bird as menacing, hectoring, and inauspicious; it spoke, too, for the moor itself – 'Go back!' – a kind of ventriloquism. It was one of the grouse shooters' articles of faith that the red grouse, *Lagopus lagopus scotica*, was Britain's only native bird species. But the bird books will refer you to the willow ptarmigan, of which the red grouse is merely a local race, along with its voice: '"*ke*-u, ke-kerrrrr-ke-kerre*he ehe ehe*", slowing down at the end and often followed (or preceded) by a few "ko*wah*".' Jeering, rooting, triumphal, aghast. Yes: go back.

I'd thought this specimen was on her own, but she was followed over the moor by first two, then five fledglings – and

when they'd gone, and crash-landed in a distant patch of taller heather, and when I myself had settled, the heather they'd fled from shuddered, and I saw three further chicks, flightless, eyeing me with something that was not yet fear. Come August, these birds would be ready for the gun.

Through the heather was cut a maze of narrow paths – too narrow to have been made by walkers. The ways of grouse and stock. I left the grouse chicks and followed these tracks, ignoring my map, only keeping the lone tree between me and the pyramid. These tracks, these cuttings in the heather, were puddled and black, and carried along their edges numerous tags of pale white fluff. Just as earlier, on Danby High Moor, I had seen the cotton-grass's fruit and taken it for wool or feathers, I saw this material, now, and assumed it was a trimming of cotton-grass – but there was no cotton-grass here. There was hardly anything but heather, and the white that edged the paths *was* wool – combings snagged on the wiry heather as the sheep filed through.

The Wintergill forestry plantation, on the edge of Egton High Moor, was dark and abandoned-seeming, as these plantations always were. A block of utter silence on the quiet moor. Alongside it, a wide firebreak had been shaved into the heather – 'swiped', using a mowing device dragged behind a tractor – to prevent flames from threatening the timber when the moor was burnt. The tree ahead, still about a mile off, was a spruce, an outlier of this plantation. It was tilted on the prevailing wind. No telling, from this far, how tall it had grown: ten foot; twenty. Between the plantation and this solitary tree (which was so conspicuous that its absence from my map seemed like an oversight) were High Birchwath Peat Bog, Duckponds Peat Bog and Pike Hill Moss.

'Those who are unacquainted with the moors', wrote Elgee, 'frequently confuse "flaughts" and "peats", two entirely dif-

ferent products', the former being a sod of turf, the latter 'obtained from a peat-hole'. (In my mind's eye he is often sat at a pub bar, after a day on the moors, holding an engraved pewter tankard.) Turbary and other 'common' rights – the right to take quantities of stone, ling and turf, as well as grazing rights – were vested in the older moorland houses, and included in farm leases. Even the deadest-seeming land has its harvest.

The peat face – called the breast – might be eight feet high. In front of your toes would be matter two thousand years old. The spade comprised a short T-shaped handle fixed to one end of a narrow tray eighteen inches long, with a winged steel fore-blade. This blade was to be pressed and jemmied into the peat breast, to the tray's full extent, then eased out with the fresh block in place. Keep your peat spade sharper than your razor. As the block was tipped onto the barrow, the outer surface was to be 'sliped' – smoothed by the action of the blade as it was withdrawn, so that the peat edge, when stacked to dry, would resist the permeation of water.

Among the many photos in Frank Elgee's beautiful book – photos that he and his father took using a heavy half-plate camera – is one of the Pike Hill Moss peat holes. It shows a black quarry. The exposed face, from which the peat has been cut, looms darkly over two pale moor-urchins, a boy perched on a ladder, and his older sister, a white shawl wrapped around her.

A well-stropped blade and a strong shoulder might cut two thousand in a day. The peats would be taken to the 'ligging ground' nearby to dry, five peats leaning against a central block, with the sliped surface outermost to repel the rain. In the spring, the pits here would have been busy with the people of Danby, Glaisdale, Fryup and Egton, the stacks multiplying hour by hour, the peat face being slowly pushed back across the moor.

Good black peat burns hot as coal, but is smoky, and in time coal was got more cheaply. The bogs are no longer cut for peat; the old cuttings have been allowed to become ponds. The peat fires, some which had, it was said, not been quenched for a hundred years (you heard this in every moorland pub), have been allowed to go out – coal is the fuel, now; or else your hearth is only an ornament, filled with dried flowers and dishes of potpourri. The heat comes from gas or oil, or from electricity; the peat, with its stored carbon, is legally protected. And it is precious – has become precious – and not only to the water companies who want to prevent downstream discoloration (peat-stained water is harmless, but householders won't tolerate it). If five per cent of its peat were to be lost, Britain's carbon dioxide emissions would double. Already, it is estimated, damaged peatlands are releasing 3.7 million tonnes of carbon dioxide each year – equal to the combined emissions of Leeds, Edinburgh and Cardiff.

The wind that had been blowing since I left Danby had stopped, and the surface of the moor was still. When the first western explorers to enter the *terra nullius* of Australia came to its southern limestone desert in the late nineteenth century, it was the treelessness that undid them – a horizontal sublime of a kind that would have been inconceivable to Edmund Burke. Imagine encountering a race of people without faces. 'A Climax of Desolation – no trees, no shrubs, all bleak, barren, undulating sand. Miserable! Horrible!' They named it fittingly: *Nullarbor*.

I veered off the path to stand beside the tree I'd been watching for the last three miles. The sole vertical in a land of horizontals, it had drawn me to it like a light. It had grown for perhaps twenty years, or thirty, and had got to about fifteen feet. Of the sycamores at Top Withens, Ted Hughes wrote:

> The girth and spread of valley twenty-year-olds,
> They were probably ninety.

To live, a seedling must either derive its sustenance from the sparse moorland soil, or else force its roots through a foot of dense pan; and then it must be spared the attention of sheep or the keepers' fires. In Turner's *Grouse Shooting on Beamsley Beacon* six blobs can be made out atop a hazy knoll: a moorland spinney of a kind rare on modern grouse moors.

In order for the vast areas of moorland forestry planted following the Second World War to thrive, the pan had to be cut deep, and the ground heavily fertilised. And then there was the wind, the winter wind that came strong enough to blow you over, and did not relent for hours. It was hardy, this specimen. Not only twigs, but its limbs lay scattered about its trunk, torn off by winds, and recently. I stepped back and saw that virtually all of the branches from its windward side had gone, and it was this that had made it seem, from a distance, as if it were leaning, when in fact its trunk was quite vertical. This was its existence. To stand here and be torn apart every year, to have its branches flung across the moor, and its cones dropped impotently into the peat. It might survive for another century in this unburned patch. In the sappy socket where a limb had broken off, a cone was lodged.

From the sentinel tree I looked down across Randy Mere Reservoir, across Coombs Wood and the village of Goathland, and followed a line of butts that pimpled the far slope, butts that would soon be occupied by eager chaps with freshly oiled guns. I counted five down from the hilltop – and then my eye settled on the pyramid.

6

By AD 71 the Romans had established their fortress at York. Dotting the coastline, from Filey to Hunt Cliff, were the ruins of their lookout posts and signal stations. The following morning I climbed from Goathland over Howl Moor, to stand on the Roman road that can be traced from the camp at Cawthorne, north to Lease Rigg: in the rain the road was a pontoon of ranked stones, floating on the moor surface. It was strange that the moor had not, over the centuries, folded these stones into itself. I had seen, two days ago, up on Danby High Moor, a tractor tyre – no more than twenty years old, surely, and five feet across – that had been absorbed by the peat right down to the last half-foot, so that only a cracked, cleated arch showed above the surface. On the lower moors you often came across discarded ploughs or harrows, half consumed by the soil. And yet this road – two thousand years old – was still here, on top of the moor, unsheltered from the rain. Perhaps it was its continued use that had preserved it – the constant course of footsteps (and not only human) preventing the moor from overwhelming it. Country lanes that carry few vehicles will soon grow a hackle of grass and moss along their central ridge. Its continued use – but also its position, here on the high moor, where its stones had not been taken for field walls and barns and dwellings, as they had been along its lowland stretches.

The road from Goathland to the A169 was a stopping-off point for those travelling across the moor between Whitby and Pickering. Salt traders (and salt smugglers) from the coast had come this way in former times. As I approached the Eller Beck bridge, the radar structure's components and textures were disclosed: it was not black, as it had appeared to be from the moors above Danby. Its base was dark grey, while

its visible face was an off-white square bearing a dark-grey circle within it. As I closed in, the off-white became a proper grey, not merely a white that had faded in the elements, and the square panels that made up the array surface could be made out, with their thousands of stubby antennae, regularly spaced. It was hard to gain an idea of its size – beyond the chain-link fence, and the higher electric fence, beyond the expanse of no-man's land and the additional barbed-wire fences, there was nothing of human scale. I had been told that it was nine storeys high; it might have been forty.

RAF Fylingdales was an American operation, British-built and run. By 1960, three years after Sputnik I was launched by the Russians, the US ballistic missile early warning system had been established. 'BMEWS' was the acronym. It was said 'Bee-muse'. There were to be three sites: the others were at Thule in Greenland, and Clear, Alaska. Between them, they would cast a radar net three thousand miles into the USSR. A missile once detected would be tracked, and its trajectory, target and strike time calculated. Twenty minutes' warning would be afforded to the US; to Britain, four. The warheads would come, the cities would be destroyed – the system would allow the RAF's V-bombers to scramble and reply.

The radomes had been replaced in 1994, but I knew them from pictures. I had seen, too, from the top of Ilkley Moor, the cluster that stood today at the Americans' listening station at Menwith Hill, a dozen or more of these white spheres. Each of the three Fylingdales radomes had measured forty metres in diameter, with the bottom eight metres sunk into a cuboid control building. They had stood in a line across the moor, just under the brow of the hill. Very quickly they became known, by the people of the base and more widely, as 'the golf balls'. They were not perfect spheres, in fact, but geodesic domes composed of hexagonal panels (this faceting

echoed the regular dimpling in a golf ball's surface). Nor were the domes white, but pale blue, in order that they would – so it was imagined – be less of a blight on the skyline of the national park. (I wondered what Frank Elgee would have made of their appearance on his adored Fat Moor.) They came to be regarded with affection by the people of the moors. Postcards of them sold well in Goathland's tourist shops.

The radomes had had no radar function; they were only to protect the delicate dishes within from the moor's high winds, from rain and snow. But it was easy to see why it was assumed, by those who had opposed the site's existence, that they were meant to conceal, too – to hide the dishes' movements. And then they had been replaced with the 'pyramid' I saw today, the 'solid-state phased array radar', which they called SSPAR (the military, where acronyms outnumber proper nouns), and which was in fact a truncated tetrahedron. The threat had changed – from Russia, to Iran and North Korea; from a fixed threat to the shifting, invisible threat of submarines – and the technology must change with it. The system's reach had been extended. The radar looked into space, too: at the International Space Station; at the satellites in their orbiting hundreds, friendly and hostile, commercial and state-owned, and the thousands of fragments of debris, circling the Earth.

The War Office had requisitioned this stretch of North Yorkshire for training, during the First World War. Thus when a site was required – unpopulated, high, with an uninterrupted east-facing outlook – Fylingdales Moor presented itself. But the original site, close to the coast, was felt to be vulnerable to seaborne rocket attack. The name Fylingdales they would keep. ('Clear, Alaska'; 'Thule, Greenland' – they couldn't, it was felt, call this vital instrument of western security 'Snod Hill'.)

242

Snod Hill had first to be cleared of ordnance left by years of army training. UXB teams scoured the moor to a depth of a metre, deeper: dozens of grenades and shells were found. On Fylingdales Moor itself, some miles away, you could see the concrete hardstandings from which the tanks fired, the adjoining ground poisoned by propellant gases still bare.

The labour camp went up first – room for a thousand, in wooden huts with sixteen beds in each and a couple of fuming oil heaters. There was the canteen, the post office, the bookies, the bar. Where once there had been only sheep, there developed quickly a township – the bar stayed open till 3 a.m.; the bookies thrived. There was some lawlessness: larceny, fistfights. Felons from Whitby and York hid out among the unregistered men.

The first tracks they laid, from the salt road into the high moor, were soon absorbed by the peat; rubble was put down, tons of it, but this too was taken in by the ground. A bulldozer sank to its roof. A Land Rover went under. Every day, vehicles had to be tugged from the morass. Perforated steel planking of the kind that had been used for runways and roads in Europe during the war was put down; it sank. Supply trucks went astray – if you were to ask a local where 'Fylingdales' was they'd direct you to the village of that name, five miles east, not this unpeopled rise of grouse-land beside the Whitby–Pickering road. It took the rest of the year to ready the ground – to strip the heather and roll the peat back to the bedrock. Three hundred thousand cubic metres of moor were bulldozed and blasted; 150,000 tonnes of hardcore were put down. The Eller Beck was dammed and a waterworks built; sewerage was put in; a powerhouse was installed (the site was to run not on the standard British mains cycle of 60 Hz, but the American 50 Hz). In November 1961 the radar sections arrived at Liverpool Docks and were edged along the salt road.

It was the isolation of Snod Hill that was its chief appeal to those American 'defense' strategists, as they considered Sputnik II, and what it meant. The designers, the strategists, knew that the era was one of flux; the requirement was only immediate. But the threat had remained; only the enemy had renewed itself. The radomes had come down, the golf balls, but the facility persisted. It had become a site of national heritage. The truncated pyramid – the SSPAR – had acquired its own nickname. It hadn't taken long: it was called 'the Toblerone'.

It was beside the Eller Beck that I met Mick, my hen harrier friend, chatting to a couple of the police officers who spend their days patrolling the perimeter. One of them was a keen birder himself. In the 1990s, when the three radomes were being demolished, Mick was contacted by the base commander. Kestrels were nesting in the RSJs. The birds were rehoused in boxes on poles at the site's perimeter. Since then he had advised the managers on ecological matters. Where the radomes had stood, on a rise of imported clay, he had arranged for ponds to be dug, and these ponds now contained great crested newts. His position meant he was allowed on the MOD land and the Forestry Commission land that abutted the base, and he had keys for the gates and barriers. The men at the base – those armed police at the security barrier and patrolling the surrounding roads – recognised his car as we approached.

We were here to meet Mr Westhead. He'd come to RAF Fylingdales as a young man in the 1960s, from Manchester, where he'd been working on the Bloodhound guided missile system. 'I was concerned with the algorithms in the software and ensuring that they were performing optimally and looking into any anomalies that occurred.'

We were sitting in the officers' mess: deep leather sofas, a broad dark coffee table. A shaded hush. When Mr Westhead had first come here, a year after the base became operational, the place had been little more than a scattering of Nissen huts surrounding the three gleaming radomes. Mick held onto his stick and drank his coffee in silence.

Mr Westhead's beard was a fine dense white, meticulously trimmed. Over a dark blue shirt he wore a white blazer with a cream stripe, with whiter linen trousers. In one hand he held a straw boater with a broad black band. He spoke with measured intensity; he was diligent in his vocabulary, careful with his facts and their implications. He had done important work – more important, I sensed, than he was permitted to let on. He had been at the centre of things. The worst had not happened, and for that some of the credit was his.

'I believe the word "moor" comes from the French *mer* – as in "sea",' he said. And it struck me that the work of building these establishments on the soft moor, miles from the normal places of human habitation, was like building something at sea – an oil rig or drilling platform.

RAF Fylingdales is a product of expediencies. The four-minute warning that BMEWS afforded the UK had value only in so far as it would allow the bombers to leave the ground before the incoming missiles struck. When Polaris, the new submarine-based 'deterrent', emerged in 1969, there was a danger that Fylingdales would be deemed obsolete. If retaliatory missiles could be launched by the navy from any-where in the open seas, then Fylingdales' four-minute warn-ing only served to prime the populace for the coming hell. What was more, the system's efficacy would only be proven when the country was already an irradiated slagheap. As one RAF officer observed in 1967, 'If the missiles are on their way (which means deterrence has failed) it is not very clear

what advantage we get from knowing this four minutes in advance of the actual strike. We shall know when we are hit anyway.'

Since the V-bombers' retirement, therefore, it was the base's ability to track space-based objects – satellites, debris, the International Space Station – and to demonstrate this ability, that recommended its continued existence. Mr Westhead admired the Americans, and felt that they alone, as a people, were capable of such ingenuity and audacity. RAF Fylingdales had been a British project, British-built, but the impetus, the demand, had been American. 'It was brilliant and most impressive that the Americans could do it. Just go in there and get it done and do it.' Now there was only a single American officer based here, when previously there had been dozens, and a handful of US civilians operating the 'sat-com' – the technology that allowed communication between these moors and the base concealed inside a mountain in Colorado, 7,400 kilometres away.

The white suit, the white hat, the smart beard, the hard and frank gaze – Mr Westhead was a handsome gentleman who had lived a life of significance and had stories to tell and secrets he shared with very few. There was patience there, and also a knowledge of his stories' value. The white suit, the white hair, the white hat – they were of a part, somehow, with those obliterated white radomes, and I wondered if the outfit had come about at the same time as his retirement, or whether the white suit and the open-necked shirt and the hat had been his daily attire for much longer. It was hard to picture him in anything else.

North of the MOD boundary were the game-lands of Widow Howe Moor. The strip-burnt surface of the hillside – ten hectares or so – was entirely regular; it was orderly and intricately patterned, yet it was baffling to look at, as if the

orderliness had no system, no purpose – part sports pitch, part crop-land. It had been burnt over and over, in stripes and patches that were at once a jigsaw and a record of the moor's recent history, of the recent history of grouse-moor management. Any visiting beings, observing this place from overhead (UFOs were occasionally reported in the area), would see the outlying terrain and believe that it was associated with the military installation, and that the runic display of the moor – one could easily read letters into its surface, an E here, an L there – was as integral to its operations as the radar building itself. In *Forty Years in a Moorland Parish*, Canon Atkinson writes about wading through heather thigh deep. On Widow Howe Moor there was scarcely a sprig that rose above the knee. Merlins no longer nested there.

Across the valley of the Eller Beck, where otters had been seen, a brown hill rose, scattered with low trees. There was heather, but not the uniform growth of the adjacent moor; it had not been patterned by burning or swiping. This was the radiation-hazard area – the 'rad-haz area'.

'You could walk all the way round it,' Mr Westhead said. 'It's closed off to human activity. It's a sort of – an unspoilt area. There are no sheep. It was quite fascinating, over the years, watching trees sprouting up. We had a meal break in the middle of the day. It was possible, with an hour in the summertime, to go out into the RHA and just wander round and explore it. The radiation levels were actually very low.'

When he went for his lunchtime walks around the rad-haz area, taking a break from his mysterious work in the administration of the apocalypse, Mr Westhead would stop at the ponds that were scattered across the surface. They were shell craters, from the artillery exercises that had been held on the moor during the Second World War. 'In the summer they were full of reptiles, frogspawn, tadpoles, newts.' Somebody

in the programmers' office brought in a fish tank, and filled it with tadpoles, and each day the programmers would watch the tadpoles grow. One day a few sticklebacks were added. In the morning the tadpoles were gone.

Wired to the boundary fence were bright hazard signs, the symbol for non-ionising radiation: a yellow triangle containing a black pillar topped with a black disc, flanked by what resembled nested brackets: (((i))). There was no significant danger, I was told (the radar beam is directed three degrees above the horizontal); and yet there had been a reason for siting the facility here, away from habitation, with only a few miles of moorland and farms between the radar and the sea. And this expanse of moorland had been deemed out of bounds for fifty years, since the radomes had first been activated. There had been a rash of cancer cases around a similar site in America. The radiation was strong enough to frazzle an aircraft's instrumentation. When, as often happened, the Whitby air ambulance was called to attend a crash on the A169, the radar's output was, at the press of a button, temporarily redirected.

It was a rare expanse of northern moorland that had not been cycle-burnt or grazed or afforested. The heather grew to a certain height (say three or four feet in thirty years), then it died and collapsed, and new growth came. There was young hawthorn, and birch. Grouse bred there, but not in the numbers that occupied the managed moor; wilder grouse – prey to fox and crow and peregrine and disease, susceptible to wildfires, but spared the shoot and the dogs, the managed burn, the swiping, the keepers' constant ministrations. If man was to be eradicated, here was what would happen.

7

The moor belonged to the hawks, Henry Williamson wrote – 'pitiless despoilers of rooted and blooded things, which man has collected and set apart for himself; so they are killed'.

Mick wore two coats, and carried two Thermoses. His stick he holstered between the seats. It was unlikely that we'd see anything: England ought to be supporting at least 320 breeding pairs of hen harriers, but in the whole country, last summer, there was a single known nest. Individuals were occasionally seen, passing through. Recently a bird that had been ringed and fitted with a tracking device (it had been nicknamed Bowland Betty) was located on the Yorkshire Dales; lead shot was found in one of its legs. It was clear that its death had not been quick. The birders I met were happier to display their anger than the keepers; the keepers' anger was of the watchful, contained sort: shaken heads, compressed lips, soft snorts. Perhaps a hissed 'jokers . . .' The birders, on the other hand, were happy to call the keepers bastards, and condemn the arrogance of the landowners and the duplicity of their spokesmen. There was no regret about their contempt, and little of the willingness to compromise espoused by the keepers and owners. If you wanted to know why there were no hen harriers, ask those individuals on their quad bikes, they said, with their long-range rifles and secret caches of pesticides.

Mick had just got back from a birding trip to Oman; he'd gone alone, despite the limp. 'The desert', he said, 'is not to be afraid of.' As we drove through Hutton-le-Hole and up onto Spaunton Moor, he told me about a Bedouin fisherman who'd towed his car from the sand. 'I said, "Look, I'll have to give you something, do you want something for t'mosque, family, *anything*?" "No, no," he said: "*inshallah*." And I thought, that's beautiful, is that.'

He'd been to the Negev five times, volunteered at the International Birding and Ringing Centre in Eilat, gone with friends to occupied Syria. He'd used the stick for twenty years, his mobility having deteriorated since he left the RAF Regiment. He'd been involved in airfield defence, in Aden, Bahrain, Cyprus, Belize, Northern Ireland. After the accident and the end of his military career, there had been 'one or two bits of depression', he said – hit the bottle. 'Even today, these lads coming back from Afghanistan, covered in their mates' blood, get no support, no nothing . . . But I've come out the other side.'

Birding had been an interest since he was a boy, growing up near Skipton, when he'd walk on the moors with his father, or cycle over to Stocks Reservoir to watch the black-headed gull colony. He'd seen the moors change around him, seen the harriers decline and the grouse proliferate, seen a new sort of moor owner emerge and the pressure on the keepers increase – which meant more burning, and more killing of the creatures that predated the grouse. 'If they could put the bloody grouse in poultry arks in the middle of the moor, and just let them go out onto the little shoots of heather, they'd do it.'

The view of the keepers was that, if they were not to kill them, they should at least be allowed to cage-trap the birds that predated the grouse, and release them where they couldn't damage people's livelihoods. 'A natural thing *breeds*,' Mick said. 'No way can you play God with God's creatures. Why do you want to remove it from its habitat and its ecosystem? It's totally wrong, it's just wrong, morally wrong. If grouse shooting can't exist as a business without going to radical means, it shouldn't exist.'

He relished the enmity; enjoyed the notoriety he believed he had achieved among the keepers. He had no time for arguments founded on the shoots' supposed economic benefits to strug-

gling upland communities – annually £5.25 million in keepers' salaries, 37,000 days' casual labour, 6,500 nights spent by the Guns in local hotels, according to the Moorland Association.

'Red grouse', he said, and I detected some mischief in his voice, 'were put on this earth to feed hen harriers.'

Mick parked up at Rosedale Head, and poured a cup of tea from one of his flasks as I scanned the horizon with his spare binoculars.

In *Avium Praecipuarum* of 1544, William Turner tried to identify the bird species named by Pliny and Aristotle: 'The Rubetarius, I think to be that Hawk which English people name the Hen Harroer. Further it gets its name among our countrymen from butchering their fowls.' In *British Birds' Eggs and Nests*, Canon Atkinson noted that the hen harrier 'appears often to consider "a chicken might suit me too", and acts accordingly'. There is little recorded evidence of such behaviour, but distrust of the bird runs deep, and existed well before the advent of organised grouse shooting.

In 1808, the Marquess of Bute required keepers on his estate to take an oath that included an undertaking to 'use my best endeavour to destroy all birds of prey with their nests, so help me God'. An article in the *Quarterly Review* of 1845 stated that 'the worst of the [hawk] family, and the most difficult to be destroyed, is the hen harrier'. By 1891, numbers had been so depleted that Atkinson could write 'I have not seen a harrier or a buzzard these thirty years', although, when he first came to Danby, he had seen a buzzard (he was fairly sure) and a pair of hen harriers. He'd also seen a white-tailed eagle, flying with a rabbit trap hanging from its leg. The name 'hawk', he added, 'was as fatal to the poor birds that bore it as the proverbial "bad name" to a dog'.

Mick had his pre-op in a few days' time. 'I believe you've got to keep going,' he said, as I looked out at the cold moor,

searching for life. 'I have an injection into my spine every six months. It keeps me going. I want to be out here amongst it. To me that's the ultimate reason for bloody living, now.'

I got out of the car, and noticed behind us, beside the road to Castleton, three steplike oblongs of sandstone, one atop the other. It was the memorial to Frank Elgee (1880–1944), put there by his friends shortly after his death. On its topmost stone was a small offering of medicated grouse grit.

In Elgee's notes towards an unwritten autobiography, kept in the Dorman Museum's archive, I'd several times come across the same quotation, taken from John Donne's sermons; Elgee had wanted it as an epigraph –

. . . put all the miseries that man is subject to together, *sickness* is more than all . . . In *poverty* I lack but other things; in *banishment* I lack but other men; but in *sickness* I lack my self.

In 1930, he published his second book, *Early Man in North-east Yorkshire*, and began work on his third and last. 'My husband broke down completely in health in 1932,' wrote Harriet, 'and the latter part of his *Archaeology of Yorkshire* was written at his bedside, whenever he felt able to deal with it. I often wondered whether he would live to see it completed . . . but he would not relinquish the task.'

In 1933 Frank was forced to resign from the museum on account of his failing health, and five years later he and Harriet moved south – once more on doctor's orders – to Alton. What took them to this particular mild Hampshire town is not recorded, but five miles south is a place Frank knew intimately, albeit, up to then, only from the pages of a book – that written by his childhood hero, Gilbert White: the village of Selborne.

On the moors we spotted only two crows. Though they were busy in the dales, they had learned not to venture up

here. A rough-legged buzzard showed itself briefly; a lone curlew drove its long bill eastwards, as if gouging a groove across the sky; a pair of kestrels braved an intake field – and, distantly, two miles off, in the light mist that hung over Rosedale, we glimpsed the slender wings and casual flap-and-glide of what *might*, Mick said, adjusting his bins – and he'd be drawn no further – *might* have been a female hen harrier.

8

Five months later, I sat on a roadside bank above Hutton-le-Hole, emptying tiny purple flowers from my boots. My trousers were powdered and tacky with pollen to the thigh. It was dusk and I was exhausted and burnt. I'd spent all day with the shoot, and it had been a reminder that the moor was unsheltered from the sun as well as from wind and rain.

'If, unacquainted with the moors,' wrote Frank Elgee, in *The Moorlands of North-Eastern Yorkshire*, 'we were told by travellers of extensive regions overgrown with dwarf, shrubby plants, possessing myriads of purple flowers, giving a definite colour to many square miles of the earth's surface, we should express our surprise at the discovery.' In my photos, the heather, newly bloomed, is intensely purple. But at the time, it had been a disappointment to me. The purple was hard to consolidate; it was irregular and uneven: it allowed only an impression of purple. It was as if I had come at the end of the flowering season, when the flowers were going over. But I knew that – late-blooming this year, on account of the wet – it was at its height. Look carefully, and the purple separated into uncountable tones, many of which had nothing to do with purple: the new blooms were silverish specks; there were pale grey, beige and mint green. I picked a sprig, but the moor-purple visible from a distance was not a colour

you could take home. That would be like hoping to capture a sea's blue in a dunked glass.

The gathering had begun shortly before 9 a.m., in a field north of Hutton-le-Hole, beside the old lodge. I'd arrived early and watched the field fill, the beaters pulling on motley gaiters, hissing at the dogs, gorgeous animals that were beloved and treated as wilful children. I watched the stubbled recruits in camouflage, laconic as they waited, garrulous and watchful in their turn – this one with a mustard-yellow baseball cap and a roll-up living at the corner of his mouth. 'Watch the seaves,' he said, with some pleasure. 'You'll break a leg.' 'Seaves' I had heard as 'sieves', which I had taken to mean the sinkholes or griffs screened – 'sieved' – by heather. But it is a local word for the rush, *Juncus effusus*, that thrives along the streams.

Keith was the only loader today; there was just one newcomer among the Guns – he was used to pheasants, but would need some watching. The trouble with new Guns is not that they're trigger-happy; on the contrary, they need to be encouraged to take the shot. Keith's beard was mythic. The moment he emerged from his car, George the head keeper called over, 'Father Christmas is here!'

'If I were Father Christmas,' Keith muttered, 'you'd be getting no presents,' as he leaned into the back seat to gather his things: binoculars, cartridges, flask, lunch; each in its own bespoke leather satchel. He'd also be carrying his Gun's kit – shooting stick, shotgun in its canvas case. These are still the materials of the shoot leaders and the pickers-up, leather and tweed; but the beaters, whose work is more energetic, wear T-shirts, and jeans under their gaiters.

Keith and I went with the other, younger George, the moor owner, to the hotel where the Guns were staying, leaving George the gamekeeper to brief his men. To distinguish him, George Thompson the keeper was called 'Tommo', but

not in his presence. I'd introduced myself to him: 'Stay out the way and don't ask questions,' he'd told me. He was spoken of with a wary smirk. From a few feet away his face was a satyric red; close up the red was composed of a network of inflamed veins centred on the plateau of his brow, as if they sprang from that point. 'You get a better class of bollocking with me,' George the owner said, as we rumbled over a cattle grid and made our way to the hotel.

In the passenger seat, Keith, twenty years his senior, made a noise that was not quite a laugh. This man, George, was the overseer: it was his moor, his business. It was not exactly authority that he possessed; there was something about him of the junior officer who has yet to face a gun. But again he wasn't disliked; he commanded a kind of deference that was unfamiliar to me.

It was an old scene in the hotel car park. The men were overjoyed. They'd eaten well and were warm and took pleasure in being in their regalia once again, in feeling the weight of the gun in its canvas or leather slipcase, and anticipating the satisfactions of the day to come. I imagined the early start to get kitted out, their dressing overseen by their wives. They'd be here for two or three days. The weather was fine, and it was likely to stay fine. They knew one another and stood about like schoolboys before an outing. The men seemed dazed with excitement, and their women – slender and glad and sexual, with a birdlike daintiness, and dressed from rural stores – were at once accomplices and servants and, above all, witnesses. Birdlike like egrets. I introduced myself to these women (the men were spellbound by one another) and gave my name, and they cried 'Yes!' and did not offer their names in return.

The men wore oversized waxed jackets, well used, and wool socks instead of gaiters, held up with tasselled garters,

into which their loose plaid plus fours were tucked. They wore thick red ties, and they all wore tweed caps; they all held wooden sticks. But there was variation in their dress – an informality that permitted character to be displayed, or perhaps it was a kind of hierarchy: bright yellow socks, say, or a bright blue satchel-strap, a stick whose head was shaped like a grouse's. One of them wore a glinting cartridge belt under his paunch. The youngest – a tanned Swede whom I took (wrongly) to be the newcomer – wore city brogues, and a white plaid shirt, and white slacks that, at the end of the day, were still white. He stood with his feet eighteen inches apart. His spine was straight and strong as a mast.

The wives perched on the 4 x 4s' open tailgates, arms around their dogs' necks, and laughed at their husbands, as George gave the men their briefing. It was hard not to like them, the wives. They were here to supervise their husbands' pleasure. Mostly they would hunker down at the butt edge, eyes half-closed, fingers in ears, or coddling their dogs.

'My view is that pickers-up who are in range are also in season!' The men liked this. They'd listened to such brief-ings before, and welcomed the irreverence; it was a necessary health-and-safety provision, but also a part of the building excitement, a part of the ritual that would conclude, later, with the counting of the 'bag' over a cup of tea. When the whistle went, said George, it meant the beaters, having har-ried the birds across the moor to the Guns, were in range and forward shooting was to cease. Frames were to be used – two poles planted in the butt-tops to prevent the Guns from turn-ing too far left or right and peppering the men in the butts ei-ther side. It was a reminder, said George. 'Mother-in-law got peppered on the Pennines recently; in fact, two mothers-in-law, and a Gun.' There'd been a peppering, too, on the Dales the week before. On a moor in Scotland, the chief auctioneer

of Sotheby's had got fifty pellets in the face. His protective glasses saved his sight. These accidents are rare enough to be regional news among the keepers, and national news if the victim is a public figure (Guns often are).

'Pigeons, rabbits and crows you're welcome to shoot,' said George. 'Ducks and pheasants are out of season.' There'd be three drives this morning, and two after lunch; from Sledge Shoe Butts, south to Sheriff Butts and Peter Butts. 'We're not expecting saboteurs, but anything can happen. Your primary responsibility is the security of your weapon and ammunition. If they do happen to turn up, I advise you to keep out of spitting range.' The men drew straws from George's fist to allocate their starting butts.

Afterwards, as we set off again, the Guns lined behind in their black vehicles, George said, 'That was rather long. Perhaps I went on a bit.' There was a pause and Keith said, 'Happens all the time.' It was a try at gentle ribbing. George said quickly, 'Pardon?' but I supposed he'd heard. Keith didn't reply.

'They're all right,' is what the beaters said about the Guns, although as they walked out to the butts and back it was not thought proper that the two groups should talk. The Guns were called 'sir', even by these day workers who might come here to beat only once or twice a year. Like the Guns, the beaters too – some of them – took pleasure in the enactment, and relished their part in it. Without them, they knew, the shoot wouldn't happen, the spectacle would be diminished. And yet there was also, among the beaters I spoke to, an acceptance of the shoot's 'barbarity'. It was as if, even for these people of the moors, that barbarity was regrettable, as if even the shoot itself was a sombre duty, a necessity. It was the message I often heard; the ungainsayable defence: without the shoot the moors would not exist. The ling would grow

uncontrolled, wildfire would be rife, scrub would take over, predators would thrive and ground-nesting birds would decline. And the iconic 'purple moors' that drew the tourists would be no more. There was no stridency in these declarations. For them they were accepted truths. But grouse shooting is not an ancient activity – it is not sheep grazing; it barely pre-dates the reservoirs, or the railways, or the ramblers' causey paving. And before the Guns, before the cosseted grouse and the curated heather – consider the Fylingdales rad-haz zone, consider Turner's 1816 painting of Beamsley Beacon – the moors existed.

Up the Blakey Road, past Farndale, onto Blakey Ridge, and then the dismantled railway bed that now serves as a track for walkers and mountain bikers, but which once delivered iron from the works whose huge kilns – a rank of arches in the hillside – were still visible.

George the keeper – Tommo – and his young new underkeeper, Ant, were already there with the dozens of pickers-up and beaters, and the game wagon where the birds would be sorted and stored, and the tarpaulined trailer in which the beaters would be taken from drive to drive. Almost everyone clutched a short white pole – furled flags used to flush the grouse from the heather, made of a long stick with, stapled to it, a rectangle of white plastic cut from a grain-bag. Tommo, standing by his Land Rover, was brash with tension; as the day went on it would ease. He was the other George's employee, but it was his day and he was in charge: if George who owned the land commanded deference, George the keeper commanded something like fear. He had a power to embarrass that his employer lacked. And yet, again, he wasn't disliked. He'd earned that power and was respected for it, as well as feared. And he required the power, of course. He had a temper; he was the kind of man of whom some people say,

with awe, 'He doesn't suffer fools gladly,' and whom some would disparage, given the right company. He had no capacity for squeamishness.

It was the underkeeper Ant's first day of shooting on this moor; he was perhaps nineteen, tall and lean, livid with expectation. Already he was well respected; he was Tommo's man, and one day would wield Tommo's authority. One day, too, if he stuck with it, if keepering continued and there was a future, he too would have those marks of a life spent outdoors. His skin was a boy's; it would weather. His manner was young also – his gentility. He squeezed his walkie-talkie, and it was as if the squeezing drew sound from it – the voice of George the keeper, his boss and mentor, or of the flankers whose job it was to keep the grouse from veering and to report the numbers and patterns when Tommo asked.

I'd assumed each Gun was known to the others, but later, as one of them came to a butt recently given up by another, he intoned to his wife: '*That one* hasn't cleared up after himself,' and I saw that the other man – it was the newcomer, who'd moved on to a further butt – had left a clutch of black shell-cases in a corner of the butt's gravelled floor. There was a hidden seriousness to the men's day out – not only a belief that there was a proper way to do this, but that one was on display, being assessed by the other Guns, friends or otherwise, and that it was important not to shame oneself, or one's wife. It mattered that easy birds were not missed (though they would be). It would go unmentioned, but not unnoticed. Something vital was being upheld, and failure would be present over dinner.

The first line of butts, at Sledge Shoe, started below us at the foot of Middle Ridge and crossed the old railway onto the flat moor above. The Guns who had drawn the shorter straws were located down the hill, where the going was trickier. One of these was called James. He and two other men with their

wives edged off the track and, crooks in hand, down the tus-socked slope; James's wife was standing on the track edge and looking down at him and the other men. 'Will I be able to make it?' James was installing himself in his butt – a newly dug sunken pit, its edges not yet covered with new growth – like a bomb crater. He was laying his sheathed weapon on the butt wall, installing the shooting frame, positioning his satch-els and shells. 'James?' she called. She was frail. Undergoing some treatment.

She began to edge down the incline to join her husband.

'Will you stay up *there*?' he called to her. 'Can't you . . . can't you go with one of the others?'

She put her weight on her stick and stood for a while. She turned and followed one of the other wives onto the flat high moor and took her elbow as they crossed the ditch that ran alongside the track.

The birds were flying low and sparsely. I stood in the bracken and tall heather at the bottom of the ridge, in a deep dell, and waited until a distant line of men and women thrash-ing white flags appeared over the horizon, flushing the grouse ahead of them. I'd encountered these butts for months, sunk-en butts like these, with their stone walls and turfed floors, and their neat upholstering of young heather or crowberry around the rim. And here they were, after a year's disuse (but careful maintenance), occupied by the men for whom they had been built and maintained. Look at them out of season and in ignorance and you'd be hard set to guess what use they might have other than a military one. The weeded turf or gravel floor, the solidity of their walls, the viewpoint, those neat stone steps leading down into each one. To stand there was to feel that you were important; to stand in one with a Gun and attended by dozens of men and women, while the quarry came flashing into sight – that was an experience of

another order. They paid by the brace (two grouse, which might cost £150), but what brought them was not just the opportunity to outdo last year's bag, or even to better the other Guns, but to stand here, amidst the noise and attention of the day, and know that this – here, among the bright heather, with a gun in one's hand and one's wife at one's side – this was one of the world's centres.

There was only the sound of the gun-dogs panting, and the voices of Swaledale sheep filing along the ridge-top. George's dogs – three black Labradors, glossy as cormorants, grandmother, mother, daughter – were restless in their eagerness to please him, brimming with it. There was the occasional dull shot to be heard from the line: the man called James winged one, sending it tumbling into the heather a hundred yards behind him; another he took almost point-blank. There was a burst of feathers and it dropped to the ground ten feet in front of his butt. The whistle blew; the men in the butts tipped their muzzles skywards as they had been instructed. The drive hadn't lasted long; only five or six birds had come over, and fewer still had been shot. 'Just odds and sods,' came a voice from a distant walkie-talkie.

Then came the search for the killed or injured birds. '*Where-is-he*,' said the pickers-up to their dogs. '*Get on. Get on then. Get on. Get on then*,' and the animals crawled over the heather and under the bracken and came up with the limp bodies of the dead or shook the life quickly from the injured, and held the birds with enormous, sombre tenderness, as a mother cat holds her young, and placed the bodies at their owners' feet. For ten minutes the dogs scoured the ground for the bird James had clipped, '*Get on, get on then, where-is-he, get on*,' until it was found, not by a dog but by George himself, who took his flagpole and dapped the dazed bird on the head, before we clambered back up the ridge to join the

others for the second drive. James was very pleased with his performance; could not help grinning when congratulated. It was a good start to his day.

One of the wives – the wives! – in ankle-length trench coat and suede chaps and a wide-brimmed waxed hat – pressed my shoulder as I walked ahead of her and another wife, and held out to me a dead grouse. 'I wonder. I wonder if you might find a use for that.' She thought I was a beater or a picker-up. I smiled and took the heather-bird and swung it by the neck between two hooked fingers, as I'd seen the pickers-up do. Its lightness was a surprise, as an empty case lifted in the hand is a surprise when you expect it to be full.

The beaters had used the word 'barbaric', a word like 'unfortunate'. But I'd seen no barbarism. It was as if the killing had been bloodless. The barbarism was inconspicuous. You pointed your gun at the incoming bird and pulled the trigger and turned it into something else, something that no longer flew, but might be eaten. I removed the protective yellow glasses I had been given and, for some seconds, as my eyes adjusted, the sky, like the moor, was lit with violet.

Beating is waiting. The sun was warming the moor. South of here was Lastingham; to our right Lastingham Ridge. Hold the line, hold the line. It is waiting, and listening: this afternoon, just the noise of bees, and Ant's walkie-talkie, and the breeze, and underfoot the crackle of dead heather. The ground where I stood was not purple or black but white – scattered with white stalks burnt last year. To my right was the rise of the ridge, with the silhouette of a beater at its top; to my left, half a mile off, the road from Hutton-le-Hole to Rosedale Abbey. For twenty minutes we stood in a line, half a mile long, from end to end, waiting for George's command. It came, and the line was made to push forward.

The line must be kept, its course to the Guns carefully measured and monitored, which, for the keeper controlling the line (Ant), means knowing the moor and holding its shape in his head, its knolls and inclines and becks. The line had also to be shaped – it was not the beaters' job simply to harry the grouse from the heather, but, with the flankers, to enclose the flushed birds in such a way that they were shepherded to the butts. As the line homes in, therefore, its curve must intensify, so that each member remains an equal distance from the line of butts as it is approached. For Ant (his first day!) this meant knowing the terrain, knowing the route from the starting point to the Guns, and commanding his line – 'Slow *down*!' 'Hold the *line*!' 'Keep *up*!' – when, with perhaps fifty metres between each member, only those on his immediate left and right were able to hear him. A beater did not require skill, exactly, but you needed to be fit in order to maintain your course through knee-high heather and knee-deep becks.

The Guns were in sight and within earshot. The whistle went. The white flags were raised and the guns ceased. Smoke and feathers hung on the air. You could feel the Guns' excitement settling; it was wet-lipped, pitiless. The dogs were panting in the heather.

At the roadside the drive's kill was sorted into crates according to age – a pile of perhaps a hundred, young and old – which were slid into the game wagon. One had been dropped on the dusty track and I carried it over to the wagon and was again struck by its lightness, and its human warmth – the warmth a child gives off when sleeping. Its eyes were shut, its beak slightly ajar, its neck between my fingers so soft as to be barely tangible. It was not 'red', any more than the moor was purple; rather a brindled motley of reddish brown and orange-brown and black and greys and white. It seemed that

you'd need to eat a dozen to satisfy the appetite generated by a day's shooting.

It was exquisite. I held it to my nose and the smell contained in the remaining warmth was the smell of the flowering heather.

James's wife was slowly walking ahead of me to her vehicle, a walking stick in each hand – it had been a long, hot day; ten metres ahead of her was James. He called to another Gun: 'I expended a certain amount of ammunition futilely!' – jovially, self-mocking, enjoying those eight words' reserve and irony, but also addressing *himself*. He said it again: 'I expended a certain amount of ammunition futilely!'

It was easy to imagine him and his friends – or their fathers or grandfathers – hunting in the preserves of, say, British East Africa, the plus fours replaced by Jaeger flannels, tweed caps by khaki helmets, elephant guns in place of shotguns. And to picture those men of an earlier generation exclaiming one to the other: 'I expended a certain amount of ammunition futilely!' – and treating their gunbearers and porters kindly and with good cheer: an extravagant tip, a clapped shoulder, the sharing of a water flask; and to imagine those African men and boys in turn thinking fondly of the visitors and looking forward to their return, when they boarded the homebound steamer stowed with ivory and pelts.

Before I left, George the keeper – Tommo – came up to me, a grouse in one hand, its eyebrows nipple pink. He was relaxed now – the day had gone well, the season would be respectable. He could afford to be genial. 'This is what we do,' he said, lifting a hand to my face and swiping a blooded thumb across my cheek. Later, before the convoy of black 4 x 4s snaked silently away from the moor, I looked in one of the vehicles' wing mirrors. There was nothing on my cheek, there had been no blood.

III

8. The Watershed

Alston Moor

I

In one of the biographies is a photo of the subject aged six, posing awkwardly over a Neolithic standing stone on a rise of spring moorland. According to the caption, these are the hills above Goathland. It is 1913, a year after the publication of Elgee's *The Moorlands of North-Eastern Yorkshire*. Like Daddy Whitehead, he is unusually pale, pale as a rhizome. The moor about him was burnt last year, and is scattered with broken stalks of bracken and whitish gouldens. He's buckled up snug in tweed jacket and waistcoat.

By 1947, the subject of that photograph – Wystan Hugh Auden – had moved to America, and settled for the summer with his partner, Chester Kallman, in a tarpapered shack on Fire Island, a sandbank off Long Island. They named the hut 'Bective Poplars', after the Irish home of its co-owner, James Stern, and Auden's grandmother's house near Repton, 'Poplars'. And on one wall – 'immense', according to one report – was a map. No irony was intended by its presence. It seems to have been the one-inch Ordnance Survey edition from 1937, or an enlargement of it. The region it depicted was the centre of what Auden called 'My Great Good Place . . . bounded on the S by Swaledale, on the N by the Romans' Wall and on the W by the Eden Valley'. In his long poem 'New Year Letter', written when he was thirty-two, he reiterates the map's boundaries:

> I see the nature of my kind
> As a locality I love,

Those limestone moors that stretch from Brough
To Hexham and the Roman Wall,
There is my symbol of us all.

For Auden in adulthood, Alston Moor was chiefly that map: its boundaries, rivers, passes and mines. But this moor, some one hundred miles northwest of Goathland, was also a remembered place. In time, Auden became distanced from the land; his viewpoint rose from the earth's surface and its evidences, and assumed a satellite's perspective – a mapmaker's. From the land's people he had always been distant: 'nameless to me, / faceless as heather or grouse, / are those who live there', he wrote in 'Amor Loci'; elsewhere 'why bother with people?'

It was those remnants – the abandoned mine works (their abandonment was crucial), the 'scribbles' made by the miners – that had moved him as a boy. For six-year-old Wystan, standing for his father's camera on the North York Moors, his envisaged grown-up self was not a cragged transatlantic poet. 'From my sixth until my sixteenth year, I thought myself a mining engineer.' It might have happened – his older brother became a geologist with the East India Company.

Whether it was his reading that inspired his first visits to lead-mining country, or those visits that prompted him to read, we know that Auden's 'nursery library' contained not only fiction (*Journey to the Centre of the Earth*, *The Child of the Cavern*, *King Solomon's Mines*, Sherlock Holmes) but volumes of a more esoteric kind: Stanley Smith's *Lead and Zinc Ores of Northumberland and Alston Moor*, E. H. Davies's *Machinery for Metalliferous Mines*, and Thomas Sopwith's *An Account of the Mining Districts of Alston Moor, Weardale and Teesdale*.

Sopwith had been a land agent for an Alston lead company and left a 167-volume diary of his experiences, written over fifty-seven years. An extract from his account of a mine visit

was included in Auden's 1971 'commonplace book' *A Certain World* ('Parties of ladies and gentlemen desirous of visiting mines can have suitable dresses provided by the landlord of an inn . . .'). In the same anthology appeared Auden's own, adult description of the moral significance of the Great Good Place:

Between the ages of six and twelve I spent a great many waking hours in the fabrication of a private secondary sacred world, the basic elements of which were (a) a limestone landscape mainly derived from the Pennine Moors in the North of England, and (b) an industry – lead mining . . . From this activity I learned certain principles which I was later to find applied to all artistic fabrication . . . In constructing my private world, I discovered that, though this was a game, that is to say, something I was free to do or not do as I chose, not a necessity like sleeping or eating, no game can be played without rules. A secondary world must be as much a world of law as the primary.

The trip to Goathland is likely to have been in connection with his father's links to York, where Auden was born and lived until the family moved to Birmingham a year later. It's known that he visited the lead-mining settlement of Rookhope, close to Alston Moor, in 1919, a year after he had received, as a Christmas present, *Machinery for Metalliferous Mines*. He returned in the summer of 1922. Around the same time, Dr Auden bought a holiday cottage in Wescoe, on the edge of the Lake District. It was from here, over the years, that Auden made forays to the moors around Alston, Nenthead and Rookhope, alone or with his brothers and friends.

In a tourist guide of 1935, entitled *Quaint Alston*, the authors (named only as 'MacKenzie & MacBride') observed that 'English people seldom think anything of a view unless many men have proclaimed its beauty'. In his 1933 memoir, *Pilgrimage from Nenthead*, Chester Armstrong, the son of a

miner, wrote of the landscape, 'It presents a violent contrast
to all that is exquisitely beautiful in scenic effects. Therefore,
to those who have taken full meed of rapture from the gran-
deur of the Lake District . . . Nenthead will hardly suggest
itself even as a temporary place of abode.' But the very fact
that Alston Moor was not the land of Wordsworth, that it was
undiscovered, or rather passed over, was part of its appeal.

Auden was no Man of the Moors, no Ted Hughes or Frank
Elgee. Being unburdened by any existential relationship to
the land, he came to 'love' Alston Moor 'more than any other
place', according to the geologist brother. What was here and
beneath the surface became a symbol, for the older Auden,
of what love – of God, of men – might be. Its faults (and not
only geologic) were undisguised. The world he had created
as a boy – the sacred, secondary Eden that was a version of
these moors – continued to be developed and lorded over by
the adult poet. In 'Amor Loci', written in 1965, he asks

> How, but with some real focus
> of desolation
> could I, by analogy,
> imagine a love
> that, however often smeared,
> shrugged at, abandoned,
> by a frivolous worldling,
> does not abandon?

From the train to Carlisle I had seen the ridge of the North
Pennines ten miles to my east, and rising from it the snow-
plastered table of Cross Fell – 893 metres, said the map –
static in its vastness as the near world furled by, the green
world of pasture and woodland. This route was one Auden
knew well – a line of transition, from the postcard Lakes,
raucous with Wordsworth 'pilgrims', to the depopulated,
unwanted limestone moors that were lying beyond that

towering barrier. 'It is not an area for those who like their landscape cosy.' Nor, he admitted, 'will it do for those who crave the romantically wild, jagged precipices, Salvator Rosa gorges, Wagnerian tempests'.

If desert and sea are 'lonely places of alienation', he wrote elsewhere, it is 'precisely because they are free places'.

2

At the Hartside Cafe – 'the highest cafe in England' – Tom Pickard was wearing a dark green fleece and a big black quilted jacket and big-pocketed combats. He had grey stubble and yellow-tinted glasses, and a tussock of grey hair that appeared to be caught in a fierce crosswind even when he was sitting quietly over his coffee. Tom has the hushed voice of one who has known long phases of solitude, but he can be moved to a sudden volubility. His anger isn't buried deep. He is a poet; one-time friends with Ginsberg and Creeley and Gordon Burn; the late Basil Bunting was the great mentor, the ruthless editor: 'Take a chisel to write.'

Tom was born in 1946, in Newcastle. There was the period dealing books, after leaving school at fourteen; there was the first marriage, the extraordinary years running the live poetry venue in Newcastle, then the marriage to the Polish lass, the time in Warsaw during the Solidarność era; the years in London squats, selling books at Camden Market; the lost house, the bankruptcy . . . And then that long period, living above the cafe, here at the highest point of the escarpment, two miles from the nearest dwelling, watching the moors, and when it closed in, watching the weather.

'I went to look at the flat and I thought: "Fuck me, I'd be an idiot not to live here."'

He came to 'lick his wounds' after his marriage ended. 'It

also turned out to be furthest possible from any job the dole could send me after.' He stayed for nearly a decade, until the wounds were clean, if not healed; he became deeply familiar with the cloughs and fells and curricks, the walls and plantations and derelict farmhouses and barns and mines; got to know the routines of crows and mist. He befriended the lasses who ran the place. He knew Fiend's Fell, half a mile south of the cafe, personally, and he had written about it – hundreds of thousands of words, in dozens of notebooks – as if it were a criminal sibling who was loved unconditionally. He was still trying to find the time to cut the journals down to size.

He'd first arrived in June. 'June can be extremely beautiful.' In the summer the cafe thrives; it is busy with bikers and holidaymakers and walkers. The benches outside are thronged at the weekends; couples eat their sandwiches and stoop to read the interpretation board. (The Hartside Pass, it says, was built by John Macadam himself, to boost the growing mining industry: 'On first surveying the roads of the area in the 1820s, he reported they were "the worst that have yet come to my knowledge".')

In October, the women depart, return to the lowlands; the 'closed' sign is turned to face outwards. A kind of transhumance. The cafe stays closed till March: there is little custom to be had during the winter months, and those who get out of their cars, at this altitude, quickly return to them. There are two existences for the building, then: the bunker of the winter, and the place of meeting and commerce and celebration of the spring and summer. For ten years Tom knew this cycle – the harshness of the solitary winter, when the water froze up and the road was unploughable for weeks; then the warmth and industry of the summer.

'Some days it'll be foggy but suddenly it'll lift and you might see half a mile, a mile, and then it'll close up again. It

is always, always changing. I'd sometimes see the hill mist blowing up one clough and going down the opposite direction in another one. You'd see these contrary winds going in opposite directions. The hill mist slides up the valley and slopes down over.'

It had been misty in Alston, when Tom picked me up, but as we had risen, the mist yielded to an aviator's clarity: from the cafe windows it was a coastal view, as if the moor sloping from the terrace were a beach descending to the shore of mist. From time to time, during his ten years stationed here, Tom had watched a short-eared owl, he said, 'surfing' ahead of an incoming tide of fog. For him the mist and fog had become, over the years, something with shape and texture and nuance: not a white blind but a tapestry. Likewise, the moor, as he had observed it, had ceased to be a simple place, and had developed a richness and complexity as unfathomable as an ancient forest.

He was conscious of the phoney heroism of what he had done, the tarnished romanticism of the solitary gone to ground. 'I think of myself as a fells *flâneur* rather than a Wanderer above a Sea of Fog.' It had not been a sojourn: it had become his life. Nor was this a monk's cell; it was an extraordinary theatre, as often above the clouds as below them or within them. There was silence but it was not the silence of the monastery. 'I accrete –' he had written, 'lichen to limestone / sphagnum to peat.'

3

Moorland's boundaries are tidal: since the eighteenth century, the trend has been piecemeal shrinkage, or rather a bite-by-bite conversion. 'Could the England of 1685 be by some magical process set before our eyes,' Macaulay wrote

in his *History of England*, 'many thousands of square miles which are now rich corn land and meadows . . . would appear as moors overgrown with furze or fens abandoned to wild ducks.' Of an estimated seven million acres of 'waste' in England and Wales at the start of the eighteenth century (heath, fen and marsh, as well as moorland), some two million had been enclosed by parliamentary act by the end of the nineteenth century. Those unbroken, unexploited voids, such as John Knight encountered on Exmoor, were a provocation – to turn them to use was no more than an Englishman's duty. But the story is not only one of attrition; the rate of reclamation – and of reversion – is influenced by the ebb and flow of factors economic as well as political: although the greatest surge in moorland 'improvement' occurred during the Napoleonic Wars, the economic privations that followed Waterloo allowed the moor to encroach once again. Even as John Knight was establishing his foothold on Exmoor, a farmer nearby in Kingsbridge, Devon, reported to the Board of Agriculture that 'the great enclosures taken from moors and commons are quietly resigned to their ancient possessors, the heath and furze, and the vast sums expended improvidently, in subjecting lands of very indifferent quality to cultivation, are lost forever'.

The economic depression of the late nineteenth century similarly saw a relinquishing of improved land to the moor, with the overall area of 'mountain and heath' in England increasing by a quarter. In turn this trend was reversed during the second half of the twentieth century, with English moorland declining in extent by sixteen per cent between 1950 and 1980. Today, about eight hundred thousand hectares of the English uplands lie within DEFRA's 'moorland line'. 'Officially', therefore, moorland constitutes about six per cent of England's total area (the non-official extent, of course, will

not be calculated, since the edges of what is called 'the moor' in any particular place are as hazy as those of the sky).

Given the right conditions, moor will quickly make its incursions, or rather retake ground it has surrendered. A farmer's drains collapse; an intake field is left ungrazed for a year or two – the moor will revert. And, in turn, that reverted land will, if necessary, be reclaimed once again – re-reclaimed. It is no wonder that Ammon Wrigley could talk of 'making war' on the moor.

Any land's owner requires that its bounds be established, that the commercial entity be defined. In the past he would commission a perambulation. When King John disafforested the county of Devon in 1204, the bounds of the Forest of Exmoor (excluded from the charter) were confirmed by a cavalcade of knights. In 1240 Dartmoor too was perambulated (that is, circumnavigated) to refix the 'markes, meeres and bounderies' of Henry III's hunting grounds. In the eighteenth and nineteenth centuries, enclosure acts once more required that the boundaries of what had been common grazing land be established – the land measured and valued, the new allotments marked out and mapped.

'Alston Moor' today is the name of a civil parish – an administrative unit, and smaller than the 'locality I love' delimited by Auden in 'New Year Letter'. It lies in the corner of Cumbria, close to the point where that county abuts Northumberland and Durham. In his copy of *An Account of the Mining Districts of Alston Moor*, the would-be mining engineer would have read Thomas Sopwith's description of the manor of 1833, which, he writes, 'nearly resembles a square of about 6¾ miles, containing about forty-five miles or 29,000 acres. It consists, as its name imports, chiefly of wild and barren land.' In 1629 the manor with all mineral rights was sold to Sir Edward Radcliffe, son of the Gunpowder Plotter Sir Francis. In

1716, Sir James, Earl of Derwentwater, was beheaded for his part in the Jacobite uprising of the previous year. His manor of Alston Moor, with its eleven working mines, was forfeited to the crown and in turn conferred to Greenwich Hospital, which remained the owner of the moor – and its minerals – until the 1960s. In 1761, in order to establish the limits of its territorial rights, both above ground and below, the hospital commissioned a perambulation.

The receivers wrote to the board that 'in doing this we had great difficulty, it not having been perambulated in the memory of man living'. It was, they said, necessary to find 'several old people . . . and by those we were directed in our perambulations from one bounder mark to another'. Eighty-one men took part, including 'a considerable number of young men . . . that in case there should be any dispute hereafter, they may give evidence'. During the eighteenth-century perambulation, or 'beating of the bounds', of Exford parish in Exmoor, children were held upside down at each bound-stone and given a sharp pinch: remember *this*!

The perambulation of Alston Moor took three days and was accompanied by pennant-carriers and musicians. A function of pageantry is that it should be unforgettable. The journey began at Ayle Burn and went on to Blacklaw Cross, and 'from thence as the Heavens water divides to High Raise, from thence (crossing the road leading from above Nentsbury) to Wellhope Head, from thence . . . to a place fifty yards east of Killhope Cross . . . from thence up the Tees to the head thereof, from thence to the summit of Cross Fell . . .'

And so on, for seventy miles. The eighty-strong procession, young and old, with its jesters and musicians, cooks and guards and scribes, was following the lines of watershed of the rivers Wear, Tyne and Tees, as if filing along a series of tightropes. It is possible to join the points on the modern

OS map, 250 years later. Whatever precedent existed for the boundary, it is noticeable that there's barely a shaft, level or quarry that falls outside it. As the Heavens water divides.

4

Joan Rockwell came to Alston in the 1970s. In the town library I found a copy of her account of her experiences. The book was called *Chronicles of Alston* – 'a retired American academic's lively and wryly humorous account of just what it is like to move into a market town in the north of England' – and almost every page had been defaced: a blue biro gripped in a blue fist. 'Rubbish'; 'Total rubbish'; 'Nonsense'; 'How?'; 'Where?'; 'Certainly not here'; 'Hardly' . . .

It went on; it was relentless. Scarcely any assertion Joan Rockwell made was allowed to stand – dates, names, locations: all were incorrect. It was not so much a matter of vandalism, or even pedantry (the scrawler wasn't exactly authoritative), as of repossession – or rather of *snatching back*. Her memoir concluded, having named names and preserved hearsay in cold ink, with an assessment of her erstwhile home's present condition: 'Now we are on the downslope: the many houses for sale, the empty shops whose optimistic owners have gone bankrupt, the many deaths – twenty-two, between Christmas and Easter; what seems like the relentless accumulation of illness in the middle-aged: asthma, blindness from diabetes, strokes, heart attacks. The town seems drawing in on itself.' It was, at least, drawing away from Joan Rockwell. She ended with the hint that her sojourn was coming to its end. Before the book was published, I'd been told, she'd moved away – 'to Sweden, or Norway'. The book's last words were not hers, but those of the anonymous commentator:
Good Riddance.

I wondered if he or she (the person with the biro) was still active. The date stamps showed that the book had been popular with borrowers, for a while. Now it had a label on its spine: 'Reference only'.

Hazard the following: Alston lies on the thousand-foot contour. It was famed for its strongmen and wrestlers. It is blackly shadowed even on a bright day; at night the street-lamps struggle to breach the massive darkness, and the only sounds are the tyres of infrequent cars jouncing up and down its steep cobbled streets.

The Methodist hall, after it was abandoned, was bought by a firm of architectural metalworkers, as a foundry and show-room. On the roof's gable ends they displayed a sample of the foundry's work: twin steel griffins. The local Methodists, those who were left, having lost their draughty hall, having seen it turned into a place of commerce, beheld the two-foot myth-birds, with their outstretched wings – and were un-happy. One winter, one of the griffins' wings became partly detached, and for months dangled thirty feet above the street by a single thread of metal. It would 'have somebody's head off'. And it had fallen, eventually, though nobody had seen it happen. Now they stood there, darkly, against the moorside, one of them with a wing too few.

From the rear of the Anglican churchyard, where the ground falls away steeply, you can make out the earthwork ramparts of Whitley Castle, the old Roman fort of Epiacum. It was built beside the Maiden Way, which connects, fifteen miles north, with Hadrian's Wall (whose builders knew *all* about peatlands). The first written record of mining on Al-ston Moor appears in the twelfth century, when a silver mine was serving the royal mint at Carlisle. Whitley Castle today is just a terraced table of moor looking back down the valley, but fragments of lead pipe, ore, slag and fluorspar unearthed

at the site suggest that it was established by the Romans as a lead-mining base and trading centre. In Brough (one of Auden's boundary markers), Roman seals have been found, indicating a trade in 'metal' from the moor – lead for the empire's waterworks and baths and coffins: pipes, culverts and linings. The molehills scattered over Whitley Castle have been sifted by archaeologists (digging is prohibited). In one, a tiny bead of jet was found. Sitting on the summit of another, a bronze scraper in the shape of a dolphin.

The Nent was full as I followed it upstream the following morning, its brown water roiling, broiling over the cracked cups of its limestone bed. Where harder stone gave way to softer – a waterfall. The limestone that gives these moors their form is by no means malleable, but no mere stone can equal the patience of water, and the pipings, scoopings and chamferings visible in the bedded stone report its long association with water. Roll back the grass and peat, and the hillsides would show their striped profiles: shale/sandstone/limestone/coal – each laid down as successive oceans filled and lingered and drained: mud and sand becoming shale and sandstone, vegetation becoming coal, the bones of sea creatures tamping into limestone.

Quarrymen and miners knew the varieties, and their uses: the grindstone sill, four fathoms thick and good for millstones; 'crow coal', smoky and cool-burning; the whetstone sill, named for its purpose; the firestone sill, quarried for building; the slate sills for roofing; the six-fathom hazel (a wall builder's sandstone); then the miners' limestones: Tynebottom, cockleshell, three-yard, five-yard, fell-top, little; then the scar limestone, second only in quality, according to Thomas Sopwith, to the 'great limestone'. It was within the limestone that the best lead deposits were to be found, and in the harder 'great' limestone most abundantly of all.

Limestone is jointed, inherently flawed. Into its flaws water infiltrates, installing fissures and sinkholes, corridors and shafts. Sometimes a stream will vanish into the moor – or emerge out of it, singing. The moor's surface is prone to dimpling, and it is these dimples, caused by underground limestone giving way, that are referred to on the map as 'shake holes'. I began to have the feeling that the ground was as much void and water as solid matter: the already honeycombed stone tunnelled out in turn by the miners' levels and shafts, like floorboards so taken over by woodworm that only a crumbly lattice remains.

Drill deeper (much, much deeper) and there is granite. Its existence was purely theoretical, until, in 1961, it was proven by the geologist Sir Kingsley Dunham, who sank a six-hundred-metre borehole into a hill above Rookhope. This granite, in its molten state, warmed and enriched the mineral solutions that surged into the faults in the overlying strata and left those deposits – lead, but silver too, and fluorspar and zinc – which man, when he came, would wish to recover. The lead ore did not lie down in solid fields – as, say, ironstone did, obediently. Rather it was to be found within vertical and near-vertical faults, as linings and clumps, and in the horizontal seepings, 'flats', that branched from these faults. Thomas Sopwith, looking out onto the moors below Cross Fell, eulogised the Creator who 'even in the barren hills poured hidden treasures of wealth for the service of His creatures' – but surely Sopwith, a mining agent, must have wished that He had not made those treasures so perilous to gather.

5

At Gossipgate Farm the undersides of the gate bars were ribbed with ice-blebs. The cattle's hoof-prints had filled with

water and each such cup had its creased skin of ice. The sun came up over the eastern hills, and scarcely seemed to rise further all day. Its brightness was of the kind that seems to dazzle not only vision but every sense. All day I kept the peak of my hat pulled down, twisting it to one side or the other according to the sun's bearing.

As I climbed through the fields towards Blagill, the terrain's shape was exposed: to my left a steep turf ascent topped with a ruined barn, to my right the six-hundred-metre upsurge of Middle Fell, the boss of tunnelled moor that stands between the South Tyne and its tributary the Nent, and is Alston Moor's centre. On the geological maps, Middle Fell is scarified by dozens of short lines marking the course of the veins, which in turn are shadowed or intersected by the miners' levels and cuts. There are more ways of passage beneath the ground than atop it, and, as I would find, it is sometimes easier to go from one part of the moor to another underground than over.

Far behind me, the great rise of the watershed and Cross Fell, its edges bright with snow above the four-hundred-metre line. From the field corner, twenty metres away, came a soft *ding*. It was repeated and I stopped and waited until it sounded again. A rusted oil drum, newly exposed to the sun, was emitting its music as it heated and expanded. My boots were soon damp; the land had not drained all year, and the valley sides were thick with rushes. The pale moor sedges shone like brushed hair; the dark rushes seemed to reflect no light. *Dong*, went the oil drum.

Bulmer's Directory of Cumberland of 1901 states of Alston Moor that 'over a wide extent the traveller searches in vain for a single spot of beauty on which to feast his weary eyes'. But Chester Armstrong saw the place more subtly, with the eyes of a native: 'Here is the type of beauty which suits my

present mood'; and on a bright clean morning beauty was not hard to find. Still it became obvious, as I edged along the moorside, that the miners' leavings were more than the 'scribbles' Auden described. The moor's interior had been picked out and tipped and folded into its surface; the giant trappings – chimneys, flues, culverts, dams, washing floors – had been discarded. The land had been visibly toxified. You saw Auden's 'focus of desolation'. The miners and their families, ever since the Romans built their camp, had lived among the mess of their ancestors. In the final decades, it was to the mess that the agents turned, and from the mess – the heaps of overburden and rejected ore ('deads') that are a mine's largest product – they extracted the stuff that their predecessors had lacked the reason or knowhow or will to claim: zinc, fluorspar, silver.

I walked for some time in the cold shadows of pines – the moor had been subsoiled and trenched and these conifers planted to feed the mines' need for props and the smelter's hunger for fuel – and the line where shadow gave way to light was also where the open moor began. The leafless roadside birches were black against its lit surface. On the moor itself vegetation had returned, but as far as the hilltop a half-mile away the surface was densely morained with spoil, and on the steeper faces of these hummocks, where the vegetation had slipped away or struggled for a footing, a glimmering dark interior was exposed.

For a region that is now so sparsely populated, Alston Moor's map is crowded with text – along every valley side: 'Levels & Shafts (disused)', 'Area of Disused Workings', 'Shafts (dis)', 'Quarries (disused)'. The words on the map are the clearest relics of the moor's past, and of a community that was once considerable. In 1777 the population of Alston Moor was 5,500; by 1831, at the height of mining prosperity,

it had risen to 6,858. In 2001 it was just 2,000. *Disused disused disused.* Even on the map, the aftermath of humankind's attention is overwhelming. This is the history of the moor; what has made its surface and its people: the staging of man's efforts to chip a useful stuff from the overwhelming matrix in which it is stuck.

I went east along the moor edge, passing alongside another small plantation, redolent with pine-scent and, inside, as lifeless as a derelict warehouse. I crossed Foreshield Bridge, then climbed north across the open moor towards the wayside marker called Blacklaw Cross, named in the 1761 perambulation. The watershed and ridges were being relieved of their snow as the day warmed. Turning, I saw a rill of incandescent mist rising over Cross Fell ten kilometres south; but for its torn upper edge, it might have been a glimpse of sunlit sea. It moved across the hills towards me even as I watched, but when I turned to look again, five minutes later, it had gone.

As the moor rose and wettened, the dry grass gave way to bogland mosses. Pillows of star moss, and cloudberry, bog asphodel, cotton-grass; the juicy, peat-building sphagnums, so clean and soft that they had once been harvested for the dressing of soldiers' wounds. At the hill called Bell's Moss I stood and looked north to the Cheviots, the Simonside Hills, and the Otterburn military ranges, where my landloping would come to an end in a few weeks' time.

On the hillsides around me were other ruins, of farmhouses and barns. It would be possible to map the contours of ruin – of disuse – I thought, the altitude above which most buildings had been abandoned. What was not clear to me was whether it was opportunity that had made their occupants leave, or necessity. At the site of a ruined farmhouse above Nenthead, I crouched and looked into the cellar, and found it was still packed hard with snow.

The land was scattered with lead-mining shafts, indicated by ring mounds, turfed calderas ten feet across, whose interiors were wet and thick with rushes. Most of them had been capped with concrete blocks or railway sleepers. These rings, being made of upthrown limestone, supported a greener, more succulent grass, and sheep were often loitering on them when I approached. The shafts, resembling inverted chimneys, had been the early miners' way into the ground. Wooden rungs would be hammered crosswise, a foot apart, into their walls.

I became lost in a fastness of rushes, and walked for an hour, from one shaft-mound to another, as if going between islets in a lake, until I emerged onto an unmapped track.

6

A drilling rig had been spotted above Nenthead, and in the *Herald* was the story: 'A one million US dollar exploratory drilling program in search of a major zinc–lead deposit in the North Pennines has just been announced.'

The men in the Turk's Head in Alston, when I'd spoken to them last night, had been sceptical. It wasn't lead or zinc the drillers were looking for, but 'rare earth elements' – scandium, neodymium, lithium – for mobile phones, electric cars, wind turbines; or, worse: the drillers had been recruited to locate deep cavities for the disposal of nuclear waste. Down the steep hill, in the Cumberland Arms, I'd found the Irish drillers sitting at the bar, red-faced, and tiredly flirting with the barmaid.

The name of the company that had commissioned the drilling was Minco. Its press release stated that it had 'mobilised Irish Drilling Limited' to begin a 'major new exploration initiative in the North Pennine Orefield . . . the largest

area of carbonate-hosted lead–zinc mineralisation within the United Kingdom'.

The Pennines had been extensively mined in the past, from the mid seventeenth century to well into the twentieth. Thus the drilling (this was the message) was a continuation of the region's long history, a resurgence. 'Minco believes that there is significant untested potential for zinc–lead mineralisation at the base of the Carboniferous succession.' Each borehole would penetrate five hundred metres, deep into the massive Melmerby limestone, far below the level of the 'great limestone' known to the old miners. There had been a public meeting in Nenthead – the young men had been avid for news. Five hundred new jobs had been mentioned. If there was dissent or concern – about the environmental impact or increased traffic – neither were vocalised. In Nenthead, at least, there was goodwill towards the prospectors and their spokesman. There was applause as the meeting closed.

Until 1753 Nenthead did not exist. There was merely a sopping valley high in the moors – the three burns that formed the head of the Nent – and a few cottages around some levels and shafts. It was the 'Quaker Company', having acquired the leases from Greenwich Hospital, that dominated and shaped the industry, and founded the modern village. The Governor and Company for Smelting Down Lead with Pit and Sea Coal (as it was formally known) had been founded in London in 1704, and its founders, board and shareholders were principally Quakers.

The company had a reputation as a paternalistic employer. While it was possible in 1880 for the company's agent to state that 'we have reduced wages below the excessive figures prevailing last year and in consequence have reformed the morals of the miners', a report two years later stressed that

the miners' wages were 'always to be equal to their support and comfort' and 'the price of food must always be taken in to account'. Excess remains impossible here; but nor, it seems, were the company's men allowed to suffer the kind of gross privations and ill health of other mining districts. At Nenthead a reading room was built, day and Sunday schools established, sanitation and medical treatment improved, and a cricket club founded. Land was given by the Quaker Company for the building of Methodist and Anglican chapels; a horticultural society was formed; the Miner's Arms was bought out and the landlord's rent reduced – 'the miners preferring books to drink'. When the village was expanded, in 1825, a market hall and four-faced clock tower were added, and later a water supply was laid on and a wash-house built. The clock was visible throughout the village, and from the surrounding hills.

1795 was the year of the bread riots. Throughout Britain it had been a wet spring and an unproductive summer. On Alston Moor the dearness of bread was exacerbated by high prices charged by millers and dealers, and by the cost of bringing grain over the moor from Newcastle. The Quaker Company sent regular contributions from London for the relief of its workers, and directed its agents to buy the old lead mill at Tynebottom, which was refitted as a corn mill. According to the company's Book of Deputations, in 1818 'Miners expressed their thanks to the Court for many acts of kindness, for the provision of "shops" [on-site accommodation] and most particularly for the provision of schools.' In 1830, while agricultural riots were occurring in the southern counties, the mine agents recorded 'great present distress, but good conduct of the miners very marked. Cannot be spoiled by the vile example setting by the labourers in the south.'

It was munificence, but the founding of the mill and the village of Nenthead itself, and the provision of grain, also

recognised what any miner knew – that even the most robust machine will seize up, and fail, if its maintenance is neglected. Nor was it possible to remove danger or hardship from the work. Where accidents happened they were recorded as results of the victim's carelessness. In 1855 Joseph Wallace was killed in Smallcleugh Mine due to 'carelessness on own part'; in the same year another unnamed labourer was 'injured in head by a shot, at Little Eggleshope mine, not attending to rules'; in 1859 John Robinson was killed in Caplecleugh Low Level 'by a fall of stone, result of his own carelessness'.

Dominating the village, still, is the zinc-ore dressing mill, the 'gravity plant' (what remains of it) – now the Wright Bros bus depot. It was built in 1919 by the 'VM', the Vieille Montagne Zinc Company, the Belgian firm that succeeded the Quaker Company. The brick-built hangar originally had six storeys; there was no bigger building on the moor, few bigger in all Cumberland. For the miners of Nenthead it was a cathedral suddenly throwing their homes into shadow. The VM reopened the 'depleted' lead mines of Smallcleugh, Rampgill, Caplecleugh, Barneycraig and Rotherhope, extracting further lead as well as zinc, and reprocessing the old heaps of waste. The history of mining is, in part, this quest to extract yet finer proportions of valuable matter from the former rubbish; an apparently unending process of refinement.

Like the mine at Killhope, three miles from here, Nenthead Mines had been regenerated, and at the entrance to the original works was a car park and a welcome sign: 'An adventure in silver and lead'. The car park was empty, the exhibition centre and shop padlocked, but the site was still accessible. On the sign were four faint whitewash handprints.

The lead-ore washing floor resembled a Roman marketplace exposed by archaeologists. It was a flat space carved

into the long, narrow mining valley, a half-mile up from the village. At first I assumed that the work had been done in the open air. This place had been the mine at its most bustling. The flagstones were still intact, so too the massive 'bouse teams', brick-built bays where the ore or 'bouse' was heaped before being broken up, and crushed and washed by the washer boys, and handpicked and sieved and handpicked once more, until even the smallest shards and beads of lead had been recovered for the smelter.

The VM expanded the workforce with foreigners; the 1911 census records five Swiss, eleven Germans, a Frenchman and a Hungarian, as well as forty-one Italian miners, most of whom had come from the Macugnaga gold mines in Piedmont. The manager in 1897 was a Belgian, Jean Fernau, who came to Nenthead with his Spanish wife, Magdalena. As well as manager, he was churchwarden and president of the cattle show, and it was he who gave the speech at the village's jubilee celebrations. In June 1903, when Fernau and his family left Nenthead, he was presented with a black marble clock, inscribed, and a gold watch-chain. By the end of July, less than a month after his departure, two hundred men were on strike – an occurrence without precedent on Alston Moor.

On arriving at their underground workings, the men would pause briefly to rest from the exertion of their journey from the surface, which might have taken up to an hour. When lunchtime came, at 10 a.m., the men would retire to a cooler, more spacious part of the mine to eat and rest. At the end of each shift the workings were blasted, and once the air had cleared, the following shift took over.

In July, soon after Fernau's departure, a list of revised rules was posted at the mine entrances: no longer would a break be permitted on arrival at the working, you were to start drilling at once; no longer would you be permitted to retire from the

workings for lunch, you would crouch at the face to eat, or sit on the ground. A settlement might quickly have been reached respecting these affronts, had they not been compounded by a third. Thenceforth, said the orders, each new team would go to its workings without delay once the previous shift withdrew; there would be no 'waiting for the air to clear' after a hole had been fired. It was this that prompted the walkout. Every miner's child knew that the fumes, dust and smoke generated by dynamite blasting would rob one of sense and consciousness, and must be allowed to disperse. There was a time when Fernau himself had doubted this, they remembered – until, going into a newly fired hole to see for himself, he was overcome and had to be carried up to the surface. It seems likely that Fernau would have been aware of the changes about to be proposed by the company, and this may explain his departure.

They had no union, but the workers were well organised. A meeting was held that night at the Rechabite hall, and a deputation sent to the managers. Following further meetings, the management announced that – in due course – an amended set of rules would be posted. According to the *Cumberland and Westmorland Herald*, 'If the men would not accept these and work as per the new instructions then the matter, so far as the Company were concerned, ended.'

Six weeks after the mines had been abandoned, the lack of maintenance was showing – workings were collapsing, roofs falling in, machinery seizing up. The revised rules were finally posted. 'The men are to fire as near as possible when they leave their shifts, and the next shift men are to start as early as they possibly can.'

'Thus,' noted the *Herald*'s reporter, 'matters are somewhere just about where they were when the dispute commenced.'

The strikers had included many of the Italian workforce,

most of whom had been brought to the mine during labour shortages caused by the increase in production. 'It has been said', wrote the *Herald*, 'that these men were offered outside work but they were honourable enough to stand by their fellow workers.' Two years later, it was reported that further Italian miners had arrived at Alston station. 'It seems these men do not supplant the local men – there is work for all – consequently no cause for grumbling . . . The Italians get the credit for being quiet and peaceable citizens.'

That same year, however, relations between incomers and moor-men had deteriorated: 'The village of Nenthead has for the past day or two been in an exceedingly disturbed state owing to fierce quarrellings between native workmen and imported foreign labourers at the works of the Vieille Montagne Zinc Company . . . and has continued in a more or less riotous state since.'

It happened on a Saturday, the day of the Alston Show; Nenthead's two pubs had just closed after a long day's trade. A dozen or more Italian miners, many of them new to the moor, had gathered outside the Miner's Arms. There had, it seems, been a disagreement, possibly a scuffle, between one or more of their number and one or more of the Nenthead boys. 'There is ground for suspicion that bad feelings had been smouldering in the minds of certain persons for some time past,' according to the *Haltwhistle Echo*. The long day's drinking had culminated in – what? – a shove, a show of teeth, some muttered foreign curse? These dark men had had their eyes or fingers on one of those Janes or Marys named in the Nenthead census. Or a dispute over mining rights or customs. They had been 'possibly lashed into a fury by jibes and firewater'. The old causes.

Two or three of them went to the public reading rooms (now the village shop), and there – of all places – carried out

a series of assaults. Will Stephens, a wagoner at the mines, alleged that the Italians had wielded knives. A Mr Fairless was 'struck and kicked'. When the Italians emerged from the reading rooms they were joined by their compatriots. The violence intensified.

Although a fellow Italian, 'Mr Jager', 'attempted to quieten them', Tom Veitch, the landlord of the Board Inn, was 'stunned by a blow inflicted with a heavy stick'. Mr Teasdale the gamekeeper and Mr Stout from the wood-yard were set upon. Tom Liddle, seventy-one, was thrown to the ground and 'kicked upon his back and thighs'. The police were summoned but the Italians were not to be quelled; all that could be done was to wait for their rage to exhaust itself, for whatever had overtaken them to abate.

A week later eight of them were taken before the magistrates at Alston: Battista Gimzatte, Francis Maroni, Germano Carzana and Andrea Ruppen, plus three brothers, Humberto, Louis and Josef Bergener, and Giulio Jaeger (the peacemaker, 'Jager', mentioned in the previous report, who'd been arrested shortly before the hearing). All were under twenty-five. The men were represented by Mr Lightfoot of Carlisle, while an ice-cream vendor from the same city acted as interpreter.

Stephens, the wagoner who had reported the Italians' use of knives, here alleged only that he had been 'seized by the throat, and one of the prisoners tried to kick him. After that he went home and stayed there.' It was this man, Stephens, whom Mr Lightfoot claimed had been the instigator of the violence, having started a row with one of the Bergeners. Stephens denied this.

Jaeger and Ruppen were discharged. At the Cumberland Quarterly Sessions at Carlisle the following week, the remaining men were judged not guilty of riotous behaviour; two of the Bergeners, Louis and Josef, were let go, while the

other men were charged with common assault. Whatever the extent to which that night's events lingered in the communal memory, it is known that the Bergener brothers Josef and Humberto (but not Louis) were living in Nenthead six years later, while 'Mr Jager' – Giulio Jaeger, who had intervened, but had been arrested all the same – married a Nenthead girl, fathered two daughters, and rose to the position of manager of the Rotherhope mine.

7

I stayed at the Miner's Arms in Nenthead. A light snow fell overnight and, in the morning, had accumulated in the shaded bouse teams. The mine site felt newly abandoned – the interpretation boards had begun to fog and acquire a spatter of green algae, as if from an aerosol's dying spray, but vegetation had not taken over, as it would have other neglected ground. Even the metallophytes, which could tolerate such soils – moonwort, mountain pansy, spring sandwort, alpine pennycress – were hard to find. 'Nothing grows in Nent,' I'd heard one of the charmers in the Turk's Head in Alston mutter. 'Even the children are stunted.'

Nature would not be obliterated, and where new soil had been able to accrete, over the years of disuse, short grasses had claimed a footing. But closer to the mine levels, where the waste was mountainous, there was only a scattering of mosses. Underfoot was a rough charcoal-coloured shingle, the broken-up bouse, scattered with orange brick-chunks from demolished mine buildings, and pieces of sandstone the size of human heads. The darkness of the valley was emphasised by the scattering of hard snow, and by the pale blue sky. Sheltered from the moor wind, and uninhabited by birds, it was densely silent here, apart from the sound of the Nent.

It was water that made the mines work, that ran the wheels and the crushers and sluiced over the 'buddles' – the washing tables – to separate the lead. When the water stopped, as it did when pipes burst or leats froze (common up here), then the mine stopped. Months passed when the washing floor was closed due either to snow or flooding, or freezing of the supply. An agent recorded in his journal of 17 March 1817, 'We have this day been taking the names of the Washers, and are almost teazed to pieces by the Applications, by both Men and Women of all descriptions . . . Numbers declare that they cannot subsist at all without employment in Washing.'

Nenthead is a place of famous winters, where the blizzards come early and continue into spring, where you might find frozen snow in shaded furrows in late June. When, during the great blizzard of 1916, a death occurred in Nenthead, the men who went to Alston to make the funeral arrangements walked with their heads level with the telephone wires.

The first thing I came upon on the mine site was not the smelt mill or the compressor plant but 'The Power of Water'. 'The Power of Water' was an L-shaped timber structure, six metres tall and fifteen long, fitted with three wooden wheels powered by water channelled from the small reservoir near-by, with a balustraded catwalk to allow visitors to look down onto the wheels as they turned. The water still flowed along the wooden channels, and it was still possible to walk on top of the contraption from one end to the other – but the wheels had not moved for two years. The continuing flow of the wa-ter, its sound, emphasised the structure's stasis.

I'd read about the centre's closure. Visitor numbers had dropped, an anticipated VAT rebate had not been paid. The grant aid from Eden and Cumbria councils had declined. Then there was the other lead-mining museum at Killhope

a couple of miles away, favoured by tourists on account of its closeness to the main road. In 2011, the North Pennine Heritage Trust, buried in debt, had gone into administration, and the Nenthead Mines Heritage Centre had shut down.

Since then, the wooden fences that surrounded the old washing floor and guarded the deep trench of the smelter's wheelpit had been smashed; slates had been jemmied from the roof of the visitor centre; the edge of the main footpath had slumped into the river; the carved wooden interpretation signs had been made indecipherable by the weather. Slowly 'The Power of Water' and the wooden launders that carried water across the site, and those renovated buildings – the assay house, the engineering workshops, the mine shops – were showing their disuse.

Looking out on the site, from the top of the spoil heap that towers over the Nent's far bank, you see first the remnants of the old Quaker Company infrastructure (the dressing floor, the ruined flue) and the newer remnants of the Vieille Montagne Zinc Company (the compressor plant, the mill), and then this grand effort, represented by the static wooden waterwheels, to get something further from the same piece of land. To envision the twice-daily marching of miners, to and from the entrance to Carrs mine, and then to picture the more recent, ice-cream-licking and safety-helmeted ghosts – school groups and families – entering and leaving that same entrance (the level had been turned into a 'show mine'), was to partake in the landscape's exhaustion.

I asked one of the trustees what would happen now. Well, perhaps there would be the odd open weekend in the summer . . . or residential courses, for enthusiasts or student geologists – but the site would not be resurrected. It was unsustainable.

In the Miner's Arms the word used was 'mismanagement'. The men at the bar believed the local community had been

sidelined from the centre's running. Its closure had generated annoyance but little surprise, and if there was regret it was only for the trade lost as a result by the pub and the shop and the guesthouses. They talked energetically about Minco. The drillers might find nothing, it might take ten years, but over their pints the Nenthead men saw the redundant moor thriving again, the population ceasing to drop. They didn't talk about heritage.

<div align="center">8</div>

Auden's poem 'The Watershed' marks the cusp between his juvenilia and the mature work. It was written in 1927, when he was twenty. The previous year he had read Eliot's 'The Waste Land'; it worked a transformation on him. It was not so much an influence as a goad to overthrow the tyranny of influence. To his brother, a couple of months earlier, he had written, 'The person who is worth anything is always I think alone.' Unable to see 'homosexual relations' as anything more than 'indecent', he had chosen, for the moment, celibacy – 'a most satisfactory cheating of life'.

In 'The Watershed' he describes the view of one who, standing on 'the crux left of the watershed',

> On the wet road between the chafing grass
> Below him sees dismantled washing-floors,
> Snatches of tramline running to a wood . . .

It seems likely that the viewpoint is the perambulators' Killhope Cross, where both the Tyne–Wear watershed and the Durham–Cumbria boundary run; the viewer is looking down onto the 'comatose' works of Nenthead. The poem goes on to tell of a miner who, while cleaning out a damaged shaft during a storm, is killed, and, 'the fells impassable', his coffin

taken to his village 'through long abandoned levels'. It is a retelling, with revisions, of Thomas Liddell's story.

It was a Thursday afternoon in March 1916. Above ground the snow was deep, and the hills were impassable. Liddell was hewing in the Barneycraig workings, which were accessed from the north side of the watershed, in West Allendale. What caused the rock-fall is not known, but Liddell was unconscious when his co-workers dug him out, and bleeding heavily. He was borne through the levels to the Rampgill Shaft, and brought to the surface at Nenthead, on the other side of the snow-covered watershed, from where it was intended that he would be taken to Alston for medical aid. The road to Alston being blocked, however, Liddell was carried to a house in Nenthead, where he was treated by the local doctor. The only surviving firsthand account is contained in a letter to Liddell's wife, Mary, from a family friend, Elsie, who was at the injured man's bedside:

'He told us what kind of life was his: how he loved work; and how quick tempered he was too. He seemed as if he regretted being quick tempered for your sake. He said on the Wednesday "I want Mary".'

His death, six days after the accident, was peaceful, Elsie says, but came as a surprise, as he was 'so tall and so strong . . . But the weather was against him . . . His clothes were wet . . . He had lost so much blood too.' On account of the snow, Mrs Liddell had been unable to see her husband before his death. 'Though you have the immense sorrow to not have been here nursing him and loving him till the last minute,' Elsie says (and her whole letter is a model of tender frankness), 'you can be sure that every thing has been done for a dear brother. Are we not all sisters and brothers?'

It was his funeral, however, that preserved his memory – or rather his funeral *procession*. It's likely that Auden heard

about it when he visited the region as a young man. The service was to take place at Sparty Lea, seven miles away, over the watershed in Northumberland. Fifty Nenthead men set out on Sunday morning, after a hymn was sung, and started for Sparty Lea, 'the larger number walking four abreast, thus making a beaten track, the rest following and drawing the coffin on a strong sledge specially made for the purpose'. At the same time, fifty men set out from the Sparty Lea side, meeting their counterparts above Nenthead at Coalcleugh, and joining them in pulling the sledge over the steepest part of the moor, where it reaches two thousand feet, and from there leading the body down to St Peter's.

'I believe miners are the soldiers in time of peace,' Elsie wrote to Mrs Liddell shortly afterwards. 'They risk their lives every day and for that reason have tighter bonds one with the other.' According to the *Hexham Courant*, 'a large number of friends gathered at the funeral service' – but Mrs Liddell herself, trapped by the snow at Allenheads, having said goodbye to her husband two weeks before, did not see him again.

<div align="center">9</div>

I was walking southwest from Killhope Cross to Garrigill, shadowing the line of the 1761 perambulation – 'from thence as the water divides, to the Nagshead'. I'd arranged to meet Tom Pickard back at the Hartside Cafe that afternoon. Next to the track that led to the old monastic moor of Priorsdale was a shaft filled with water, an eye glaring at the sky, the cloud-reflections in its surface warped by the skitterings of pond skaters. I left the track to see the reservoir called Perry's Dam, which provided the water and power for the mines' washing floors. Once you climbed the mossy retaining bank,

the reservoir itself was a disappointment – more than that, grievously ugly: a half-drained gash. The remaining water seemed powerless, and lifeless. But as I stood and waited, I became aware of the sounds of birds, and with this came an awareness of corresponding movements – along the banks, in the shallows, and overhead: lapwings, golden plovers, oystercatchers, redshanks, curlews. As I returned to the track, I passed a shake hole filled not with water but with a rind of dirty snow, the surrounding grass still flattened, as if it had been slept upon by some large mammal.

Garrigill today is a cluster of cottages around a lush village green, with a handful of B & Bs and a pub, the George & Dragon, that seemed to be thriving on the custom of ramblers (the village is a stopover on the Pennine Way). Historically it was a centre for poaching, and game dealers knew that when the season came, and even before the 'Glorious Twelfth', grouse could be obtained from certain individuals at the Old Fox Inn. As many as you could carry. During the reign of James I, an act was passed making the qualification for killing game £40 per annum, derived from landed property. If the working men of Alston Moor were found with dogs, nets, snares or horsehair nooses, they were liable to be heavily fined. Nevertheless, when August came and the grouse were becking – well, you went out, and shunned the exposed ridges. The miners had always practised a dual economy.

In 1819, a company of Hussars was sent to Alston Moor to apprehend the poachers. It is this event that is recounted in an anonymous novella of the period ('these late oppressive times'). *Emma, or the Miner's Cottage* is subtitled: 'A Moral Tale Founded on the recent adventures of the Poachers and the attempts of the Soldiers and Constables to take them, in Alston-Moor, in 1819.' When Emma's lead-miner father is injured in a roof-fall, her pregnant mother, thinking him

dead, experiences a shock that kills her. With their father unable to work, Emma's brothers resort to poaching. 'The game laws are too strict,' one argues. 'What harm can there be in shooting these birds which fly where they please?' Emma replies: 'You may as well ask, what harm there could be in our first parents pulling a single apple.'

It was the mines that saved the poachers of Alston Moor; the Hussars dared not follow them in when they fled, and the men were brought food by their women, who knew the mines' secret entrances. The siege was broken and a settlement reached: the men's freedom for their weapons. This they agreed to, having first obtained for the purpose the oldest, cheapest guns they could find, while keeping their own for next summer. For the Hussars the moor and the mines had been a chartless hell; for the miners, who knew the shafts and levels like the rooms of their own cottages, their victory was a repossession.

If Ted Hughes's Scout Rock overshadowed his childhood and shaped his writer's mind, how much greater must be the influence of Cross Fell over those who live under it? It had the hugeness of something meteorological. My plan was to follow the perambulators' route over its plateau, approaching from the east, then crossing the watershed over Green Fell, Melmerby Fell and Fiend's Fell, to the Hartside Cafe.

The story went that Cross Fell was originally called Fiend's Fell, on account of the demons that had claimed its plateau; St Augustine of Canterbury, it was said, trudged up and erected a cross and an altar, and performed the Holy Eucharist. The demons having been banished, the fell was rechristened. The unlikelihood of St Augustine ever having come here is beside the point. It was – anyone could see – a haunted place, a place that required purification. For Auden

it was 'numinous'. But it was clear, even on the approach, that any exorcism had been a waste of holy water. That the map still had its Fiend's Fell, five miles northwest, to the rear of the Hartside Cafe, suggested that the demons had merely been relocated, like raptors caged and let go where they could do no harm.

A sign at Garrigill Gate informed walkers that 'any traps set within the area are for the legal control of vermin for the benefit of ground-nesting birds. Due to recent damage the area is currently under surveillance.' This was walking country, and it wouldn't be difficult to push a stick or drop a stone through the steel-grate tunnel of a rail trap, and spring the mechanism – nor were the traps hidden: it seemed that every ditch, drain and culvert, every breach between hags, was bridged by a post with its attached trap. The moor had been ringed off defensively from the wider ecosystem. Walkers were admitted reluctantly. 'Ground-nesting birds' – as if it were golden plovers the traps were to protect. As if it were hen harriers.

Where the valley pasture merged with the moor (the threshold was fuzzy) the sky was flurried with curlew – I had never seen so many in one place: curlew wafting bright and numerous as blown seed-heads, and their call – not 'mournful' (Daphne du Maurier), not a 'trilling cry' (Henry Williamson), not a 'wobbling water call' (Ted Hughes), but a horse's alarmed whinny – and then a lapdog's crazed yapping. Ecstatic, furious, witchlike entities.

The old mine track was a grey winding course pared into the green-brown moor, littered with shiny pinkish crystals of fluorspar from the mines, and trending gently uphill towards Cross Fell. I began to notice the steel cages, like upturned baskets, that covered the entrances to the mine shafts. In some cases the stones that had been walled around them had

been thrown aside by modern-day mine explorers wanting to get in, the steel hacksawed and wrenched back. *Frantic* to get down there, into the dripping darkness.

With the long snowy ridge of Cross Fell ahead of me, I came to a heap of waste and wasted footings that indicated the presence of a working – up here, in the sky, ten kilometres from the nearest house. This was Cashwell, where Auden had set 'The Watershed', another of those mines he named with such tenderness, as if – it seemed to me now, as I thought about the darkness under the moor – as if they had been *conceived* as relics, like the picturesque 'ruins' that were commissioned to adorn eighteenth-century country estates. *Why bother with people?*

At the foot of Cross Fell, with its scree escarpment partly concealed in a crown of mist, was a small pond, hundreds of dead black reeds piercing its surface, and in one corner a flurry of movement that settled as I approached – a horde of frogs, furiously entangled, the water gloopy with spawn. Thomas Sopwith, who knew these moors (and knew his Wordsworth), called the slopes of Cross Fell a 'wild and sterile prospect, void of any remarkable feature save that of wide and solitary desolation' – and when the fence wires made their coppery sound in the wind, and you were walking towards a fog-bank like a lead curtain, it was easy to see what he meant. For W. H. Auden, sterility held a certain appeal. But hold your breath for a moment —

The frogs are burping, the curlew are whinnying, the larks are unanimous in the mist – there was *no* sterility, *no* barrenness; it was not the celibate, evacuated landscape of Auden's experience. Even on the edge of Cross Fell itself, nine hundred metres up – a flock of golden plover, like a handful of gravel chucked across the moor. And, as I clambered over the broken peat to the plateau summit, I remembered that

the *perambulators* had come here in 1761 – eighty-one of them! – commissioned by the Greenwich Hospital to define the bounds of its property. With their pomp and their musicians, old men and little laddies. It had been August; dazzling, sweaty work.

I had risen above the moor to a prostrate mountain-face, where the menace was of a different order, and more immediate. The place *was* haunted – and when, for a few seconds, the mist to the south eased, the sunwashed lowlands ten miles away were of the finest lucent green, and the word I heard myself saying, as I looked down, was not the usual whispered 'shit', or even 'holy shit' – but merely: 'holy'. I sat on a rock and had a packet of BBQ Beef Mini Cheddars and a carton of strawberry Ribena.

Not since I'd been walking on Exmoor's Chains, eighteen months ago, had I found myself in a proper fog. It was one of the trinity of moor notorieties (the bog, the dog . . .), but it hadn't become the theme I'd expected it to be. Like the slathering mire or the slavering hound, fog was chiefly an occurrence for fiction. Its effect, here on Cross Fell, was not a blinding but a framing: sensation was reduced to an ambit of ground ten metres wide, a spotlight's spot.

At first it was a scree-land, the limestone boulders badged with lichen and caulked with woolly fringe-moss; after ten minutes of walking on this ankle-turning rubble it flattened to a hard heath of wind-clipped grass, herbs and bryophytes, sheep's fescue and flattened bedstraw. Alpine species, associated with late-lying snow and constant winds. Again I felt as if I had passed beyond the moor into a rawer place, absent of the softening of peat or grass. Out of the mist the curricks emerged – stone-built cairns, taller than the tallest person, but possessing the shouldered proportions of a human figure. But as I followed the line they formed across the plateau, just

as the perambulators had, and down the wet northern slope, and onto the stone-scattered ridge of Brown Hill, I began to see them as chaperones, quite tender – and not simply as guides but, like the cross purportedly put up on Cross Fell by St Augustine, *exorcising*, and in their human aspect they ceased to seem at all menacing and became companions, company, and accompanied me as I hauled west against the rain.

It took me three hours to reach Fiend's Fell, via the watershed and stretches of the Roman road. When I crested the top of the fell, there it was again, the cafe, perhaps a mile off, like a trawler anchored against a storm.

<div align="center">10</div>

There has been a cafe on the Hartside Pass for eighty years; it has been burnt down, rebuilt, renovated and extended. It's not pretty; it's a low white blockhouse, designed to shoulder the winter. While I waited for Tom Pickard, I sat and ate my date slice and drank my coffee by the wood burner, and watched the young waitress attending a succession of scuffed bikers and spandexed cyclists (they sat grouped on opposite sides of the room). The broad picture windows looking out onto the moor were decorated with vases of bright daffodils; from the ceiling hung swags of floral bunting. The bunting was left over from a wedding that had been held last week – the owner of the cafe had obtained a licence a few years ago at the request of two affianced bikers. The wedding had been Tom's. For years, he told me when he arrived, he'd wanted to show his wife-to-be a short-eared owl, one of the diurnal owls, which he'd often seen during his time here. As the two of them stood in front of the picture window, completing their vows, a solitary individual leisured past behind them, east–west, hunting low over the fell.

When the weather was fine, you could see to the Solway Firth. When the fog came down (or, sometimes, up), your own hand could be concealed from you. 'In the winter it was a full-time job staying alive,' he said. 'There's an open fire but it gives no fucking heat whatsoever. The winds just whip the heat away. Just zooms up the chimney. It gets extremely cold. There's no real insulation. The winds are ferocious, and relentless and merciless, and the draught was phenomenal.'

Tom's bed had been in the converted attic, where he could look up, through the dormer window, into the unsullied night sky. The moor at night was one of his pleasures. 'I woke up one morning, the windows tight shut, and the bottom of the bed' – his fingers became callipers – 'was about that much snow, tiny little pinpricks of snow, which the wind had driven through the cracks, so I wake up and there's a fucking *layer* of snow on the bed.'

He wrote every day, walked every day. 'The light was extraordinary. You see sights that are unbelievable. I would open the window, try and take pictures. I couldn't expose my hands for more than twenty seconds for fear of frostbite.'

One night, on his birthday, he and his then girlfriend had spent the night drinking, when a wind such as even he had not known came to the escarpment – a 'come-to-kill' wind. Tom, who when sober was perfectly conscious of the dangers of the place, was ecstatic: in only his dressing gown, he stood in the black gale as if against the full force of a breached dam, and shrieked into it, delighted in it. The weather station nearby recorded a wind speed of 128 mph. In the morning, the car park was scattered with tiles from the roof: 'I was lucky not to have been decapitated, or worse.' When he returned to the cafe he was naked apart from his shoes. Twenty yards away, in the road, he found the upturned hulks of two wooden picnic tables and their attached benches, prised from

the viewpoint terrace on the other side of the cafe, and (was this possible?) thrown clean over his bedroom roof.

'Most of the time I was completely alone up there,' he told me, as we drove down the pass to Alston (he and his new wife lived ten miles away now). 'And when the lasses came back it was like the swallows returning. I used to say that to them: the swallows are back!' It was the annual routine that had allowed him to stay: the knowledge that, even while the snow blocked the light from his windows, a time would come when not only would the snow thaw and the wind let up, but the lasses would return, the kitchen would become active once more, the car park would be busy, and he would be living in a place whose majesty was recognised by all who passed through. In the summer he was envied. When he moved out, the lasses bought him a leaving present. It was an old wooden box in the shape of a book ('for my pens'), and inlaid into its lid were marquetry-work birds in flight – swallows, swooping.

9. The White Lands

The Otterburn Training Area

I

The windows of St John's in Otterburn depicted the three great saints of Northumbria: Cuthbert, Ethelburga and Aidan. In the north wall was the roll of honour to the war dead. I'd arrived late, or the service had begun early; I edged in and was pointed to an empty pew. To reach it I had to disturb a man on crutches. He winced as he shuffled aside. I was conspicuous among the dark-clad congregation – an underdressed stranger. The church's acoustic didn't seem to consent to a second's echo.

The commandant read the beatitudes of Matthew. He wore a kilt below his uniform jacket. He was on show. When I had met him in his office at the camp he was wearing shapeless camouflage fatigues. He carried a massive and unassailable confidence, as if it were a trusted firearm. The first thing he said to me was: 'A little knowledge is a dangerous thing.' He said: 'We have a saying: "Train hard, fight easy". We train men and women to put themselves in harm's way. We train them to kill. That is sometimes forgotten in today's "touchy-feely" society. We are training them to kill.'

Otterburn, another moorside village, lay in the broad notorious valley of the Rede, and from a distance it was picturesque and appealing: from the ringing hills the church steeple and the tiled roofs were scattered between the oxbows and aits of the Rede and the Otter Burn itself, the moors a backdrop; and the hotels – the Percy Arms and the Otterburn Castle – were bustling and their car parks were full at night. But I felt nervy. The road was busy and noisy, it was the road

to Scotland and the lorries didn't slow as they passed through the village. Once you left the village there was no pavement, and to walk along the narrow verge was punishing. I met a man in Byrness who was walking from John o' Groats to Land's End, by road – every step of it along the thunderous gutters and strewn verges. The Pennine Way passed nearby. It was common, along the established routes, to meet these men – always men, and usually alone – for whom walking was not quite a matter of pleasure.

The footpath to the south circled back to the road after a mile or so; if you went north or northeast you came to the red flags of the ranges, and were not permitted to go further. There were no public buses, only the infrequent long-distance coach between Edinburgh and Newcastle, which had brought me here. I was trapped in this grey village in the Middle Marches.

I learned later that what the soldiers called a 'calfex' was occurring: a combined-arms live-firing exercise. I watched two or three unmarked white coaches move along the road towards Scotland and turn off to the camp – new recruits from Catterick or Belgium or Holland, here on pre-deployment training before being flown to Afghanistan. I spent most of the day listening to the road, and watching the military helicopters from my window: Chinooks filing low up and down the valley, often chaperoned by smaller helicopters; and, much higher, two more black helicopters hovering incessantly, sunlight flashing on their hulls – Apaches, 'nasty machines', the commandant had told me; and then a double clatter of automatic fire from the moors, or a dull rumble, miles away, in the impact zone.

As we filed blackly from the church, the blue lights of police cars were blinking, blocking the road, for the laying down of the wreaths outside the community hall. The four wreaths

were laid, the commandant read the Ode of Remembrance, we filed into the village hall for tea and Nice biscuits. The traffic was released. And in the hall it was as if a great relief descended, as if a complex national performance had been successfully completed; and the people – uniformed police and soldiers, the vicar, all the people of Otterburn and the nearby villages – were suddenly voluble and laughing and seeking out their friends.

I climbed up Blakeman's Law, one of the ridges that gives a view back over the valley and north over the ranges, and looked up at the red flag flaunting above the trig point. At the edge of a cattle grid stood an identical pole, this one with a red lantern on its top, and a sign warning of 'slow-moving military vehicles'. On the other side of the track a list of Statutory Instruments had been posted, outlining the 'Otterburn Training Area Bylaws 1971' made by the Secretary of State for Defence.

It was the idea of Winston Churchill himself that the range be sited here, following a hopeless day's grouse shooting with his friend Lord Redesdale, the then owner of Birdhopecraig Hall and its moors. He had stood on a ridge and looked back onto the birdless waste, and deemed that it would be better used for firing howitzers and testing men for battle. Gesticulating with a damp Romeo y Julieta.

That was the story. But it was a story whose origin it was impossible to trace. It was repeated in the few short histories of the ranges that appeared in larger books about the region. Churchill had been here, it was true, had even shot on these moors – but his imprimatur felt forged. It was a good story.

After the national shaming of the Boer Wars, and in light of the perceived threat posed by Germany and Russia, a commission was set up under Richard Haldane, Secretary of

State for War, to review Britain's military capabilities. Haldane's recommendation was that Britain's militias and yeomanry, relics of the Napoleonic Wars, be consolidated and expanded into a 'territorial force'. They would be trained to support the regular troops abroad, with the focus of their activities moving from fortress artillery to field artillery – that is, from fixed guns to mobile guns. The old expression was 'fire and manoeuvre': now the soldiers called it 'shoot and scoot'. But the strategy remained the same: to fire and move before the enemy could pinpoint your location and return fire. There was insufficient space for such training on the existing artillery ranges at Dartmoor and Salisbury Plain, and nowhere of adequate size in the north of England.

It was in 1909 that twenty thousand acres of moorland above Redesdale were bought by the War Office, from Lord Redesdale and other owners, to enable the new territorials to train with sixty-pounders, eighteen-pounders and six-inch howitzers. Telephone lines were laid and a fifty-mile network of new tracks built over the moor. North of Silloans, I was taken to the silted remains of a system of trenches dug to train men for the Western Front: you could still stand in the front-line trench and look out over the moor, eye level with the ground.

Firing commenced in June 1912, with training intensifying as war became inevitable. Birdhopecraig Hall became the senior officers' mess. A huge tented camp was established adjacent to it, overlooking the Roman camp at High Rochester: in pictures from the 1920s the hundreds of round white bell tents, with horses milling between them, resemble a Native American encampment. The Redesdale camp was the territorials' jolly, the highlight of the year: two weeks of artillery training, interspersed with dances and gymkhanas, and drinking at the Redesdale Arms. The men's families sometimes came with them, staying at local inns and farmhouses.

Following the armistice, the army consolidated its hold on the area, requisitioning or compulsorily purchasing a further twenty thousand acres from farmers. The commandant told me about a deputation of farmers coming to the then commandant to complain: six hundred sheep had been killed during a recent exercise. Very well. They had two choices: go away and bury their animals, or renounce their reserved-occupation exemptions and join Britain's other able-bodied men on the beaches of France. The deputation quietly filed back to their farms.

The training area continued to expand, as the range of the guns extended: part of the southern Cheviot was taken in for 'dry-training' and outlying pastures and forestry were bought up, piece by piece. A blacktop runway was built, concrete observation bunkers were put in along the ridges, a mock airstrip ploughed into the ridge above Stone-in-the-Mire, and loops of small-gauge track laid down for mobile targets. Later, above Silloans Farm, I pressed my face to the window of a Nissen hut. Inside, stacked against the wall like scenery flats, were the MDF outlines of target tanks.

'The Danger Areas', the sign by the cattle grid said, 'may be used for the firing of all artillery, infantry and tank weapons and for the firing or dropping by aircraft of air to ground missiles and all activities ancillary to such firing or dropping and the destruction of explosives or ammunition.' Each of the dozens of locations at which boundary flags or lamps were to be situated were listed, like the merestones of an ancient perambulation: '650 yards east of Watty Bell's Cairn'; '5 yards west of Crow Stone'; 'At a place where the road crosses the River Coquet 400 yards east of Chew Green Camp'; 'At a place 80 yards east of Otterburn Camp and on the crest of a hill known as Knowe End' . . .

From Blakeman's Law you could see five miles over the moors into the southern part of the training area – the dull yellow of the moor-grass scattered with the small angular conifer plantations. It was predominantly a 'bent' or mat-grass moor, as it had been for hundreds of years. In the old Border ballads, including descriptions of the Battle of Otterburn, 'bent' represents 'moor'. In the account given by Walter Scott, for instance, Douglas's men 'lighted high on Otterbourne, upon the bent sae brown'.

The plantations of spruce were maintained not for timber, but to provide cover for soldiers – 'shelter-woods' or 'hides' – and to conceal what were called 'battery echelon areas' and gun-spurs, from which the missiles were fired into the impact zone.

As I looked north, I was conscious of standing on a periphery, at the wings of a stage forbidden to all but the performers; and this feeling, of always being at the far edge of an inaccessible centre, however close I seemed to get to it, strengthened as I gained my bearings. I'd hoped to see soldiers, or tanks, or a distant flash of pyrotechnics, but there was no movement on the moor. The soldiers, if they were there, were hidden in the plantations, or working their way along the wooded valleys. Everywhere were signs identical to those I'd seen on the Dartmoor ranges the previous winter: 'Do not touch any military debris it may explode and kill you', and 'Keep out when red flags or lights are displayed or barriers closed'. In the corner of each sign was the logo of the MOD's land-management contractor Landmarc, with its slogan: 'Partners in possibility'.

The steel flagstaff was rusted to a deep umber, but the flag itself, a king-size bed-sheet, looked newly washed; even the white seam through which the rope was threaded was pristine. Its leading edge, however, had begun to fray. For ten

minutes, as I went back down to the village, I could hear the flap and snicker of the flag, and the ding of its halyard against the metal pole.

I made my way along the verge of the A696, past Otterburn First School, which stood alone at the edge of a field, a mile from the village (motto: *Be happy, aim high and achieve your full potential*), to the narrow roadside plantation where Percy's Cross stood, commemorating the old carnage. When the Duke of Northumberland offered to build a monument to the battle, Mr Ellison, who owned the site, fearing that the duke would lay claim to the land once he had planted his cross upon it, had this one made and installed. It was an old fireplace lintel turned on its end and set into a round stone pedestal. The hooks for hanging cooking pots were still visible.

The Battle of Otterburn was fought in August 1388, between the Scottish Earl of Douglas and the Earl of Northumberland. There are four historical accounts. Two of them are ballads entitled 'The Battle of Otterbourne', an English version and a Scottish, the latter popularised by Walter Scott in his *Minstrelsy of the Scottish Border*. In the third, 'The Ballad of Chevy Chase', the battle comes about as the result of an episode of cross-border poaching on the part of Percy ('our poet', observes Thomas Percy in *Reliques of Ancient English Poetry*, 'has evidently jumbled the two subjects together'). The fourth and most detailed report was written by the French chronicler Jean Froissart, who, having interviewed survivors on both sides, would seem to have the greater claim to impartiality. The battle, by most accounts, was little more than a score-settling, an extension of a family feud between Douglases and Percys, given fuel and pretext by the national rivalry – and distinguished, it's true, by its torrential bloodletting.

The English version of 'The Battle of Otterbourne' records that the men fought 'tyll bloode from their bassonets [helmets] ran, / As the brooke doth in the rayne'. In 'The Ballad of Chevy Chase' the men fight 'tyll the bloode owte off thear basnetes spreate, / As ever dyd heal or rayne', while in Scott's version the blood pours from the soldiers' helmets 'as the roke doth in the rayne'. The image finds no counterpart in Froissart's account.

The Scottish bivouac – 'on the bent sae brown' – is usually taken to be the old Bronze Age camp on Fawdon Hill, a mile north of the village. Percy approached at night, with eight thousand English infantry and six hundred spearmen. In their exhaustion, and in the confusion of darkness, it was the army's foot-followers whom the forces at first engaged – allowing Douglas to attack the English flanks with his main force. The fighting continued through the night. Froissart says, 'Douglas took his axe in both his hands, and entered into the press . . . in such wise that none durst approach him.' The lyric accounts have it that he was ultimately felled by Percy himself, but Froissart paints a messier picture: 'At last he was encountered with three spears all at once, the one strake him on the shoulder, the other on the breast and the stroke glinted down to his belly, and the third stroke strake him in the thigh.' According to Scott's version, to maintain morale, Douglas's body was hidden from his men under 'a bracken bush' (bracken still grows thickly on the well-drained hills). Percy, meanwhile, was taken for ransom: 'My hosen and my greaves are full of blood,' he told his captor.

The battlefield itself, beyond the wood-ringed monument, was just a fenced-off field; there was nothing there. Next to the lintel monument was an interpretation board, carrying a coat of arms and the words 'Northumberland Battlefields' (you could do a tour from site to site, and view other fields).

It included Froissart's summary of the battle – 'the sorest and best foughten without cowardice or faint hearts' – and a black-and-yellow graphic of the fighting at its height – pikes, swords, battleaxes, chainmail, hosen and greaves and bassinets.

A visitor had taken a sharp-edged stone, or a penknife, and slashed the board, twelve vertical slashes, three horizontal. Not wanton – not out here. Not kids. There was something amiss in the interpretation, a perceived favouring of the Scottish or English line, and someone who had stopped here had been moved to violence.

When the firing let up, and the flag on Blakeman's Law was lowered, I walked north, into the ranges, towards the impact zone.

2

The camp lay on the moor a half-hour's walk north of the village, a square mile of green barracks, offices, training buildings, a canteen and supply stores, screened by long plantations of spruce. To one side was a shining field of concrete as big as three football pitches. This was the Central Maintenance Facility, a tank park, featureless but for the black corrugated servicing hangar at its edge. Otterburn Camp was a focus of population within an otherwise sparsely peopled landscape: 1,300 soldiers were here at any time, but they did not stay for long. The Redesdale Arms, which once had been a centre of military social life, seldom saw a soldier now. The most tangible aspect of the range's presence locally was the noise of its artillery, and the noise of helicopters and jets and unmanned aircraft, and the coming and going of supply vehicles and coaches. But in the surrounding villages the military was liked, despite the disturbance it caused: the camp and its contractors employed a hundred or so people;

there was a belief that it contributed to the local economy; there was, too, a certain quiet pride attached to the association. The tolerance of the civilian population was a mark of its patriotism. The noise and disruption, the loss of the odd sheep or a fence knocked down: these were minor nuisances compared to what the young people training on the bent were preparing for. I did not forget what the commandant told me: 'We train men and women to put themselves in harm's way.'

Close to the entrance of the camp was another kind of fort – one of the circular drystone sheep stells that scattered the hillsides. Beyond the gate, with its watchful guard, a group of teenagers in camouflage were waiting on a patch of lawn, daubing their faces black.

It was a day of rainbows – the sun low and dazzling, the miles of mat-grass a pale intense orange, the horizon always weighted with clouds coloured the gauzy mauve-blue of veins ('Cloudland', G. M. Trevelyan called the Middle Marches). My destination, now that firing had paused, was the Forward Operating Base in the Wilkwood valley, half a mile into the Danger Area – although it wasn't clear to me, now that the flags were down, whether it lay in the zone permanently off limits to civilians.

A half-hour from the camp I came to a turning to the ammunition compound. The Range Head Store was three low sandstone buildings ringed by banks of earth, resembling a town-edge supermarket, but with walls thicker even than those of the local fortified farmhouses or 'bastles', and light-weight roofs designed to vent explosions. Hunkered, compacted. This store, and the Central Maintenance Facility, and these fresh wide roads, and many of the hardstandings and other structures I came across – all had been constructed in the early 2000s, at enormous cost, to allow the use on the ranges of two new weapons, 'self-propelled artillery systems':

the AS90, 'Artillery System for the 1990s'; and the MLRS – the Multiple Launch Rocket System.

You could travel all day on the military roads without retracing your steps – where else could you walk for so long on surfaced, unpotholed roads and see almost nobody? It was as if civilisation was over. Wherever I went, the ground shimmered with rainwater, and in the valley the flooded shell holes glinted – though, that morning, it seldom rained for me. It was as if I were following a cloud that was always sending rain onto the land ahead, but which rolled on before I arrived beneath it. I remember the roads as intensely blue. It felt like a blessing – the sun, the light, the lack of rain, the absence of people, the views that made you feel as if not only the world but you yourself had been enlarged.

But the land had been spoiled; the range was a sort of factory, and the sense of release, of *privacy*, that was available on other moors was withheld here: everywhere were limits – not fences, but warning signs, barriers – here you may walk, here you may not – and nowhere was it permitted to leave the roads or the few footpaths. You were not allowed to forget the debris that 'may explode and kill you'. When I strayed to a black observation hut, a hundred yards from the road, having seen nobody since passing the camp two hours earlier, I emerged to find a pale green Land Rover idling on the verge, and inside a warrant officer who did not smile back. Where had I come from this morning? Had I undergone a safety briefing? There was always the feeling of walking between minefields. If I was an observer, I was also observed.

I practised a form of beachcombing, as I had on every moor I'd been to, seeking out first the moor's own anomalies, and then those that had been left behind by man. To find these leavings, on other moors, had been a solace – just as a set of footprints in the desert can be a solace to a traveller, even if

it cannot be known if their owner is a friend. Here it was like finding the discarded tools of a crime.

The military presence overwhelmed my awareness of everything else, in a way that, say, the grouse-shooting or mining relics of other moors had not. Nowhere else was the moors' utilisation so fresh and so conspicuous and so complete. The signage, the flag- and lantern-posts, the whitewashed concrete bollards and fluorescent cruciform barricades, the target railways, the creosoted troop shelters and latrines, the black tank hulks in the valleys – the place was being used with complete efficiency, and in this sense it was valued. For the MOD, it was a unique asset, after all – nowhere else could the giant guns be used; here alone, in Britain, was it possible to fire your missiles over a horizon.

There was, too, the smaller, more temporary rubbish of military training, which marked the soldiers' passage across the moor, the aftermath of that recent 'calfex'. There were the prints of tracked vehicles on the verges (and occasionally foot-deep ruts), and the tinkle underfoot, now and again, of an empty brass bullet casing. There were lids prised from wooden ammo crates, discarded at the roadside. The favoured drinks of the soldier in training, going by the roadside litter, are Lucozade Sport and Red Bull. The internal windowsill of a checkpoint hut was lined with wrappers: Crunchie, Snickers, Curly Wurly. Close to the Crow Stone, with its nearby flagstaff, I found on the verge a charred steel can strung by a plait of fibres to a heap of green fabric. It lay there like a beached jellyfish – a burnt-out parachute flare used to light up night-time manoeuvres. On some nights eight hundred soldiers would be making their way across the pitted moor below.

I saw to my left, rising fifty metres above the orange-pink moorland, a dark prominence marked on the map as 'Black

Stitchel'. It had a seductive, shimmering quality, from this distance – numinous – and must have been meaningful, in the way that islands or oases are meaningful, long before the modern military came – to the Bronze Age people and the Romans and the reivers. It rose from a sea of bent, a proxy for a hundred other positions across the contested planet. But although there was a wish to recreate the conditions of warfare here, the moor stood for nothing but itself. It was not Afghanistan, or even the Falklands. That the soldiers who came here hated it was desirable: it was meant to be 'testing', degrading. Train hard, fight easy. Ask a squaddie; browse the web forums – *Otterburn? Shit-hole.*

3

To reach Yardhope I walked north from Otterburn Camp, past the cluster of bastle houses that lies in the milder country above Penchford Burn. For three hundred years prior to the Acts of Union the borders had barely known a proper peace, and it was the march towns on both sides of the border that bore the brunt of each invasion and counter-invasion. The borderers, wrote John Leslie, Bishop of Ross, in 1572,

. . . assume to themselves the greatest habits of licence . . . For, as in time of war, they are readily reduced to extreme poverty by the almost daily inroads of the enemy, so, on the restoration of peace, they entirely neglect to cultivate their lands, though fertile, from the fear of the fruits of their labour being immediately destroyed by a new war. Whence it happens that they seek their subsistence by robberies, or rather by plundering or rapine.

And this insecurity, this unrootedness, accounted, in part, for the sparse population and meagre cultivation that existed today.

Since the thirteenth century the border had been divided into three 'marches' on either side, each one facing its equivalent and administered by a warden; thus there was a Scottish Middle March and an English Middle March, and their Eastern and Western counterparts, with each March Warden communicating with his cross-border opposite, in order to maintain peace and collaborate in the administration of justice. Few were fitted for the job. Peregrine Bertie, Warden of the English East March, wrote, 'Yf I were further from the tempestuousness of the Cheviot Hills, and were once retired from this acursed country, whence the sun is so removed, I would not change my homlyest hermitage for the highest palace therein.'

The brutal prospered. To live here between the late Middle Ages and the early 1600s was to be subjected regularly to the forays of 'reivers', or raiders, and often to number oneself among them. The absence of Scottish records of English raids can give the impression that reiving was one-way, but it has been calculated that the booty from English raids in certain years greatly exceeded that of the Scottish. Nor was it merely a north–south activity: he who stole an Englishman's cattle or burnt his home to the ground was as likely to be from Redesdale as from the Scottish Marches. The reivers were no patriots.

They came in October and November, between Michaelmas and Martinmas, when the cattle were close to the farms and 'the fells good and drie and the cattle strong to dryve'. Sometimes armies of three thousand rode over the moonless winter wastes, astride their sturdy 'hobblers' and 'all clad a lyke in jackes coverd with whyte leather, doblettes of the same or of fustian, and most commonly all white hosen'. The weapons of these men in white were the sword, the cleaver, the 'Jedburgh axe' and the lance. Bishop Leslie stated that

'the more skilful any captain is to pass through those wild deserts, crooked turnings, and deep precipices, in the thickest mist and darkness, his reputation is the greater and he is looked upon as a man of excellent head'.

Walter Scott knew this country well: his novel of misanthropy, self-exile and revenge, *The Black Dwarf*, said to have influenced *Wuthering Heights*, is set on the moors above Liddesdale. The reivers, he wrote, 'abhorred and avoided the crime of unnecessary homicide', but the records suggest that they often found homicide to be 'necessary'. If killing was avoided it was not on account of the reivers' moral qualms but to avoid feud or reprisal. On awakening, it was said, a borderer would first put his hand to his throat, to see that it had not been slit.

The Book of Losses in the Middle Marches, presented at Alnwick in 1586, is extensive. In 1577 'the Elliots and 24 others from Liddesdale' killed Rafe Hall, 'and drave away 40 kye and oxen, 2 horses and £30 worth of household stuff, and in the pursuit thereof Roger Wanless and his brother John . . . were slain and their 2 horses taken'; in 1581 'the inhabitants of the town of Rochester complain of the Elliots for coming there several times and taking 180 kye and oxen, gotes, sheep, and household stuff, so that the town has lain waste for five years'; in 1583 'John Hall of Otterburn, Percival Reed of Troughend, and their men rescued 24 kye and oxen which the Elliots were driving away when 200 of the Olivers and others came and interfered and killed Allen Wanless'. In a period of ten years the Elliots of Liddesdale stole three thousand cattle and 'insight' to the value of £1,000; they destroyed sixty-six buildings, kidnapped 146 individuals and murdered fourteen.

The names stay with you: Fingerless Will Nixon, Ill-drowned Geordie, Curst Eckie, Unhappy Anthone, Out-

with-the-Sword, Sweetmilk, Ill Will, Ower-the-Moors. When reivers were spotted, beacon fires were lit and white sheets flown from the moor's high places. A cognate is 'bereave'.

Above Watty's Sike the road is flanked by ruined block-houses. These bastles, with walls two feet thick, were built by the wealthier march families. In the event of a raid, blood-stock was herded into the ground floor, while the upper storey, reached by a removable ladder, was used to secure 'insight gear' (valuables) and human beings. The structure beside the verge, Highshaw, had been levelled to its ground floor, and on its top was a thicket of dead broom. I looked in through the small triangular window. From the black interior came a fluttering of wings. In the field opposite, the few remaining stones of the Ironhouse bastle stood in the small-arms range, below a new black troop shelter. Dwellings, homes – but also artefacts of a long war.

It was in this area, this sheltered country where the bastles are clustered, that the majority of the new gun spurs were built ten years ago. From these positions the guns receive targeting intelligence from the observation points along the Crow Stone ridge, and send their projectiles into the impact area five kilometres north. The Iraqi soldiers are said to have had a name for the MLRS rockets, with their hundreds of bomblets (who knows if this is true): 'steel rain'. The AS90, I was told, possesses such accuracy that from one of these spurs it could pivot and fire a missile onto the pitch of St James's Park in Newcastle, fifty kilometres away. It was used in Croatia, and in the war in Iraq in 2003. Its reliability is such that an 'outside firing point' was established, from which shells pass directly over Otterburn First School.

Before coming here I had looked at the old range maps in the British Library, rumpled broadsheets from the fifties and

sixties, showing details unavailable to today's civilian: on each was plotted in broad red the boundary of the ranges, within which were further shapes outlined in blue or green or brown, showing digging areas, or non-firing areas, or areas where artillery was not to be engaged; as well as smaller red circles, arrows and symbols: target areas (Field, Medium-and-Light), impact lines, communications tapping-in points, arcs of fire, observation posts – and, on an overlaid sheet of tracing paper, the named 'firing zones': Davyshiel, Wilk-wood, Sills, Ridleeshope, Quickening Cote . . . There were place names where no feature was displayed save the land's dense contours: Scald Law, Deerbush Hill, Noutlaw Rigg, Yearning Law, Bloody Moss, Foulplay Knowe.

A week later, near Foulplay Knowe, I was looking for the figure known as the Red One. Rearing to the east was the high ridge of the Simonside Hills, under a brown pelt of heath-er. As I continued north I was conscious of walking along a seam, with the uniform dark heather to my right and the uni-form pale grass to my left, and the burns threading along the valley between. Locally the moors where the bent grew were known as the White Lands; where heather grew, the Black Lands. The distinction, I knew, was partly geological: the range's mat-grass – bent – was growing on limestone, while it was the drier sandstone to the east where the heather thrived. And of course the heather on those moors was encouraged – tended like a crop. The only gunfire I had heard all morn-ing was the shotguns of the keepers on the Simonside Hills, destroying crows. The farmers did not carry out controlled burning of grass or heather on the ranges: if a fire became too fierce there was a danger of old shells lodged in the peat 'cooking off'. The land could be cleared – it was necessary each time a farmer wanted to lay a drain, or a new track or observation point was to be built. But it was a painstaking

activity – like the node-by-node elimination of a cancer – and it was impossible to be sure that every shell had been found.

The Red One was quite naked apart from a close-fitting skull cap; his eyes were wide hollows and his arms and legs etiolated. In the pictures, he had no genitals. But he was clearly a killer. His arms were upraised; in his left fist was a spear, in his right a circular shield. His name was Cocidius, and he was a war-god, Celtic, but adopted – as *genii loci* frequently were – by the occupying Romans.

It had been true of the flagstoned stretches of the Pennine Way, as it was here: it was hard to experience the moor without walking on it, but whereas it was possible to stray from the paving of the Pennine Way, here to leave the tarmac was not only prohibited but, it was implied, suicidal. And it was this – part cowardice, part obedience, part ignorance – that prevented me from finding the shrine, which was situated, I had read, high up on the steep defile of Holystone Burn, built into a natural fault beneath the sandstone ridge, overlooking the site of a small marching camp.

So well hidden had it been that even the tenant farmer of forty years had been unaware of its existence when it was found. Others knew of it, however. When the site was excavated by archaeologists, in the early 1980s, little of interest was uncovered other than the carving itself: remnants of birch bark used as flooring, a sooty hearth and flue, a groove for the support of a roof, a ledge for a lamp or for offerings, and a bench cut into the bedrock. More conspicuous than all this, however, were the shreds of camouflage, rusty ration tins and spent cartridges. At some time, soldiers had found the shrine and made it their bivouac. When the archaeologists tested the carbon from the hearth, they found that it was not Roman – it had been there for no more than forty years. Did they notice him, the soldiers, when they cast their

torches over the walls of their sleeping place? Did they pause when the beam settled on that mushroom-shaped niche by the entrance, with its bas-relief warrior?

Between Longtae Burn and Trouty Sike it is possible to trace a section of the Roman branch-road that extended east from the fort at High Rochester, just north of Otterburn, to the camp at Low Learchild on the Devil's Causeway. High Rochester – Bremenium – was a key camp on Dere Street, the chief instrument of the empire's incursion into the unpacified north. Extending three hundred miles from York to the legionary fortress on the river Tay, Dere Street passed the smaller camp of Chew Green, which lay in what is now the northwestern corner of the training area.

Now the stones of Dere Street lie beneath the tarmacked military road from which modern-day officers watch their men manoeuvring on the moorland plains below. It was a matter of pride for the commandant that his soldiers marched along the line of the very road, Dere Street, that Roman legionaries had trodden two thousand years before.

4

I came to a right-hand junction that led north towards the impact zone. From this aggregate track a series of eighteen 'hardstandings' extended north. From these hardstandings, observation crews in Challengers were to look over the ridge, into the enemy valley below, and, using lasers, acquire and relay target coordinates to the guns situated on the spurs three kilometres to their rear, before jockeying back from the ridge to safety. Like much of what was visible of the military presence here today, these 'tactical observation posts' were

new, having been constructed during the massive works that occurred in the early twenty-first century.

The same things that suited the moors to military training had always presented a challenge to transportation. Even tracked vehicles became mired. Main Battle Tanks could not be deployed here, as they were on the harder chalk of Salisbury Plain, and so-called 'free tactical manoeuvring' was impossible. You only had to look down on the cratered impact zone to see how soft the ground was, like the bubble-pitted surface of a sponge. Or push your walking pole into any patch of wet ground. There were stories here, as there were of the ranges at Fylingdales and Dartmoor, of howitzers complete with horses and crew being sunk forever in bogs. And it was this softness that had made essential (as far as the MOD was concerned) many of the developments that were proposed in the 1990s to allow training on the ranges with those new 'artillery systems', the AS90 and the MLRS.

The ranges lay within Northumberland National Park. When the MOD's original notice of development was rejected, a public inquiry was announced. The MOD's proposals included widening the road from Ponteland to Otterburn, strengthening bridges, and renovating fifty kilometres of roads within the training area. Six new 'gun deployment areas' would each include a series of aggregate observation points, gun-firing spurs, command posts and 'battery echelon areas'. A thirty-thousand-square-metre Central Maintenance Facility would also be required for the new weapons – the pitch of concrete I'd seen beside the camp.

The National Parks Act of 1949 had conceded that 'It may be necessary . . . to permit some part of the national park area to be used for purposes of national defence.' Baroness Sharp, in her 1977 report as chair of a public inquiry into the continued use of Dartmoor for military training, acknowledged that

the practice was both 'exceedingly damaging to the National Park' and 'discordant, incongruous and inconsistent' with the stated aims of the national parks. Nevertheless, she said, 'I cannot accept that they are incapable of living together.'

There was no question of the military presence on the Otterburn ranges being diminished. It had been the planners' decision to include the training area within the bounds of the new national park in the 1950s, just as the well-established army ranges south of Okehampton were consciously included in Dartmoor National Park. The forces were here first – and besides, it couldn't be doubted that conservation was a by-product of the military presence. Stock grazing was lighter on the ranges than on other parts of Northumberland National Park, raptors were not persecuted as they were on the grouse moors, and the forestry that covered huge areas of the Northumberland moors in the post-war years was absent here. Kielder Forest, which darkens the horizon beyond Redesdale, stops at the range's western edge. In its depths, in the shadow of Sitka and Scots pine, you come across old circular sheep stells, even derelict grouse butts.

There were merlin on the military moors, dunlin and snipe, and curlew. They thrived. Shell holes, the MOD pointed out, could also be ponds. What better way of safeguarding black grouse against human disturbance than sowing their breeding grounds with unexploded bombs?

When the public inquiry opened in 1997, it was clear that its bounds would be limited: it would determine the details of the MOD's vital consolidation of its estate, no more: 'Forty-six gun spurs, the equivalent of six GDAs, Technical or Tactical Ops, a Central Maintenance Facility, a Regimental Replenishment Point and additional accommodation facilities are the minimum and cannot be compromised.' It was the impact on the human experience of the landscape that

was the focus of the inquiry – the *view*. According to the MOD, 'only some of the road and/or track would be visible from any one point', and besides, the existing visibility of the military, here on the southern edge of the ranges, meant that 'the scenic quality and unspoilt character are also lower'.

The question was of 'mitigation'. The military stance – that such weaponry was essential to the country's security, that no alternative means of training existed – was not to be challenged. 'We do not expect anyone to deny this,' said the counsel for the MOD. 'Nor do we expect it to become an issue, because failure to be properly trained in the use of these weapons means greater difficulties in succeeding in military conflict objectives and more casualties.' The proposals were 'of the highest national importance'; they were 'self-evidently in the public interest'. These were assertions that brought to mind Baroness Sharp's report on the Dartmoor public inquiry thirty years earlier: 'It was not possible', she wrote, 'to examine the continuing defence need to retain training areas in the national park. It was not within our terms of reference to do so, nor could it have been within our competence.' And that was critical: those opposing the army's plans at Otterburn, being civilians, were unequipped to interrogate the military or strategic necessity of either the weaponry or the developments, nor, as civilians, could they be given access to such information as would have allowed them to form an opposing case.

Sixteen years later, it was hard to see a difference between the infrastructure as proposed originally and what existed on the ground today. There had been those 'mitigations' – the colour of the aggregate, the installation of oil interceptors and closed-loop drainage systems to prevent groundwater pollution – but there had been no concessions.

As I passed Watty Bell's Cairn, at the eastern end of the new line of observation hardstandings, I saw, in the Wilkwood

valley a mile below, the Forward Operating Base – it had been built only a couple of years ago, when it became clear that the British military presence in Afghanistan would not end soon. It was a hectare of blue-grey aggregate and pale concrete, walled on two sides with steel hoarding, and on the other two, facing the threat from the moor, by steel-mesh gabions lined with felt and packed with sand, a metre across and laid two high – blast walls. It had been built as a proxy for the forward operating bases in Afghanistan's Helmand Province (it was familiar from news footage). It would be populated, for days at a time, by territorials and regulars, before they went to Afghanistan. The perimeter would be patrolled, the horizon monitored, attacks repelled.

In the middle of the compound were a turfed bunker and twenty-five shipping containers, painted green. It was in these containers that the trainees slept. Along the western edge, inside the blast wall, facing out over the Wilkwood valley and the impact area, was a line of five watchtowers (each with its neatly painted number), again built from those sand-filled cages, and accessed by a wooden staircase. I climbed up one of these, to the platform where a machine-gunner would await the night-time incendiaries that he knew would come, and looked out over the impact area, at the Russian tanks scarcely visible through the drizzle, and down at the hollows blasted deep into the perimeter peat, and the brown water that had collected in those hollows. The concrete and the watchtowers, and the wood and sandbags they were built from, and the gabions, and the concrete walls that surrounded the sleeping-containers: all were pale grey or pale beige – it was the colour of both Helmand and the White Lands.

I walked back up the hill, past the observation point at Watty Bell's Cairn, and back to the road that led to the Crow Stone. The surface, which had been deep blue under the ear-

lier light, was almost black now that the sky had darkened, and as I dropped my face from the rain, I saw that the road was strewn with small pink worms.

5

An observation hut stood at a place called Middle Golden Pot, close to the socket of a lost wayside cross. These huts resembled birdwatching hides, with long unglazed windows framing the view, and long tall benches. The training area was formed of asymmetric ridges, arrayed around the impact zone like the petals of a rose. Always there was the feeling – and this, too, explained the siting of the range – of looking down into a mile-wide amphitheatre. It was as much a landscape of observation and assessment as of performance. The wooden sill of the observation hatch, softened by the damp, carried the carvings of the recruits who'd waited here: E BTY PARA, BIDDY, MAC, TREV, BUSHY, JEW.

I looked down into the valley of the Ridlees Burn: the hillside to the north had been made dark by shell holes. Occasionally, a mortar will land in a field and kill a few sheep, or cause injuries so severe that the animal has to be shot. Stock stray into the path of army vehicles: twenty-six-tonne Warriors, fifty-six-tonne Chieftains. When the wire-guided Milan anti-tank missile was in use, sheep got snared in its fine wires – stretched out two miles between launch and target – and would be found by a stockman garrotted in the peat, or with a leg cheesewired clean off, or dead from the struggle. In softer peat, the shell holes can be deep enough when filled with water to drown sheep; the problem is worse during hot summers, when the water level drops, and the animals stooping to drink tumble in, to be sniffed out by the farmer's dog, weeks later.

Between Brown Law, Rookling Law and Hindsike Hill, the Soviet tanks were massed – driven or towed onto the mire to represent a Russian mobilised rifle regiment. Many of the ancient farmhouses have gone – Carshope has become a troop shelter, Wilkwood and Pity Me are bombed ruins. In the Ridlees valley below me, Old Ridlees had once stood. In 1584 John Forster, Warden of the English Middle March, made a complaint against the Liddesdale Elliots 'for stealing from his place called Ridleie borne . . . seven score kye and oxen, with insight worth 40l sterling'. The farmhouse was demolished during the Second World War, when it seems every moor of England – Bodmin Moor, Dartmoor, Exmoor, the moors of Yorkshire and the Pennines – was given over to military training. On the pocked valley floor, a few stringy birches marked where a garden had been.

I spent the rest of the afternoon walking along the army roads to Chew Green, the Roman camp on the Scottish border. From time to time I would be stopped abruptly by the sight of a rusted shell the size of a fire extinguisher, resting at the side of the road. From Dere Street you could look right, into the arena of the impact zone, with its arrayed tanks and the pale emplacement of the Forward Operating Base, and the Black Lands on the horizon – and then follow the line of yellow snow-poles that flanked the road down to the Roman camp, its ramparts rising out of the choppy grass. *Ad Fines* was the Romans' name for Chew Green; and this name had been taken up by the twentieth-century recruits, tongue-in-cheek, for their camp at Rochester: *Ad Fines* – 'the end'.

And perhaps it was tiredness – sensitivity dulling as the sun set – or else a real softening of appreciation caused by the dimming light, but in the last miles of the day, and the last of my landloping, as I made my way back to the village, the moor, without my knowing, settled back into homogeneity

and monotony – landocean – *nullarbor* – so that a heron, when it dislocated from its watching place by the Otter Burn and eddied low over the river conifers, was for me a sudden symbol of all that was not the moor, of the vibrancy and variety of the cultivated land; the welcome elbow of the particular.

Epilogue

Spaunton Moor

The heat on my face was almost intolerable. The smoke was dense but not acrid. It didn't sting the eyes. When I'd arrived, the men had been parked up in two ATVs and were eating quietly from their lunchboxes. George the head keeper was easier today, he seemed younger and more nimble than he had been at the shoot; this was his real work – managing the moor.

I'd taken a detour to Spaunton Moor on my way back from Newcastle. Three months had passed since the shoot. Those few days in August and September were an anomaly from George's day-to-day activities, but they were also the test of that work. With him was a man I knew from the shoot, Keith (not the loader – a different Keith). He was wearing a fire-retardant snood and a dark blue fireman's jacket, thick as a duvet, with 'FIRE' emblazoned on the back. A pro. He'd worked for twenty-five years with the brigade based at RAF Fylingdales. In the other vehicle were Ant, the underkeeper, and two others, one much older than Ant, the other a teenager. Their faces and hands were smutty with soot, and they looked tired and slightly exhilarated. The whites of their eyes were bright.

It was George's invention, he said. Surprising nobody'd thought of it before. Whereas previously the heather had been lit with a match and controlled with shovels or birch brooms, George's men had these aluminium trailers, which were towed behind the ATVs: a water tank, with a cage on top that contained a propane canister, a generator pump and a

hose-reel. To the canister was fixed an orange hose leading to a long-handled plumber's torch; the pump fed a longer hose, attached to an industrial pressure washer.

Ant and his men were sent off to work on the other side of the moor. I stayed with George and Keith. A westerly wind, rare here, meant it was possible to burn the leggy heather beside the road, downwind along its eastern verge. The wind would blow the smoke away from the road. A downwind fire burns cool and quick, upwind hot and slow. The ATV with its hydrant-trailer crawled along the verge, with George at the wheel and Keith following behind, touching the heather with the torch.

The air was damp, but the heather took almost instantly. He'd worked with fire most of his life, and yet it still excited him, you could tell, and he was still taken aback by its ferocity and volatility, and its power to exhaust you. He'd return to the trailer with a wry smile. Burning in a controlled way means understanding the wind, knowing how the moor's surface and vegetation will influence the fire's speed, heat and direction – a patch of bog will slow a fire, a change in wind redirect its course or speed, a stream will stop it dead.

Twenty metres from the road a strip of heather had been swiped to create a firebreak. Between this strip and the verge, the breast of the fire worked its way alongside the road in a straight line, the heather first roaring into flames two metres tall, then quickly mollifying as the fuel was consumed, and continuing to burn until Keith unreeled the water hose to douse the lingering flames.

After the first burn it was easy to be transfixed by the display: by the intense heat on your face while your nape was blasted by a freezing wind. Half a year after the heather had flowered, the smoke contained some of its honey sweetness. When I unlaced my boots that evening, the eyelets and cleats

that had been clogged with pollen and flowers six months ago were clogged with soot and cinders.

George crouched and, from the burnt ground, picked a grouse's breastbone – still whitish-green, despite the flames. Lifting it to my face, he fingered the notches that toothed the scapula: 'Peregrine,' he said.

The second area was bigger, a belt twenty paces wide that would be allowed to burn the three hundred metres of tall heather between the road and Loskey Beck. Once it had taken, I stood in the centre of the newly burnt area, ringed with fire as the breast moved away on all sides. Within that ring the smoke was so thick that the flames were only their heat and a tremendous jet-engine roar and crackle. The stems of heather, their tiny enfolded leaves having been turned to ash, continued to glow once the flames had moved on, and these shuddering tendrils were hypnotic, the molten colour slowly leaving them, like the dying filament of a lightbulb, until their true final grey became visible.

The sun itself was hidden. The ground close to me was black and grey with a sifting ash, fuming still, and hot underfoot. The moor started to clear and quieten down, as if a ceasefire had been called – and there was George, coming out of the smoke, striding towards me, blackened gloves hanging at his sides.

Acknowledgements

I would like to thank Professor I. G. Simmons, Emeritus Professor of Geography at Durham University, for commenting on the typescript. I'd also like to acknowledge the importance of his book *The Moorlands of England and Wales* in the development of this one.

In Bishop's Waltham I'd like to thank Peter Potts, of Hampshire County Council, for telling me about the Moors. I'm also grateful to the Macleod-Clarkes of Suetts Farm and Rod Murchie of the Environment Agency.

I'm very grateful to Mark de Wynter-Smith of Cornham Farm on Exmoor for his time and hospitality. I'm also grateful to Anne Williamson, for sharing information about, and writings by, her father-in-law, Henry Williamson; to Rob Wilson-North and Lee Bray of Exmoor National Park Authority; and to Meriel Martin, who told me about her research into Exmoor dialect terms.

The Rt Rev. David Charlesworth, Abbot of Buckfast, was a kind host at Buckfast Abbey, where I am also grateful to Br. Daniel Smyth and the other members of the community – and to the abbey's apiarist, Clare Densley, for introducing me to Angela, Joyce, Sue, Henrietta, Sammy and Heather. I'd like to thank Louise Cooper, and 'David' and the other inmates of HMP Dartmoor. Simon Dell was an erudite guide to the moor, and introduced me to Beatrice Chase. Anton and Alison Coaker of Sherberton Farm told me about moorland farming, and allowed me to spend some time working with them and their beautiful Galloways, as well as giving me access to Brother

Adam's bee-breeding station. In Widecombe-in-the-Moor, Peter Hicks was generous with his time and his memories of Beatrice Chase, and I am indebted to the family of Enid Shortridge for allowing me to reproduce extracts from personal correspondence between her and Chase.

Peter Fox, curator of Saddleworth Museum, Uppermill, was a knowledgeable guide to the area and to the museum's collection. I'm also grateful to Danny Ewington of the Greater Manchester Police Museum.

Thanks to Robin Gray and Anna Carter of Pennine Prospects, Hebden Bridge; and to Johnny Turner, for his company and for teaching me about mosses. The late Donald Crossley was an affectionate and passionate guide to Mytholmroyd and the surrounding moors, and kindly shared his memories of his friend Ted Hughes. I would also like to thank Mark Hinchliffe of the Elmet Trust. I'm grateful to Deacon Claire Gill and the Methodist congregations of Oxenhope, Haworth, Lees and March, for their warm welcome.

In Haworth I'm indebted to Steven Wood for his friendship and for sharing some of his vast knowledge of Haworth township. I'm also grateful to Simon and Judith Warner, for their company and good humour, and for providing a wonderful place to work. I'd also like to thank Ann Dinsdale and Sarah Laycock of the Brontë Parsonage Museum. I'm very grateful to Elinor Klein, for sharing her memories of visiting Top Withens with Sylvia Plath and Ted Hughes. Professor Simon Dentith's talk on moorland literature, at the 'Unbounded Moor' symposium in Haworth in 2012, influenced some of the ideas contained in this book. Kevin Jaundrell taught me much about grouse-moor management, and I'm also grateful to Richard Bannister, Jill Laws, and Jason, Robbie and Freddie.

Thanks to Mick Carroll: I couldn't have asked for a more knowledgeable or enthusiastic guide to the North York

Moors and their birdlife. I'd also like to thank Nick Adams of the RSPB. At RAF Fylingdales I'm grateful to Flt Lt Richard Weeks and Graham Bedford. Leo Westhead spoke eloquently of his time working at the base. Thanks to Amanda Anderson and Edward Bromet of the Moorland Association. George Winn-Darley allowed me to attend a shoot day on Spaunton Moor, and George Thompson and his team were generous with their time and expertise. I'm also grateful to Louise Harrison of the Dorman Museum, Middlesbrough, for giving me access to Frank Elgee's papers.

I'm extremely grateful to Tom Pickard for his company, his recollections of life at the Hartside Cafe, and his poetry. Robert N. Forsythe was an invaluable guide to the lead-mining industry of Alston Moor and Auden's relationship with the area – I draw heavily on his original research. I would also like to thank Alastair Robertson and Sheila Barker.

Lt Col. R. N. R. Cross, former commandant of Otterburn Training Area, gave freely of his time, memories and knowledge, and shared with me the unpublished history of the area written by the late Major John B. Keenan RA. I would also like to thank Chris Livsey and Joanne Tully of DIO Otterburn, and the current commandant of the training area, Lt Col. N. MacGregor-Smith. I'm extremely grateful to Professor Rachel Woodward of Newcastle University, whose account of the Otterburn Public Inquiry was an invaluable source of information. I'd also like to acknowledge the assistance of June Holmes of the Natural History Society of Northumbria, David Gardner-Medwin, Terry Carroll, John Steele, and Joyce and Colin Taylor of Forest View Walkers' Inn, Byrness.

At David Godwin Associates I owe a great debt of thanks to Kirsty McLachlan for her commitment and encouragement,

and to David Godwin. I'm also grateful to Patrick Walsh. At Faber & Faber I'm deeply indebted to Lee Brackstone, for his faith and his guidance, and to him and Silvia Crompton for their editorial acumen and support. I'd also like to thank Eleanor Rees, Eleanor Crow, Kate Burton, John Grindrod, Mary Morris and Lisa Baker. An Authors' Foundation grant from the Society of Authors enabled me to complete the writing of this book. I'm grateful to Simon Armitage, Richard Skelton, Jeff Barrett, Robert Macfarlane, Tim Dee and Philip Hoare.

Thanks to Guy Griffiths and Stuart Evers for reading the typescript, and for much else besides, and to Lucy Abraham, and Neil, Betsy and Thomas Cameron.

Thank you, Charlie Yates, for your help in Yorkshire; and thanks to Katherine, Richard, Evie and Judith Yates; to Chloe Atkins; and to my parents, Keith and Gill. Finally to Thalia Suzuma – without whom no beginning, no middle, and no end.

Quotation Acknowledgements

Extracts from W. H. Auden, 'New Year Letter', 'Amor Loci' and 'The Watershed', taken from *Collected Poems*, and extract from *A Certain World*, copyright © 1940, 1965, 1927, 1970 by W. H. Auden, renewed, reprinted by permission of Curtis Brown Ltd; extract from John Fowles, 'The Hound of the Baskervilles', taken from *Wormholes*, published by Vintage, reprinted by permission of the Random House Group Limited; extract from Glyn Hughes, *Millstone Grit*, reprinted by permission of Macmillan Publishers; extracts from Ted Hughes, 'Walt' and 'Wuthering Heights', taken from *Collected Poems*, and Foreword from *Remains of Elmet*, reprinted by permission of Faber & Faber; extracts from 1999 interview with Ted Hughes taken from *Wild Steelhead and Salmon* magazine, reprinted by permission of Thomas R. Pero; extract from Marianne Moore, 'A Graveyard', taken from *Complete Poems*, reprinted by permission of Faber & Faber; extract from Tom Pickard, 'Lark and Merlin', reprinted by permission of the author; extracts from Sylvia Plath, *Letters Home*, and 'Initiation', taken from *Johnny Panic and the Bible of Dreams, and Other Prose Writings*, reprinted by permission of Faber & Faber; extract from Joan Rockwell, *Chronicles of Alston*, reprinted by permission of Janus Publishing; extracts from the writings of Henry Williamson reprinted by permission of the Henry Williamson Estate.

Every effort has been made to trace or contact all copyright holders. The publishers would be pleased to rectify at the earliest opportunity any omissions or errors brought to their notice.

Bibliography

General

Andrew Bibby, *Backbone of England: Life and Landscape on the Pennine Watershed* (London: Frances Lincoln, 2011).

Aletta Bonn et al. (eds), *Drivers of Environmental Change in Uplands* (Abingdon: Routledge, 2009).

Thomas Hardy, *The Return of the Native* (Oxford: Oxford University Press, 2008; originally published 1878).

Adam Hopkins and Dudley Witney, *The Moorlands of England* (Ontario: Key Porter Books, 1995).

W. G. Hoskins, *The Making of the English Landscape* (London: Hodder & Stoughton, 1955).

David Jasper, *The Sacred Desert* (Oxford: Blackwell, 2004).

W. H. Pearsall, *Mountains and Moorlands* (London: Collins, 1950).

Oliver Rackham, *The History of the Countryside* (London: Dent, 1986).

Ian D. Rotherham, *Peat and Peat Cutting* (Oxford: Shire Publications, 2009).

I. G. Simmons, *The Moorlands of England and Wales: An Environmental History 8000 BC–AD 2000* (Edinburgh: Edinburgh University Press, 2003).

Prologue

Anon., *The History of the Blacks of Waltham in Hampshire; and those under the like Denomination in Berkshire* (A. Moore, 1723). The authorship of this pamphlet, one of the few contemporary accounts of Blacking, has been ascribed to Daniel Defoe. Other details come from the *London Journal* and the Ordinary of Newgate's *Account*.

John Bosworth, 'The Moors', unpublished typescript pages, Bishop's Waltham Museum (undated).

Edmund Burke, *A Philosophical Enquiry into the Origin of Our Ideas of the Sublime and Beautiful* (London: Penguin, 1998; originally published 1757).

Alan Inder, *The Changing Face of Bishop's Waltham* (Bishop's Waltham: Bishop's Waltham Society and Bishop's Waltham Museum Trust, 2011).

E. P. Thompson, *Whigs and Hunters: The Origin of the Black Act* (London: Allen Lane, 1975).

Peter R. Watkins, *Bishop's Waltham: Parish, Town and Church* (Swanmore: Swanmore Books, 2007).

1. The Monster Meeting

E. C. Axford, *Bodmin Moor* (Newton Abbot: David & Charles, 1975).

Sabine Baring-Gould, *A Book of the West, Being an Introduction to Devon and Cornwall*, vol 2: Cornwall (London: Methuen, 1899).

Mark Camp, *An Introduction to Bodmin Moor* (Launceston: The Best of Bodmin Moor, 2009).

Cathy Farnworth et al., *The Reverend Frederick William Densham (1870–1953)*, self-published pamphlet.

Margaret Forster, *Daphne du Maurier* (London: Chatto & Windus, 1993).

William Gilpin, *Observations on the Western Parts of England* (London: T. Cadell and W. Davies, 1808).

Daphne du Maurier, *Jamaica Inn* (London: Victor Gollancz, 1936).

—, *Myself When Young: The Shaping of a Writer* (London: Virago, 2004; first published 1977).

—, *Vanishing Cornwall* (London: Victor Gollancz, 1967).

Pat Munn, *The Charlotte Dymond Murder* (Bodmin: Bodmin Books, 1978).

—, *The Story of Cornwall's Bodmin Moor* (Bodmin: Bodmin Books, 1972).

Tony Olivey et al., *Warleggan*, self-published pamphlet (Warleggan, 1999).

Helen Taylor, *The Daphne du Maurier Companion* (London: Virago, 2007).

2. Less Favoured Areas

R. D. Blackmore, *Lorna Doone: a Romance of Exmoor* (Ware: Wordsworth Editions, 1997; first published 1870).

Hope L. Bourne, *A Little History of Exmoor* (London: Dent, 1968).

Waldo Hilary Dunn, *R. D. Blackmore* (London: Robert Hale, 1956).

Geoff Dyer, *The Missing of the Somme* (London: Hamish Hamilton, 1994).

Daniel Farson, *Henry Williamson: a Portrait* (London: Robinson, 1986).

Barry Gardner, *Lorna Doone's Exmoor* (Dulverton: The Exmoor Press, 1990).

William Hannam, *A History of Twelve Years Life on Exmoor*, unpublished manuscript, 1845–*c*.1857, Bodleian Library: MS. Top. Devon e. 11. Extracts can also be found in C. S. Orwin and R. J. Sellick, *The Reclamation of Exmoor Forest*.

Jack Hurley, *Murder and Mystery on Exmoor* (Tiverton: The Exmoor Press, 2003).

Edward T. Macdermot, *A History of the Forest of Exmoor* (Newton Abbot: David & Charles, 1973; first published 1911).

C. S. Orwin and R. J. Sellick, *The Reclamation of Exmoor Forest* (Newton Abbot: David & Charles, 1970; first published 1929).

Hazel Riley, *Metric Survey of Pinkery Pond and its Environs*, project report (Exmoor Mires Project, 2012).

Mary Siraut and Rob Wilson-North, *Exmoor: the Making of an English Upland* (Chichester: Phillimore, 2009).

Simon Trezise, *The West Country as a Literary Invention* (Exeter: University of Exeter Press, 2000).

Anne Williamson, *Henry Williamson and the First World War* (Stroud: Sutton, 1998).

—, *Henry Williamson: Tarka and the Last Romantic* (Stroud: Sutton, 1995).

Henry Williamson, *The Children of Shallowford* (London: Faber & Faber, 1939).

—, *Devon Holiday* (London: Jonathan Cape, 1935).

—, *The Gale of the World* (London: Macdonald & Co., 1969).

—, *The Patriot's Progress: Being the Vicissitudes of Pte John Bullock* (London: Macdonald and Jane's, 1968).

—, *Tales of Moorland and Estuary* (London: Macdonald, 1953).

—, *Tarka the Otter* (London: Penguin, 2009; first published 1927).

—, *The Wet Flanders Plain* (London: Faber & Faber, 1929).

—, 'Withypool: June, 1940', *The Adelphi* (October–December 1944).

3. The Abbot's Way

Sabine Baring-Gould, *A Book of Dartmoor* (London: Wildwood House, 1982; first published 1900).

Lesley Bill, *For the Love of Bees: the Story of Brother Adam of Buckfast Abbey* (Mytholmroyd: Northern Bee Books, 2009).

Noel Thomas Carrington, *Dartmoor: A Descriptive Poem* (London: John Murray, 1826).

Brian Carter, *Dartmoor: The Threatened Wilderness* (London: Century, 1987).

Judy Chard, *The Mysterious Lady of the Moor* (Newton Abbot: Orchard Publications, 1994).

Robin Clutterbuck, *Buckfast Abbey: A History* (Buckfast: Buckfast Abbey Trustees, 1994).

Anton Coaker, *All the Usual Bullocks: a Glimpse into the Life of a Peasant Farmer* (Sherberton: Anton Coaker, 2011).

Arthur Conan Doyle, *The Hound of the Baskervilles* (Ware: Wordsworth Editions, 1999; first published as a single volume 1902).

William Crossing, *Crossing's Guide to Dartmoor* (Newton Abbot: David & Charles, 1965; first published 1912).

John Fowles, *The Journals*, vol. 1 (London: Jonathan Cape, 2003).

—, *Wormholes* (London: Vintage, 1998).

Jonathan Gathorne-Hardy, *Inside the Cloister: the History of Monasticism and a Day in the Life of Buckfast* (Buckfast: Buckfast Abbey, 1984).

Crispin Gill, *Dartmoor: A New Study* (Newton Abbot: David & Charles, 1970).

Christina Green, *Beatrice Chase: My Lady of the Moor* (Newton Abbot: Ideford Publications, 1979).

Dom Adam Hamilton, *History of St Mary's Abbey of Buckfast* (Buckfastleigh: Buckfast Abbey, 1906).

L. A. Harvey and D. St Leger-Gordon, *Dartmoor* (London: Collins, 1962).

W. G. Hoskins (ed.), *Dartmoor National Park* (London: Her Majesty's Stationery Office, 1976).

Ted Hughes, 'Address Given at the Memorial Service at St Martin in the Fields, London, at 12 Noon on Thursday, 1 December 1977' in Brocard Sewell (ed.), *Henry Williamson: the Man, the Writings: a Symposium* (Padstow: Tabb House, 1980).

—, *Moortown Diary* (London: Faber & Faber, 1989).

Trevor James, *About Dartmoor Prison* (Newton Abbot: Orchard Publications, 2001).

Patrick Leigh Fermor, *A Time to Keep Silence* (London: John Murray, 2004; first published 1957).

John Oxenham, *My Lady of the Moor* (London: Longmans, Green and Co., 1916).

Olive Katherine Parr, *Completed Tales of my Knights and Ladies* (London: Longmans & Co., 1919).

—, *The Innocent Victims of War* (London: R. & T. Washbourne, 1914).

—, *My Chief Knight, John Oxenham* (London: Herbert Jenkins, 1943).

—, *White Knights on Dartmoor* (London: Longmans, Green & Co., 1917).

— (as 'Beatrice Chase'), *Devon and Heaven* (Widecombe-in-the-Moor: the author, 1924).

— (as 'Beatrice Chase'), *The Heart of the Moor* (London: Herbert Jenkins, 1914).

— (as 'Beatrice Chase'), *The Passing of the Rainbow Maker* (Bristol: Burleigh Press, 1926).

Clifford Rickards, *A Prison Chaplain on Dartmoor* (London: Edward Arnold, 1920).

Samuel Rowe, *A Perambulation of the Antient and Royal Forest of Dartmoor and the Venville Precincts* (Newton Abbot: Devon Books, 1985; first published 1848).

Elisabeth Stanbrook, *Dartmoor's War Prison & Church 1805–1817* (Brixham: Quay Publications, 2002).

Dom John Stéphan, *Buckfast Abbey* (Buckfast: Buckfast Abbey, 1970).

David Taylor (producer), *The Monk and the Honeybee* (DVD, York Films, 2005).

Philip Weller, *The Hound of the Baskervilles: Hunting the Dartmoor Legend* (Tiverton: Devon Books, 2001).

Anne Williamson, 'Cranmere Pool', *Henry Williamson Society Journal*, 22 (September 1990), 38.

4. The Waste

'Anniversary of Dakota Crash', *Oldham and District Chronicle*, 22 August 1970.

Anon., *The Guide to Hayfield and Kinder Scout, by a Member of the Hayfield and Kinder Scout Ancient Footpaths Association* (Manchester: 1877).

'Melancholy and Untimely Death of James Platt, Esq. M.P.', *Oldham Chronicle*, 29 August 1857.

Joseph Bradbury, *Saddleworth Sketches* (Oldham: Hirst and Rennie, 1871).

Mike Buckley et al. (eds), *Mapping Saddleworth* (Uppermill: Saddleworth Historical Society).

John Bull, *The Peak District: a Cultural History* (Oxford: Signal Books, 2012).

Glyn Hughes, *Millstone Grit* (London: Victor Gollancz, 1975).

Geraldine Jewsbury, 'The Great Saddleworth Exhibition', *Household Words*, 6 (3 September 1854).

Moors for the Future, 'Moorland Restoration in the Peak District National Park: research note no. 7' (Moors for the Future, 2008).

Benny Rothman, *The Battle for Kinder Scout* (Altrincham: Willow Publishing, 2012; first published as *The 1932 Kinder Trespass*, 1982).

Derek Seddon, 'Benny Rothman, the Peak & Northern and the Kinder Trespass', *Signpost: the Newsletter of the Peak and Northern Footpaths Society*, 6 (Spring 2002).

Sam Seville, *With Ammon Wrigley in Saddleworth* (Uppermill: Saddleworth Historical Society, 1984).

Duncan Staff, *The Lost Boy: the Definitive Story of the Moors Murders and the Search for the Final Victim* (London: Bantam, 2007).

Peter Topping, with Jean Ritchie, *Topping: the Autobiography of the Police Chief in the Moors Murders Case* (London: Angus & Robertson, 1989).

George Halstead Whittaker, *Bill's o' Jack's: A Moorland Mystery* (Stalybridge: G. Whittaker & Sons, 1932).

Ammon Wrigley, *Songs of a Moorland Parish* (Saddleworth: Rotary Club, 1980).

5. The Desert

George G. Cragg, *Grimshaw of Haworth* (London, Edinburgh: Canterbury Press, 1947).

Elaine Feinstein, *Ted Hughes: The Life of a Poet* (London: Weidenfeld & Nicolson, 2001).

Nick Gammage (ed.), *The Epic Poise: A Celebration of Ted Hughes* (London: Faber & Faber, 1999).

Gerald Hughes, *Ted and I: A Brother's Memoir* (London: Robson Press, 2012).

Ted Hughes, 'The Rock', in Charles Causley (ed.), *Worlds: Seven Modern Poets* (Harmondsworth: Penguin, 1974).

—, Paul Keegan (ed.), *Collected Poems* (London: Faber & Faber, 2003).

John William Laycock, *Methodist Heroes in the Great Haworth Round* (Keighley: Wadsworth and Co., 1909).

William Myles, *Life and Writings of the Late Rev. William Grimshaw* (1813).

John Newton, *Memoirs of the Life of William Grimshaw* (1799).

Ted Hughes, Christopher Reid (ed.), *Letters of Ted Hughes* (London: Faber & Faber, 2007).

— and Fay Godwin, *Remains of Elmet: A Pennine Sequence* (London: Faber & Faber, 1979).

Keith Sagar, *The Art of Ted Hughes* (Cambridge: Cambridge University Press, 1975).

John Wesley, *The Journal of the Rev. John Wesley*, 8 vols (London: Robert Culley, 1909).

6. The Flood

Information about relations between the Walshaw Moor Estate, Natural England and the RSPB is taken from Mark Avery's blog, www.markavery.info. Avery describes Natural England's 2011 legal case against the estate, the dropping of this case in 2012, and the RSPB's subsequent complaint to the European Commission. Relevant entries can be found under the title 'Wuthering Moors'. Other information, including land-management agreements and press releases, can be found at www.naturalengland.org.uk and www.rspb.org.uk.

Juliet Barker, *The Brontës* (London: Weidenfeld & Nicolson, 1994).

—, *The Brontës: a Life in Letters* (London: Viking, 1997).

The Brontës, Christine Alexander (ed.), *Tales of Glass Town, Angria, and Gondal* (Oxford, Oxford University Press, 2010).

Emily Brontë, *Wuthering Heights* (London: Penguin, 2008; first published 1847).

—, Rosemary Hartill (ed.), *Poems of Emily Brontë* (London: Tom Stacey, 1973).

Patrick Brontë, *Two sermons preached in the Church of Haworth* . . .
*Also A Phenomenon, or, an Account in verse of the extraordinary
disruption of a bog, etc.* (Haworth: R. F. Brown, 1885).

Edward Butscher (ed.), *Sylvia Plath: the Woman and the Work*
(London: Peter Owen, 1979).

Edward Chitham, *A Life of Emily Brontë* (Oxford: Basil Blackwell,
1987).

Florence Swinton Dry, *Brontë Sources*, vol. 1: 'The Sources of
Wuthering Heights' (Cambridge: W. Heffer & Sons, 1937).

Elizabeth Gaskell, *The Moorland Cottage* (London: Hesperus, 2010;
first published 1850).

—, *The Life of Charlotte Brontë* (London: Penguin, 1997; first
published 1857).

Winifred Gérin, *Emily Brontë* (Oxford: Oxford University Press, 1991).

Peggy Hewitt, *Brontë Country: Lives and Landscapes* (Stroud: Sutton,
2004).

Christine Kayes, 'The History of Top Withens', in *Brontë Studies*,
31 (March 2006).

Lucasta Miller, *The Brontë Myth* (London: Vintage, 2002).

Sylvia Plath, *Johnny Panic and the Bible of Dreams, and Other Prose
Writings* (London: Faber & Faber, 1979).

—, Ted Hughes (ed.), *Collected Poems* (London: Faber & Faber, 1981).

—, Karen V. Kukil (ed.), *The Journals of Sylvia Plath* (London:
Faber & Faber, 2000).

—, Aurelia Schober Plath (ed.), *Letters Home* (London: Faber &
Faber, 1976).

Fannie Ratchford, *Gondal's Queen: a Novel in Verse* (Austin:
University of Texas, 1955).

Elizabeth Southwart, *Brontë Moors and Villages: from Thornton to
Haworth* (London: The Bodley Head, 1923).

Muriel Spark and Derek Stanford, *Emily Brontë: Her Life and Work*
(London: Peter Owen, 1953).

Anne Stevenson, *Bitter Fame: A Life of Sylvia Plath* (London: Viking,
1989).

J. Horsfall Turner, *Haworth, Past and Present* (Nelson: Hendon
Publishing Co., 1999; first published 1879).

Whiteley Turner, *A Spring-time Saunter: Round and about Brontë-
land* (Halifax: Halifax Courier, 1913).

Mary Visick, *The Genesis of 'Wuthering Heights'* (Hong Kong: Hong
Kong University Press, 1958).

Simon Warner, *Ways to the Stone House*, exhibition catalogue (Haworth: The Brontë Society, 2012).

Steven Wood, *Haworth: 'A strange uncivilized little place'* (Stroud: Tempus, 2005; revised reprint: Stroud: The History Press, 2012).

7. Blackamore

J. C. Atkinson, *British Birds' Eggs and Nests* (London: Routledge, 1898).

—, *Forty Years in a Moorland Parish: Reminiscences and Researches in Danby in Cleveland* (London: Macmillan, 1907).

Tom Scott Burns, *Canon Atkinson and his Country* (Guiseley: M. T. D. Rigg, 1986).

Ronald Eden, *Going to the Moors* (London: John Murray, 1979).

Frank Elgee, *The Moorlands of North-Eastern Yorkshire* (London: A. Brown & Sons, 1912).

—, unpublished notes towards an autobiography and other papers, Dorman Museum archive, Middlesbrough.

—, Harriet W. Elgee (ed.), *A Man of the Moors: Extracts from the Diaries and Letters of Frank Elgee* (Middlesbrough: Roseberry Publications, 1991).

Harriet W. Elgee, 'A Memoir of Dr Frank Elgee', *The North Western Naturalist*, December 1944.

Jay Griffiths, *Wild* (London: Penguin, 2007).

Marie Hartley and Joan Ingilby, *Life in the Moorlands of North-East Yorkshire* (London: J. M. Dent & Sons, 1972).

David Hudson, *Grouse Shooting* (Wykey: Quiller, 2008).

A. S. Leslie (ed.), *The Grouse in Health and Disease: Being the Popular Edition of the Report of the Committee of Inquiry on Grouse Disease* (London: Smith, Elder & Co, 1912).

Killian Mullarney, Dan Zetterström and Lars Svensson, *Collins Bird Guide* (London: HarperCollins, 2011).

Graham Spinardi, 'Golfballs on the Moors: Building the Fylingdales Ballistic Missile Early Warning System', *Contemporary British History*, 21:1 (2007).

Adam Watson and Robert Moss, *Grouse* (London: Collins, 2008).

Donald Watson, *The Hen Harrier* (Berkhamsted: T. & A. D. Poyser, 1977).

B. C. F. Wilson, *A History: Royal Air Force Fylingdales* (Fylingdales: Royal Air Force Fylingdales, 1983).

8. The Watershed

Anon., *Emma; or, the Miner's Cottage: a Moral Tale Founded on the Recent Adventures of the Poachers and the Attempts of the Soldiers and Constables to Take Them, in Alston-Moor, in 1819* (Alston: John Pattinson, 1821).

W. H. Auden, *A Certain World: A Commonplace Book* (London: Faber & Faber, 1971).

—, *Collected Poems* (London: Faber & Faber, 1976).

—, *The Dyer's Hand, and Other Essays* (London: Faber & Faber, 1963).

—, *The Enchafèd Flood* (New York: Vintage, 1967).

—, Katherine Bucknell (ed.), *Juvenilia: Poems 1922–28* (London: Faber & Faber, 1994).

Basil Bunting, *The Complete Poems* (Oxford: Oxford University Press, 1994).

Caesar Caine, *Capella de Gerardegile* (Haltwhistle: R. M. Saint, 1908).

Humphrey Carpenter, *W. H. Auden* (London: George Allen & Unwin, 1981).

W. H. R. Curtler, *The Enclosure and Redistribution of Our Land* (Oxford: Clarendon Press, 1920).

Richard Davenport-Hines, *Auden* (London: William Heinemann, 1995).

Peter Davidson, *The Idea of North* (London: Reaktion, 2005).

Robert Forsythe, *An A–Y of Auden's Pennine Landscapes* (unpublished typescript, 2012).

'MacKenzie and MacBride', *Quaint Alston* (Penrith: Herald Printing Company, 1935).

Dave McAnelly, 'The Tragic Death of Thomas Parker Liddell', *North Pennine Heritage Trust Newsletter*, 45 (Spring 2001).

Alan Myers and Robert Forsythe, *W. H. Auden: Pennine Poet* (Nenthead: North Pennines Heritage Trust, 1999).

Charles Osborne, *W. H. Auden: The Life of a Poet* (London: Eyre Methuen, 1980).

Isaac E. Page, *Walks Round Alston* (Carlisle: W. Etchells, 1893).

Tom Pickard, *Custom & Exile* (London: Allison and Busby, 1985).

—, *The Dark Months of May* (Chicago: Flood Editions, 2004).

—, *High on the Walls* (London: Fulcrum Press, 1967).

Arthur Raistrick, *A History of Lead Mining in the Pennines* (London: Longmans, 1965).

—, *The Pennine Dales* (London: Arrow, 1972).

—, *Two Centuries of Industrial Welfare* (Buxton: Moorland, 1977).

Alastair Robertson, *The Foreigners in the Hills* (Alston: Hundy Publications, 2012).

—, *A History of Alston Moor* (Alston: Hundy Publications, 1999).

—, *Whitley Castle: Epiacum* (Alston: Hundy Publications, 2007).

Joan Rockwell, *Chronicles of Alston* (London: Janus, 1993).

T. Sopwith, *An Account of the Mining Districts of Alston Moor, Weardale and Teesdale* (Alnwick: W. Davison, 1833).

Louise M. Thain, *The Story of Nenthead* (Nenthead: Nenthead Women's Institute, 1960).

W. Wallace, *Alston Moor: Its Pastoral People: Its Mines and Miners* (Newcastle: Mawson, Swan, & Morgan, 1890).

9. The White Lands

Beryl Charlton, *The Story of Redesdale* (Hexham: Northumberland County Council, 1986).

—, *Fifty Centuries of Peace and War: an Archaeological Survey of the Otterburn Training Area* (Otterburn: Ministry of Defence Otterburn Training Area, 1996).

Richard Cross and Beryl Charlton, *Then and Now: Otterburn Training Area: the First 100 Years* (Defence Estates Infrastructure Organisation, 2012).

George Macdonald Fraser, *The Steel Bonnets: the Story of the Anglo-Scottish Border Reivers* (London: Collins Harvill, 1989).

Frank Graham, *Otterburn and Redesdale* (Newcastle: Frank Graham, 1976).

John Keenan, *The First Eighty Years: A Short History of Otterburn Training Area* (unpublished typescript, 1994).

Alistair Moffat, *The Reivers* (Edinburgh: Birlinn, 2007).

Thomas Percy, *Reliques of Ancient English Poetry* (Edinburgh, James Nichol, 1858).

H. G. Ramm et al., *Shielings and Bastles* (London: Royal Commission on Historical Monuments, 1970).

Evelyn Adelaide Sharp, *Dartmoor: a report by Lady Sharp G.B.E. to the Secretary of State for the Environment and the Secretary of State*

for Defence of a public enquiry held in December, 1975 and May, 1976 into the continued use of Dartmoor by the Ministry of Defence for training purposes (London: HMSO, 1977).

George Macaulay Trevelyan, *The Middle Marches* (Newcastle: Northumberland and Newcastle Society, 1935).

Rachel Woodward, *Military Geographies* (Oxford: Blackwell, 2004).

—, *Defended Territory: The Otterburn Training Area and the 1997 Public Enquiry*, research report (Centre for Rural Economy, University of Newcastle upon Tyne, 1998).

Index

The following letters denote locations: A (Alston Moor); B (Bodmin Moor); C (Calder Valley); D (Dartmoor); E (Exmoor); H (Haworth moors); N (North York Moors); O (Otterburn Training Area); S (Saddleworth Moor)

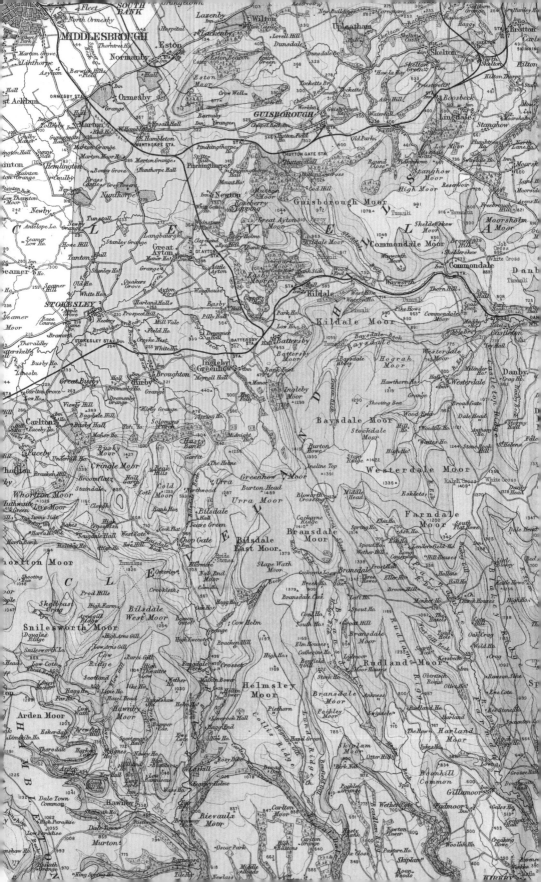